365 WAYS TO SAVE THE EARTH

Philippe Bourseiller

Foreword by Elizabeth Kolbert
Text by Anne Jankéliowitch and Ariel Dekovic

Translated from the French by Simon Jones

Harry N. Abrams, Inc. Publishers

To Frédéric and Nicolas with all my heart

"You cannot stop a bird in flight..."

The book that you are holding in your hands is based on contradiction or, if you prefer, disproportion. Each date presents a bit of advice for ordinary urban and suburban living: dispose of leftover paint properly; check your car's exhaust; boil only as much water as you need when making tea or coffee. Paired with each proposal is one of Philippe Bourseiller's spectacular photographs of the natural world—Alaska's Denali massif, Hawaii's Kilauea volcano, or Patagonia's Cerro Torre. On the left is the quotidian, on the right the sublime.

The amazing thing about this disproportion is that it turns out to be not at all disproportionate. How we go about our daily lives—what we eat, how we get to work, where we build our houses—has a transformative effect not just on our immediate surroundings, but on places as far away as the North Pole and Antarctica. In days spent moving from underground parking garages to hermetically sealed office towers and back again to air-conditioned homes, this fact is easily overlooked, and therefore it is all the more imperative that we attend to it. The food we buy in the supermarket often comes from halfway around the world; by purchasing it, we may be supporting the destruction of distant forests and indigenous cultures. The fertilizer we apply to our lawns washes off into streams and eventually into the sea, where it contributes to algae blooms that produce eutrophic "dead zones" where no fish can survive. The water we pump from underground aquifers cannot be replaced as quickly as it is withdrawn; what we waste running half-empty dishwashers today will be lost to future generations that surely will need it.

Global warming is perhaps the clearest example of how our ordinary, everyday actions alter the planet. One of the most astonishing places that Philippe Bourseiller photographed for this volume is Greenland, which, after Antarctica, is home to the world's largest ice sheet. Last summer, I visited Greenland to interview scientists who

were studying the effects of warming on the ice. I spent a day in a village on Disko Bay watching icebergs float out to sea and while I was there I spoke with some native fishermen. They described how they have seen the icebergs in the bay steadily grow smaller in recent years; instead of towering mountains of white that drift around for weeks, the icebergs now tend to be low and more likely to break apart. They also told me that for as long as anyone could remember, the bay had remained frozen over for several months each winter. For the last few years, however, there has been open water in Disko Bay all year long. The fishermen are alarmed by the change, as we all should be.

Sea ice reflects sunlight; open water absorbs it. Great stretches of Arctic sea ice are disappearing and as they vanish the earth's reflectivity decreases. The result is a feedback mechanism that amplifies human-induced global warming and pushes us closer and closer to catastrophe. Scientists warn that if we do not take steps soon to curb our emissions of greenhouse gases, we could begin to melt not just the sea ice, but the Greenland ice sheet itself. Greenland's ice sheet holds enough water to raise global sea levels by twenty-three feet.

Americans make up only four percent of the world's population, and yet we produce nearly a quarter of the world's greenhouse gas emissions. This imposes on us a particularly heavy responsibility for the way the planet is changing. Roughly three-quarters of all electricity in the United States is produced by burning fossil fuels, so every time we flip on the lights, turn on the coffee maker, or watch the news on TV, we are adding to the problem, if indirectly. We contribute to it directly whenever we go out for a drive. Probably the single-most important step any individual can take to reduce his or her emissions is to purchase a fuel-efficient car and then, as often as possible, leave it in the garage. Global warming is

not a problem that can be "solved" by individual actions; that demands a concerted international effort—one that will stretch over decades. However, unless we Americans take steps to reduce our impact on this issue, it is hard to imagine how it can ever be addressed successfully.

One of the themes of Philippe Bourseiller's photography is the power of nature; another is nature's vulnerability. This, too, seems to be a contradiction that ultimately is not. The forces that have shaped the planet over eons—whether volcanic eruptions or tectonic shifts—remain beyond man's influence. A human figure walking across the Greenland ice sheet or scaling Trou de Fer on Réunion appears as little more than an orange or grey dot in Bourseiller's photographs. At the same time, we tiny human beings have already proved to be quite capable of, and indeed adept at, destroying species that inhabited the planet long before our own species evolved. We are now in the process of altering the chemistry of earth's atmosphere by burning fossil fuel deposits that were laid down during the age of the dinosaurs. Already we have succeeded in raising carbon-dioxide concentrations to a level higher than at any other point in the last three-and-a-half million years. "The lifetime of one human being is nothing on a geological scale, but the traces he leaves behind can be unbelievably destructive," Bourseiller observed.

For all their grandeur, the photographs collected in this volume are elegiac. "I do not change or transform reality," Bourseiller has said about his work. "I am content with just seizing an instant of it. I hope my photographs help people become aware and fully conscious of the fact that the extraordinary landscapes that surround us are extremely fragile and they must be protected constantly."

—Elizabeth Kolbert

Categories

Home

January: 2, 4, 5, 7, 13, 16, 18, 26, 28, 30
February: 1, 3, 6, 7, 10, 15, 17, 21, 23, 25, 28
March: 1, 10, 12, 14, 18, 23, 26, 28, 30
April: 2, 7, 8, 17, 19, 22, 26, 28, 29
May: 4, 5, 7, 13, 14, 17, 20, 22, 23, 25, 28, 30, 31
June: 1, 2, 5, 6, 7, 11, 13, 21, 22, 24, 26, 27, 30
July: 5, 8, 9, 18, 19, 24
August: 1, 7, 9, 17, 21, 24, 28
September: 5, 6, 8, 14, 18, 21, 24, 25, 27, 30
October: 1, 3, 6, 9, 11, 12, 16, 17, 18, 20, 23, 30, 31
November: 5, 7, 8, 10, 11, 16, 18, 21, 29
December: 2, 5, 6, 8, 11, 14, 16, 17, 19, 28, 30

Shopping

January: 1, 8, 9, 12, 15, 17, 20, 22, 27, 31
February: 4, 16, 19, 22
March: 2, 5, 9, 11, 15, 19
April: 1, 3, 5, 15, 18, 23, 27
May: 2, 8, 9, 18
June: 12, 15, 16, 23, 28
July: 3, 6, 11, 17, 23, 25, 27, 28, 29
August: 3, 11, 19, 22, 23, 27
September: 2, 9, 11, 23, 26, 29
October: 8, 15, 21, 24, 29
November: 4, 9, 12, 15, 17, 19, 23, 26
December: 20, 24, 27, 29, 31

Leisure

January: 10, 11, 24
February: 2, 5, 13, 14, 26
March: 3, 13, 16, 24, 29
April: 6, 13, 14, 16, 21, 25
May: 6, 12, 16, 19, 26, 27
June: 3, 8, 9, 14, 17, 19, 20, 29
July: 7, 10, 13, 14, 15, 16, 19, 20, 26, 31
August: 2, 6, 14, 18, 20, 25, 26, 31
September: 1, 7, 13, 19, 28
October: 4, 7, 19, 26, 27
November: 6, 24
December: 12, 18, 22, 25, 26

Transportation

January: 19, 23, 25

February: 11, 20

March: 4, 6, 8, 20, 31

April: 4, 11

May: 10, 21

June: 10, 18, 25

July: 2, 12, 22

August: 4, 5, 8, 13

September: 10, 22

October: 2, 14, 28

November: 2, 22, 27

December: 1, 7

Children

January: 6

March: 22, 27

April: 10

May: 1

June: 4

July: 21, 30

August: 10, 16, 29

September: 3, 16, 20

October: 10

November: 30

December: 15, 21, 23

Office

January: 14, 21

February: 9, 18, 27

March: 7, 17

April: 9, 30

May: 15

July: 4

August: 30

September: 4, 15

October: 5, 13, 22, 25

November: 1, 3, 13, 14, 20, 28

December: 3, 9, 10

Gardening

January: 3, 29

February: 8, 12, 24

March: 21, 25,

April: 12, 20, 24

May: 3, 11, 24, 29

July: 1

August: 12, 15

September: 12, 17

November: 25

December: 4, 13

Buy recycled.

To save natural resources, it is essential to buy products that can be recycled. For recycling to work, recycled goods must find a buyer. Contrary to popular belief, recycled goods are not of poorer quality; on the contrary, they perform at least as well as products made from new raw materials. And, while it is true that some recycled goods are more expensive, others, which have been on the market for years, have already fallen in price. It is up to consumers to help this process by buying them.

Consider buying recycled office supplies; building materials; textiles, like fabric and carpeting; and products for your car.

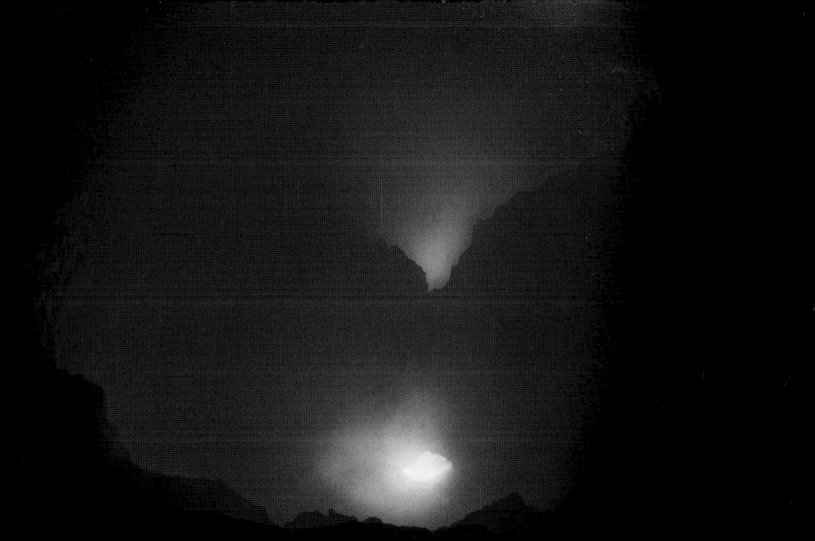

Turn down your heating by 5°F.

Buildings are a major source of the greenhouse gases responsible for climate change. Two-thirds of the energy used by buildings is for heating and hot water. Carefully managing our domestic heating allows us to minimize global warming and to avoid further polluting the air around us.

Our homes are often heated to excess. The ideal living room temperature is 68°F, and bedrooms are healthier at 64°F. Each 5°F increase in temperature produces a 7% to 11% increase in energy consumption (depending on how well-insulated your home is). Use your heat wisely, and insulate well.

Whale shark, Australia

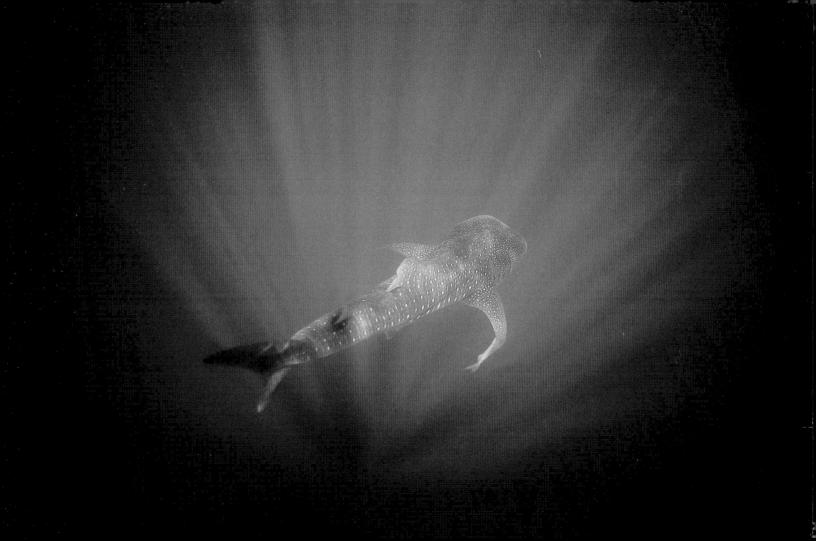

Recycle your Christmas tree.

As soon as Christmas is over, countless Christmas trees are dumped on sidewalks, to be picked up with the household waste and burned in incinerators. This process, which is costly for the community, involves the waste of a raw material that could benefit the soil. Some towns collect the trees for composting. In Georgia, more than 135 communities and organizations sponsored a Bring One for the Chipper Christmas tree composting event. Over the last 15 years, the program has recycled almost 4 million trees.

If your local authority does not collect Christmas trees, ask if it can arrange to do so. Also, consider alternatives, like a potted Christmas tree that can later be planted in the garden.

Blizzard over the inlandsis (continental ice sheet), Greenland

Lobby for the right for access to renewable electricity.

In some states it is possible to sign onto renewable energy choices through your electricity provider. Other states do not provide this option. Renewable energy has far less negative impact on the environment than fossil fuels and nuclear power. If you are able to invest in renewable energy, usually it is not delivered to your location, but rather is supplied elsewhere on the grid; your contribution goes to "displacing" the use of non-renewable power elsewhere.

Find out how you can buy green electricity. If you do not have access to it through your utility, press your local officials to make it an option. Everyone should have the right to invest in renewable energy.

Aurora borealis, Finland

Improve the efficiency of your radiators.

The world's consumption of energy produces vast amounts of pollution and waste, especially that produced by the nuclear industry. Today there are 438 nuclear power stations in the world; an additional 34 are being built, of which 20 are in Asia. Among them they produce 17% of the world's electricity, and 10,000 tons of nuclear waste per year, in addition to the 200,000 tons already in existence.

To reduce your domestic energy consumption, make your radiators more efficient by placing reflective panels behind them that will bounce the heat back into the room.

Namib Desert, Namibia

Suggest composting at your children's school.

The organic part of our household waste can be converted, through the action of microorganisms that cause decomposition, into a substance called compost. This entirely natural fertilizer improves the soil, increases the soil's ability to retain air and water, checks erosion, and reduces the need for chemical fertilizers. One pound of organic waste produces almost 6 ounces of compost.

———

The composting of organic waste is unquestionably in the best interest of the community. For your children's cafeteria, or your workplace eatery, take the initiative by explaining the economic and ecological advantages of composting. Encourage them to study the foods that are discarded most and urge them to think of alternatives, or of solutions to the waste problem.

Klyuchevskaya volcano, Kamchatka, Russia

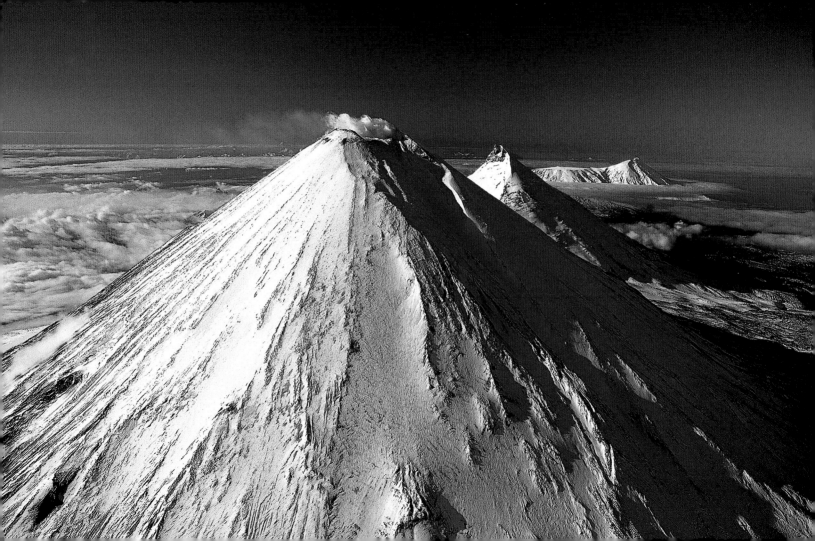

Reduce the amount of water flowing into your toilet's tank.

Any water that has been used in the home, except water from toilets, is called graywater. This water—from dishwashers, showers, sinks, and laundry machines—accounts for at least half of all residential wastewater and may be used for other purposes, especially in yards and gardens. While some ecologically oriented buildings in the United States have installed graywater systems, it has yet to make an appearance in this country on a larger scale.

By placing a bottle filled with sand in your lavatory cistern you will reduce the volume of water used with each flush, saving the volume of the bottle each time you flush. Don't use a brick—pieces of decaying brick can get into the toilet's system and cause leaks. Better yet, replace your toilet with a low-flow toilet, which can decrease water use to 1.6 gallons for every flush.

Iceberg, Greenland

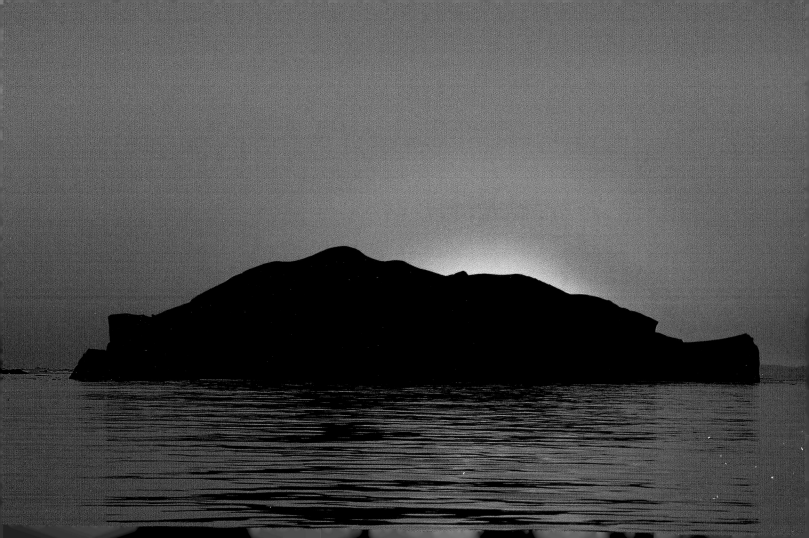

Buy fair-trade products, and help combat child labor.

Worldwide, approximately 211 million children between the ages of 5 and 14 years are forced to work. Three-quarters of these children work in agriculture. Employed on sugar cane, tea, tobacco, and coffee plantations, they often work in fields freshly sprayed with pesticides, sometimes working even while spraying is taking place. The fair-trade label guarantees that a product comes from an equitable situation in which there is fair payment for workers, forced labor is forbidden and, of course, children are not used as cheap labor.

Buying fair-trade products is, among other things, a way of safeguarding basic human rights, in particular the rights of children.

Lagoons, Baja California, Mexico

Make it a rule to buy only organic of a given product.

To protect crops from parasitic insects and plants, farmers use pesticides; to increase the yields of their crops, they spread fertilizers. World consumption of these chemicals is growing nonstop: it leaped from 30 million tons a year in 1960 to 140 million tons in 2000. The U.S. Environmental Protection Agency estimates that pesticides contaminate groundwater resources of 38 states; 67 million birds were among the victims of pesticides in the last year.

Organic farming spares the environment this degradation. To help encourage it, choose a product that you will always buy from an organic producer. Some good choices for this strategy are strawberries, apples, and spinach; these products retain the highest levels of pesticide residue. You can then broaden the range of products for which you buy organic at your own pace.

Acacia, Namibia

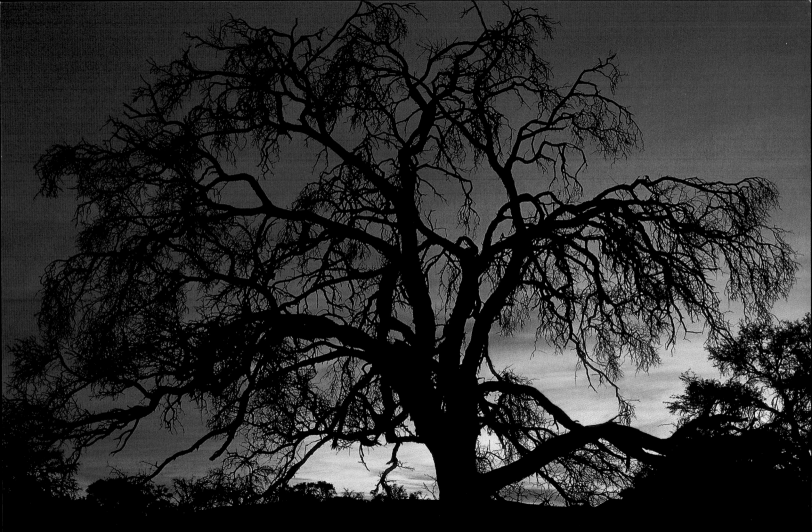

Sign an environmental charter for your favorite leisure activity.

Sometimes an unscrupulous diver returns from an outing carrying some magnificent pieces of coral. What would remain of the surrounding fauna if hundreds of others did the same? Sometimes a yachtsman will tip several quarts of oil overboard. What would happen to the environment if dozens of boats followed that example in some remote cove?

———————

Make sure you respect nature in your outdoor activities. Lovers of mountain climbing, of diving, and of sailing find that there is an environmental charter for their sport, to encourage responsible behavior. Check with your national federation and if such a charter does not exist, suggest that one be drawn up.

Soft coral, Indonesia

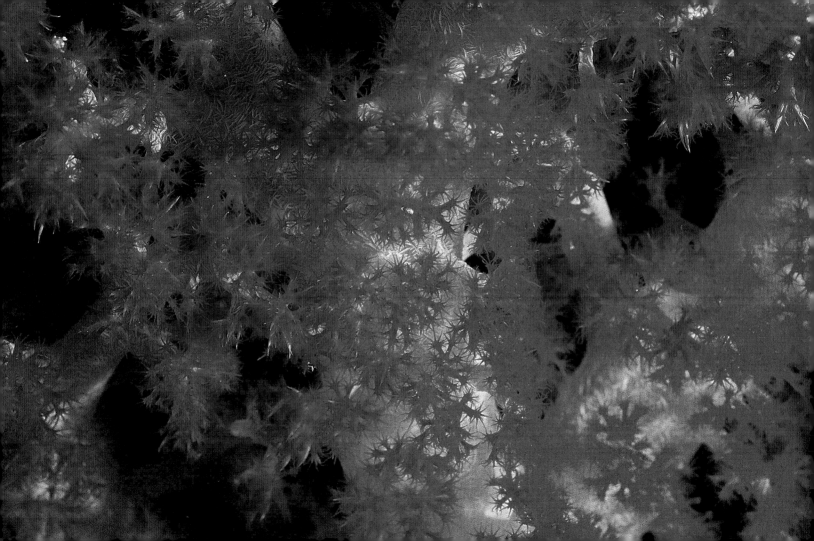

Do not feed wild animals.

Whether they are birds or mammals, on land or at sea, feeding wild animals changes their diet and can alter their behavior; they may grow accustomed to the presence of humans and risk becoming dependent on receiving food instead of obtaining it themselves. Moreover, touching them may endanger their health by exposing them to illnesses to which they are not immune—as well as put your own health at risk.

Be content to watch wild animals from a distance without trying to attract them with food. Make sure you put your own food and trash out of reach of wild animals, so they are not tempted to help themselves while you are not looking.

Marine iguanas, Galápagos Islands

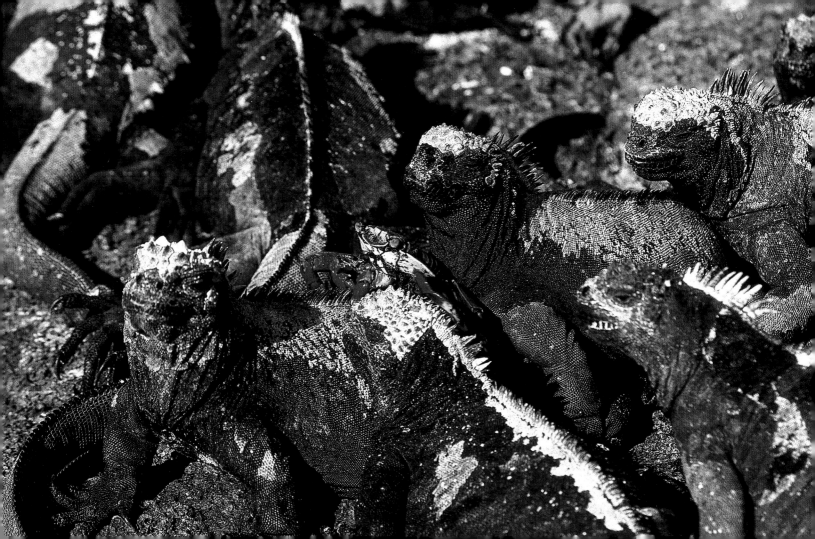

Reward socially responsible companies by investing in them.

Socially Responsible Investments (SRIs) are made with companies that take into account the social and environmental impact of their activities. Such investments support projects that encourage social integration and job creation, as well as initiatives in areas such as ecology, renewable energy, fair trade, and organic farming and food.

SRIs, which generally carry little risk, are offered by various savings institutions and include simple mutual funds, life insurance contracts, and deposit accounts. There is certainly one to suit your needs and interests.

Patagonia, Argentina

Use the refrigerator properly.

Refrigerators and freezers require large amounts of energy to chill foods. However, with a little care you can avoid waste without losing any of the benefits of this essential everyday comfort. Perhaps the greatest impact on energy use of a refrigerator is the temperature of the room it is in. A 10°F decrease in the ambient room temperature can decrease energy use by 40%.

Do not place your refrigerator or freezer near a heat source, such as a cooker, a mini-cooker placed on the appliance, a heater or radiator, or a south-facing window. Also, take care not to place hot dishes in the refrigerator, or to overfill it. Such bad habits will waste energy.

Hoarfrost, Sweden

Coffee, milk, and sugar: say "no" to individual portions.

Coffee in mini-portions uses 10 times as much packaging as when it is purchased in bulk. This extra packaging adds 20% to 40% to the cost of a product.

———

At your workplace, suggest that individual servings of coffee, tea, sugar, and cream be replaced by large packages for everyone's use. You will reduce the amount of packaging and the cost. The price of individually packaged foodstuffs is often in inverse proportion to the serving size.

Sandstone menhirs, Chad

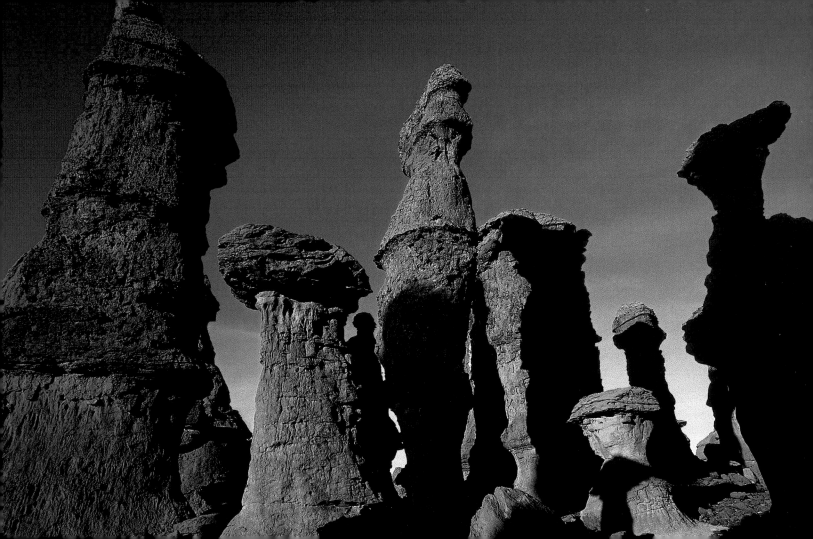

Use natural paints.

Many paints are veritable cocktails of chemicals. Avoid paints that contain heavy metals (especially those made from lead, a lethal poison), VOCs (volatile organic compounds), toxic organic pigments, and antifungal compounds.

Replace them with natural paints made from plants that have a mineral base, such as vegetable oils (linseed, castor oil, rosemary, or lavender), beeswax, natural resins (such as pine), casein, or chalk as binders; balsamic oil of turpentine, or citrus distillates as solvents; and vegetable pigments (valerian, tea, onion), or mineral ones (sienna, iron oxides). All you have to do is choose your color.

Sand dunes, Algeria

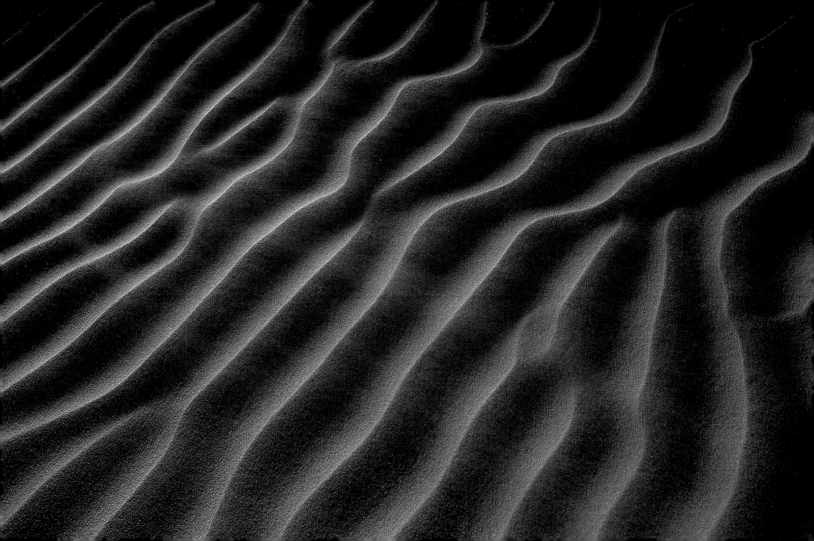

Switch off lights you don't need.

Greenhouse gases are naturally present in the atmosphere and maintain temperatures on earth that are favorable to life. Too much greenhouse effect, however, leads to warming of the global climate. In the space of a century, world energy demand—used for electricity, heating, and transportation, for example—has increased by a factor of thirteen. Most of this energy comes from oil, gas, and coal, which produce greenhouse gases.

Make a point of switching off lights that do not need to be on, especially when you leave a room, and try to use daylight instead wherever possible. The less that electricity is used, the less energy is needed, and therefore less greenhouse gas is pumped into the atmosphere.

Lava, Kilauea volcano, Hawaii

Check the energy efficiency rating when you buy household appliances.

The energy consumption of household electrical appliances can vary by a factor of up to five, depending on the model. When you are buying a new appliance, take care to find out its electricity consumption: your bill will benefit.

The Energy Star, an internationally recognized symbol of energy efficiency, means that a product meets strict environmental standards set by the U.S. Environmental Protection Agency. Qualified televisions use 3 watts or less per hour when switched off, as compared to conventional televisions, which can draw 6 watts. Always buy products with the Energy Star when you replace your old appliances.

Piton de la Fournaise volcano, Réunion

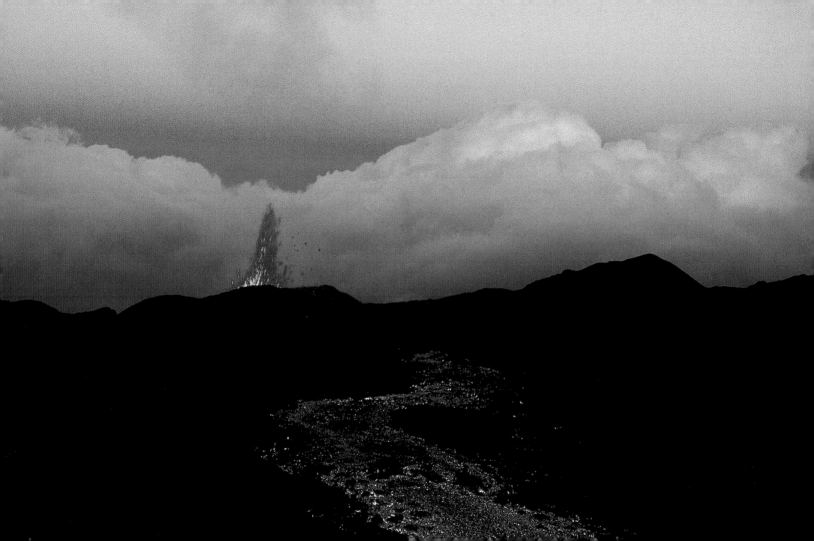

Rediscover your grandmother's remedies.

Chemicals have invaded our lives. In the 1980s there were 500 times as many chemical products as during the 1940s. Today, an average family uses 30 gallons of various chemical cleaners each year. These products, which generally contain substances harmful to health and the environment, inevitably find their way into water, air, and soil.

Rediscover your grandparents' natural remedies: dishwashing solution for oil stains, benzene soap for grease stains, milk and lemon for ink, lemon juice for polishing copper, and so forth.

Mud cauldrons, Kamchatka, Russia

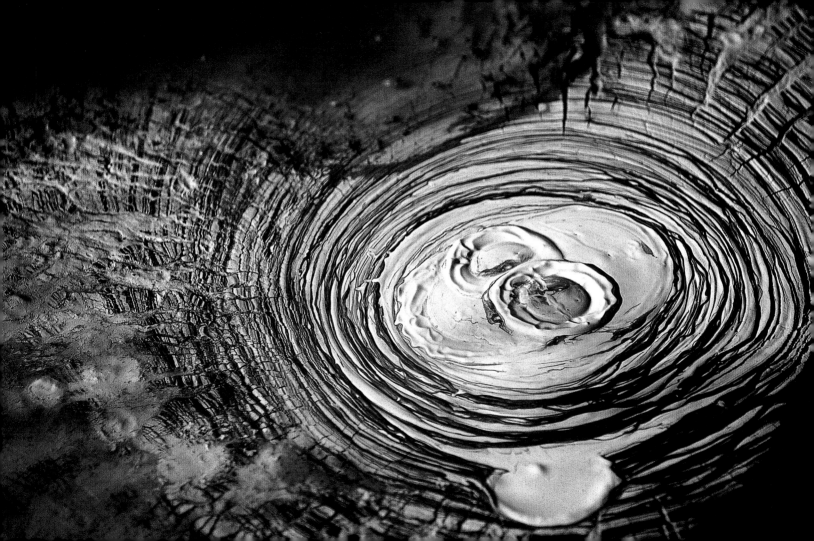

Drive more slowly.

It has taken nature 250 million years to produce the oil that we will probably use up in the next century. Every American burns the equivalent of 8.2 tons of oil per year; a European uses 3.3 tons; and the inhabitant of a developing country uses only 0.6 tons. Use of oil for transport continues to rise at 4% per year, but this increase masks certain inequalities. The average American citizen consumes the equivalent of 1,722 gallons of oil annually; each German citizen consumes 1,050 gallons annually; and a citizen of Japan, 756 gallons.

———

Gas mileage declines quickly when traveling above 60 miles per hour. Each 5-mile increase above 60 is like paying an additional 10 cents a gallon for gas.

River, Iceland

Write to manufacturers urging them to keep GMOs out of animal feeds.

In 2003, 165 million acres of transgenic crops were grown worldwide; about 60% of these were grown in the United States. The global spread of GMOs is not the response to a need for new varieties; it is dictated purely by the desire for short-term profits. Present labeling regulations do not require disclosure of products from animals that have been fed GMOs (such as meat, fish, eggs, dairy products, desserts, or pre-packaged meals). Eighty percent of GMOs find their way into our food by this indirect route.

――――――――――――

You can write to farmers and distributors and urge them to keep GMOs out of animal feeds. In this way, you will keep them off your plate, and protect the environment.

Sea lion, Galápagos Islands

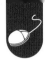

Choose "draft" quality when printing.

Printer cartridges contain pollutants such as aluminum, iron oxide, and plastic. Luckily, the cartridges are perfect for recycling. Whether damaged or empty, they can be dismantled and reassembled; defective parts may be recycled and refilled cartridges are of comparable quality to new ones. Ink powder, which is highly toxic, contains chemical pigments made from cyanide. If this finds its way to the dump, it will contaminate soil and water. During the recycling process, this powder is instead incinerated at 2,700°F.

The best way to reduce the pollution produced by ink cartridges is to use less ink. Remember to choose "draft" quality for all print jobs that do not require flawless print quality, in other words, most of them. Only print when necessary, as well.

Volcanic lake, Iceland

Avoid big box stores.

In wealthy countries today, consumers travel by car to do their shopping in big box stores built on the edges of urban areas. They store their food in freezers, which use more energy because products are sold in overpackaged portions. This system gives large retail organizations a high degree of control, which they use to force down farm prices or to import products from countries where labor is cheap and environmental legislation almost non-existent.

———————

Shop closer to home. Every new supermarket that opens causes hundreds of jobs to be lost. Pollution and congestion would be a fraction of what they are now if consumers frequented their local shops.

Pink flamingoes, Kenya

January 23

Properly dispose of old car batteries.

Car batteries are rechargeable electric cells containing lead and acid. These substances are extremely toxic to nature: a battery left in the countryside pollutes nearly 50 square feet around it for several years. The lead used in cars, in general, is the largest remaining source of lead pollution, and the majority of current lead use is for car batteries.

———

To recycle your old battery, call your department of public works to find out where to bring it, or take it to your local resource recovery center.

Lake Magadi, Kenya

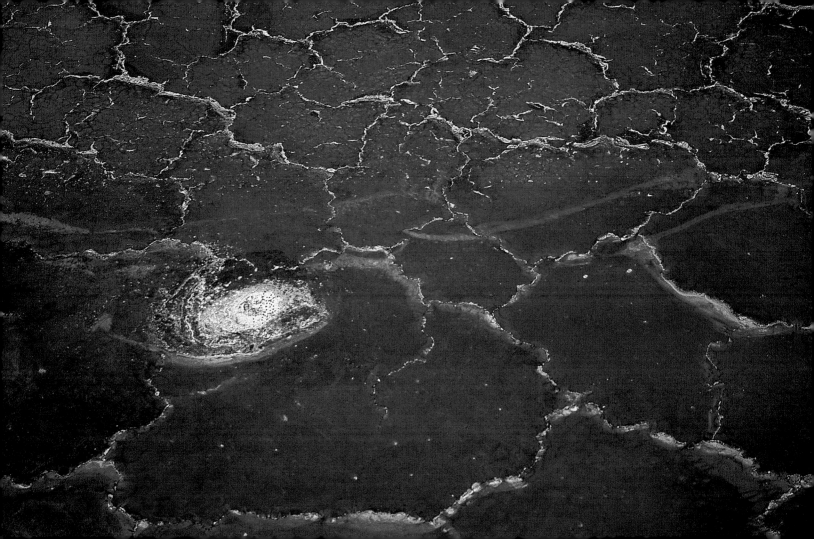

Support animal-friendly or animal-free circuses.

Wild animals used in circuses or traveling shows rarely live in humane conditions; they are often deprived of any kind of regular veterinary care, and are usually chained in one position for long periods of the day with no opportunity to move. Federal legislation meant to protect these animals is ineffective and rarely enforced. In addition, the transitory nature of circuses means that violators are rarely, if ever, pursued and prosecuted.

Do not patronize circuses or traveling shows that keep wild animals in captivity. Some communities have passed ordinances that prevent these shows from operating within their jurisdictions. Encourage your community to pass such an ordinance.

Clown fish, Australia

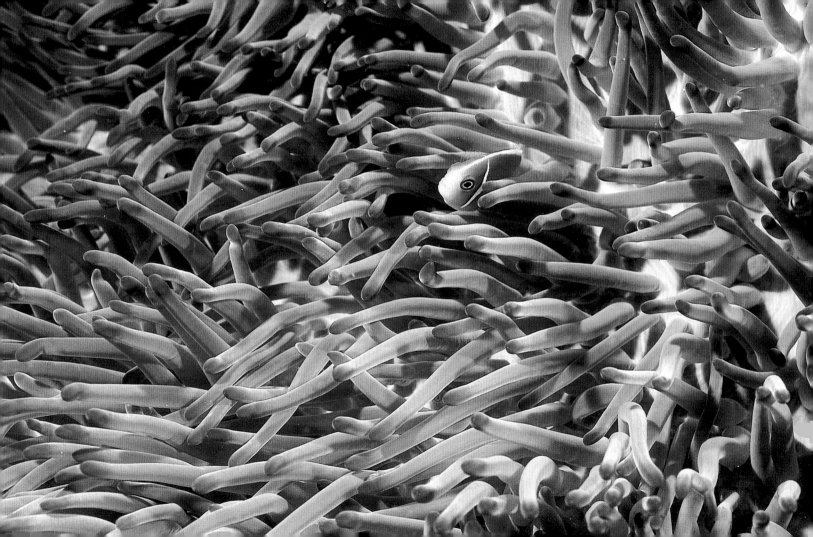

Use public transportation.

Air pollution is at the top of the list of problems caused by motor vehicles, followed by car accidents, noise, erosion of habitats by roads and freeways, and damage to plants and animals. Finally, cars take up too much space in cities, where 4 out of 5 trips are made by car. This congestion costs us dearly: drivers in one-third of U.S. cities spend the equivalent of one workweek in bumper-to-bumper traffic every year.

Use public transportation wherever possible. A bus can take 40 single-passenger cars off the road. Public transportation saves more than 855 million gallons of gasoline per year.

After the eruption of Mount Pinatubo, Philippines

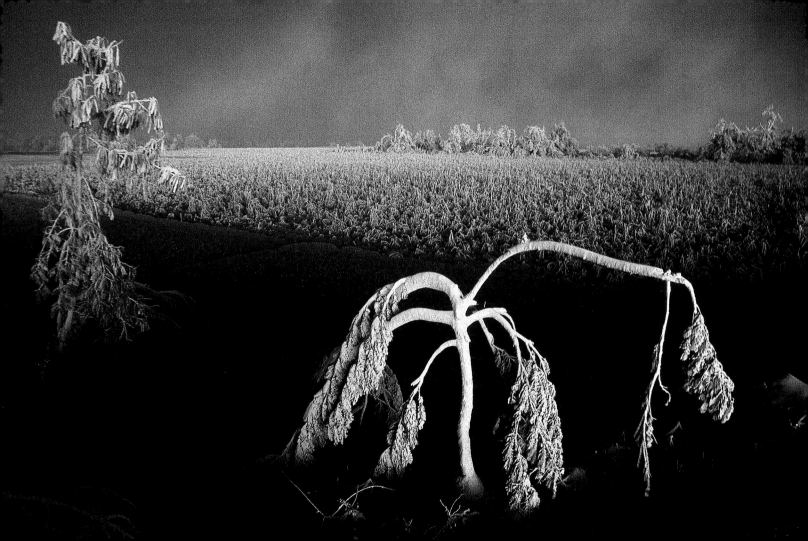

Have your boiler serviced regularly.

Domestic hot water should never be above 120°F. Above that temperature the excessive heat tends to lead to lime scale and corrosion of pipes and apparatus. Lime scale increases heating costs by insulating the water from the heating source, and therefore more energy is needed to heat the water. Moreover, a badly maintained boiler can also lead to air pollution within the home.

——————————

To check whether your apparently harmless boiler is poisoning the air in your home or contributing excessively to warming the planet, have it serviced once a year.

Sea lion, Galápagos Islands

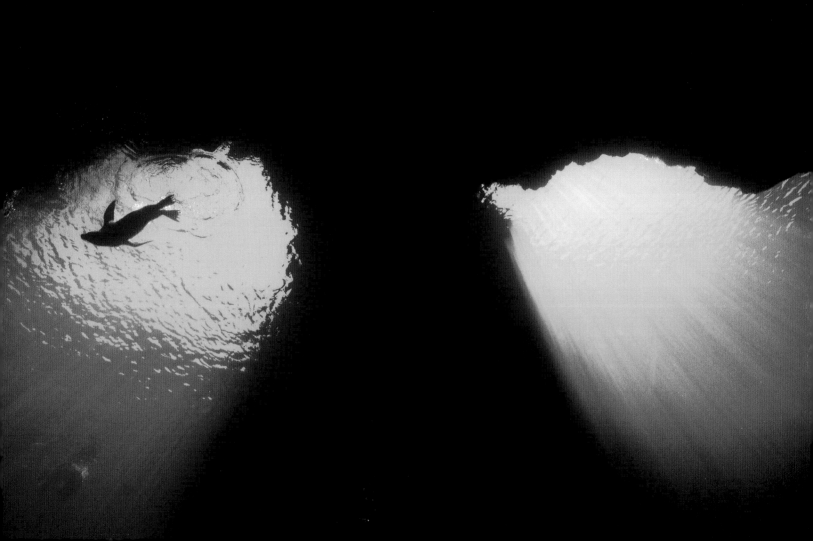

Buy low-phosphate soaps and dishwashing detergents.

Increased phosphorus concentrations cause excessive algae growth in our nation's water bodies. Though algae are the basis of life for many ecosystems, an overabundance causes lower levels of dissolved oxygen in the waters, which in turn disrupts ecosystems and causes fish kills. Algae blooms also result in decreased aesthetic and recreational values.

—————

You can choose low-phosphate or phosphate-free soaps and dishwashing liquids. Many popular brands, now widely available, have low phosphate levels.

River, Iceland

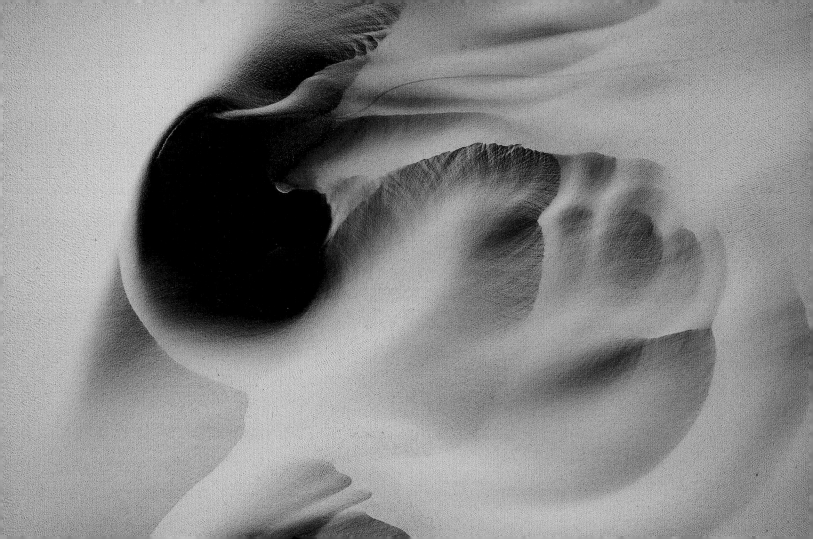

Turn off the vegetables early.

Climate change will have severe repercussions on plant and animal life. By changing natural habitats, it will create havoc, especially with species distribution. Many terrestrial species whose habitats will change will not be able to migrate quickly enough, will have nowhere to go, or will not have time to evolve and adapt to new conditions. Thus climate change is likely to threaten a quarter of the world's species directly. Certain studies have even suggested that by 2050 almost one in five species will have disappeared from the planet, even in the unlikely event that global warming is minimal.

In the kitchen, switch off the gas or electricity a few minutes before cooking is complete. You will make use of residual heat, which will continue the job while saving energy.

Vulcano, Aeolian Islands, Italy

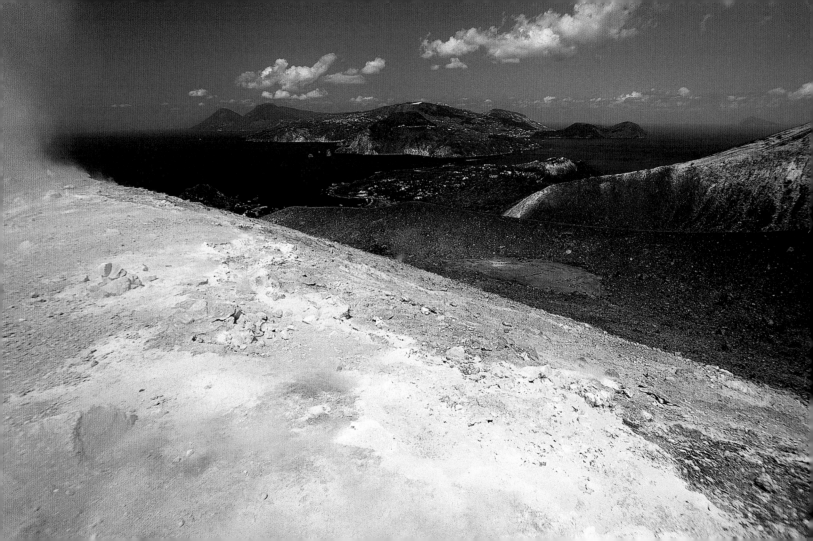

Compost nonrecyclable cardboard and paper.

You can reduce the volume of your trash by 80% simply by sorting your packaging, and composting all waste that is suitable. Yard trimmings, food residue, and other compostable items account for about a quarter of our annual waste.

———————

You can add some types of nonrecyclable paper and cardboard (such as tissues, wipes, egg cartons, and ash from your fireplace) to your compost as well. Their fibers will aerate the compost and thus help the organisms that cause decomposition.

Dwarf birches, Iceland

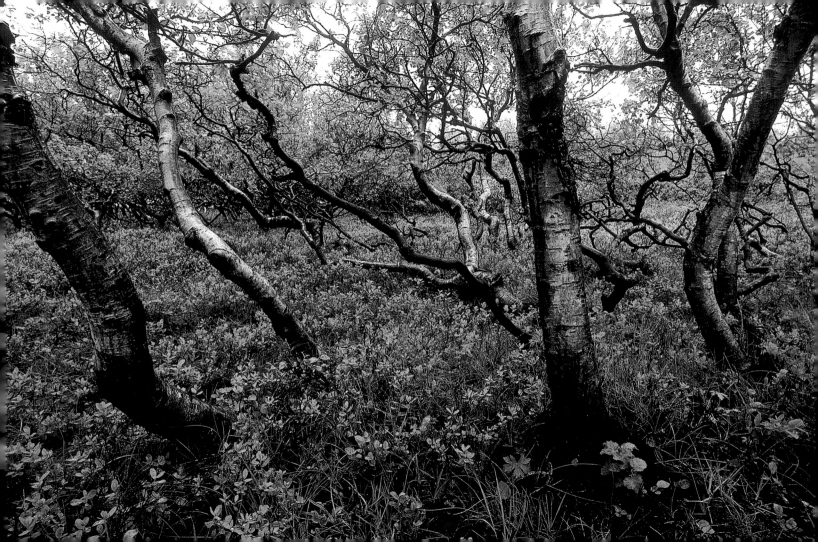

Reduce junk mail to reduce waste of raw materials.

Every year, 100 million trees, 28 billion gallons of water, and $320 million in local tax money are used for the production and disposal of junk mail. The general cost of transportation of junk mail is more than $550 million.

———

Having your name removed from a junk mail list can be as easy as sending a letter, postcard, or email, or making a phone call, to the source of the mailing.

Icebergs, Greenland

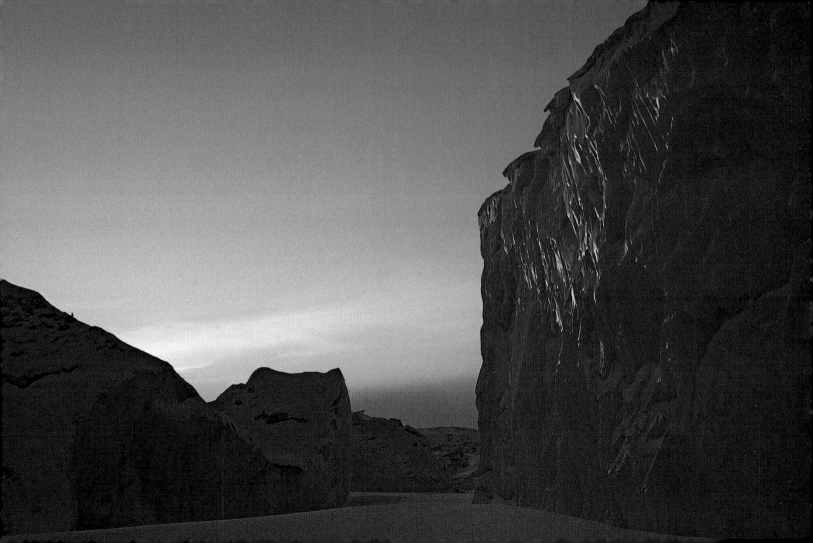

Be an ethical consumer.

The conditions of workers in developing countries, especially in Asia, are well known today. Some work up to 80 hours per week, and earn just a few cents per hour. It is impossible to continue to drive prices down and raise productivity indefinitely without abusing human rights or exploiting workers.

Buying a product means that you keep the company that made it in business, approve the conditions under which its employees work, support the way it makes its products, and encourage its environmental commitments—if it has any. Choosing everyday purchases in a way that reflects respect for the environment and society is one of the most direct influences you can have.

Murzuq *erg* (sand desert), Libya

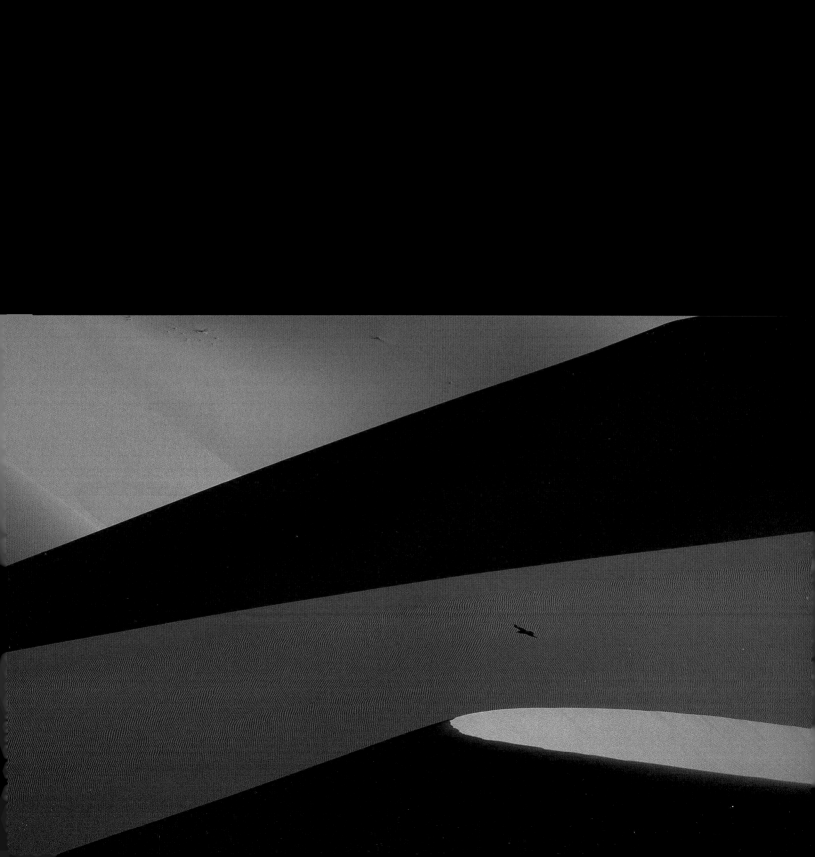

Investigate Zero Waste programs

Where is the "away" in "throw away"? Eighty percent of what we produce is thrown away within six months of its production. Rather than focus solely on the "end-of-pipe" solutions, we have to think about how to prevent the manufacture of products that quickly end up in the waste cycle. Zero Waste programs, which seek to reform the systems of production, construction, and consumption in order to address the growing waste crisis, have been successful in encouraging communities to adopt zero-waste resolutions.

Research Zero Waste programs and encourage your city or town to adopt a resolution.

Wayana Indians, Guyana

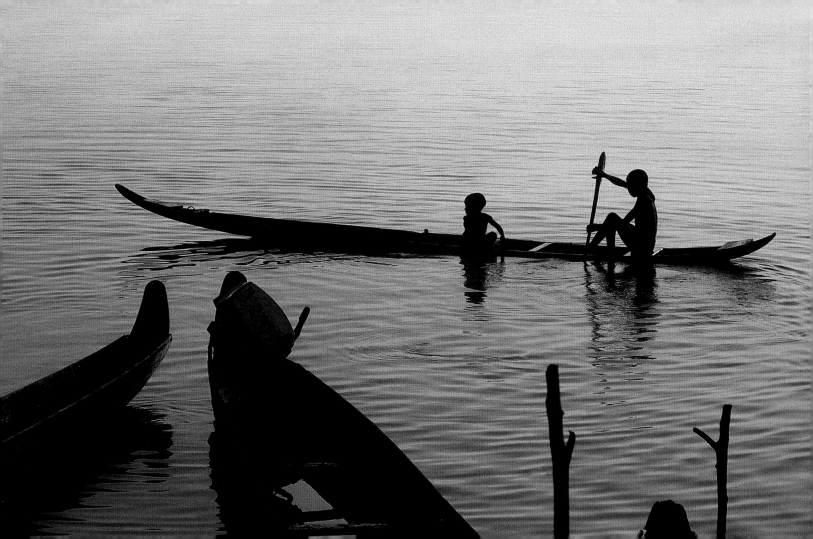

Take part in a bird population census.

For more than a century, the National Audubon Society has organized the Christmas Bird Count, an all-day census of early-winter bird populations. The data retrieved from this count represents the longest running database in ornithology. The primary goal of the project is to monitor the status and distribution of bird populations across the Western Hemisphere.

Lend your eyes and a little of your time to help with the next census. Among other things, you might learn how to recognize sparrows, cormorants, finches, herons, and gulls.

Sparrow, Galápagos Islands

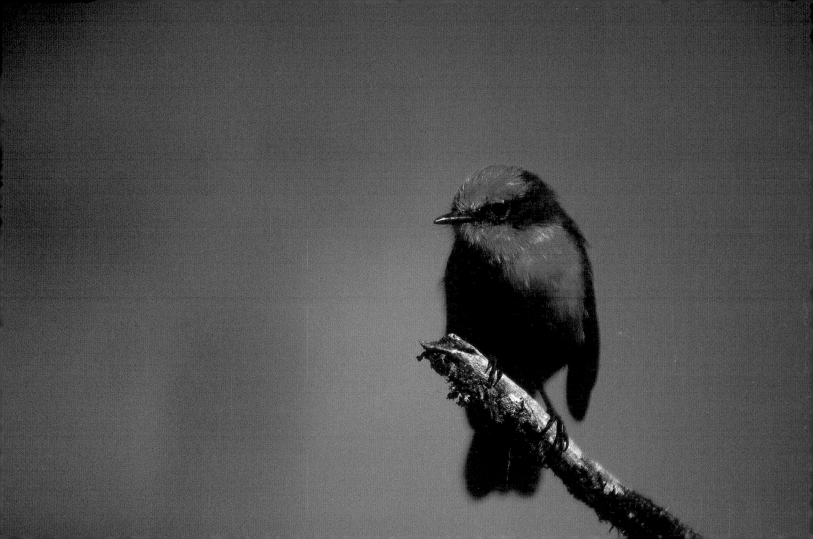

Turn off the tap while you brush your teeth.

Earth has been nicknamed the "blue planet" because of its abundance of water. This is misleading, however. If all the water on earth could be contained in a big bucket, the frozen fresh water at the poles and in glaciers would fill a small cup, and all the fresh water available to people—lakes, rivers, and ground water—would fit into a teaspoon. Our natural fresh water reserves are not expandable, and they must be shared among an ever growing global population.

Turning off the tap during the time it takes to brush our teeth saves almost five gallons of water. That is more than an average citizen of Kenya makes do with throughout an entire day.

River, Iceland

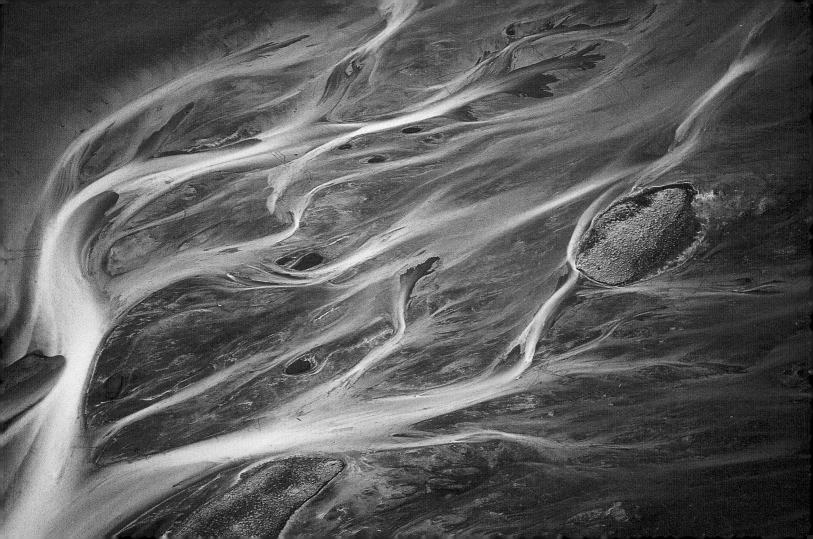

Don't eat swordfish.

North Atlantic swordfish, the type found in most East Coast restaurants and grocery stores, have been severely over-fished. At the turn of the twentieth century, the average swordfish weighed around 350 pounds; by the close of the century, the average fish weighed just 90 pounds. Swordfish populations today are at the lowest level ever recorded. More than half of the swordfish caught and sold today are juveniles that haven't had a chance to reproduce.

Don't purchase swordfish at the grocery store or in restaurants. Their populations are simply too threatened by today's fishing methods.

Kokerbooms (or "quiver trees"), Namibia

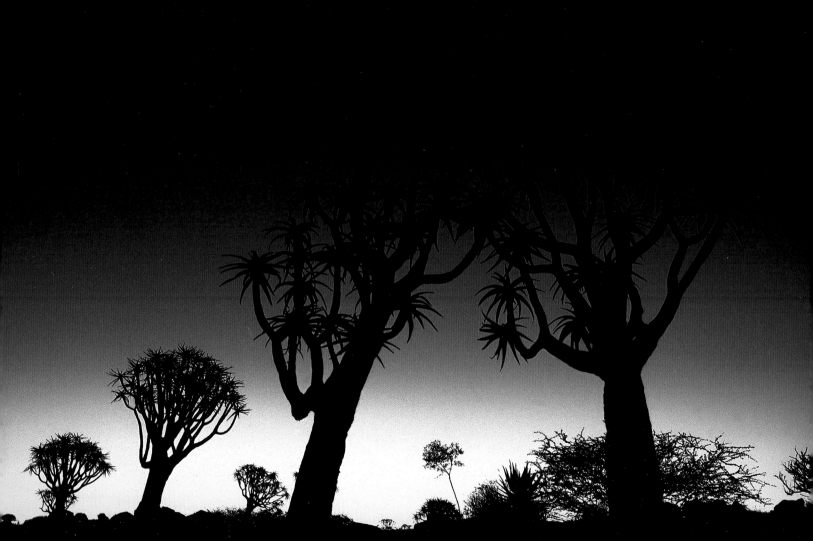

Do not litter in the mountains or on high summits.

Mount Everest, the highest point on the planet, has been a well-traveled destination for decades. As many as 300 climbers a day may gather at base camp during the peak season, and the area has suffered considerable pollution as a result. Recently, several cleanup campaigns have removed piles of trash from the roof of the world; the first operation at base camp eliminated 30 tons of waste. Nor has Mont Blanc in Europe been spared by the 3,000 climbers who trample its summit every year. Between 1999 and 2002, cleanup operations removed almost 10 tons of waste from the summit. The fragile environments of the high summits are sensitive to the slightest disturbances and easily damaged by mass tourism.

Do not contribute to the degradation of high places; leave nothing behind, and pick up what others irresponsibly throw away.

Cerro Torre, Argentina

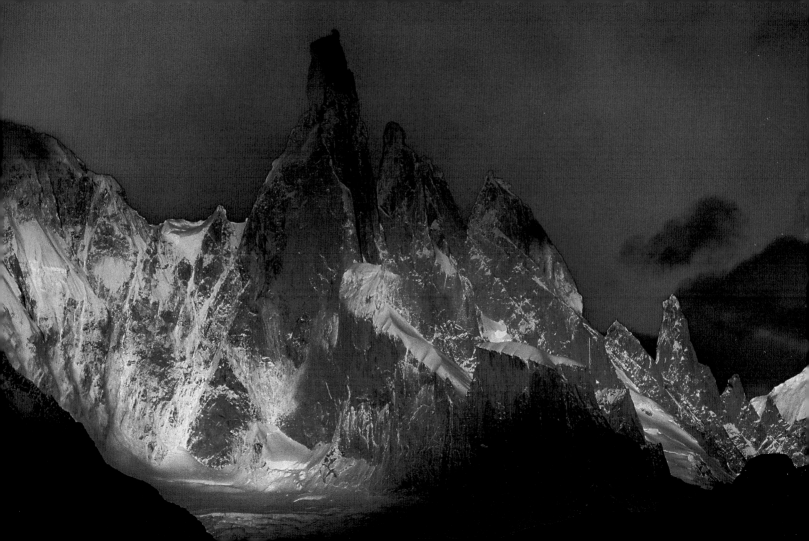

Do not leave the tap running while you wash dishes by hand.

The average American uses anywhere from 70 to 110 gallons of water per day. In developing countries, the amount of water used per person ranges from 5% to 20% of that amount. Indeed, we are easily fooled by the generosity of our taps. Each time we use them, a large part of the water goes down the drain without even being dirtied.

When you wash the dishes by hand, fill the sink rather than washing each plate under a continuously running tap. Also, turn off the tap while soaping your hands, shaving, washing the car, or hand-washing clothes. When a tap is turned on, 5 to 15 gallons of pure drinking water flow out every minute.

Inlandsis, Greenland

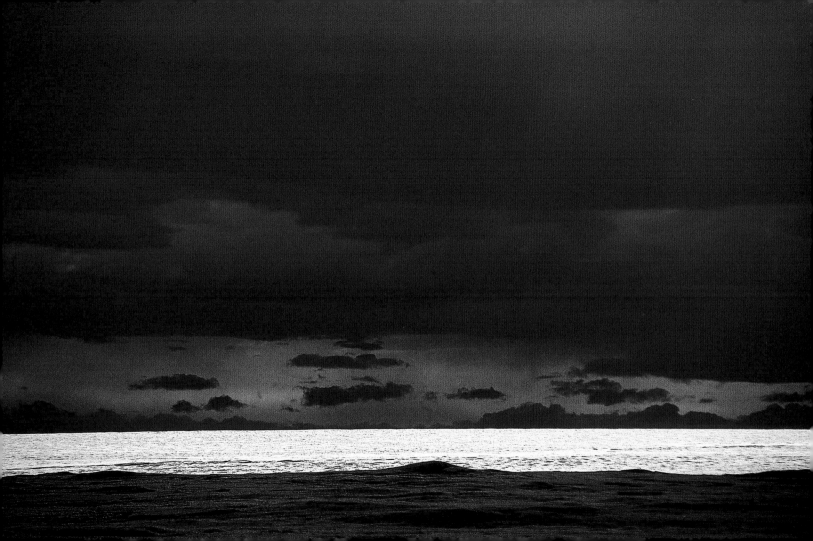

Prepare your glass bottles for recycling.

Every individual in the United States uses approximately 500 pounds of glass products each year. It is estimated that Americans discard over 11 million tons of glass bottles every year. If we recycled this glass, for every ton we would save 1,330 pounds of sand, 433 pounds of soda ash, 433 pounds of limestone, and 151 pounds of feldspar.

You can facilitate and improve glass recycling. Remove corks, and plastic and metal lids and rings from bottles, and make sure that windowpanes, light bulbs, mirrors, Pyrex items, porcelain, and earthenware go into the trash can. These are not recyclable and will contaminate your recycling collection.

Air bubbles trapped in ice, Canada

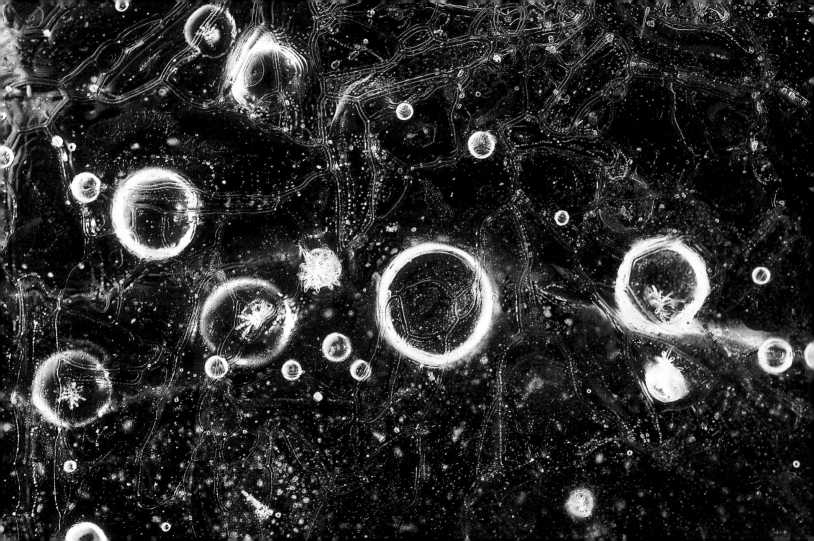

Collect rainwater.

Nature gives us rain, and for this, we pay nothing. Like solar and wind energy, collecting rainwater is a means of protecting the environment in a sustainable way. The rain that falls on the roofs of our houses could cover as much as 80% of our current annual domestic water consumption. In addition, collecting rainwater prevents it from flowing along the street, picking up pollutants, and depositing them into stormdrains and eventually into our waterways. Rainwater collection systems do double-duty, conserving water and protecting our environment from pollutants.

Have a rainwater collection system fitted to your house to meet outdoor water needs, like watering the lawn and washing the car. At the very least, put a rubber garbage can beneath your rain gutter to collect water.

Sossusvlei dunes, Namibia

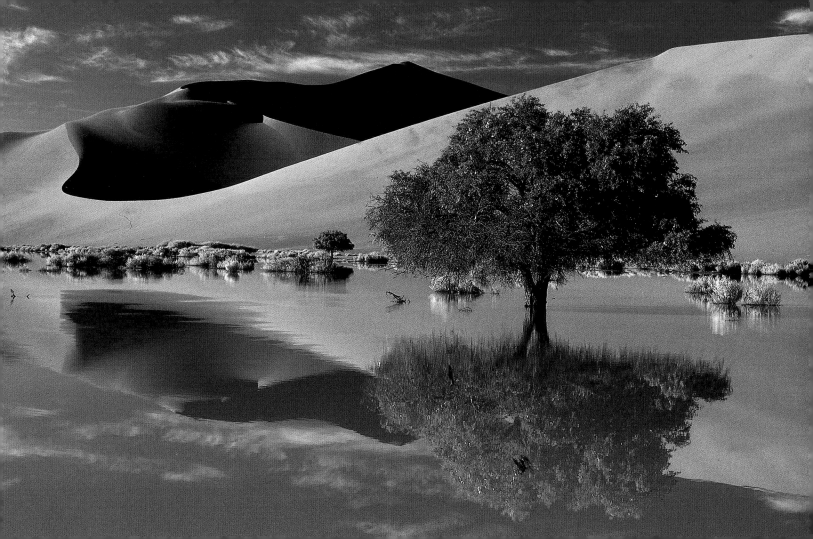

Use information technology rather than traveling.

To reduce the risk to climate change, the concentration of carbon dioxide in the atmosphere would need to be reduced by one-third to one-half of what it is now. That means that the Kyoto Protocol, which was considered too demanding by the United States—the world's chief producer of greenhouse gas emissions—falls far short of what is needed to stabilize our global climate.

Reduce transportation costs and save time by using the Internet or telephone when possible. Some tasks can also be carried out by video conferencing, telephone conferencing, and email.

Erta Ale volcano, Ethiopia

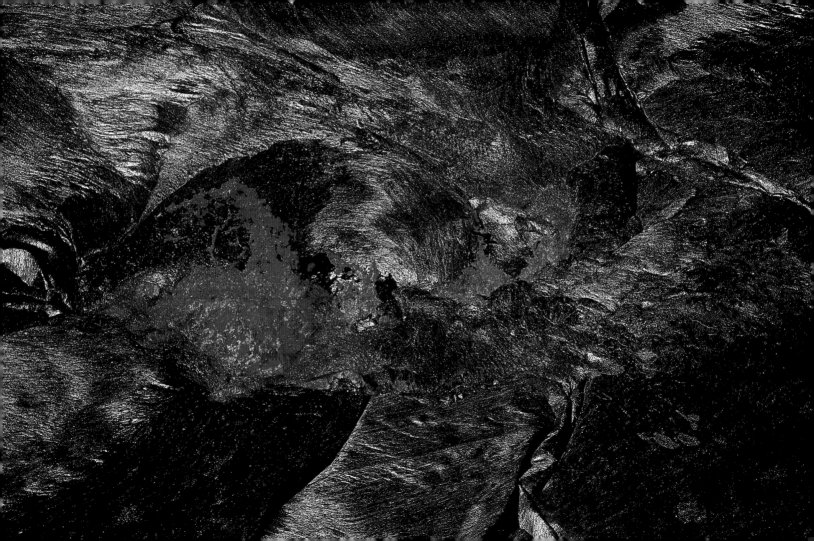

Sort actively and effectively; make inquiries.

Take part in your local recycling program: note the collection times and learn how to sort from your local public works department. Proper sorting is vital to making your recycling efforts meaningful. Be sure to consult the guidelines until they become second nature. Recycling is important, but it is essential to do it properly.

———————

If you are uncertain about what to do with a particular item of waste, put it among the non-recyclables, because mistakes (or lack of consideration) can be more complicated for the recycling center. If your local authority does not offer sorting facilities, take your waste to a recycling center yourself.

Close-up of coral, Thailand

Don't idle your car.

One of the gases that contributes most to the greenhouse effect is carbon dioxide. Since 1900, emissions of carbon dioxide have risen dramatically as a result of growing consumption of coal, oil, and gas, and its concentration in the atmosphere is the highest it has been in the last 20 million years. On average, an American produces 20 times as much carbon dioxide as someone from India; however, carbon-dioxide emissions in developing countries will rise considerably in the coming decades.

When you start your car engine, it is pointless to run it while remaining stationary in order to "warm it up." Instead, just drive gently for a few miles: the engine will warm up while avoiding needless pollution, carbon dioxide emissions, and fuel consumption.

Lava cliffs, Hawaii

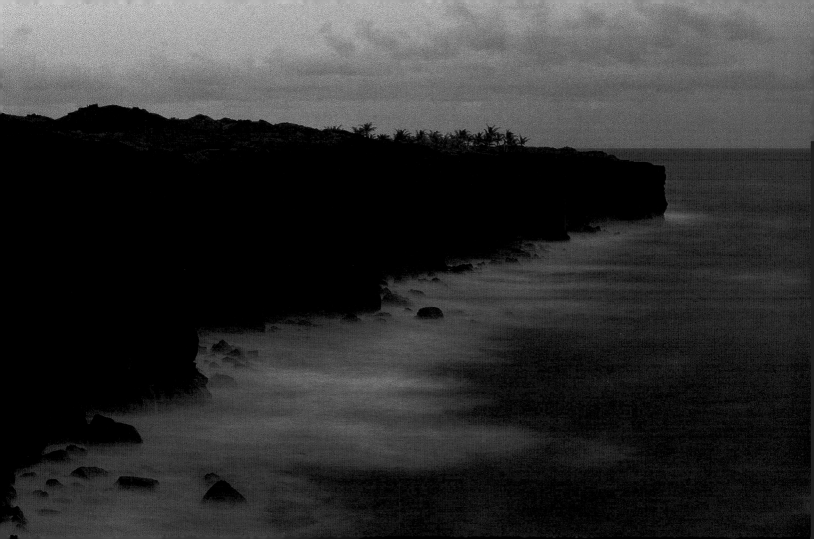

Report illegal dumping.

Illegal dumping is a growing problem in the United States. It should be a concern to everyone, since illegal dumping often is seen as a "gateway" act; if it is tolerated in a particular area of a community, it sends the message that other illegal activities may also be tolerated. Since no federal statutes exist to protect the environment from illegal dumping, some states have tried to mitigate the problem with a variety of regulations. Apart from being a blight on the landscape, bulky waste can also contain dangerous substances that can pollute the soil, water, and air.

If you notice illegal dumping happening in your neighborhood, make a note of the location, the surrounding environment, and type of waste, and report it to your public works department or board of health. They have the power to have it properly removed, even from private land.

Merapi volcano, Indonesia

Choose solvents made from plants.

Solvents are powerful enough to dissolve other substances: they attack fats and keep certain products that contain them, such as glues and paints, liquid. Most solvents are organic (acetone, ether, white spirit) and belong to the family of volatile organic compounds (VOCs). White spirit is one of the most deadly solvents: it is harmful if touched or inhaled.

For decorating, maintenance, or spare time hobbies use plant-based solvents, which are less harmful to the environment—for example, turpentine and other products made from terpenes, which you can buy in health stores.

Islets, Galápagos Islands

Give a potted plant as a gift rather than a bunch of flowers.

A lovely bunch of flowers bought from the florist or the supermarket may have been grown in a greenhouse thousands of miles away. Apart from the environmental issue of transportation over long distances, the boom in horticulture in some developing countries has a high social and environmental cost. In Colombia, the flower industry uses enormous amounts of polluting pesticides and exposes poorly paid garden workers to chemicals that may be carcinogenic or toxic. In drier regions, such as Kenya, horticulture requires substantial amounts of water and, as a result, overuses local water resources.

Make a gift of a potted, organically grown plant from a local nursery instead. It will last far longer.

Always answer questions about sustainable development.

In 2050, the Earth will be home to almost 3 billion more people, most of them in developing countries. How can the economic growth of these countries take place alongside the economies of industrialized countries and remain within the limits of the Earth's natural resources? An answer might include: by choosing to produce material using less polluting technologies that use less energy and water; by consuming less in smarter, more efficient ways; by conserving and sharing resources equitably; and finally, by creating a fairer world. This is the principle of sustainable development, which can be summarized as meeting the needs of the present without jeopardizing the capacity for future generations to meet theirs.

———————

When those around you ask: What is sustainable development, anyway?, do not leave the question unanswered. Explain!

Coral island, Australia

Look at where your purchases originate.

Everyone knows that private cars pollute. But we often forget that food travels long distances, too. The environmental impact of transporting food is considerable: the farther it travels, the more greenhouse gases are emitted.

To minimize this waste of resources and pollution, check the label to see where the fruit and vegetables you buy come from. And look again at the gardener's calendar to remind yourself what is in season, and when, in your area. Then find a local farmer's market or farm.

Dune, Mauritania

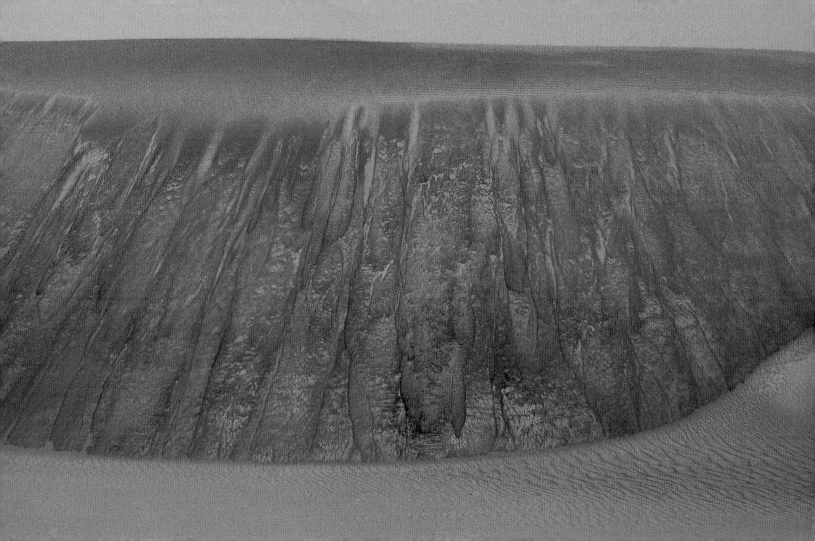

Insulate your home.

Even if you do not drive a car, you can take action to reduce climate change. Through its consumption of energy (for hot water, heating, electricity, and lighting), an average dwelling produces 6 tons of carbon dioxide per year—more than a car does. In Europe about a quarter of all emissions of carbon dioxide, the main greenhouse gas responsible for climate change, comes from homes.

To reduce the need for heating, you can prevent heat from escaping: insulate the roof, floors, and walls with fiberglass wool, rock wool, mineral wool, cork, cellulose (from recycled newspapers), or hemp. This will save 20% on your heating bills, and will pay for itself within five years at most.

Iceberg, Greenland

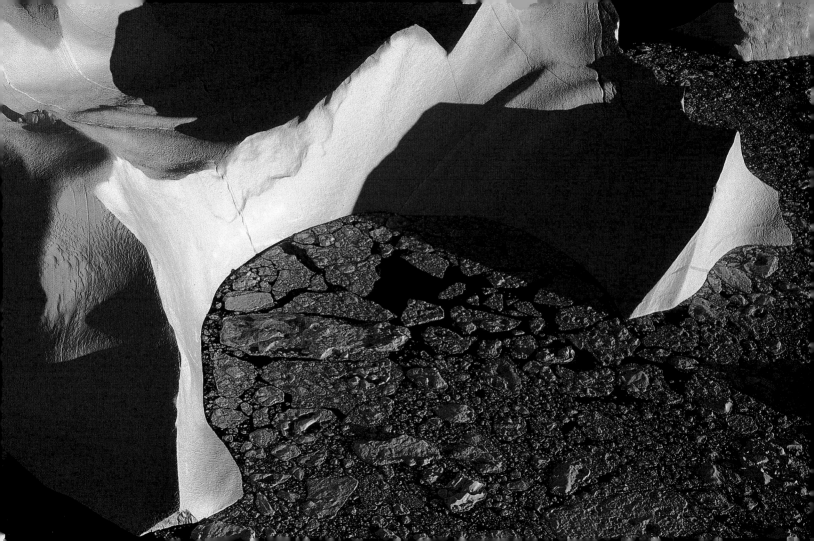

Recycle paper.

Many of us associate the idea of recycled paper with saving trees. However, this process also allows us to save the equally precious resources of water and energy, and to reduce pollution. Every ton of recycled paper saves 17 trees, 7,000 gallons of water, and the energy equivalent of 380 gallons of oil.

Today, less than 15% of the paper used in offices is recycled. There is considerable room for improvement. Mention it at work, so that a used-paper collection program can be put in place.

Acacia tree, Mali

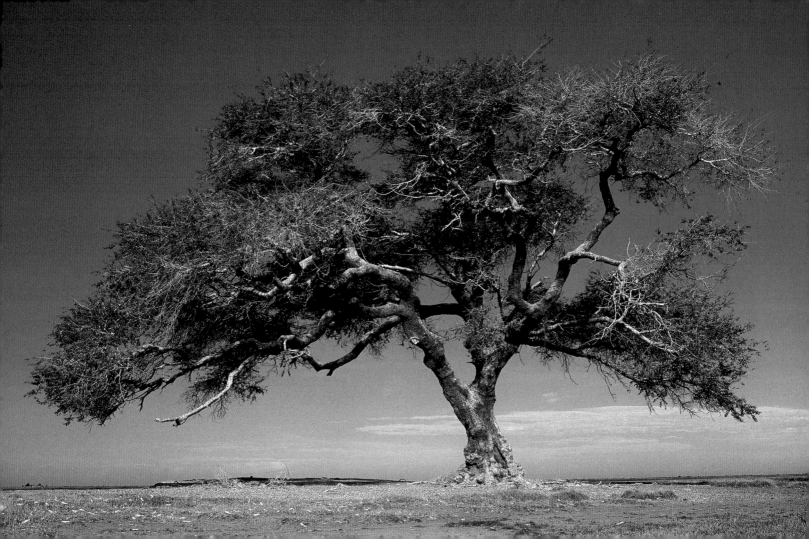

Buy local produce.

Transporting kiwifruit from New Zealand (where it grows) to Europe produces carbon-dioxide emissions equivalent to five times the weight of the fruit itself. But kiwifruit is affordable in the shops because we are not forced to pay for their true cost—the environmental and social costs that accompany it.

Look at where your foods come from: green beans from Kenya, carrots from Israel, and apples from Australia are sold cheaply because the costs of bringing these goods to the store do not reflect the true cost of their transport. Choose local produce: by supporting your local agriculture, you will help reduce climate change.

Cranberries, United States

Consider a hybrid car.

Hybrid cars combine an electric motor and an internal combustion engine. They run on electricity in town and use gasoline at highway speed at which point, ingeniously, the batteries are recharged by the movement of the car. Thanks to this optimized use of energy, hybrid cars offer excellent performance and are much cleaner in town; they produce 75% less pollution than standard vehicles. Several already on the market are very, very popular.

Hybrid cars are costly at present, but the price will come down when they are produced in large numbers.

Caymans, Venezuela

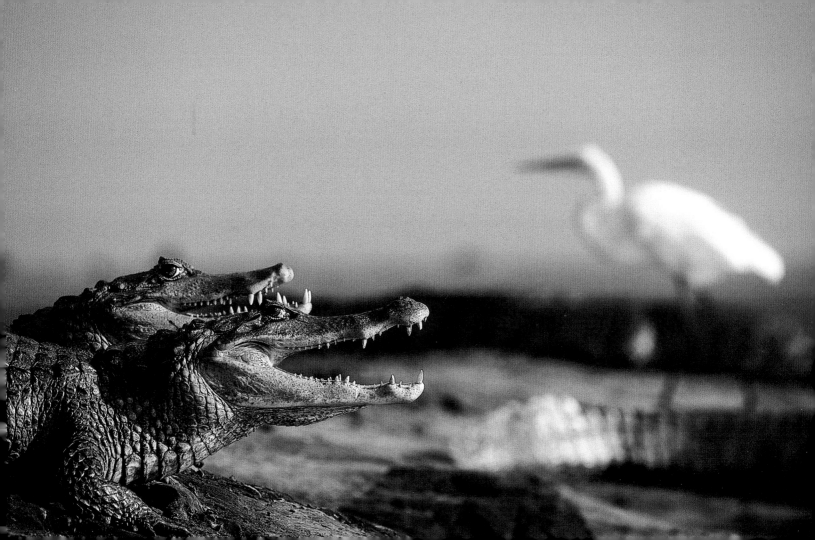

Use a low-flow showerhead.

To attempt to meet our escalating need for energy, humans have built dams and diverted rivers: 60% of the planet's rivers have been tamed in this way, and more than 45,000 large dams produce 20% of the world's water. Building these dams, however, has displaced between 40 and 80 million people—few of whom were consulted beforehand—and has caused extensive deforestation and species loss. Harnessing rivers bears a heavy cost to the environment, yet we continue to exploit them.

You can reduce water consumption by replacing your showerhead with one that aerates and increases the flow of the water to produce a finer spray. A low-flow showerhead uses 2 gallons per minute less than a conventional showerhead; it costs around $8 for a standard model, and $20 for a designer model.

Islet, Iceland

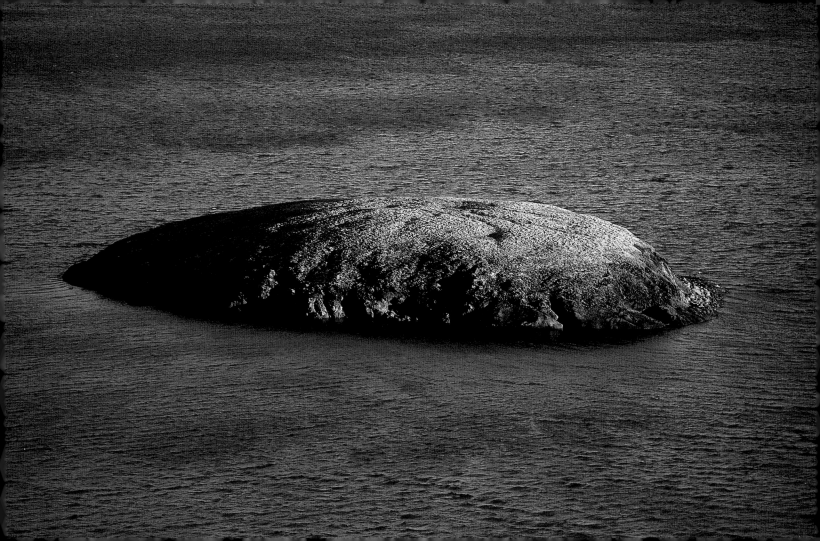

Take back your unopened medicines so that they can be distributed for reuse.

In developing countries, every day 30,000 people die for lack of medicines or the money to buy them, while we throw our unused medicines in the trash. But there are humanitarian organizations that collect these unused medications and redistribute them to the poorest people around the world. In 2003, 510 tons, or the equivalent of 20 million boxes, were redistributed.

——————————

Find a non-profit organization that accepts unused medicine donations. This is also a safer choice for your household, because it will reduce the amount of medicine that could fall into a young child's hands. Forty percent of poisonings involving children are a result of ingesting medications.

Bacteria, Kamchatka, Russia

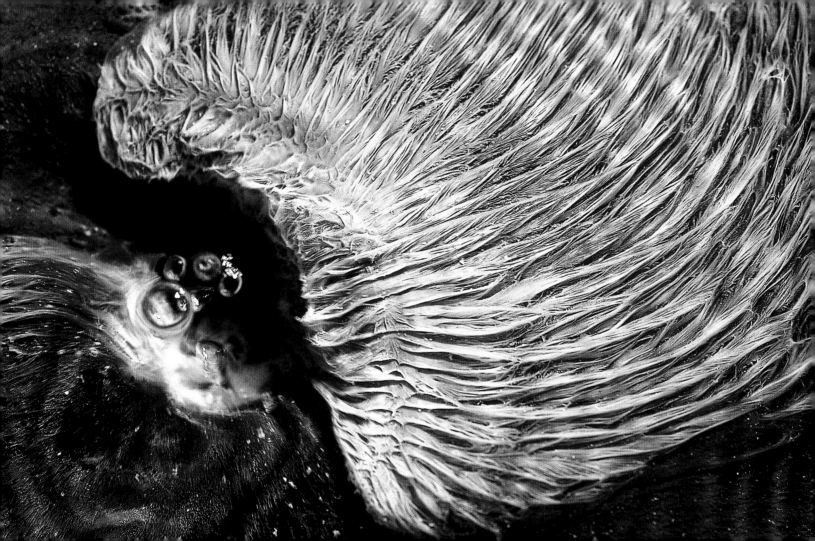

Have your heating checked and maintained regularly.

Air pollution is always more obvious in the middle of a traffic jam than when you are back at home. However, even indoors, you are not immune from harmful emissions, especially carbon monoxide. This gas is produced by incomplete combustion of coal, wood, gas, or fuel oil, which may be caused by a blocked flue, the use of old or badly maintained stoves, boilers, or oil heaters, or clogged ventilation ducts that prevent air circulation. Carbon-monoxide poisoning kills more than 500 Americans each year.

Keep your air clean: have your home and water-heating equipment checked and maintained by professionals—and don't forget the ventilation ducts.

White Desert, Egypt

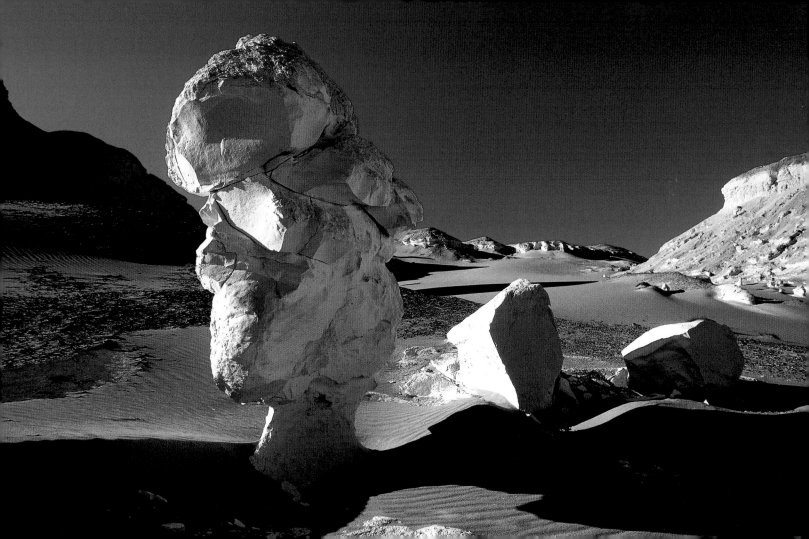

Make compost with organic waste.

In nature, compostable waste, like the waste found on the forest floor, decomposes into soil through the action of microorganisms, and returns energy and nutrients to the forest floor. Our trash contains a large amount of organic waste, which, instead of being returned to the natural cycle, is cut off from the soil and added to our landfills.

Leaves, branches, and grass from the garden, eggshells, fruit and vegetable peelings, coffee grounds, tea bags, and bread from our tables can all join the compost heap. If mixed well and aerated regularly, stirred to avoid clumping, and kept sufficiently moist, in a few weeks this will yield compost, a natural fertilizer that is good for the soil. Whether you make a compost heap or use a bin, there is certainly a composting option suitable for the amount of space you have available.

Tundra, Russia

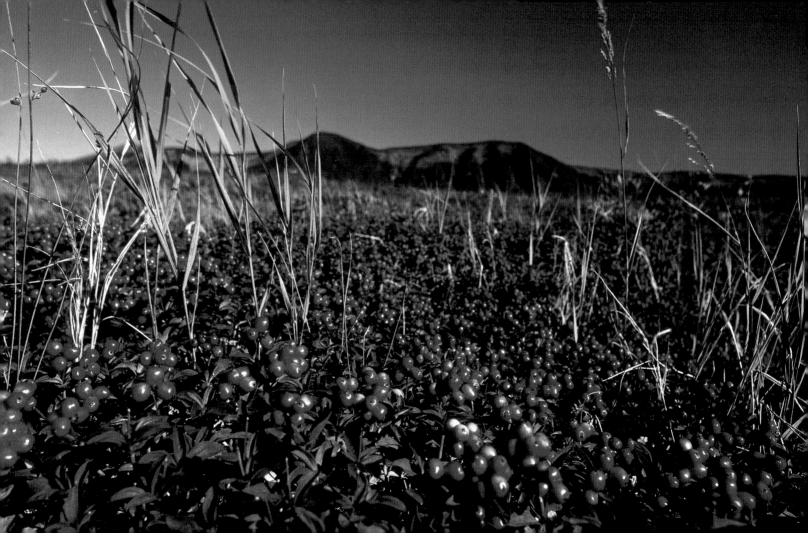

Take legal action, if necessary.

State environmental agencies, burdened with protecting and restoring your state's environment, may fail to do so, at times out of negligence but more often due to lack of state funding. Do not let your state put environmental concerns last on the list of budgetary priorities—human health and safety is at stake. Pay attention to your state's budgetary process and monitor the trend in funding for environmental programs.

If you want to be involved in public inquiries do not hesitate to approach a lobbying group or, if necessary, to complain about a government body or a company if they do not comply with environmental legislation.

Anaconda, Venezuela

Do not drop your garbage indiscriminately when traveling.

American domestic waste now goes to different destinations, depending on where you live and the type of waste. Eight states still send 80% of their solid waste to landfills. Eighteen states incinerate less than 1% of their waste. Across the country, however, the average rate of recycling is 28%. This is not the case everywhere, however. Worldwide, only 20% of household waste is treated in one of these ways. In some poor countries, rubbish bins are rare or altogether absent.

———

Do not drop your trash just anywhere—especially if you are on an excursion—even if the environment already appears to be dirty or strewn with dumped waste. Take your trash back to where you are staying. If necessary, point out to those traveling with you that nature should be protected.

Volcanic cone, Iceland

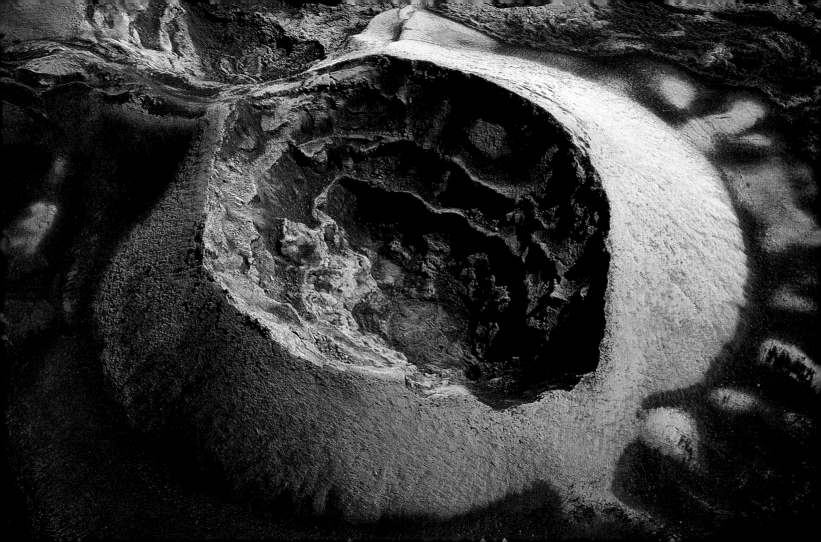

Choose your materials wisely.

Just over 15% of the steel in America is recycled, as compared to some European countries that recycle upwards of 80% of their steel products. You may already recycle steel containers, but you can do even better—by avoiding the needless use of steel.

––––––––––

With steel and other materials—especially those that cannot be recycled, such as certain plastics—make it a habit to buy something new only if there is no reusable alternative.

Humpbacked whales, Polynesia

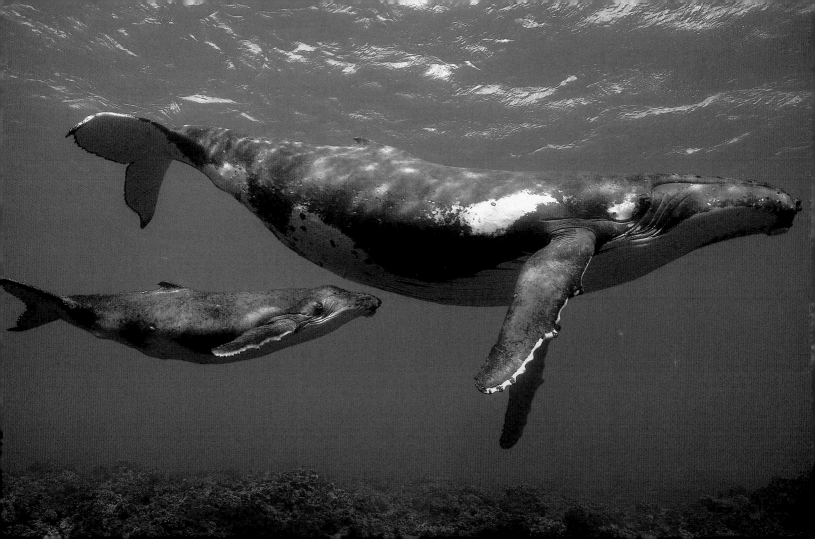

Do not defrost in the microwave.

Renewable energy—from the sun, wind, the heat under the earth's crust, waterfalls, tides, the growing of vegetables, or the recycling of waste—is infinite. Harnessing it produces little or no waste or polluting emissions. In countries like Germany, government officials have recognized the benefits of investing quickly and heavily in these technologies and they have set a goal to transition to 100% renewable energy. Part of this goal is to reduce their energy needs by 37%.

Rather than adding to your electricity bill by using the microwave to defrost your food, remember to take food out of the freezer earlier and let it defrost at room temperature.

Erg (sand desert), Mauritania

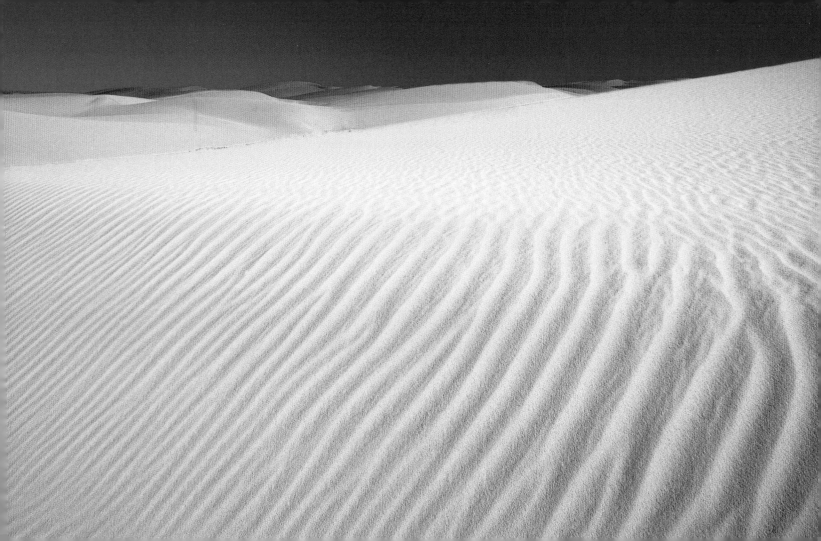

Boil only as much water as you need.

Whether you use an electric kettle or a saucepan, heating water uses energy. There is no point in doubling the energy you use, for no purpose: boil only what is necessary. A British study found that if all English people—who are great tea drinkers—did this on just one day, the energy saved could power all the country's street lamps through the following night.

When you boil water for tea or a hot drink, try to boil only what you need, or pour the surplus into a thermos flask to keep the water very hot until you need it.

Lake Assal, Djibouti

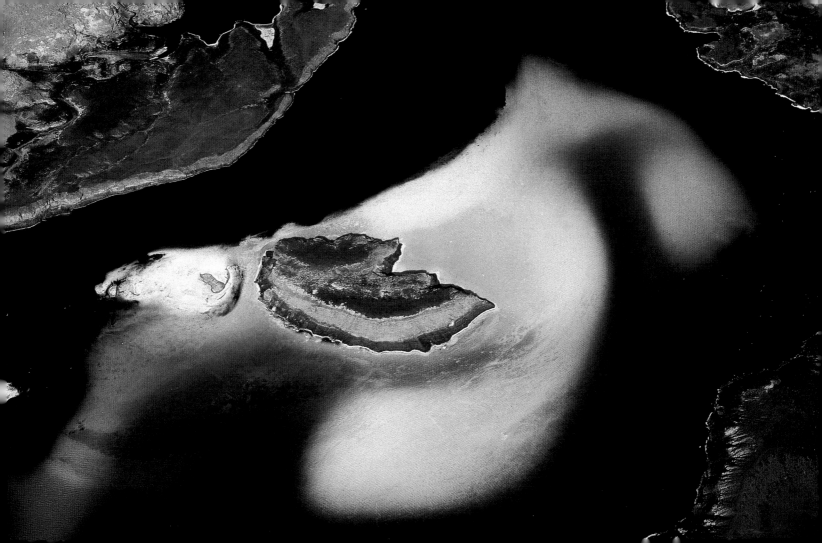

Avoid eating farmed fish.

At present, fish farming accounts for 30% of the world's fish production. However, it will never offer the diversity of species that are found naturally in the oceans: 300 species of fish are farmed, but 19,000 exist in the wild. Moreover, to produce 1 pound of farmed salmon, 3 pounds of wild-caught fish are needed to provide meal and oil. And, like all intensive farming, fish farming uses chemicals and antibiotics, which affect humans.

So as not to encourage intensive farming, which only exhausts wild stocks further, avoid eating farmed fish such as bass, salmon, and trout.

Rhinopias aphanes, Australia

Don't pollute storm water—it all ends up in the sea.

Most American towns have a wastewater treatment plant or send their water to a plant located elsewhere. At present only 10% of the world's towns are thus equipped. All the rest empty their dirty water into rivers and the sea. Even rain, which picks up poisonous elements, such as oil, salt, herbicides, and other pollutants, from our streets and buildings and causes sewer lines to overflow, can add contamination to the planet's seas. Oil spills, dramatic though they are, are not the worst damage the sea suffers.

———————————————

Do not forget that 75% of the pollution in the sea comes from the land. So don't pollute our streets and storm drains, and try to use as few chemicals as possible in your yard.

Laguna Colorada, Bolivia

Take your old motor oil to the dump.

Motor oil contains substances—especially heavy metals (lead, nickel, and cadmium)—that are toxic to our health and the environment. A third of used motor oil is refined to make new lubricants, and the remaining two-thirds is used as fuel, chiefly in cement works. Approximately 60% of Americans change their own oil. Most simply dump the used oil into the gutter or into stormdrains. Over 200 million gallons of motor oil is disposed of every year. One quart of motor oil can pollute 250,000 gallons of water.

Recycling old oil saves raw materials and energy, and spares the environment. It also reduces our dependence on the ever vanishing hydrocarbon: a barrel of crude oil can yield 2.5 quarts of virgin motor oil. It takes only a gallon of used motor oil to get the same amount of high-quality motor oil. Motor oil is collected at dumps and garages. Always bring your old oil there.

Volcanic lake, Kamchatka, Russia

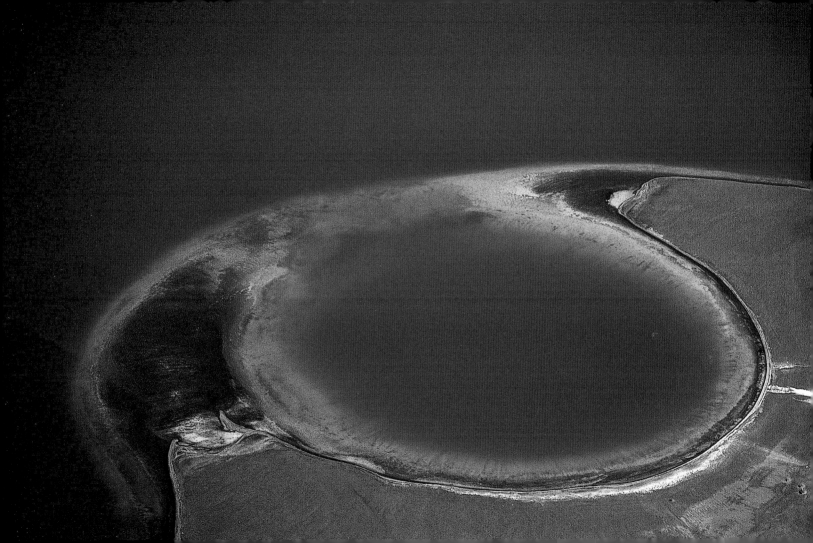

Don't use the prewash on your washing machine.

Worldwide, 80% of the energy consumed comes from the burning of fossil fuels—oil, coal, and natural gas—which emit polluting gases and increases the greenhouse effect. Renewable energy, which comes from natural sources, only accounts for a small fraction of the energy used, even though it is inexhaustible and nonpolluting: one wind turbine saves 1,000 tons of greenhouse gases per year. The European Union has announced that by 2010, 10% of its electricity must come from renewable sources. The United States has not yet endorsed a program for renewable energy.

As we await the arrival of this cleaner energy, we should not wait to start consuming less. Today's washing machines, which are highly efficient, allow you to bypass the prewash, thus saving 15% of the energy required for the full cycle.

Kilauea volcano, Hawaii

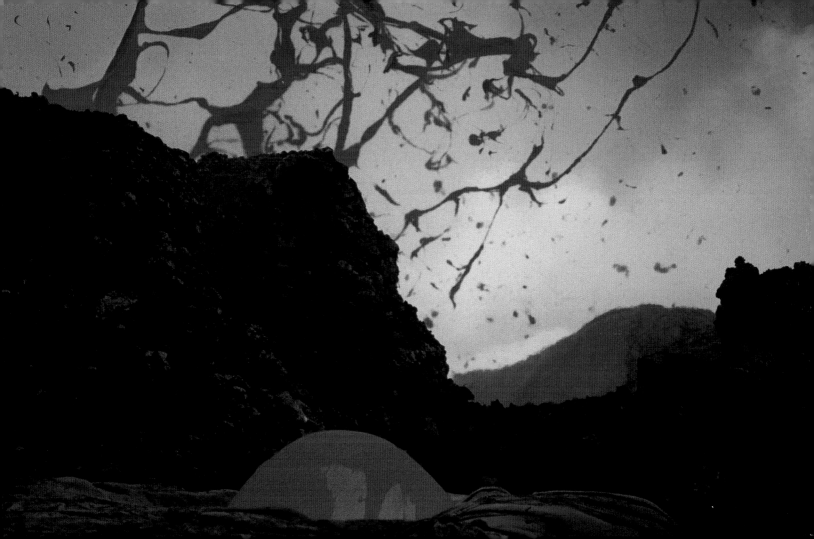

Consider getting rid of your car.

The toxic fumes emitted by industry and vehicles contain nitrogen dioxide and sulfur dioxide. In the air, these compounds are converted into nitric acid and sulfuric acid, and fall back to earth in rain. Acid rain eats away at the stone of historic buildings, destroys forests, acidifies lakes and rivers, and attacks crops. Atmospheric pollution has done more damage to the Acropolis in Athens in 25 years than natural erosion has done in 25 centuries.

If you live in a large city and use your car only occasionally, consider renting a car, short- or long-term. It often works out to be more economical if you take into account the cost of buying a car, depreciation, insurance, a parking space, and parking fines.

Glacier corridor, United States

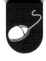

Do not throw out reusable paper products.

Europe, Japan, and North America combined are home to just 20% of the world's population but swallow up 63% of its paper and cardboard. Increasing consumption of these products is relentless: the wealthiest countries use three times as much paper today than they used in the 1960s. Over the next decade, the volume of paper used worldwide could increase by as much as 40%.

To avoid contributing to this overconsumption, cut back on your paper use, and keep reusable paper products, such as manila envelopes and file folders. Cut scrap paper into quarters and use it to write phone messages rather than buying a new pad. Keep reusable paper clips, elastic bands, and binders in a drawer. And choose rewritable CD-ROMS—you will use fewer of them.

Mehedjibat *erg* (sand desert), Algeria

Calculate the greenhouse gas emissions your air travel produces.

A 747 jet aircraft consumes 5 gallons of fuel per mile flown. Airplanes account for 13% of the worldwide, transportation-related carbon-dioxide emissions released each year.

———————————

There are Internet sites that enable you to calculate the greenhouse gas emissions your next air journey will produce. One transatlantic flight produces almost half as much carbon dioxide as a person produces, on average, in meeting all their other needs (lighting, heating, and car travel) over a year.

Sea of clouds, Indonesia

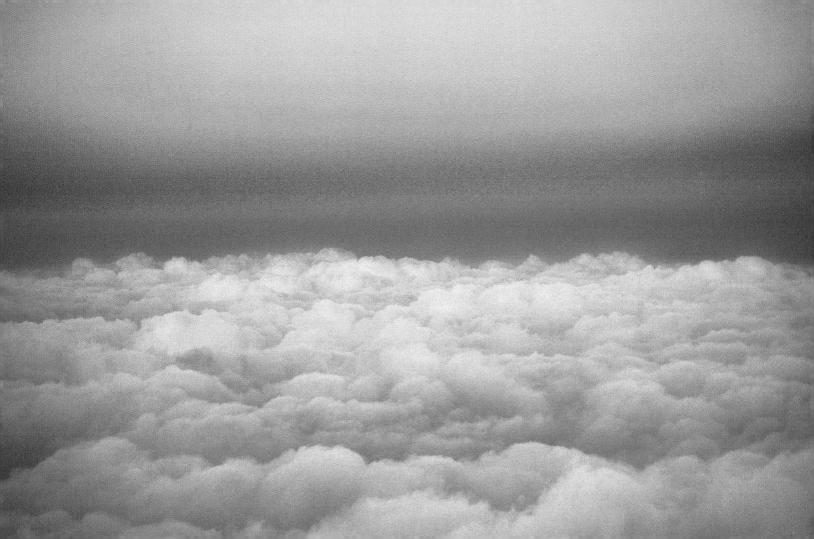

Avoid a second Aral Sea.

The Aral Sea, on the border of Uzbekistan and Kazakstan, was once the world's fourth largest inland sea. Today it has lost 75% of its volume, and since 1960 its surface waters have retreated by nearly 80 miles, leaving the region's fishermen, who once used to haul 45,000 tons of fish per year, high and dry. What was the cause of this ecological disaster? During the 1960s, the two great rivers that fed the sea were partially diverted to irrigate the region's cotton fields. The sea dried up, and the land, contaminated by salt and pesticides, turned to desert.

———————

It is possible to grow cotton without causing ecological devastation. Organic cotton is cotton that has been grown for at least three years without chemical pesticides, defoliants, or fertilizers, and processed without the use of harmful chemicals. Encourage this production by choosing clothes made from organic cotton—start with the products your children wear.

Acid lake, Kamchatka, Russia

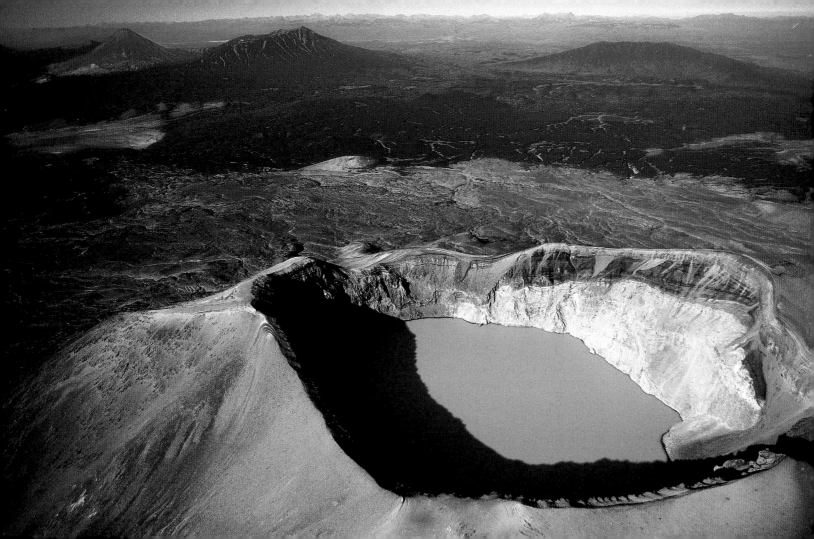

Ventilate your home regularly.

Indoor air pollution affects all enclosed spaces. This can be caused by a ventilation system that does not remove stale air properly, by a faulty gas stove or heater, or by the improper use of products that require a high degree of air circulation to dissipate pollutants, such as paints, varnishes, and household cleaners. Some pollutants, such as mites and molds, are of natural origin.

On average, we spend 80% of our lives in buildings. The quality of the air indoors can therefore have a major effect on our health. To circulate the air and remove pollutants, ventilate your indoor space regularly and generously, even in winter.

Denali massif, Alaska

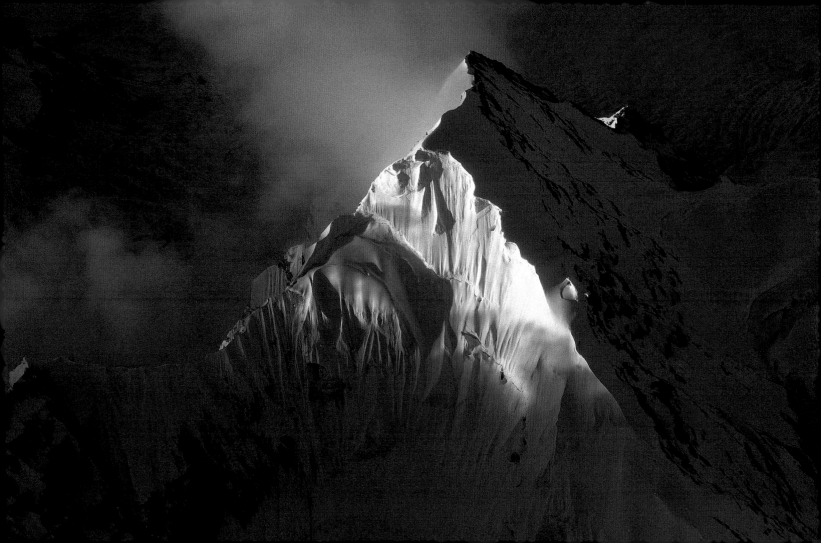

Take a different approach when buying clothes.

Dressing ourselves is such a commonplace act that we rarely question the social and environmental impact of the clothing we buy. Who made it and what is it made of? How far did it travel before being sold? Polyester, nylon, and fake fur are not biodegradable, and their manufacture from non-renewable petrochemical products requires large amounts of water and energy. Growing cotton uses large quantities of pesticides. Wool, linen, and hemp, on the other hand, are more environmentally friendly, as is organic, locally made cotton.

Choose clothing and shoes that are made from organic crops, and manufactured in the United States or Canada, or fairly traded. Consider buying second-hand clothes from thrift stores and consignment shops.

Iceberg, Greenland

Do not throw your waste into the gutter.

Globally, most domestic and industrial wastewater is returned to the environment untreated. In China, 80% of industrial wastewater, often loaded with toxic substances, is emptied directly into the environment and destroys fauna and flora. The impact of such actions is made all the more serious by the fact that industries in developing countries often produce much more pollution than their counterparts in wealthier countries.

In cities, runoff water, which trickles along gutters and then into storm drains, is not treated either: it flows directly into rivers. Do not throw litter or waste into the gutter: it will go the same way as the water.

Cerro Torre, Patagonia, Argentina

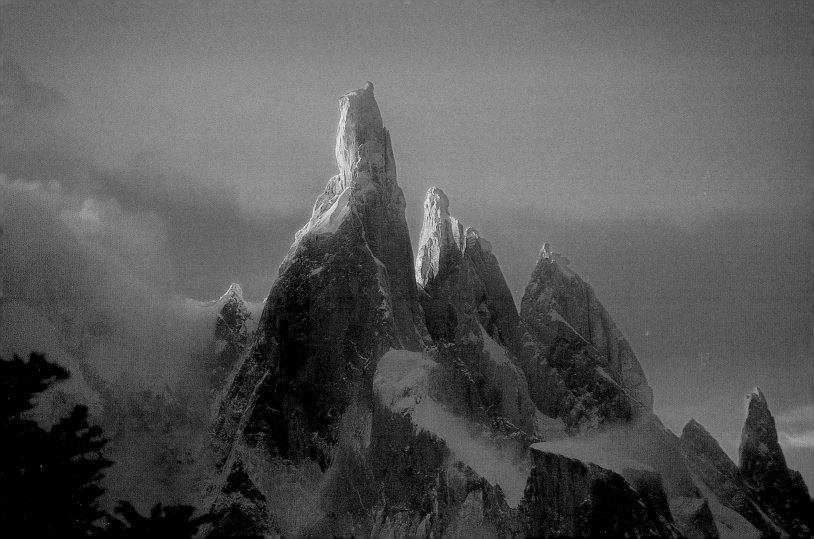

Don't keep exotic animals as pets.

Over the last decade it has become fashionable to keep exotic animals as pets. These animals, snatched by the thousands from their natural habitats and carried to the other end of the world, end up in captivity, where they usually survive for a short time, being suited neither to their new climate nor to life out of the wild. The black market for exotics has devastated the populations of some unfortunate species. The highly-sought-after horned parrot of New Caledonia, for example, has been the victim of ferocious poaching: only 1,700 remain in the wild. Similarly, there are approximately 5,000–7,000 tigers in captivity in the United States. Ten percent of those are in zoos; the rest live in circuses, roadside menageries, big-cat rescues, and in backyards, as pets. Consider the same number of tigers are believed to be living in the wild.

Think carefully before imprisoning a languid iguana or a brilliantly colored parrot in your home.

Marine iguana, Argentina

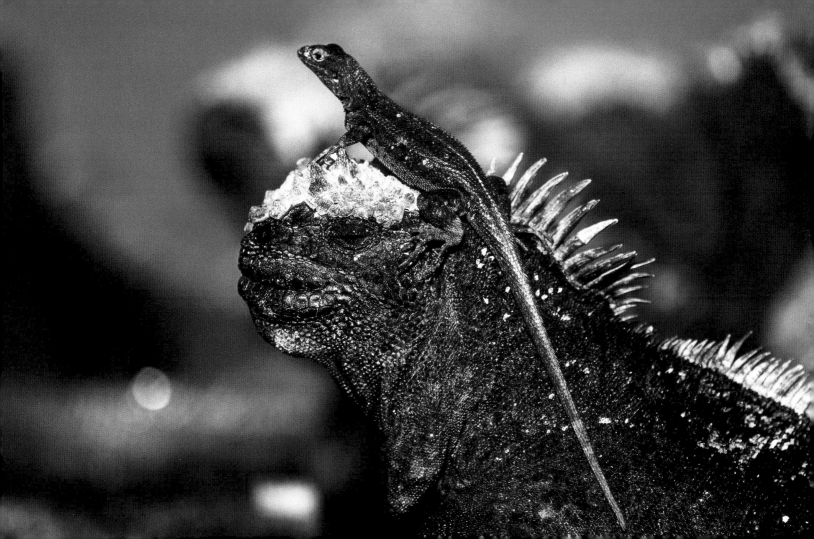

Watch out for the plastic rings that hold together six-packs of cans.

Pollution severely affects the world's oceans, and three-quarters of the debris that pollutes the seas comes from the land. Every year, 14 billion pounds of garbage are released into our oceans worldwide. The flexible plastic loops that hold together six-packs of beverage cans are often dropped on beaches. They seem harmless, but they become deadly once they float out to sea, where sea birds, seals, and dolphins may trap their beaks, heads, or snouts in them—often with fatal results.

A study in Texas found that 70% of all the trash found on that state's beaches was made of plastic. Plastic never biodegrades; instead it photo-degrades, a process in which it breaks into ever smaller pieces, which then may be consumed by fish and wildlife. Make sure your own rubbish does not reach the sea. Help reduce litter on the street or it will end up in storm drains, which eventually empty into the sea.

Nudibranch (sea slug), Australia

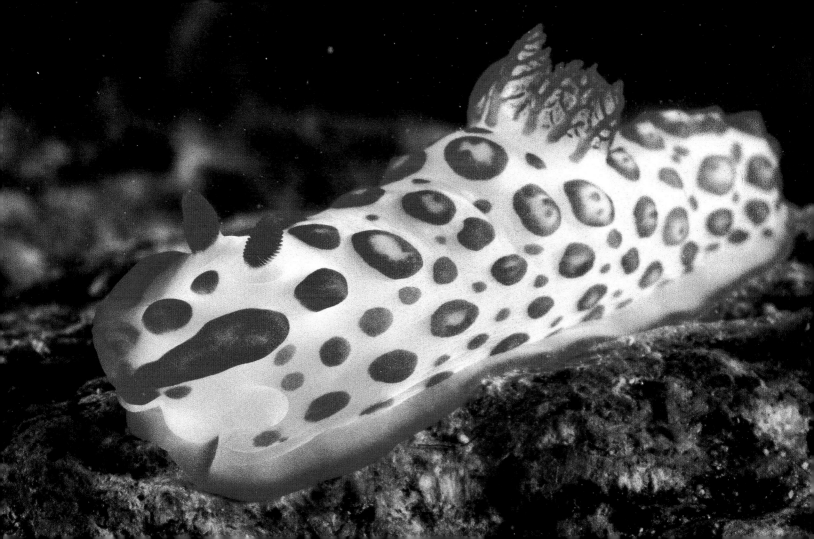

Choose goods with less packaging.

When we buy something, we tend to look at its quality and its price. Little attention is paid to the packaging, even though it accounts for part of the cost of the product—sometimes a considerable part.

———————————

Why does a tube of toothpaste have to come in a cardboard box? Why do printer cartridges come in both cardboard and plastic packaging? Does this excess packaging really improve the quality of products? When you have a choice between equivalent products, choose the one with less packaging.

White Desert, Egypt

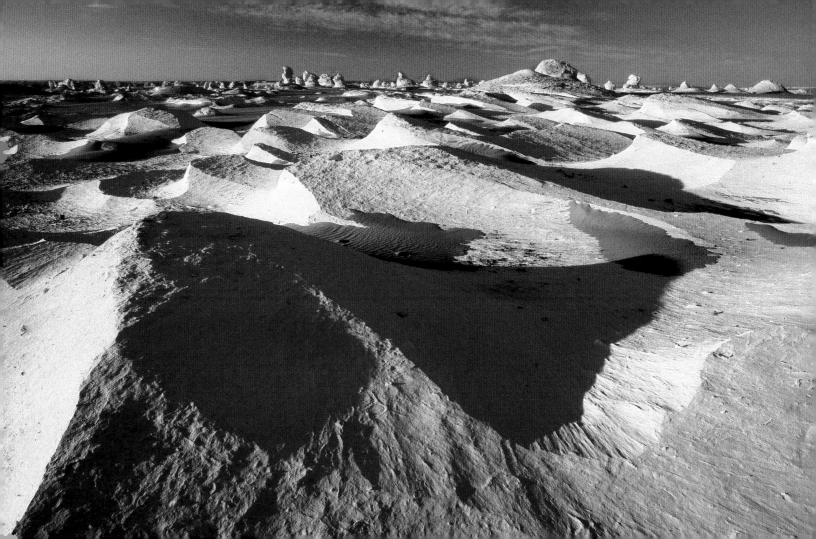

Offer a skill to a local environmental organization.

Different types of environmental associations use conspicuous but peaceful means to make themselves heard by authorities and to make the public aware of issues. Some wage spectacular media or legal campaigns; other organize animal censuses and nature walks, clean up beaches after an oil spill, or collect garbage on beaches and in rivers. All of them, however, need volunteers!

Support, or join, an organization involved in the protection of the environment. Are you skilled in a trade? Offer it to an organization. By giving a little of your time, you are taking concrete action, and also speaking for the concerns of a great many of your fellow citizens.

Iceberg, Greenland

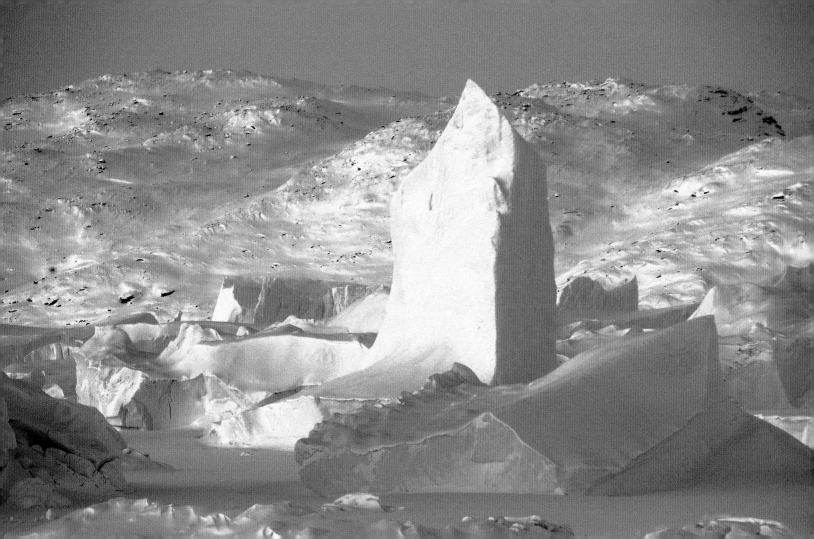

Look for the Energy Star label.

The Energy Star label is a mark of the energy efficiency of office equipment based on the energy-saving recommendations of the Kyoto Protocol. The Energy Star logo appears on all computer equipment (monitors, scanners, printers, and so forth) that incorporates energy-efficient features. A monitor that meets the Energy Star standard uses less than 8 watts when on standby mode, and 60 watts during normal use.

Look for the Energy Star when you buy computer equipment. The savings will benefit your electricity bill as well as the environment.

Lava, Kilauea volcano, Hawaii

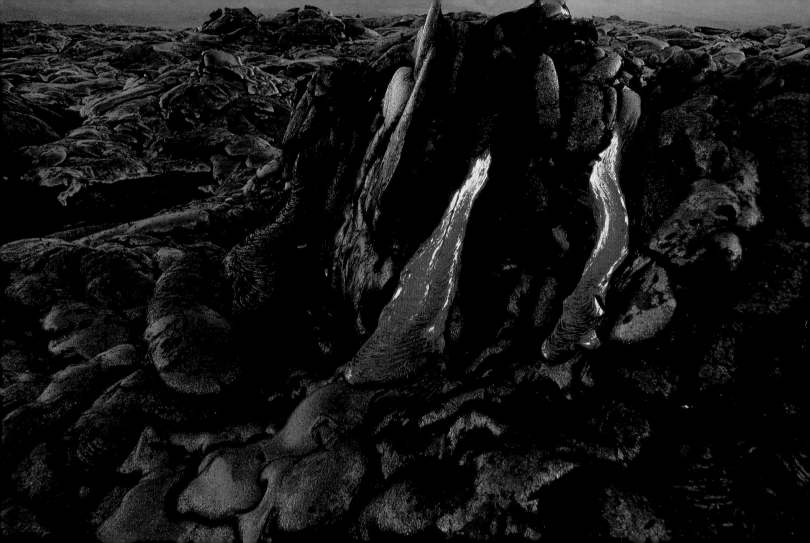

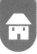

Use aerators on faucets.

Eighty percent of the fresh water used in the United States irrigates crops and generates thermo-electric power. A one-acre cornfield gives off 4,000 gallons of water per day in evaporation. Throughout the world, irrigated areas—which have multiplied sevenfold in the space of a century—use up two-thirds of the water that is drawn off rivers and from aquifers. The amount of water drawn off is expected to rise by 14% by 2020.

——————

You can reduce your domestic consumption by having faucets fitted with aerators. These cost about $4. The flow will feel stronger, but it actually contains less water and more air. Conventional faucets use 5 to 15 gallons a minute; aerated faucets reduce use to 3 gallons per minute.

Niagara Falls, United States

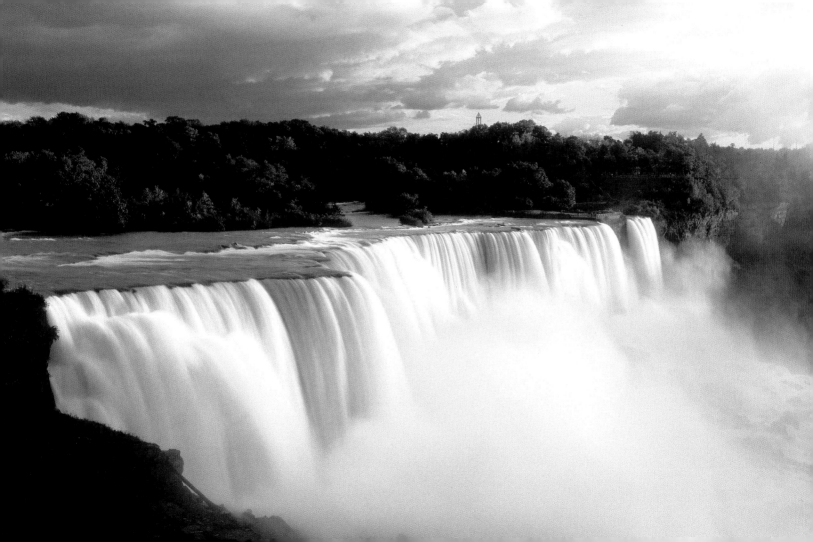

Do not buy foods containing genetically modified organisms.

Humans have mastered technologies that enable them to modify the genes of plants and animals directly, producing genetically modified organisms (GMOs). These transgenic plants—maize, cotton, and soy, for example—are immune to insects and diseases, resistant to drought, and richer in vitamins. Unfortunately, these crops also pose health and environmental risks, some of which are known, but most of which remain a mystery to us. Since the U.S. government does not require companies to test for the safety of GMOs, there is no way to know what their ill effects could be.

The vast majority of GMOs currently on the market have been modified to withstand herbicides, or to produce their own insecticide, and so contribute to today's skyrocketing levels of pesticide use. Sixty percent of the processed, non-organic foods consumed in the United States include ingredients from genetically engineered crops. The only way to avoid GMOs in the United States is to buy organic foods.

Miachik volcano, Kamchatka, Russia

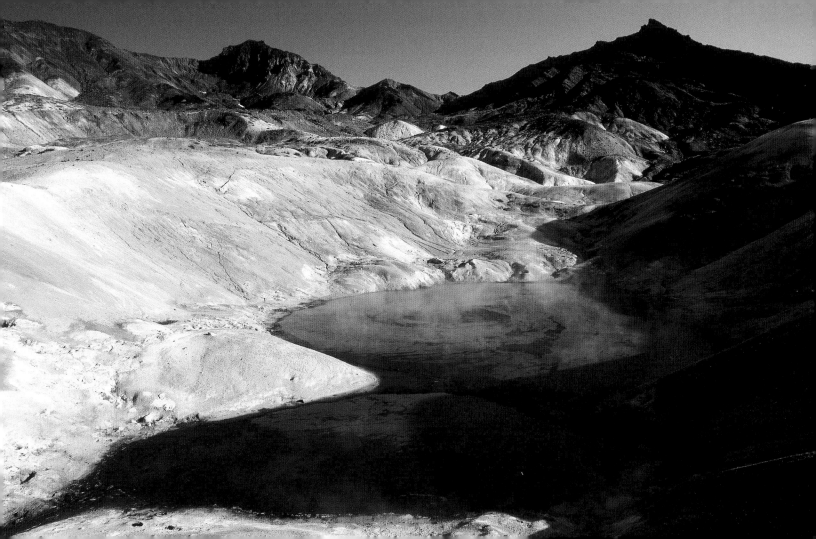

Change your car over to biodiesel.

Biodiesel is a clean-burning alternative to both conventional diesel and gasoline, though conventional gas cars have to be retrofitted to burn biodiesel. Biodiesel is simple to use, biodegradable, nontoxic, and emits far fewer emissions than petroleum diesel. Biodiesel cars give off 78% fewer emissions and, because biodiesel is made from vegetable and animal fat, it does not draw from the already-dwindling oil supply.

Private individuals who invest in biodiesel for their vehicle will see the price begin to fall significantly as more people invest in it. A tax incentive has been added into the price already, making it as cheap as conventional diesel to power your car.

Sunset, Sudan

Celebrate the vernal equinox—the arrival of spring—by doing something for the earth.

Every year, nearly 15 million acres of land become desert, worldwide. Overgrazing, excessive deforestation, rain and wind erosion, and salt contamination all cause soil degradation. Already, desertification has affected a global area equivalent to the combined territory of United States and Mexico, and every day the Earth's productive capacity is reduced. The planet will need to feed 8 billion people by 2025. We must seek to halt the practices that cause desertification and invest in methods to stop it.

The vernal equinox falls on March 20 or 21 every year. On that date, day and night last equal lengths of time. It is an ideal opportunity to offer the planet a few hours of respite. Next vernal equinox, make a gesture for the earth. The choice of what to do is vast.

Mount St. Helens National Monument, United States

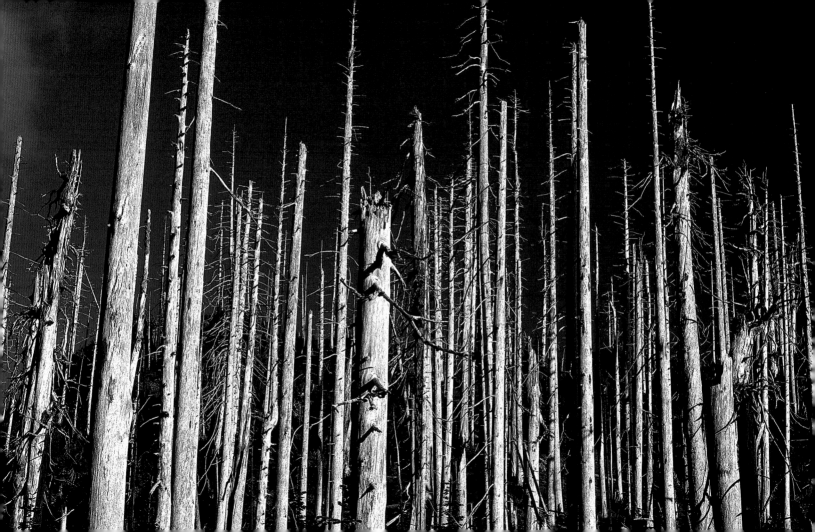

Do not let the children play with water.

It seems to us so natural that our taps deliver clean water that we assume it is a lifetime guarantee to everyone. This is not the case. Every morning, millions of people walk several miles to collect the water that is essential to meet their modest needs. The average African woman walks more than 3.5 miles per day to obtain water for her family—or the equivalent of a marathon every week. March 22 is World Water Day every year, and aims to make people in the world aware of the importance of preserving this vital resource.

Teach your children to treat water with respect. The faucet in the bathtub and the garden hose are not toys—do not let your children play with the running water.

Autumn, Canada

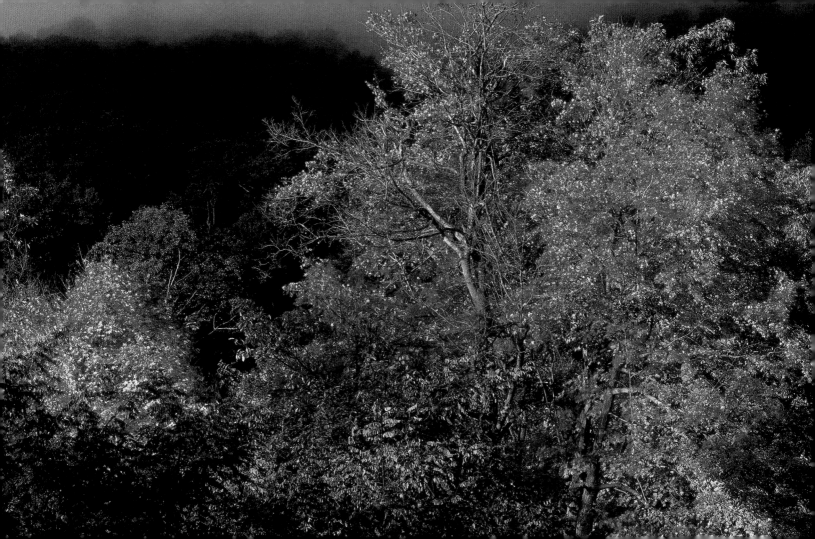

Run the dishwasher only when it is full.

A large volume of the water taken from nature to meet humanity's growing needs is drawn from rivers. Rivers such as the Colorado in the United States and Mexico, the Jordan in the Middle East, the Indus in Pakistan, the Yellow River in China, and the Nile in Egypt vanish into the earth at certain times of the year in certain places because their flow is not enough to reach the sea. Rivers and streams in the United States suffer the same fate because of groundwater depletion. This happens during the dry months of the summer when the baseflows of rivers are low and water is being pumped to irrigate lawns and gardens, as well as for use in homes.

Your dishwasher uses 15 gallons per cycle, which is less than washing dishes by hand. To further save water, only run it when it is completely full.

Guelta (water hole), Niger

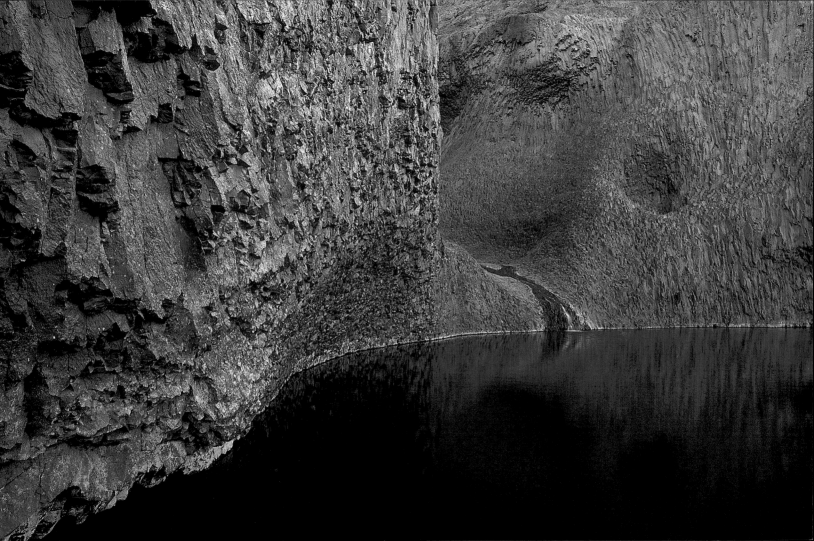

Don't patronize fast-food chains.

Eight hundred and fifty-two million people around the world live in poverty. Of these people, 815 million of them live in developing countries. In 1996, governments of the countries that belong to the United Nations Food and Agriculture Organization (FAO) made a commitment to halving the number of malnourished people in the world by 2015. At the present rate of progress this target will be achieved in 2150, or more than 100 years late.

Meanwhile, no part of the world is spared the wave of fast-food chain restaurant openings, a veritable standard-bearer of globalization. If you visit fast-food restaurants, think about what you are doing, and make your children aware of the other results of mass-produced food: intensive, polluting agriculture, poor nutritional quality, mountains of non-recyclable packaging, and standardization of tastes.

Vestmannaeyjar Islands, Iceland

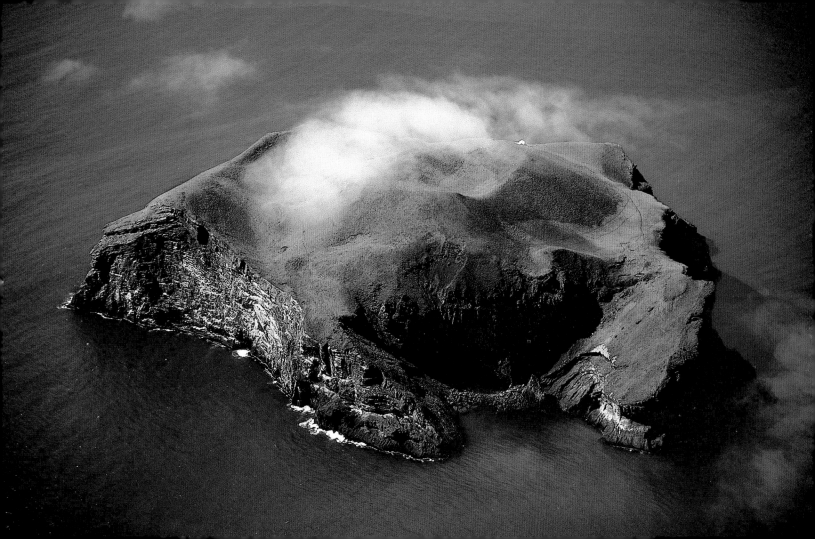

Water your garden in the evening.

All the water we use runs into rivers, where it flows to the sea to evaporate and fall back to the earth once more as rain. This endless process is called the water cycle. The water that quenches our thirst today may have been drunk by dinosaurs millions of years ago, for the amount of water on our planet is always the same. We need to look after it as our population continues to grow and our use of water increases.

—————————

Wait until evening to water your garden; during the cooler hours of the night, plants lose less through evaporation, and use half as much water. Also keep the weather forecast in mind: there is no sense watering your garden if rain is in the forecast. It is pointless to water the lawn in the dry summer months—your shriveled grass will become green as soon as the rains return.

Niger River, Mali

Choose a dishwasher with a "booster" heater and lower your water heater temperature.

More than a third of the electricity used by an average household goes to supply power for washing machines, dishwashers, and clothes dryers.

—————————

To reduce this consumption of energy, choose a dishwasher with a "booster" heater. This will add about $30 to the cost of a new washer, but it should pay for itself in water-heating energy savings after about a year if you also lower your water heater temperature. Some dishwashers have boosters that will automatically raise the temperature, while others require a manual change before beginning a wash cycle.

Hot springs, Kamchatka, Russia

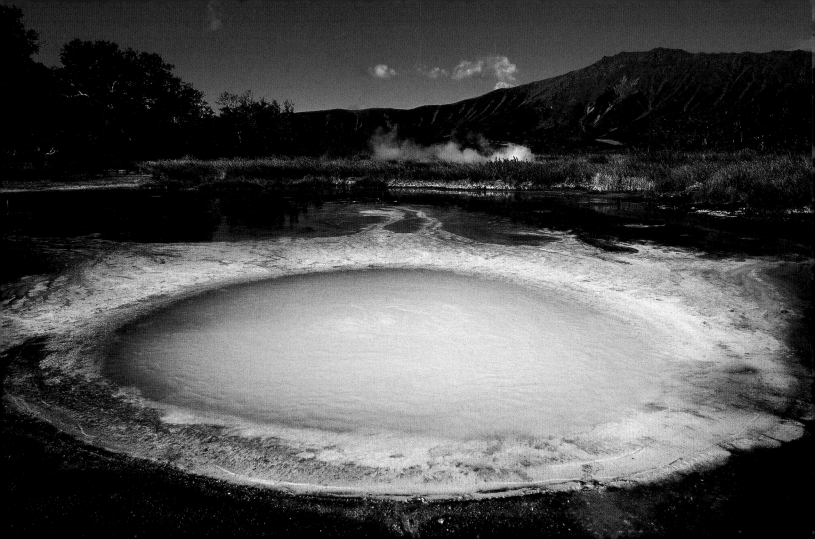

Consider a toy library.

Too many children never experience childhood. More than 300,000 young boys worldwide are enlisted as child soldiers. Many are not even 10 years old. A total of 352 million children between the ages of 5 and 17 are forced to work, more than 246 million of these work illegally, and almost 171 million work under dangerous conditions.

To teach your children values that are not oriented exclusively toward consumption or buying things, consider organizing a toy library with their friends in the afternoons. The variety of shared toys will certainly please them, and the toys will be used by more than one child.

Kilauea volcano, Hawaii

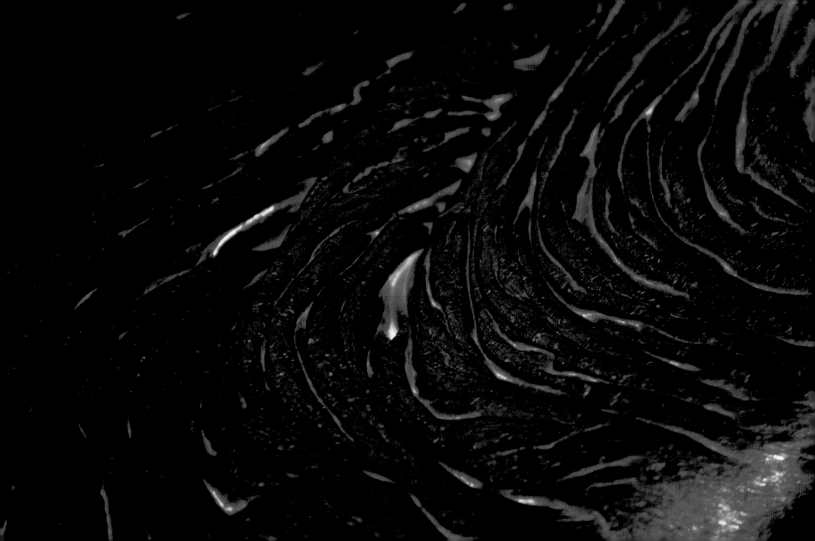

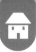

Leftover and stripped paint should go to the dump.

Painting the house is a polluting business. Cans of leftover paint, soiled cloth and packaging, solvents, and glue thrown in the trash become mixed up with other household waste. They have a damaging effect on the decomposition of the gases produced by incineration and on the effluent from dumps. If the liquids are poured down a drain, their toxicity interferes with the processes of water treatment stations. Half of all this waste is not treated and thus ends up in rivers and the sea. Three quarters of marine pollution comes from fresh water.

There are several ways to minimize the polluting effects of painting your house: take careful measurements and buy only the amount of paint that you need; once you are done with the project, take leftover paint to a paint exchange program, or donate it to a local charity. Finally, if you must dispose of the paint in the trash, be sure to let it dry completely (adding sawdust or kitty litter as needed) before putting it in the garbage.

Glacier, Greenland

Do not eat turtle meat.

Six of the seven species of sea turtles on the planet are in danger of being wiped out. Everywhere, they are caught for their meat and shells, their eggs are collected, their laying sites are disturbed, and they suffer from pollution. In Malaysia, the number of leatherback turtle nests has dropped by 98% since 1950. About 100,000 green turtles are killed each year in the islands that lie between Australia and Malaysia, and in Indonesia their numbers are a tenth of what they were during the 1940s. The killing of young adult turtles for their meat is even more damaging because turtles do not reach sexual maturity before the age of about 25.

When you are on vacation, you will see turtle meat on some restaurant menus. Eating it encourages a trade that threatens to wipe out a species that has been internationally protected since 1990.

Leatherback turtle, Guyana

Take a shower rather than a bath.

More than a third of humanity lacks adequate sanitation. It is estimated that half the world's hospital beds are filled with patients suffering from preventable, water-borne diseases. In 2004, the World Health Organization estimated that more than 2.6 billion people—40% of the world's population—do not have access to basic sanitation, and more than a billion people use unsafe sources of drinking water. This lack of access to clean water kills 4,000 children every day.

Don't take for granted what the rest of the world sorely needs. Moderate your water use-start by taking shorter showers. A 5-minute shower uses 12 to 25 gallons, while a filled bathtub holds 70 gallons of water.

Glacier National Park, United States

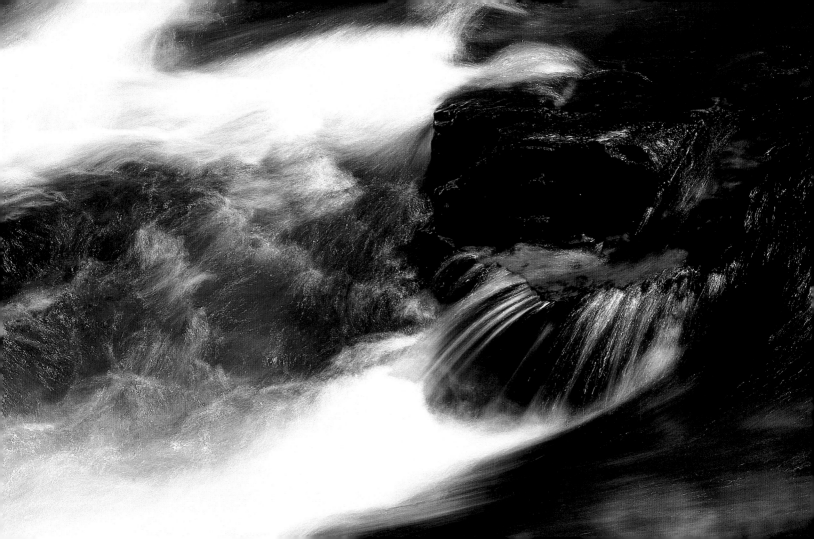

Have your car's pollution emissions checked.

All new gasoline and diesel cars are fitted with a catalytic converter, which cuts noise and treats the car's exhaust before it leaves the tailpipe, significantly reducing the pollutants that enter the atmosphere. This is not enough to stop air pollution, however, because the increase in the number of vehicles on the planet is too overwhelming. Today there are 800 million vehicles; if present trends continue, by 2050 there will be 2 billion.

It is essential to have your car's exhaust emissions checked regularly. Before purchasing a new car, decide whether or not you absolutely need one. If you live in a city, perhaps it is possible to use public transportation, using your car only when necessary. Or consider carpooling with a coworker.

Red ibis, Brazil

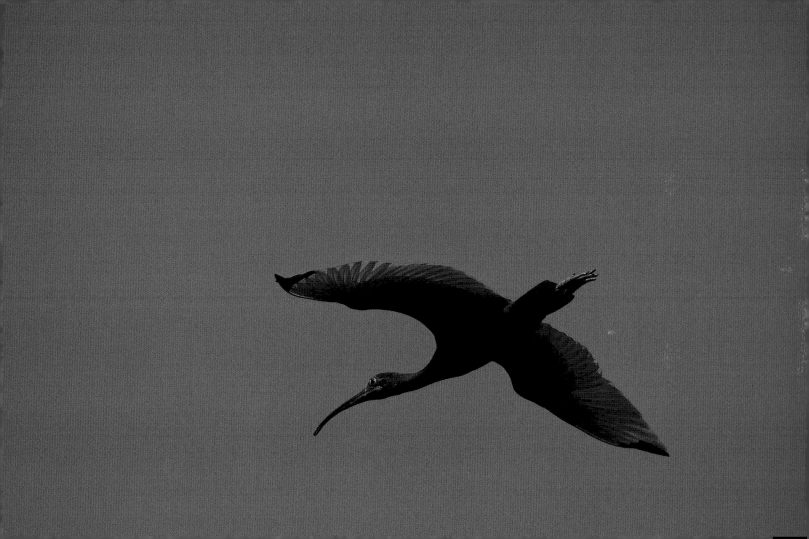

Buy other fair-trade products.

Fair trade accounts for less than 1% of world trade. It directly benefits about 800,000 producers and their families (or more than 5 million people in about 50 countries) and enables them to meet their needs for food, health, housing, and education. However, broadening the fair-trade market to embrace new cooperatives in developing countries relies on demand, which in turn depends upon the awareness of consumers in the United States, Europe, and Japan.

Don't stop with fair-trade coffee and tea. Broaden your purchasing to include other widely available fair-trade products, such as bananas, chocolate, honey, orange juice, pineapples, rice, sugar, and many others.

Yellowstone River Canyon, United States

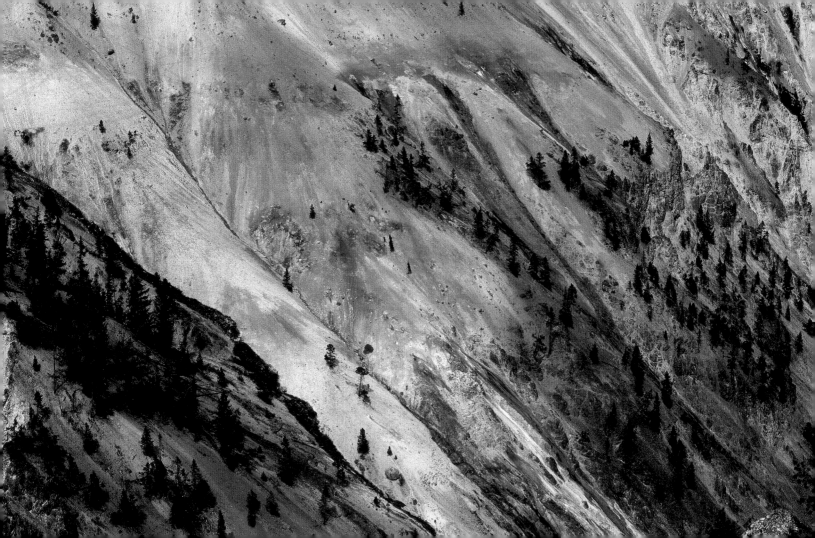

Act to preserve the environment without waiting for someone else to do it first.

It is easy to think that one small, damaging action does not endanger the Earth's future. In practice, however, such actions are never isolated events! It is the repetition and accumulation of all these small acts that takes on dramatic proportions. In the same way, a small, isolated gesture to preserve the environment will not improve matters on its own. It is all the simple gestures, repeated every day by millions of people, that will have a significant effect when added together. If the majority adopts them as a new way of life, they will contribute to preserving the planet and its riches for future generations.

Do not wait for your neighbor to act. Make the first move. He or she is probably waiting for you to take the first step.

Icebergs, Greenland

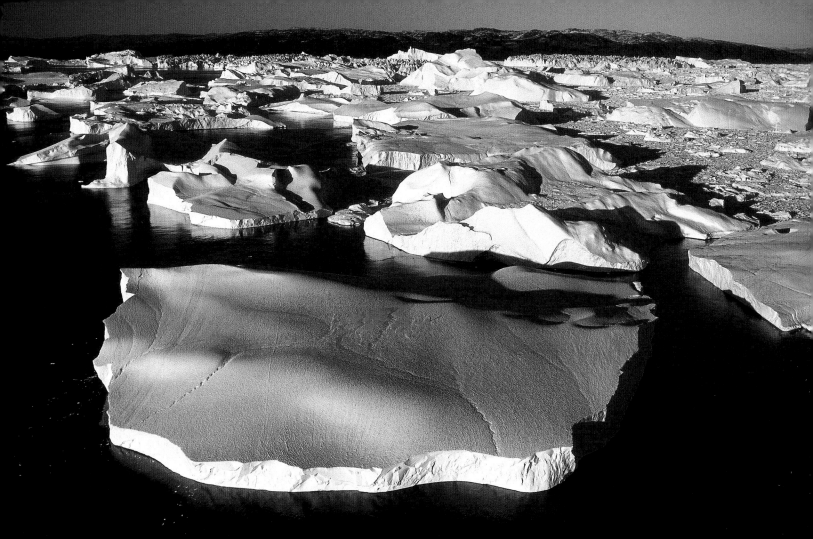

Use biodegradable cleaning products.

In the local supermarket we can buy acids, phenols, oil derivatives, corrosive solutions, chlorine, and a whole arsenal of toxic products that are supposedly necessary, according to advertising, to keep our homes clean.

Choose environmentally friendly and biodegradable household cleaning products, which do not contain the most dangerous substances. You will be contributing to the preservation of the soil, air, and water.

Giant clam, Australia

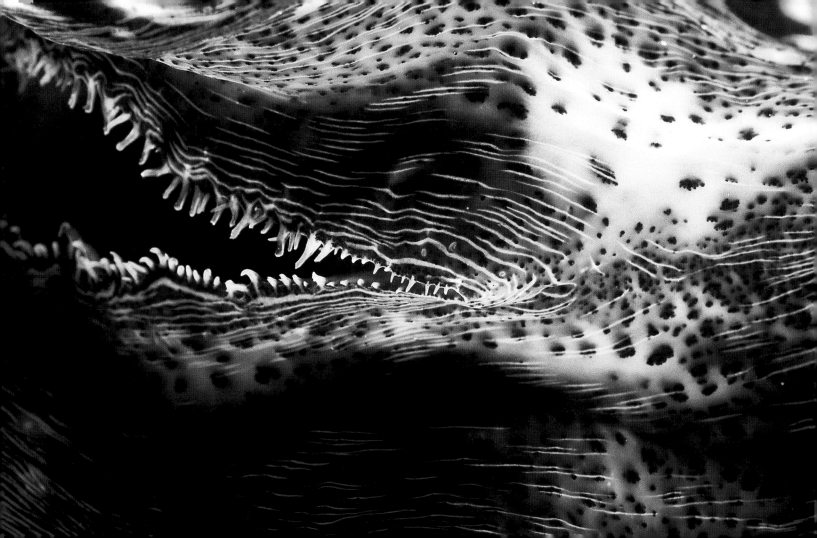

Try an electric bicycle.

Preserving the quality of the air around us is indispensable to life. Air pollution kills three times as many people as road accidents. It causes respiratory diseases (chronic bronchitis, asthma, sinusitis) and is responsible for 3 million deaths worldwide every year.

———

Try an electric bicycle. It is an attractive alternative to the car for short journeys. The electric motor ingeniously spares your legs by reducing the effort needed to pedal, and the removable, easily rechargeable battery has a range of 12 to 26 miles, depending on the terrain. Above all, it emits no pollution, is silent, and is considerably faster in a traffic jam.

Uzon caldera, Kamchatka, Russia

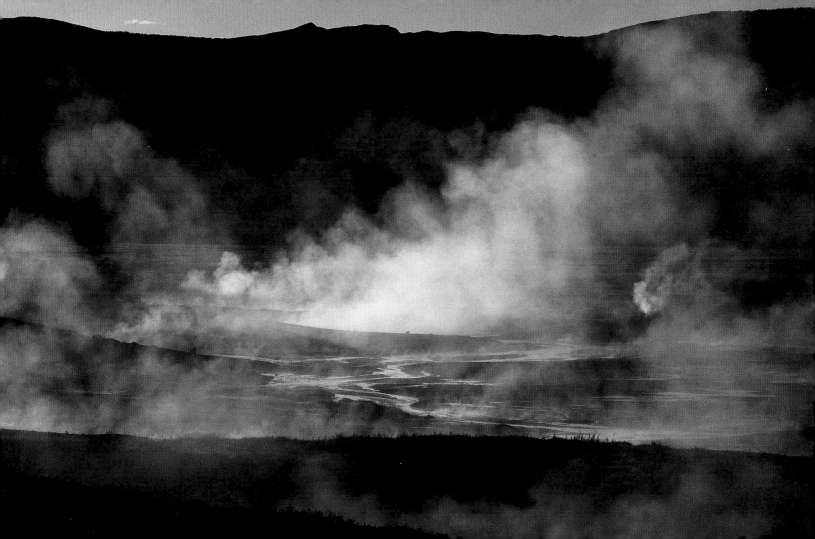

Buy forgotten varieties of fruit and vegetables.

In its headlong rush for profitability, the agriculture industry favors the most productive and pest-resistant types of produce at the expense of many domestic varieties of fruits and vegetables regarded as less efficient. At the beginning of the twentieth century there were more than 7,000 varieties of apples in the United States. Today, only about 10 are available commercially. Over the same period, 80% of tomato varieties, and 92% of lettuce varieties have been lost, or survive only in special conservation facilities.

Standardization is gaining ground, and biological diversity is in free fall. Consider varying your choices of fruits and vegetables; try different types, and rediscover the flavor of heirloom varieties. Local farms often revive these and sometimes develop their own delicious types of produce based on them.

Cranberries, United States

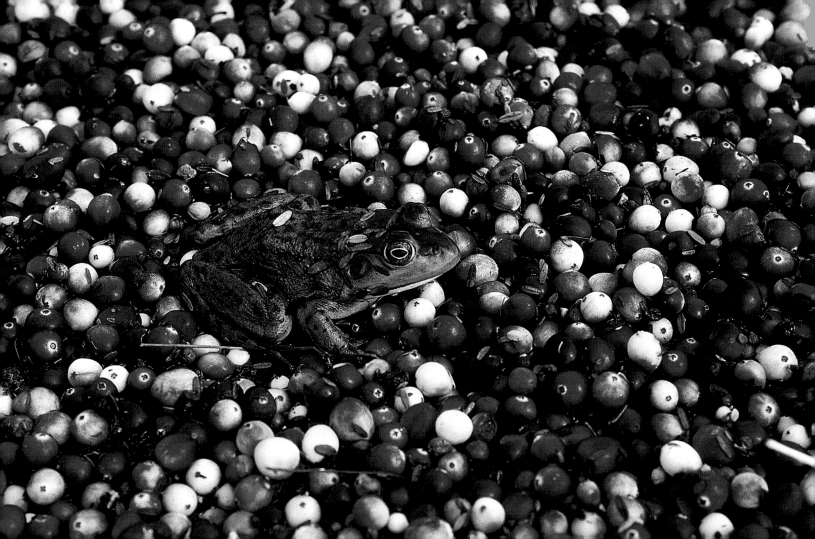

Leave protected plants and animals alone.

Every hour, at least two species of living things disappear from the planet. In the space of a century, more than 100 mammal species and 150 bird species have been wiped out forever. The chief causes of loss of biodiversity are destruction of natural habitats, introduction of alien species, and the excessive exploitation of species. Some especially endangered species are now protected: whales, turtles, rhinoceros, tigers, pandas, and orchids are the best known. Thousands of other threatened species are less well-known but equally significant.

When you visit wild places, do not destroy or remove protected plant or animal species. Find out more about them and discover how you can contribute to their protection and restoration.

Albatross, Roaring Forties

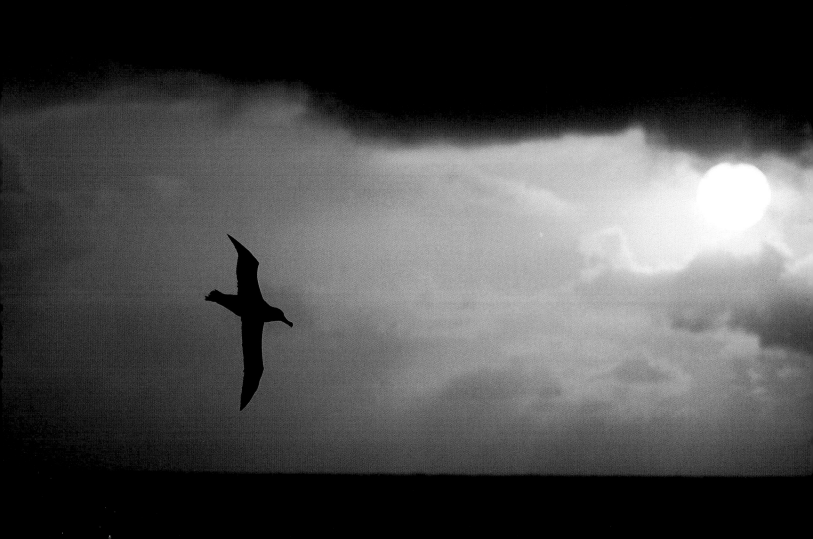

Wash your windows with vinegar.

Most of the world's pollution comes from developed countries, which produce more than 95% of dangerous pollution. However, in those countries the regulations governing the disposal of dangerous industrial waste have become so strict and involve so much expense that companies have turned to developing countries to take their waste. And industry is not the only area in which chemical products proliferate.

Most window-cleaning fluids contain synthetic compounds that are harmful to rivers. Replace them with a gallon of water to which you have added a few spoonfuls of vinegar. Apply this with a cloth or newspaper rather than with a paper towel.

Bacteria, Kamchatka, Russia

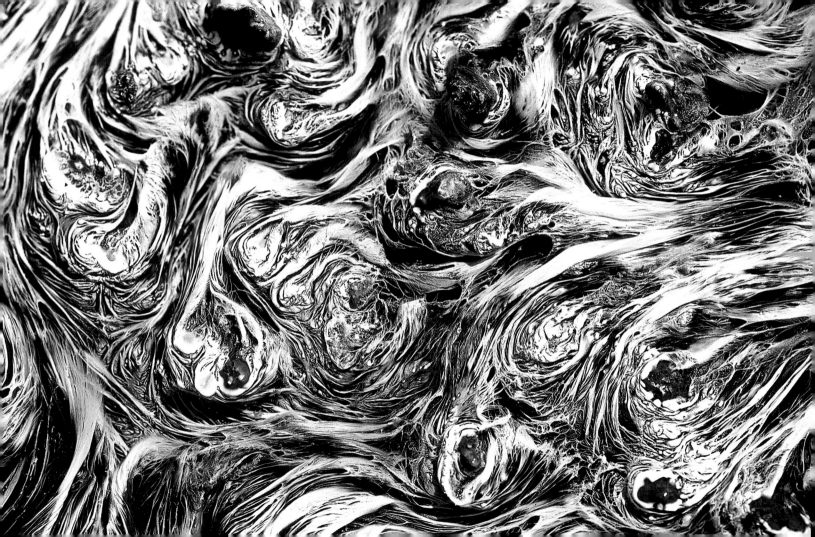

Make demands upon elected representatives.

If you feel that your local authority should adopt the LEED (Leadership in Energy and Environmental Design) standard for new buildings and use more renewable energy; if you feel that energy is used wastefully in public buildings and street lighting; or if you disagree with your area's transportation and development plans, make your thoughts known.

Do not hesitate to write to your mayor, state representatives, or senators and congressional representatives, to make them listen to your environmental concerns and urge them to make decisions that are consistent with sustainable development. To work, democracy needs input from the people, and remember, your elected officials represent you!

Mount Fitz Roy, Argentina

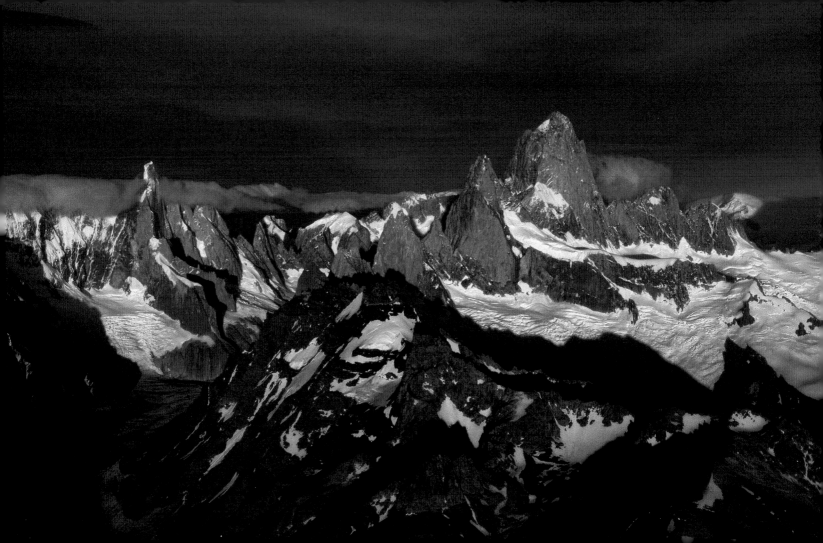

When you eat out, eat in.

In the space of about 30 years the volume of waste generated by household packaging has risen five-fold, and in terms certain materials such as plastic, by as much as 50 times. During the 1970s, the appearance of PVC (polyvinyl chloride) containers allowed the manufacture of so-called disposable items that could be discarded after one use. This trend has intensified and is now closely connected to the recent fashion for consumers to nibble food while on the move.

When you stop for lunch during the workweek avoid buying takeout food, which produces large quantities of waste; in particular, nonrecyclable plastic. Take the time to sit down and eat your food at the restaurant.

Scorpion fish, Thailand

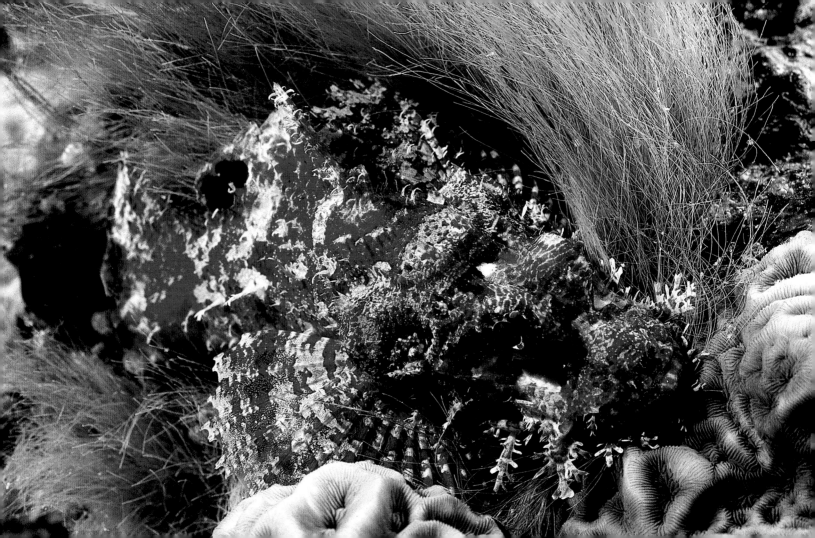

Buy organic food for your baby.

Studies have shown that human exposure to pesticides can cause neurological disturbances, increase the frequency of certain cancers, damage the immune system, and reduce male fertility. Pesticides also degrade soil and contaminate drinking water, leading to significant cleanup costs. These chemicals also kill non-targeted insects and affect organisms throughout the food chain. A conventional farmer can use any of 450 different authorized pesticides; an organic farmer can use just 7 natural pesticides, and that usage is strictly controlled.

If "going organic" for the whole family seems daunting, at least give priority to feeding organic food to babies and young children. Pesticides can increase susceptibility to certain cancers by breaking down the immune system's resistance to cancer cells. Infants and children are among those at greatest risk.

White Desert, Egypt

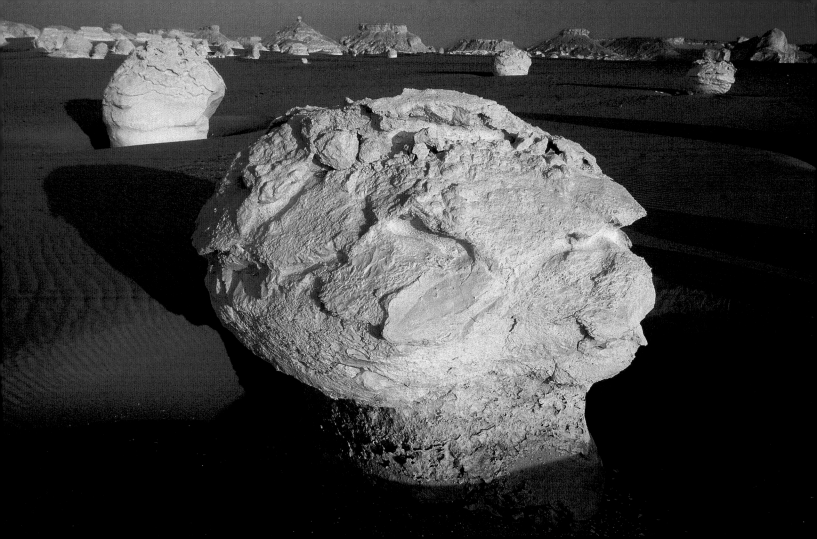

Bike or walk for short trips.

We cheerfully use the car to travel short distances. A national survey showed that half of all auto trips in the United States are less than 2 miles long. The survey found that drivers took an average of 7 trips in the car each day. Just under one-third of the trips were one mile or less, which means two of the trips could have been a very short, easy bike ride.

Choose to bike or walk instead of driving. A half-mile walk into town takes 10 minutes! It is difficult to beat that in a car, when you factor in the time spent looking for parking. You will save fuel and the planet will be spared greenhouse gas emissions and climatic upheaval.

Salar de Uyuni, Bolivia

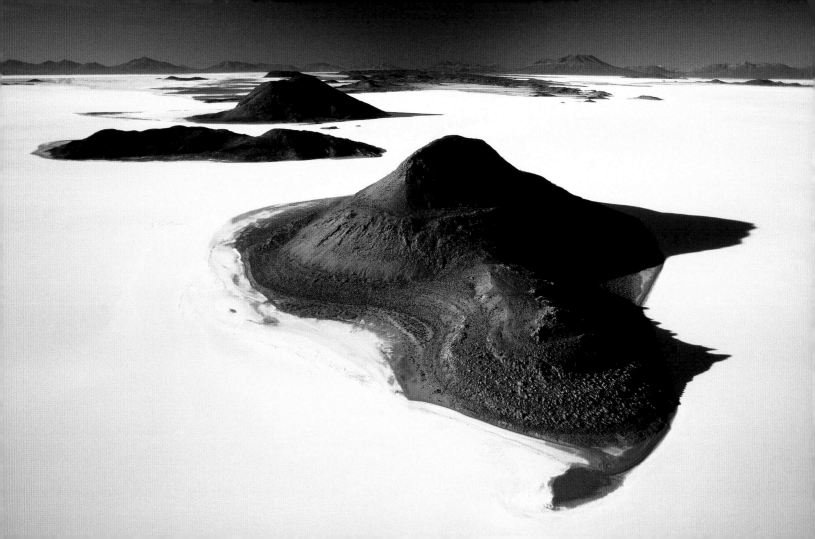

Use natural treatments for plant diseases.

In both agriculture and gardening, the intensive use of chemicals and defoliants impoverishes the soil, which, in the long term, becomes sterile. Even worse, repeated, systematic treatment with these agents encourages the development of resistance in the targeted pests. Since the 1950s, the number of insect and mite species immune to insecticides has increased from a dozen to about 450.

The best way to deal with plant diseases is to prevent them in the first place. Choose the right plants for your site, use disease-resistant varieties, keep a clean garden, create well-balanced soil, and don't overwater or overmulch.

Seeds, Shenandoah National Park, United States

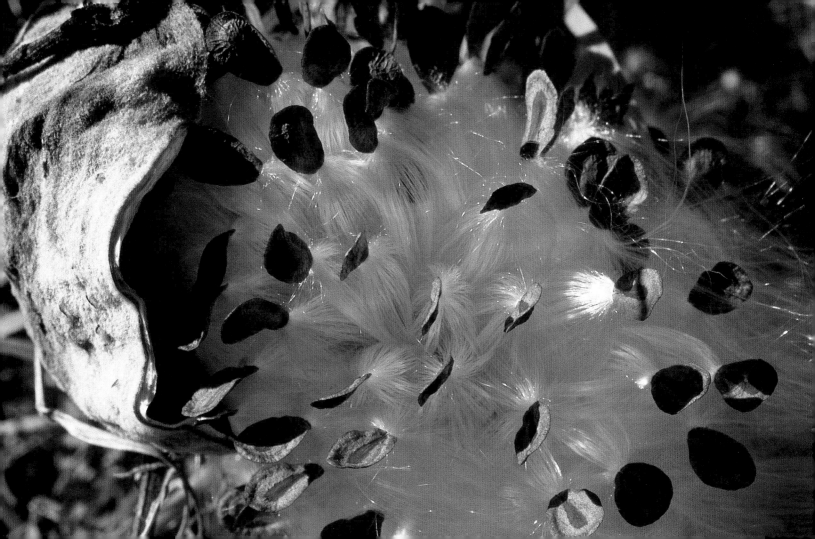

Do not waste water when traveling to places where it is scarce.

About 65% of the water human beings use is pumped from underground aquifers. However, more is drawn off than is naturally replaced because impervious surfaces such as pavements and buildings prevent rainwater from entering the ground. As a result, aquifers are gradually being drained dry. Some aquifers close to the sea—in Spain, for example—have started to fill up with saltwater. In India, the water table has dropped between 3 and 9 feet over three-fourths of the country's area. This shortage speaks to the need for proper conservation and management to access more water, instead of technological fixes such as desalinization plants.

In some countries, water is scarce. Think about it when you are traveling. In developing countries the average tourist uses as much water in 24 hours as a local villager does in 100 days. Be careful: take as few baths as possible and avoid wasting this precious liquid.

Namib Desert, Namibia

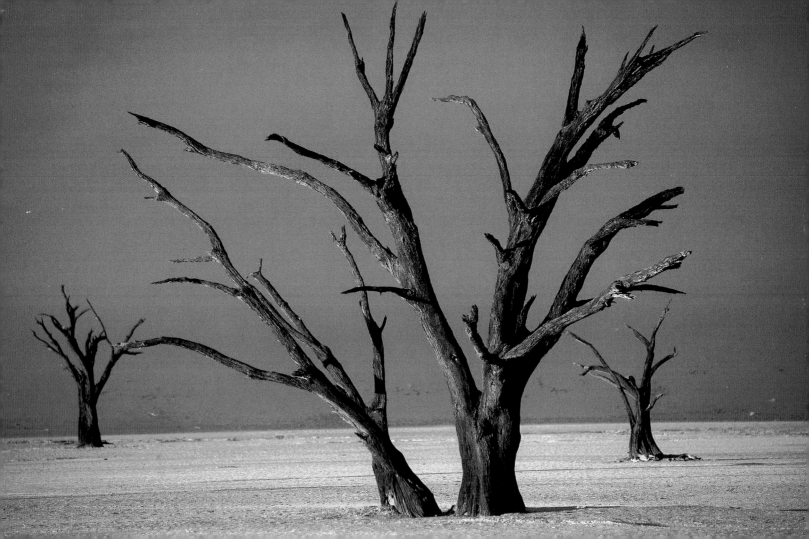

Refuse to buy objects made from ivory.

Massacred for the ivory that is its defense against attack, the African elephant has almost disappeared from the planet. In Kenya and Tanzania about 70,000 African elephants were killed each year between 1975 and 1980. Between 1980 and 2000, their numbers fell from 1.4 million to 400,000.

Although the international ivory trade was banned in 1990, ivory jewelry and statuettes can still be bought in African and Asian markets. Traders may offer to sell ivory objects illegally. Do not yield to the temptation to buy them: this encourages trafficking and, since this trade is illegal, you will not be allowed to take them home.

Elephant, Kenya

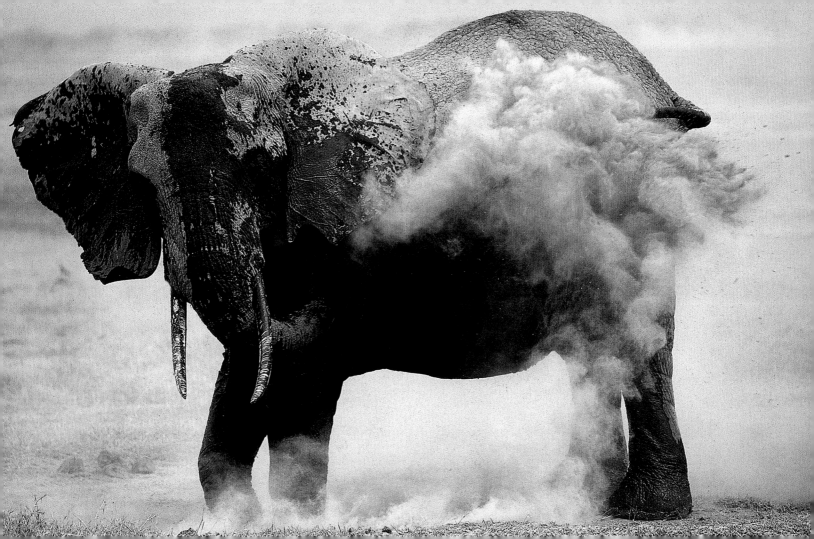

Read and know your poultry labels.

By choosing the breeds that produce the highest yields, farmers have succeeded in reducing the average time it takes to raise a 5-pound chicken from 84 days in 1950 to 50 days today. Living conditions for these animals are grim. Free-range chicken has become more widely available as an alternative, but be aware that American labeling is not yet standardized. The label "free-range" requires only that hens have access to an outside area, but it does not stipulate a space requirement per hen. Until national labeling standards are established, it is difficult to identify exactly how a chicken was raised.

Look for labels that specify traditional free-range chicken or total-freedom free-range chicken. These are most likely to comply with our idea of chickens that are free to roam the farm. Introduce healthier free-range chickens into your diet gradually. It is better to eat organic poultry at least once a week than to cook less-expensive, commercially farmed chicken three times a week.

Drifting ice floe, Antarctica

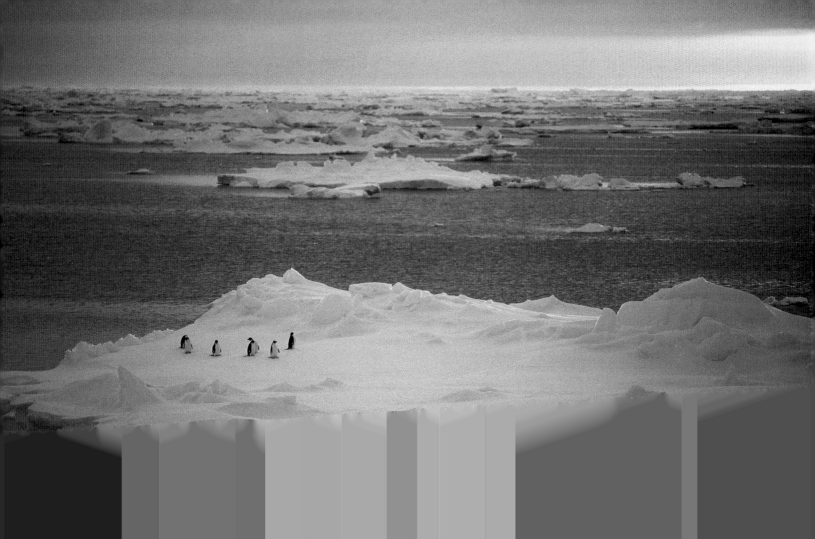

Be unobtrusive while out hiking.

Twenty-one species of birds in the United States are now extinct. Birds are vulnerable to habitat damage from intensive agriculture and forestry, the growing impact of development on the land, unrestricted water use, and pollution of all kinds.

When you are out hiking, treat wildlife with respect. Do not disturb animals, especially young animals and chicks. Watch them discreetly, at a distance, without disturbing their quiet and tranquility.

Primary tropical forest, Australia

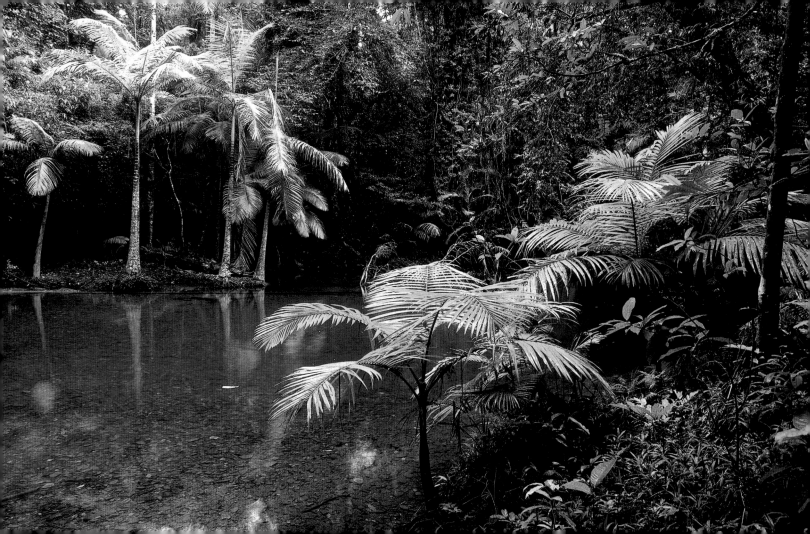

Trace leaks.

On average about half the water in cities and in distribution grids worldwide is lost to leakage. The volume of water lost to leaks and illegal siphoning in Nairobi could meet the needs of Mombasa, Kenya's second-largest city.

Trace the leaks in your home's plumbing. A dripping faucet can lose 5 gallons of water a day if it drips at a rate of one drop every second; a leaking toilet can lose 15 gallons a day.

Mud flats, Alaska

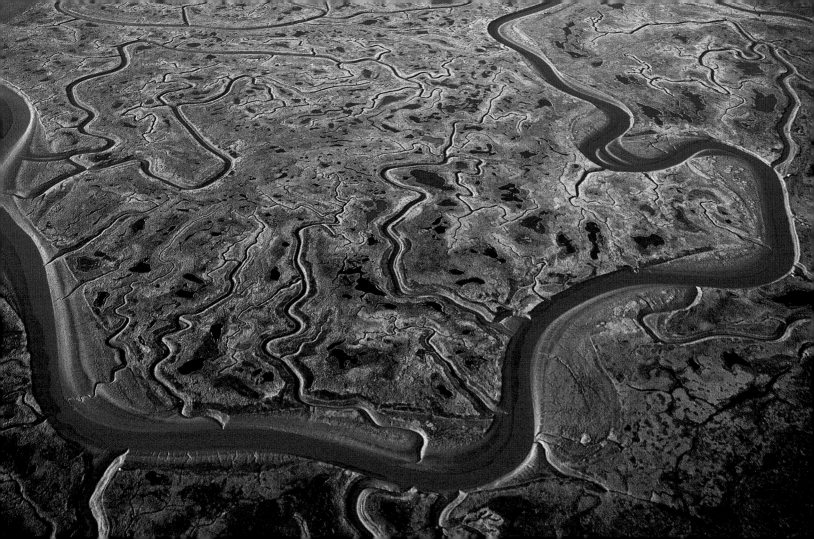

Count your calories (production calories, that is).

Every food product you purchase has two caloric values: the amount of energy you receive from it (the value printed on the side of the package), and the amount of energy required to produce it. In today's food industry the second caloric value comes from a variety of sources: the sun, the human energy involved in production, and the fossil fuels that drive the machinery used in the farming process and power the production of chemicals. Some of the statistics are hard to swallow: the modern production and distribution system spends 10–15 calories for every calorie it produces; the United States expends three times the energy per person for food that developing countries use per person for all energy activities.

Two pounds of flour requires less than 500 calories of energy for processing; the comparable amount of soda requires over 1,400 calories; chocolate requires over 18,500 calories. To reduce production calories try to buy as few processed foods as possible.

Salt lakes, Chad

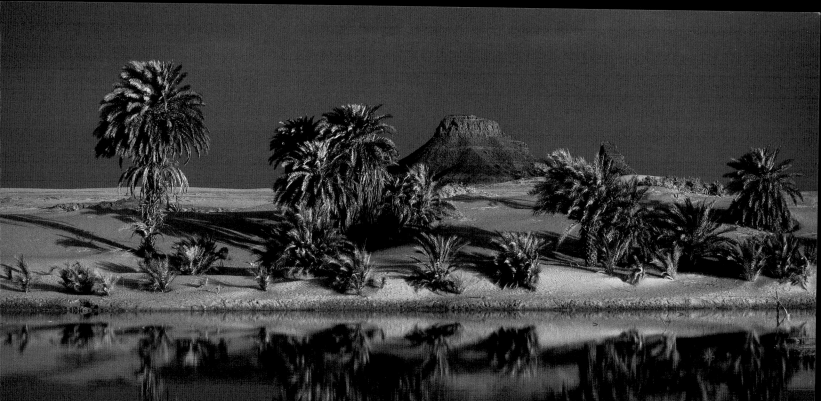

Do not build in high-risk areas—consult the local building plan.

There is a close relationship between the impact of a natural disaster and the level of development of the country affected. Natural disasters cause 47 times as many deaths in poor countries as in wealthy ones. Often lacking appropriate infrastructure and proper protective measures, developing countries are more vulnerable, particularly to extreme weather conditions. The fact that 45% of the population of large cities in developing countries live in dwellings without building permits contributes to the problem.

To reduce the social and economic costs of natural disasters, consider two factors: where you build and how you build. Proper adherence to building codes is necessary to construct a safer, more resilient environment.

Erta Ale volcano, Ethiopia

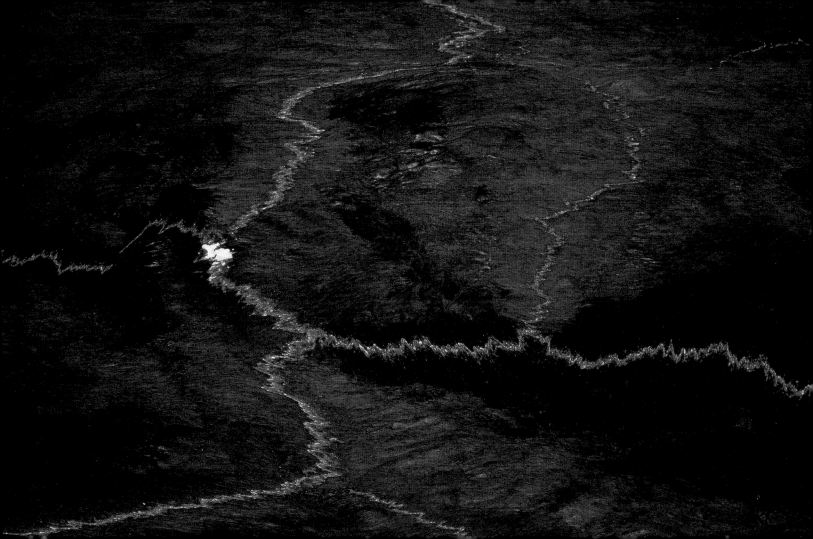

Weed mechanically or by hand.

In the United States, gardening expenditures total around $40 billion every year. The average U.S. household spends $444 on lawn and garden goods every year. Flower, seed, and potted plants made up only half of the expenditures. The rest of the spending goes to products involved in cultivating and caring for these plants. Excessive use of pesticides threatens biodiversity and fresh water resources, two essential elements of life on earth.

Avoid using chemical weed killers. To remove weeds from your garden, hoe regularly, and pull weeds out before they can seed.

Lobelia, Uganda

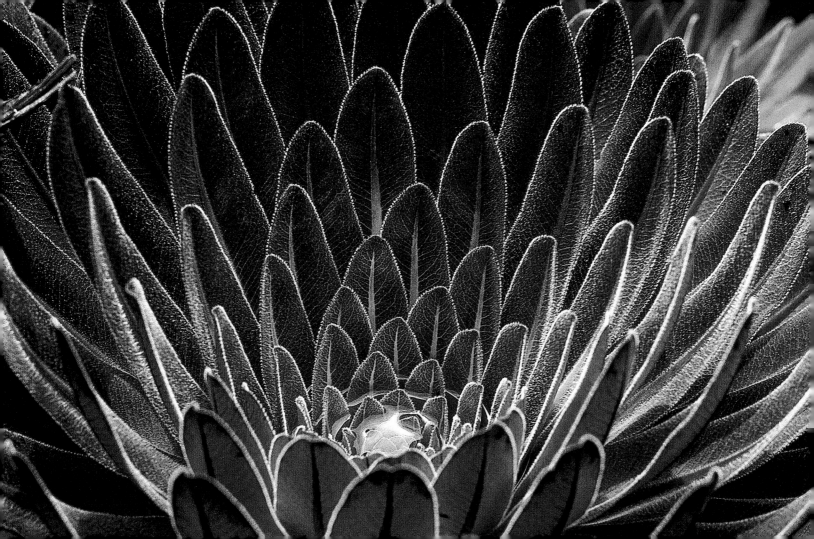

Join the activities of environmental volunteers.

Whether guarding turtles laying their eggs on Mayotte; helping to protect wolves in Romania, iguanas in Honduras, or griffon vultures in Israel; or assisting scientists in the conservation of endangered primates in Kenya, the possibilities for volunteering for environmental work are (sadly!) endless. Helping in this way enables you to understand a country by living as local people do, while working for the protection of fauna, flora, or habitats.

Are you looking for a way to spend your next vacation by doing something both original and useful? Consider volunteering for nature conservation; you will have the opportunity to work with specialists and to do something positive in support of a major ecological cause.

Scorpion fish, Australia

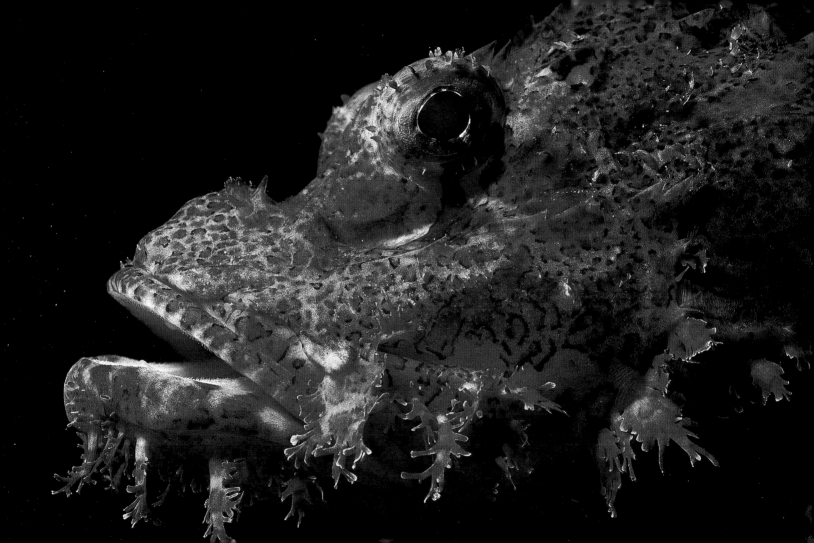

Do something for the planet on Earth Day—and every day.

In 1998, 25 million environmental refugees fled from desertification, deforestation, industrial accidents, and natural disasters. This was more than the 23 million who became refugees because of war. As a result of climate change, environmental refugees will become ever more numerous, driven from their homes by droughts, floods, extremes of weather, or rising sea levels. By 2020, it is estimated that 20 million people will be forced to leave Bangladesh, a vast delta that is especially vulnerable to being inundated. Where will they go?

Every year on April 22 more than 180 countries celebrate Earth Day. Join the party: take part in events organized that day. Then, through your own behavior, make every day an earth day.

Salar de Uyuni, Bolivia

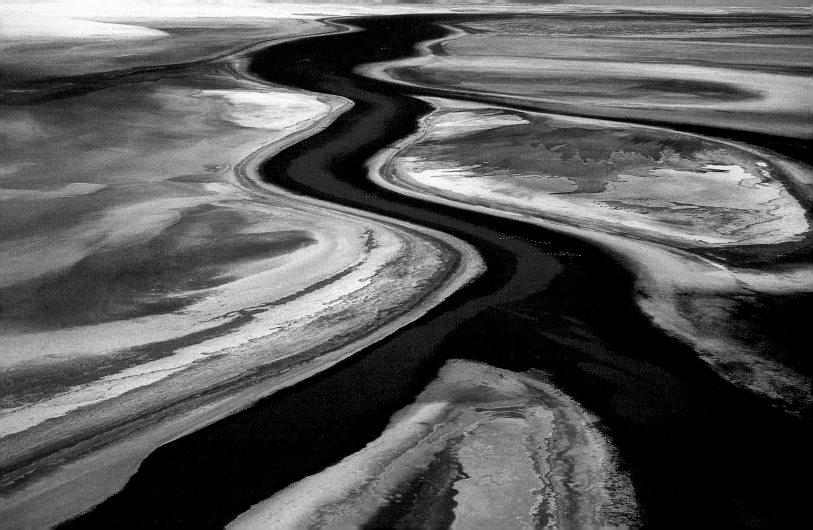

Try trading skills instead of purchasing services.

People all around you have a wealth of specific talents and knowledge that perhaps you do not share. Your own abilities may take another form. These may range from the sophisticated—computer programming, financial investment, or portrait photography—to the basic, like lifting boxes or feeding a cat while the owner is away.

Instead of looking in the phone book for a service for hire, reach out to your neighbors and friends and offer to trade talents. Perhaps someone living near you will offer the help you need in moving house, in exchange for your help with child care. It is another way of encouraging a more humane society.

Waimea Canyon, Hawaii

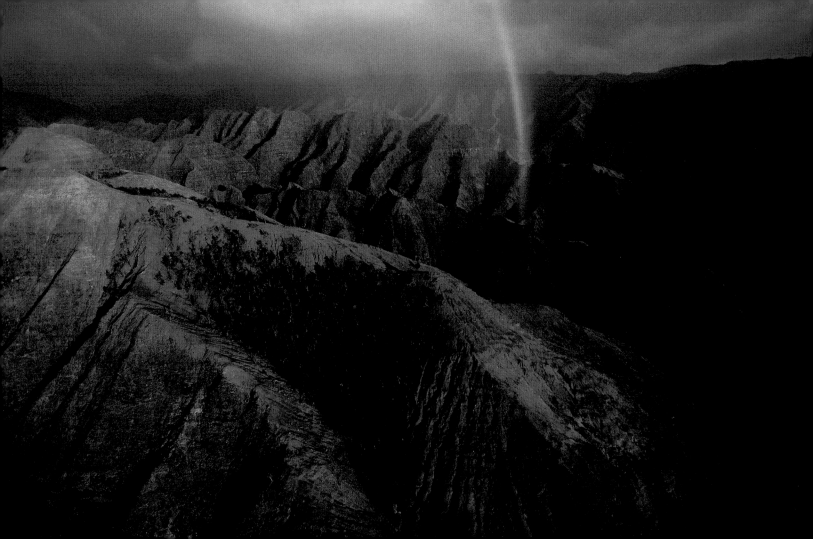

Choose compost and natural fertilizers rather than chemical fertilizers.

Overuse of chemical fertilizers containing nitrogen contributes to pollution of water by nitrates. Highly soluble, these chemicals are easily washed away by rain and carried into rivers and aquifers. Nitrates contribute to the eutrophication of rivers by causing them to become overrich in nutrients, so that algae grow rapidly and deplete the oxygen supply, which suffocates all water life. Large amounts of nitrates in groundwater interfere with drinking-water supplies.

In your garden, use natural fertilizers (stone meal, bone meal, or wood ash) and compost made from organic waste to improve soil structure and fertility naturally, effectively, and sustainably.

Moss, Kamchatka, Russia

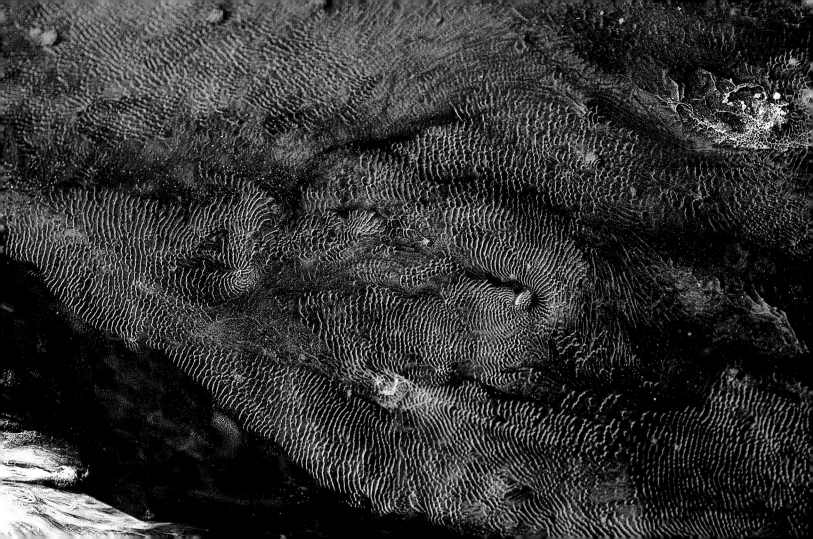

Protect rivers: don't dump or litter in storm drains.

No fewer than 114 great rivers, or half the planet's biggest watercourses, are severely polluted. The Ganges, sacred though it is for Indians, receives 300 million gallons of wastewater every day, which transform it into a vast open sewer. Worldwide, 2 million tons of waste are poured into lakes and rivers every day. As a result, a fifth of the planet's 10,000 species of freshwater fish are in danger of extinction.

Protect rivers from all pollution. Don't dump into storm drains, which discharge into water-bodies without any filtration or treatment. Also, don't drop litter in the street or countryside. Sooner or later, it will be washed into a river, lake, or harbor.

Guelta (water hole), Chad

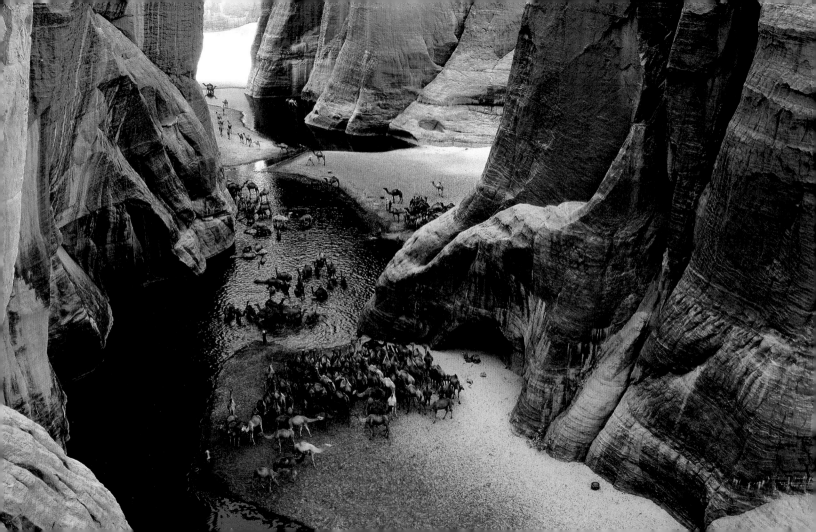

Cool off without resorting to air-conditioning.

Despite its environmental impact—namely, the creation of hundreds of thousands of tons of cancer-causing radioactive waste—nuclear power is still considered an option because it emits no carbon dioxide. This is undeniably a plus in trying to limit global warming. However, this does not solve the problem of the 200,000 tons of nuclear waste now stored on the planet, 5% of which will remain dangerous for several thousand years. Using less power, however, reduces the amount of nuclear waste that is produced.

Consider carefully before having air-conditioning installed; it can increase your electricity bill by a third. A fan uses one tenth of the energy; window shades, blinds, shutters, and the cool of the night use no energy at all.

Iceberg, Greenland

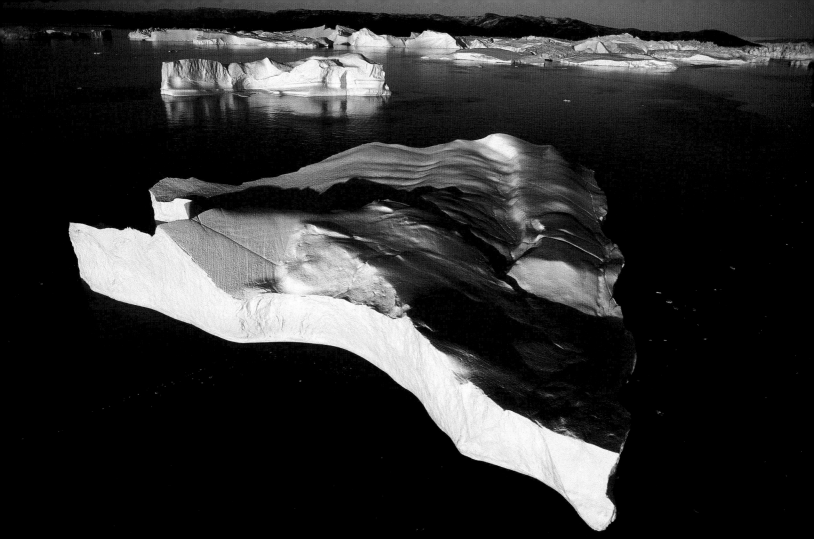

Choose FSC- or SmartWood-certified products.

In 1997, the Brazilian government admitted that 80% of the wood taken from tropical forests was removed illegally, and a World Bank report declared that 80% of Indonesia's wood products were also illegal. When we buy FSC- (Forest Stewardship Council) or SmartWood-certified products, we can be sure they come from a sustainable, managed forest where strict environmental, social, and economic standards are observed, and that they have not contributed to the worldwide plundering of tropical forests.

Only consumers have the power to increase the area of certified forest by demanding better product labeling. The FSC label alone appears on about 10,000 products (furniture, floor tiles, shelves, paper, garden furniture, and barbecue charcoal); SmartWood certified products and companies number around 900. Take advantage of these options.

Mangroves, Australia

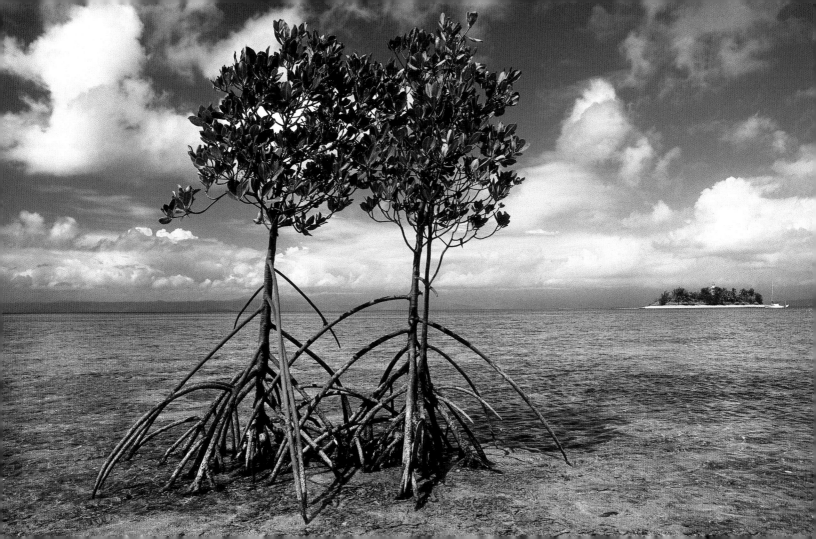

Use photovoltaic panels to produce electricity for your home.

Solar energy is available everywhere. It is free and easily harnessed by fitting photovoltaic (PV) panels to your roof. PV panels convert sunlight into electricity without producing noise, pollution, or dangerous waste, and without contributing to global warming.

Grants and tax breaks are often available for such installations, and if you produce more electricity than you need, you can sell the excess back to the electric company.

Antarctic peninsula

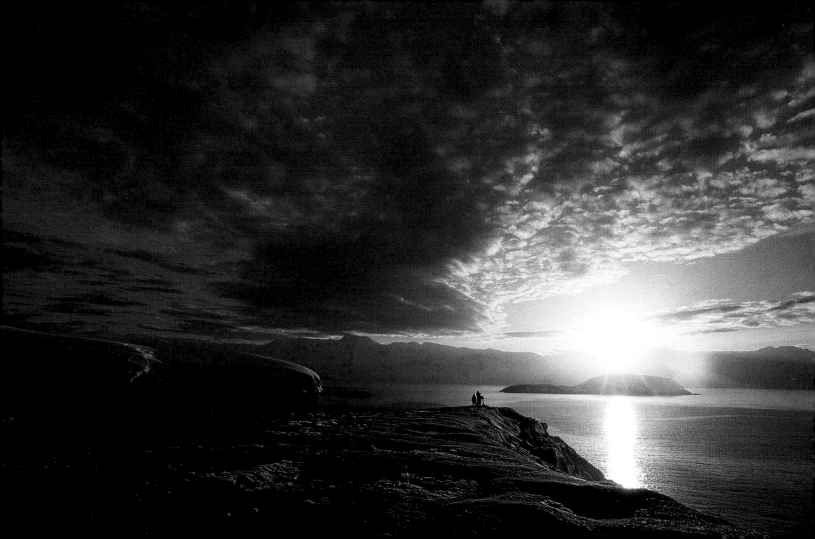

Have a dual-flush fixture fitted to your toilet.

All our buildings are supplied with drinking water, yet only 1% of the water treated to those standards is actually drunk. A dual-flush toilet fixture can reduce the use of potable water for non-potable actions. Although Europeans and Australians have been using them for some time, the dual-flush fixture was introduced to the United States just over 5 years ago. The dual-flush fixture senses the contents of the toilet and uses an appropriate amount of water to flush.

Dual-flush fixtures are now available to be fitted to your toilet and will allow you to reduce your household water consumption by half.

Lake Turkana, Kenya

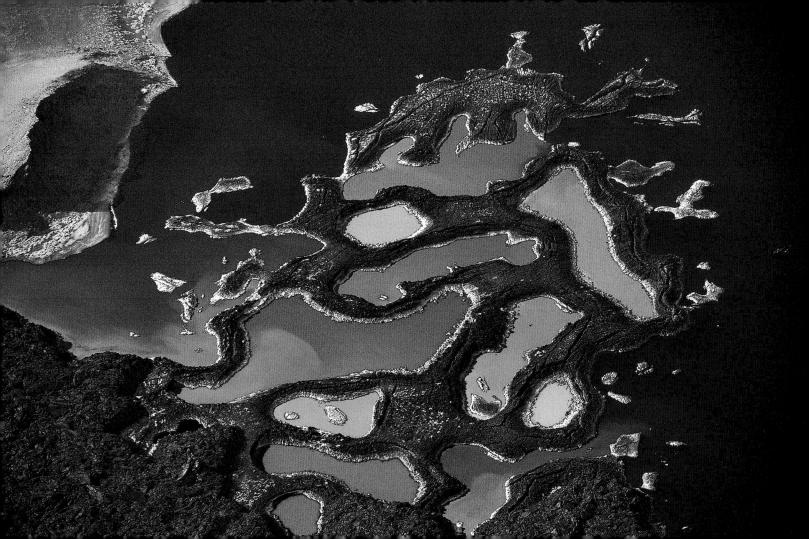

Demand organic products in institutional cafeterias and eateries.

Every year throughout the world about 3 million people are poisoned by, and 200,000 die from, pesticides. In fact, today these products are between 10 and 100 times more toxic than they were in the 1970s. A common way for pesticides to affect human health is for the chemicals to seep into groundwater supplies, which provide the bulk of our drinking water. Since it takes several centuries for these supplies to be replaced, this contamination poses a grave threat. Therefore, practicing less-polluting agricultural methods also safeguards the future of our drinking water supplies.

Organic food also has a place in educational institutions and places of business: help your child's school and the cafeteria at your workplace begin to buy more organic and locally grown products.

Piton de la Fournaise volcano, Réunion

Do not throw out your children's old toys.

Unchecked consumption of the world's natural resources and increasing production waste are mostly because of the actions of the United States, Europe, and Japan, home to 20% of the world's population. An American produces 1,460 pounds of household garbage per year, or about twice as much as a European, and 10 times as much as someone in a developing country. During its lifetime, a child born in an industrialized country will consume more resources and generate more pollution than 40 children in a developing country.

When your child outgrows a toy, it is pointless to keep it as relic; encourage your child to donate old toys to charities, or to children's hospitals or foundations, and explain the benefits of doing this.

Weddell seal, Antarctica

Support Community Sponsored Agriculture.

The average American-grown tomato may travel as much as 1,500 miles from vine to salad bowl in a journey that leaves a trail of serious environmental and societal consequences. The food shipping industry relies heavily on cheap energy sources, and air pollution from food transport contributes to our smog-choked atmosphere. Farmers see only a fraction of every dollar spent on their produce while the rest is paid to various middlemen in the food production process. Unable to compete with large-scale farms, small farmers are forced to close up shop.

Community Sponsored Agriculture (CSA) programs seek to alleviate these problems by localizing food production and consumption. Consumers who invest in a farm at the beginning of a growing season receive regular deliveries of seasonal, usually organic, vegetables that have been locally produced, and are able to develop a relationship with their farmer and food provider.

Erg (sand desert), Algeria

May 3

Cover soil to protect it from evaporation and weed growth.

When weeds appear in the garden, there is a strong temptation to eliminate them using an environmentally damaging chemical treatment. It is better, however, to prevent them from growing in the first place by using natural mulch cover that also helps to keep moisture in the soil. Protected from weeds as well as from drying out excessively, the garden will be healthier.

You can mulch the soil around the base of plants, trees, and bushes using hay, dried grass cuttings, leaves, wood shavings, chippings, cocoa bean shells, and so forth. Mulching also protects soil from the action of sun and wind, and helps to keep it moist.

Acid lake, Vanuatu

Invest in a tankless water heater.

Fossil fuels are substances extracted from the earth's crust and burned to produce heat or energy. These reserves are finite; at current rates of use, oil will be exhausted in about 50 years, gas in about 80, and coal in 300 years. It took millions of years for these deposits to form; two centuries will have been enough to exhaust them.

A gas boiler that heats water only as required is better than an electric one, which works continuously. A tankless water heater only burns gas when you need water, and can deliver as much as 200 gallons of hot water per hour. Tankless water heaters can also save as much as 50% of the cost of heating water.

Trou de Fer, Réunion

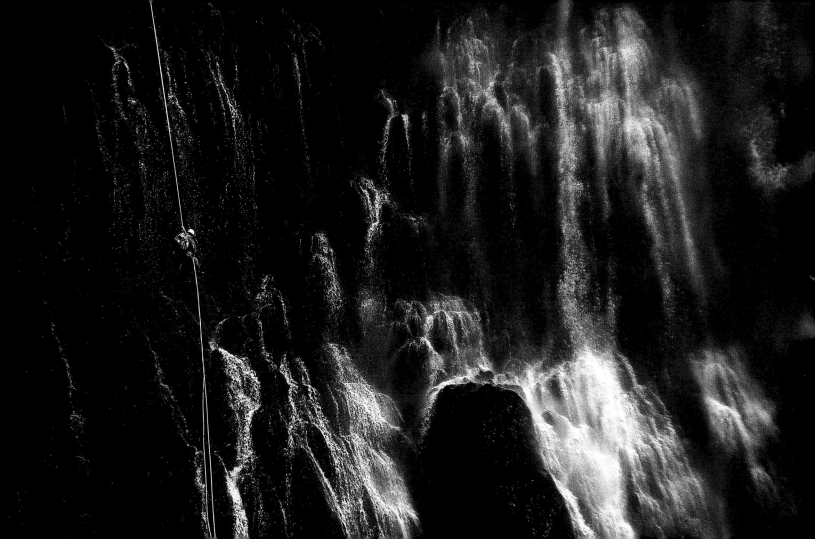

Use concentrated dishwasher liquid.

Packaging has gone beyond the function of protecting a product and informing the consumer, and has become a marketing tool. Over-packaged goods vie with each other to seduce potential buyers at first glance, so that a product that was not on the shopping list ends up in the shopping basket.

When buying dishwasher liquid, ignore boxes of individually packed tablets and instead choose less polluting and more easily carried alternatives, such as refillable packages, especially concentrated liquids. Dishwasher detergent in tablet form is also higher in phosphorus, which disrupts ecosystems when released into our waterways.

Inlandsis, Greenland

Contribute to enhancing biodiversity in your area.

The Natural Heritage Central Database lists 526 animal and plant species as extinct or missing. Approximately one-third of all U.S. plant and animal species are at risk for extinction. In the eastern United States, forest ecosystems contain the greatest number of endangered and threatened flora and fauna; in the West, the rangelands are home to the most endangered and threatened species. Wetlands, which comprise only 5% of the continental United States, contain nearly 30% of the endangered or threatened animal species, and 15% of the listed plant species.

Threatened and endangered species can be found throughout the United States in all kinds of ecosystems. Learn the species that are listed in your area and commit to assisting in the preservation of their habitat.

Osprey Reef, Australia

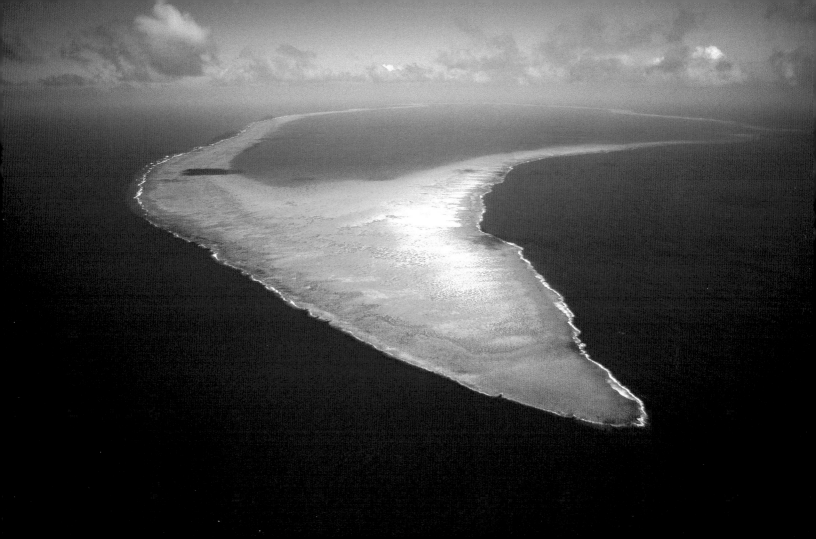

Recycle glass.

Making new glass products from recycled glass saves 80% of the raw materials and 30% of the energy needed to make glass from scratch. The energy is saved because crushed glass melts at a lower temperature than the raw materials used to make glass. Today more than 25% of all the glass made in the United States is recycled. Compare that to Europe, where 50% is recycled. In England, 600,000 tons of glass recycled over the course of one year saved the same amount of energy used by all the country's primary schools in a year.

Glass can be recycled indefinitely. Keep your glass in the production stream!

Ol Donyo Lengai volcano, Tanzania

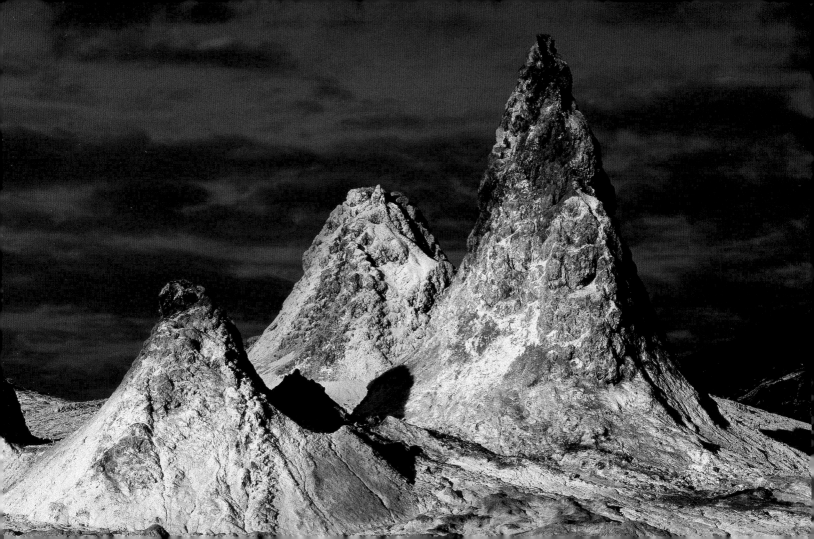

Choose natural cosmetics, labeled with the Leaping Bunny logo.

The Coalition for Consumer Information on Cosmetics was created in response to a lack of certified cruelty-free labels in the cosmetics and body care industry in the United States. The Leaping Bunny logo is an internationally recognized, comprehensive standard, and many popular products abide by it. Without independent oversight, many companies claim to be cruelty-free in the production of their goods but have found ways to violate consumer trust: by contracting out animal-testing they can claim that they don't test on animals; or, by testing the ingredients separately on animals they can then claim that the product is free of animal-testing.

Don't be fooled by claims of cruelty-free production. Without the Leaping Bunny certification, the only way to learn what the claim on a label means is to contact the manufacturer directly.

Lake Natron, Tanzania

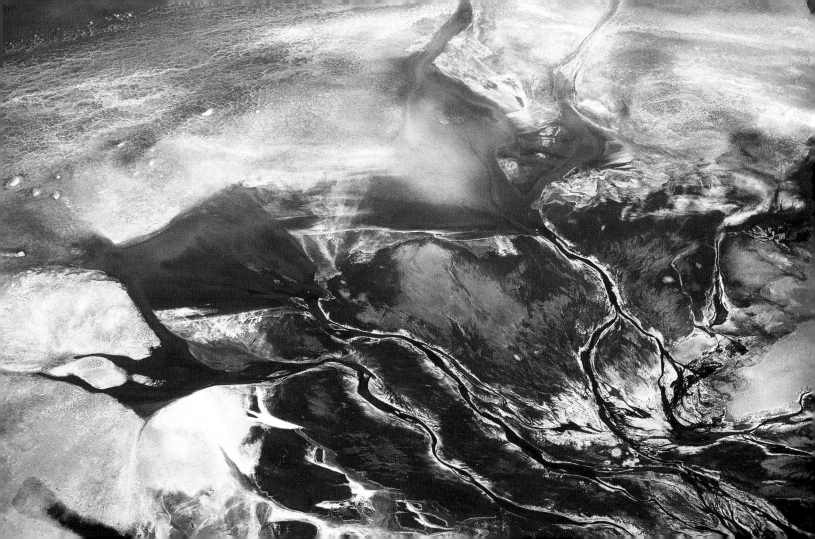

Buy products that are durable and can be repaired.

Every manufactured product often requires a degree of raw materials and energy from the environment out of proportion to its weight. If wealthy countries maintain their present rates of consumption, each individual will consume an average of 100 tons of the earth's nonrenewable resources and more than 134,000 gallons of fresh water each year (30 to 50 times the amount that is available for each person in the poorest countries). Buying durable goods that can be repaired will help reduce the impact of this consumption.

The next time you buy something, ask the seller about the length of its guarantee, how easily it can be repaired, and whether spare parts are available.

Descent into a glacial crater, Greenland

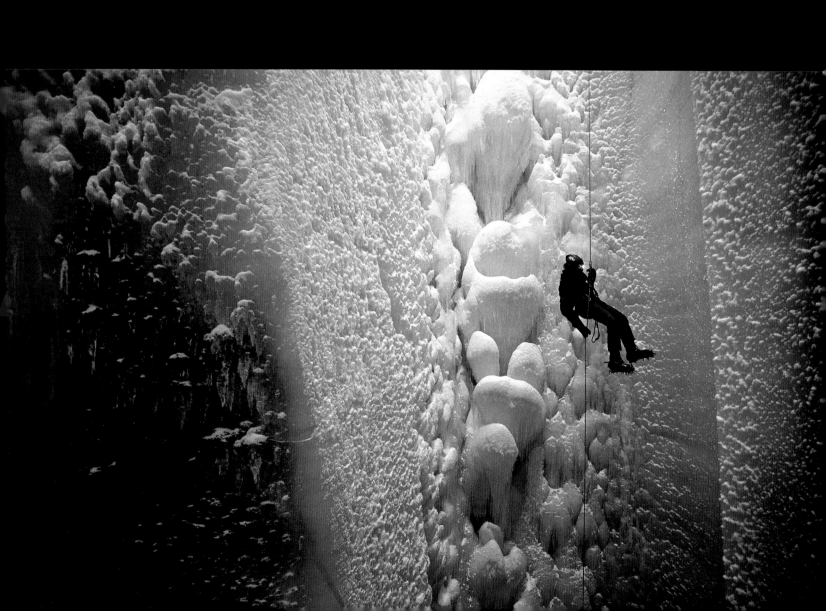

Take part in National Bike Month.

The League of American Bicyclists has been celebrating National Bike Month in May for almost 50 years. Bike-to-Work week, a celebration of the national campaign to get commuters out of their cars and onto a bicycle seat falls at the end of the month.

When Bike-to-Work week rolls around, use it as an excuse to tune up your bike before summer so it will be ready to take around town. If you don't know how to tune your bike or change a flat tire, take a class; many bike shops offer them free, or for a nominal fee.

Volcanic ash, Iceland

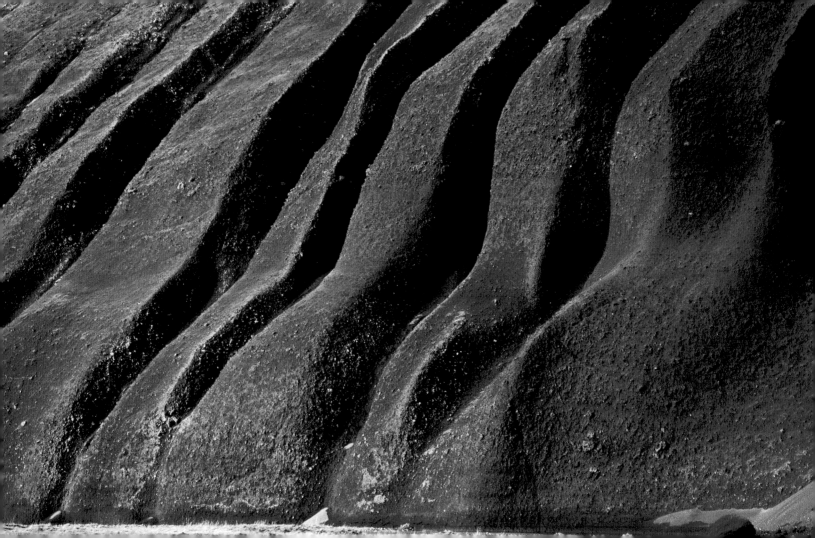

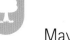

Keep ash and eggshells to use in the fight against slugs.

Eliminating unwanted visitors to the garden does not necessarily require chemicals. Tricks and traps sometimes work much better, are easier on your pocket book, and cause absolutely no damage to the natural environment.

———————

Use cunning to wage war on slugs and snails. Drive them away by spreading ash or crushed eggshells around the plants you wish to protect or, alternatively, plant herbs. Slugs dread pungent aromatic plants. You can also lay planks alongside your flowerbeds. All you need to do is turn them over regularly to collect and destroy the slugs that seek shelter from the sun beneath them.

Cactus, Bolivia

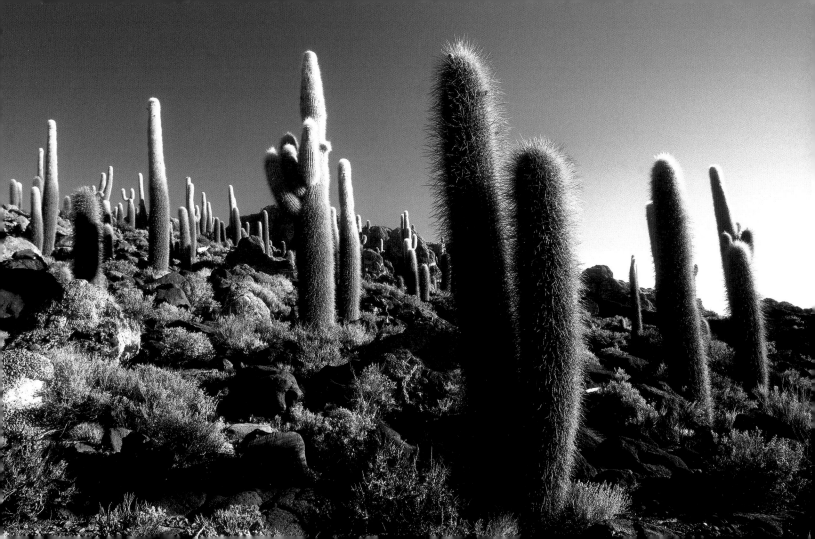

Visit regional nature preserves and state parks.

America's countryside constitutes an extraordinary natural and cultural heritage. State parks and forests; nature preserves that are privately run but open to the public; and historic sites offer insight into regional natural and cultural histories. The views and recreational challenges of our country's national parks might inspire awe and wonder, but it is ordinary, everyday nature and history that tells us who we are.

Find a state park, forest, or reserve in your area. Learn about the species that inhabit it and any developments that might threaten it.

Massif Central, France

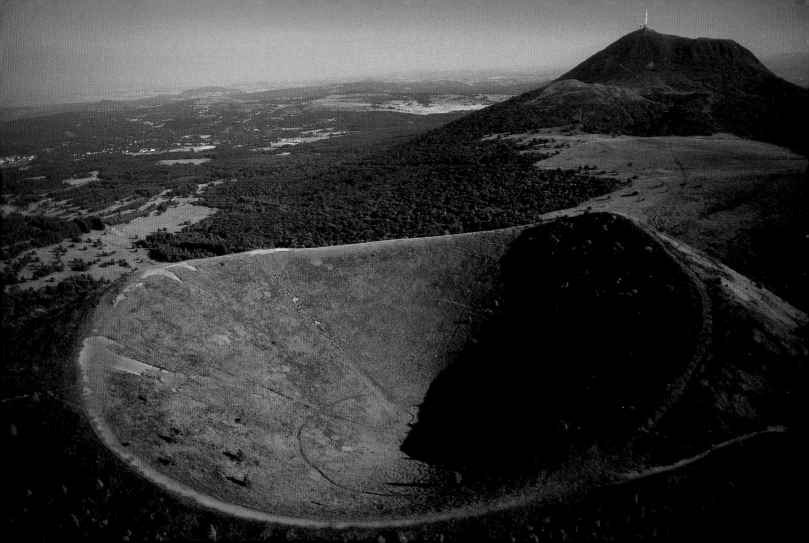

Give your clothes a second life.

Fashions change and clothes gradually accumulate in wardrobes. If they are in good condition, they can be put back into circulation on the second-hand market, sold cheaply, or distributed to charities. The second-hand market offers an economic, environmentally friendly alternative to new clothes. On average, the manufacture of 1,000 items of clothing produces 500 pounds of waste as cloth, paper, and packaging. To work, however, the second-hand market needs consumers.

Sift through your clothes, and donate those that have gone out of fashion to charitable organizations (such as the Salvation Army or Goodwill Industries International, Inc.) that put out collection containers, or organize door-to-door collections. Your town hall can also tell you about clothing collections. And remember to patronize second-hand shops.

Volcanic cone, Indonesia

Urge your mayor and municipality to upgrade existing municipal buildings to LEED-certified standards.

In 2004, the United States Green Building Council announced that it had established a rating system for existing buildings. Based on a similar premise as the LEED standards for new construction, the system for existing buildings addresses energy savings, water savings, and healthier indoor environments.

Encourage your city or town to adopt LEED standards for its existing buildings and in the long-term your municipality will save environmentally and economically.

Lake Magadi, Kenya

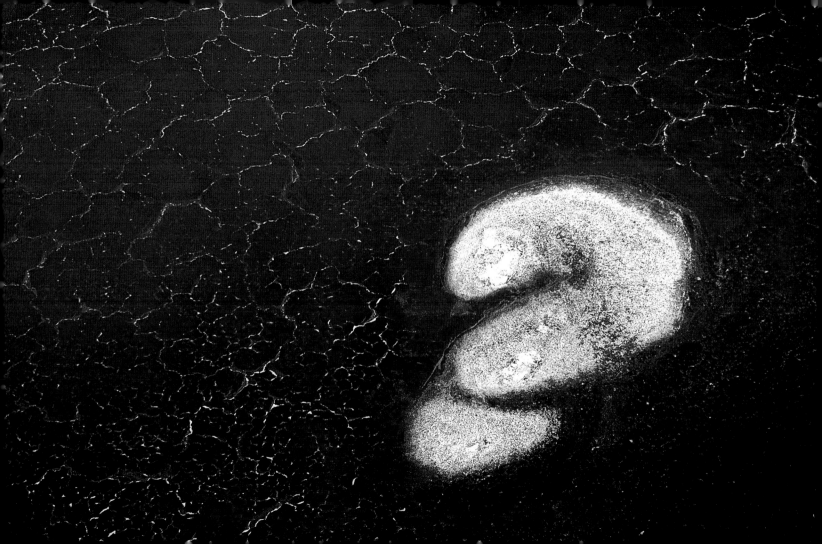

Do not print out your email.

Paper and cardboard, which are both recyclable, make up 80% of office waste. Despite the introduction of the paperless office, workplaces continue on an upward trend in paper use. Between 1995 and 2000, use of copy paper increased by 30%.

To reduce this wasteful consumption, do not automatically print out the emails you receive. Organize your computer to file your email electronically, and only print out email when it is essential. The average office worker uses 10,000 sheets of paper a year—don't be part of the statistic!

Stream, Greenland

On horseback, respect the environment.

Nature constantly provides us with a multitude of free goods and services: clean air to breathe, a favorable climate, food (including a considerable reserve of biodiversity), fresh water (that is naturally purified), medical treatments (many of which remain undiscovered), energy resources, natural plant pollination by wild species (notably of a third of the plants we use for food), and more. Our dependence on the natural world should encourage greater respect in us, since the future of our species depends on it.

Horseback riding is a very environmentally friendly way of seeing the countryside: the horse's smell masks your own and allows you to approach animals without frightening them away. However, when on horseback always keep to marked trails.

Tassili du Hoggar, Algeria

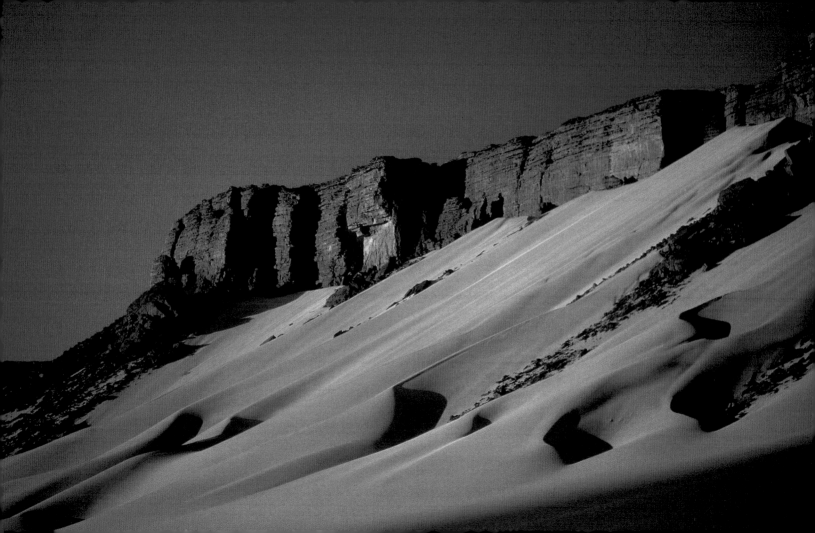

Don't discard the carpeting in your home because you're tired of the color.

More than 2 million tons of carpeting material ends up in American landfills every year. Seventy percent of it was replaced for reasons other than wear. Replacing a carpet is not only economically expensive, but also environmentally costly.

Find a service that will re-dye your carpet rather than replacing it. These companies can also restore an old carpet to its original quality.

Tiger shark, Australia

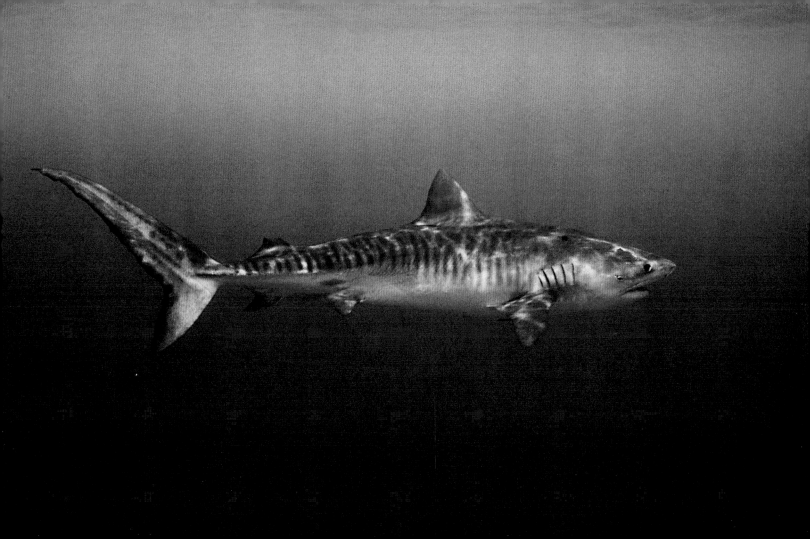

Shop at the local produce market.

Three quarters of the edible varieties of produce that were cultivated at the beginning of the twentieth century have disappeared. Today's fruits and vegetables, which have survived the race to increase productivity, are mostly hybrid varieties chosen for their ability to withstand the various demands of mechanized farming and produce distribution. Picked prematurely and ripened artificially, once they are on the shelf, their appearance is almost perfect—and generally hides their lack of flavor and nutritional value.

Buy your fruit and vegetables in the market, from local producers. You will be supporting the local economy, and your purchases will be environmentally friendly, because they involve less transport and packaging, and therefore less waste and pollution. They will taste better, too.

Landmannalaugar, Iceland

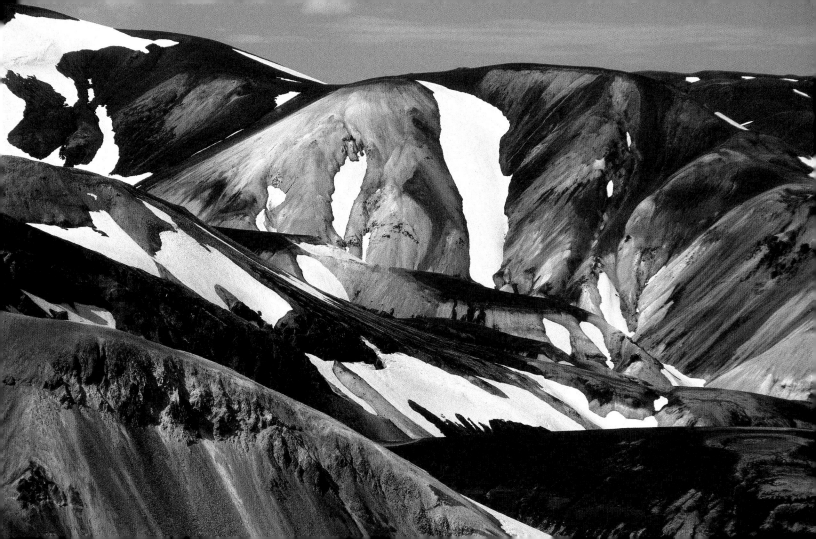

Have your pet neutered.

Between 6 and 8 million dogs and cats enter animal shelters every year, largely because breeding is poorly controlled and too many puppies and kittens are being born. As many as 3 to 4 million of these animals are euthanized every year simply because there is not enough space to hold them.

Have your animal neutered. You will be contributing to reducing the number of abandoned animals and to stabilizing the population of stray dogs and cats.

Wayana Indians, Guyana

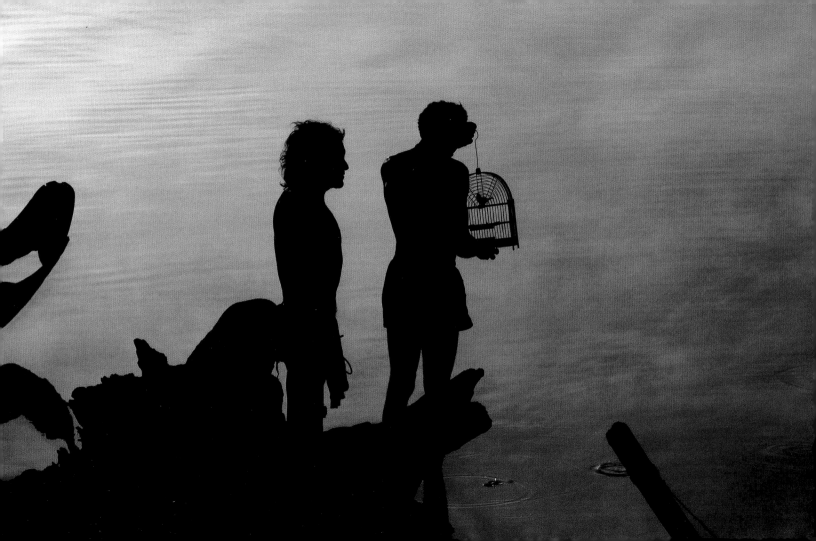

Clean the coils on your refrigerator.

In projections for the year 2025, world production of coal, oil, renewable resources, and nuclear power are all expected to remain level or decline. Natural gas is the only energy resource expected to climb in production. Natural gas is closely related to crude oil, and like crude oil cannot be replenished on a human timescale. While it has far fewer carbon-dioxide emissions than crude oil, byproducts such as methane emissions (another potent contributor to the greenhouse effect), and heated water that must be discharged into waterways (thus disrupting fisheries and habitat) are of concern.

Check your refrigerator's electricity consumption: dust or pet hair on the coils at the back can cause your compressor to have to work harder, and may increase energy use by 30%. Clean the coils twice a year.

Crevasses, Alaska

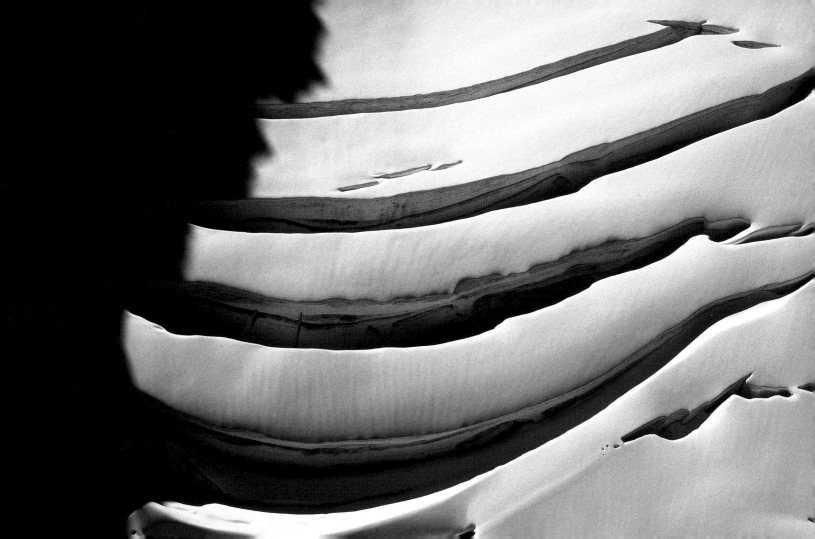

Use bicycle couriers.

With the materials and resources that it takes to produce a single mid-sized car, 100 bicycles could be produced. Around 8 million Americans live in areas that continually fail to meet federal air quality standards. These conditions take their toll—by the end of the last century, car emissions killed 30,000 people every year in the United States.

In town, the bicycle, which produces neither greenhouse gases nor pollution, is one of the most promising transportation solutions. For your business needs, use bicycle couriers if they exist in your town. You will be contributing to improving urban air quality, and to developing an environmentally friendly, sustainable means of transport.

Pink flamingoes, Kenya

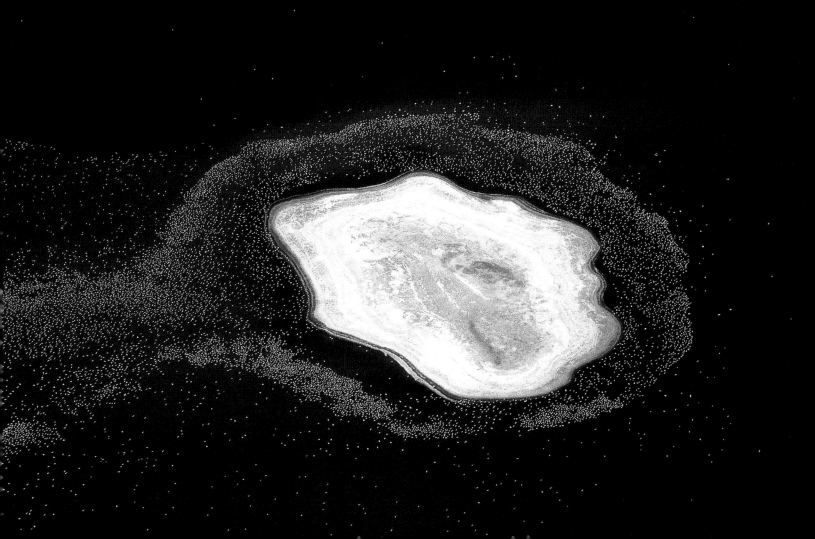

Reduce the amount of electricity used for lighting.

Electricity for lighting accounts for an average of 15% of your annual electricity bill, and is the second biggest item after refrigeration. By taking a few simple measures, you can save up to 70% of the money you spend on electricity for lighting. You will also preserve the planet's energy resources and its atmosphere.

Choose natural light wherever possible, switch off unnecessary lights, and choose bulbs with a wattage that suits your needs. Do not use halogen lights as spotlights, install energy-saving bulbs, and install lighting with motion-sensor capabilities on your stairs and in hallways.

Piton de la Fournaise volcano, Réunion

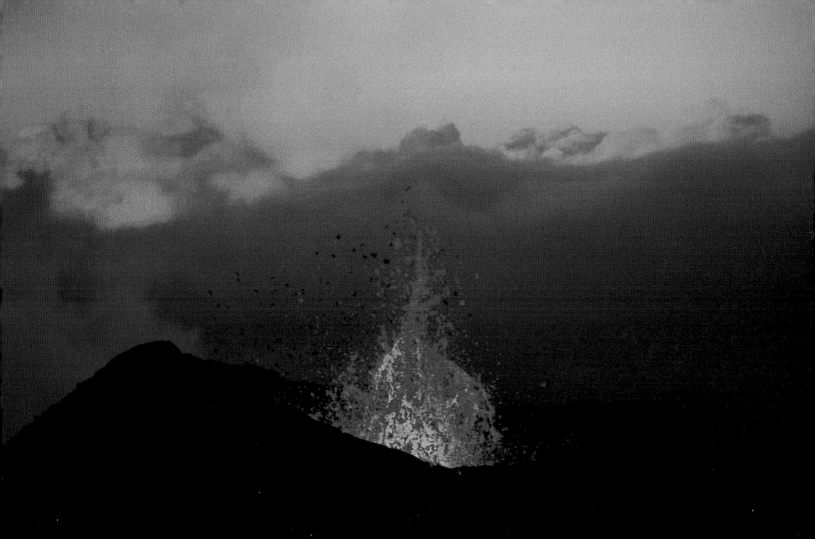

Do not use mothballs in wardrobes.

The mothballs people place in wardrobes give off naphthalene and para-dichlorobenzene fumes. The former is a carcinogenic substance; prolonged, repeated exposure to high concentrations can damage the nervous system and affect the lungs. Exposure to high levels of naphthalene can cause headaches, fatigue, and nausea. Most toxic substances we use are intended to eliminate something, so we should not be surprised that they are detrimental to our health.

In your drawers and wardrobes, choose bags of lavender or cedar chips, which smell so much nicer than mothballs. Protect delicate woolen clothes by keeping them in sealed boxes.

Great Barrier Reef, Australia

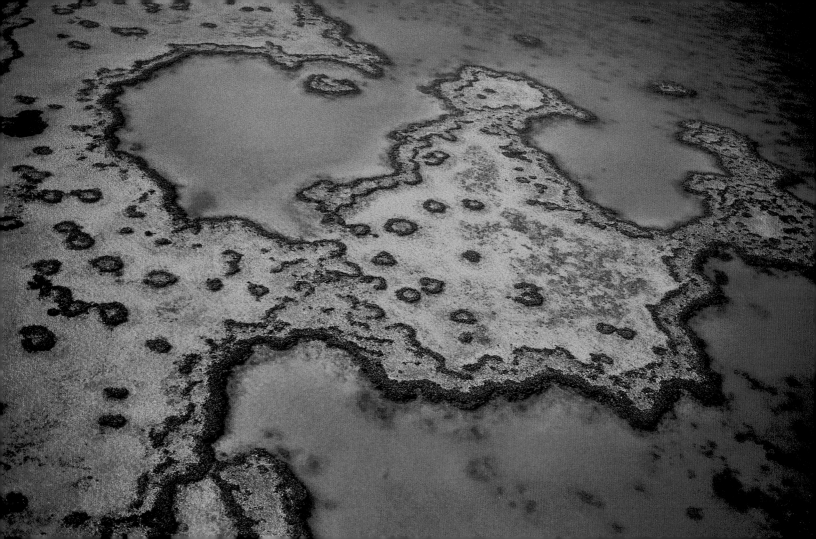

Putting the hoe to the soil makes watering more effective.

Among gardening jobs, hoeing is one of the most significant. It is essential for the health of the soil and for removing weeds, and hoeing aerates the soil and allows it to retain moisture. It is crucial after a heavy rain because the surface of the soil, smooth and packed tight by raindrops, will cause water to run off the next time it is watered. Loose, well-worked soil allows water to reach the roots of plants and drains water better, rendering watering more efficient.

Hoe your garden! Smart water use is essential when trying to make your garden as environmentally friendly as possible.

White Desert, Egypt

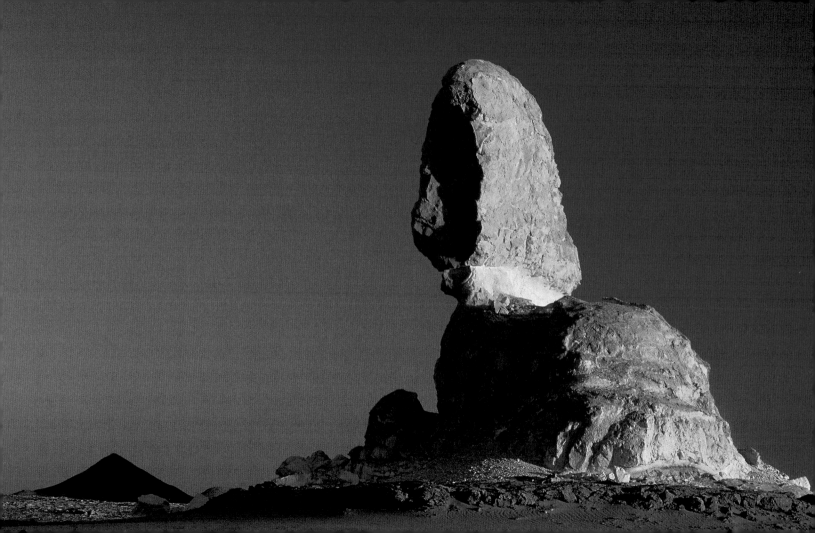

Install flow restrictors in your home.

The world's need for water is growing faster than its population. Since 1900, the population has tripled, but world water consumption has risen sevenfold. Agriculture demands 70% of this for irrigation, and industry requires 20%. Domestic use accounts for 10%.

To reduce your daily consumption, fit your taps with flow restrictors, which cost between $5 and $10. If all U.S. households installed these water-saving features, water use would decrease by 30%.

River, Iceland

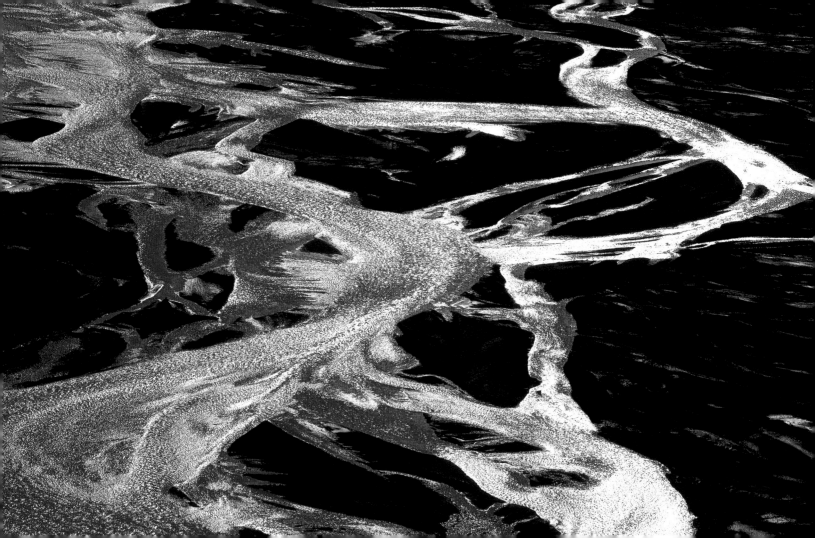

Respect tropical reefs.

A refuge for prey, a lair for predators, a shelter, nursery, food source, and spawning ground: coral carries out a multitude of functions. Despite its appearance it is not an inert mineral but alive and growing extremely slowly. It takes coral a year to grow 3 to 4 inches, and it may have taken it more than a century to grow a 3-foot block. In a fraction of a second, a clumsy kick or blow with a flipper can destroy a coral formation that has been growing for centuries.

If you are vacationing by a tropical lagoon, do not walk on the reef. When diving, be careful of your flippers. And never break off a branch of coral to take it home as a souvenir.

Coral, Australia

Ride a bicycle in the city.

Ninety percent of the planet's vehicles belong to people living in the world's 16 wealthiest countries—just a fifth of its population—however, the effects of car use, especially extreme weather events produced by global warming, are felt all over the planet and especially in developing countries, which are generally the most vulnerable. Using a bicycle to commute to work four out of five days a week for an eight-mile round trip would save 54 gallons of gas annually. If every American worker did this, our demand for and reliance on oil would plummet.

Cyclists sit higher up and breathe in less pollution. Go by bicycle. You will preserve both air quality and your own health.

Ténéré *erg* (sand desert), Niger

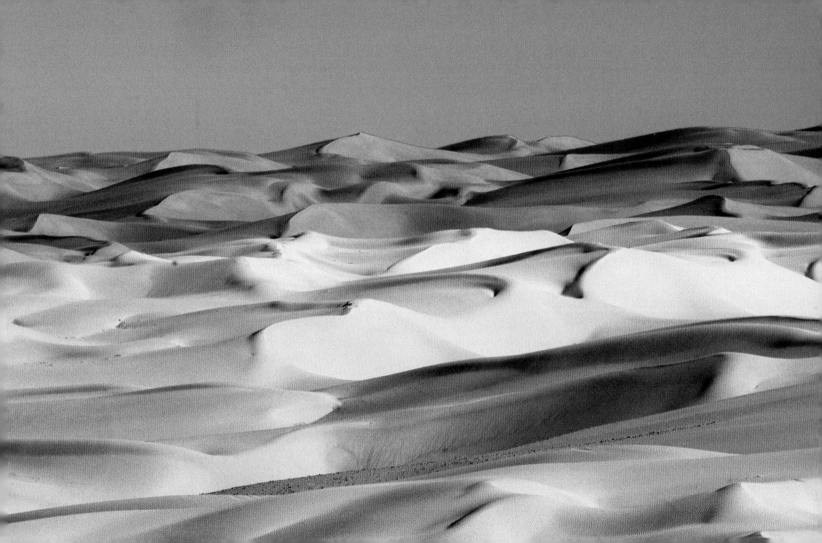

Recycle your steel cans.

Steel is 100% recyclable. One ton of recycled steel saves 2,500 pounds of iron ore, 1,400 pounds of coal, 120 pounds of limestone, and the thousands of gallons of water needed to produce steel.

Each of us uses recyclable steel packaging every day in the form of cans. Make sure you include them in the waste collection and recycling process: they will be transformed into new cans, or into sheet metal for various uses.

Frozen lake, Greenland

Grow your own vegetables.

Spraying pesticides on crops increases productivity in the short term. The long-term use of chemicals, however, produces resistance in pests while wiping out their natural predators. The farmer must increase the dose, thus exacerbating pollution of the soil, air, and water. As a result the world market in agricultural pesticides has almost tripled over the last 20 years.

Rediscover the flavor of something you have grown yourself. A vegetable garden or a few vegetables grown in window boxes will provide produce that is free of both pesticides and superfluous packaging. Cucumbers, potatoes, and squash have high levels of pesticide residue when grown conventionally, but can be grown easily in container gardens or in your yard in many regions.

Volcanic cone, Iceland

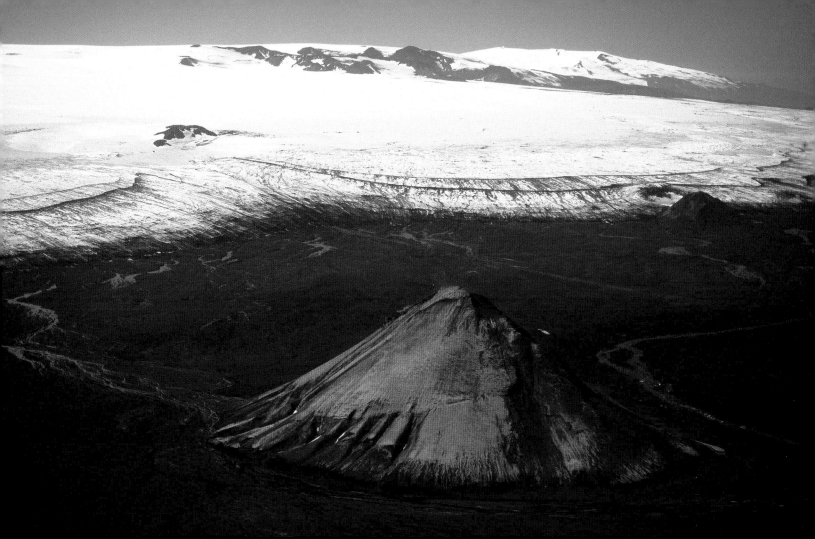

Sort your waste to reduce the amount that needs treatment.

More than 40% of our waste is incinerated. Incineration reduces its volume by 90%, thus saving space in landfill sites. It also produces energy that can be converted into electricity or heating. However, the burning also produces fumes that contain dioxin (which is carcinogenic), acid gases, and other toxic particles. Anti-pollution regulations demand that they be treated with filters which, once saturated with toxins, also become waste that requires disposal.

By sorting waste (glass, paper, batteries, engine oil, aluminum, and so forth) that can be re-used, you will reduce the volume to be incinerated by up to 70%, and in so doing will reduce air pollution as well.

Scorpion fish, Australia

Wash laundry only when it is dirty.

The quality of fresh water is constantly deteriorating because of heavy contamination by polluted storm water running off streets; organic matter; fertilizers; and chemical waste from agriculture, industry, and households. The large quantity of the waste and poisonous products poured daily into rivers constitutes a danger that is all the more severe because water use—and the elimination of wastewater—is increasing daily. In some areas, tap water is regularly cut off, temporarily, because of pollution.

It may seem like common sense, but the best way to conserve water in the laundry is to do less of it! Only wash your clothes when they are really dirty; one wear does not automatically make the clothes dirty.

Geysers, Kamchatka, Russia

Find out how your local authority manages waste.

In addition to ecological benefits, recycling also creates jobs. Recycling creates 36 jobs per 10,000 tons of recycled material compared to 6 for the same amount of material brought to traditional disposal facilities.

Ask your local authority how it manages your area's waste, and what happens to it. Is it dumped or burned, and where? If your local authority has not put in place a comprehensive recycling program, ask why. Encourage other voters to ask similar questions.

Mud springs, Iceland

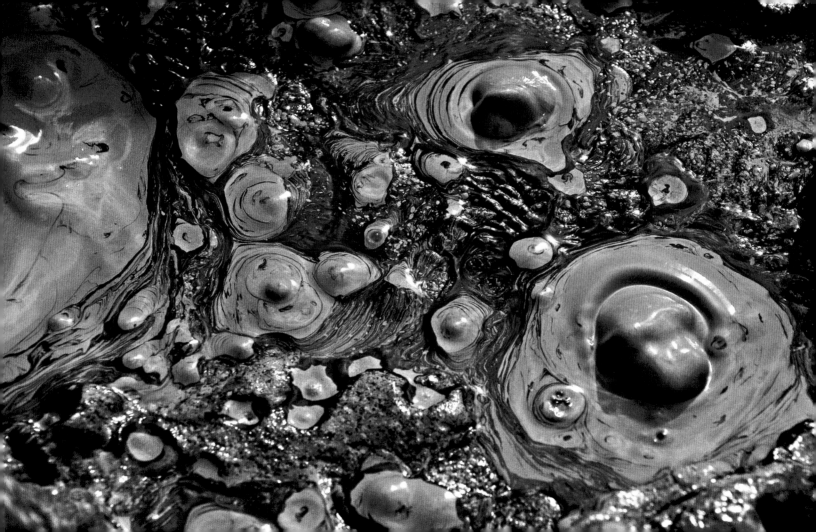

Use multiple sockets fitted with a switch.

In the most affluent regions of the world, energy consumption per person is, on average, 10 times that in developing countries, and 4 times the world average. The world average is about 53 billion kilowatt hours (kWhs) of electricity per year, and Americans use 3.6 trillion kWhs. Compare this with Ecuador, which uses 9.5 billion kWhs.

Power consumption from our appliances on standby (and therefore, are not being used) can be as much as 10% of your electricity bill. To switch off your living room appliances—television, video, and sound system—completely, plug them into a multi-socket surge protector, and switch the surge protector off when you are not using the appliances.

Ounianga Kébir lake, Chad

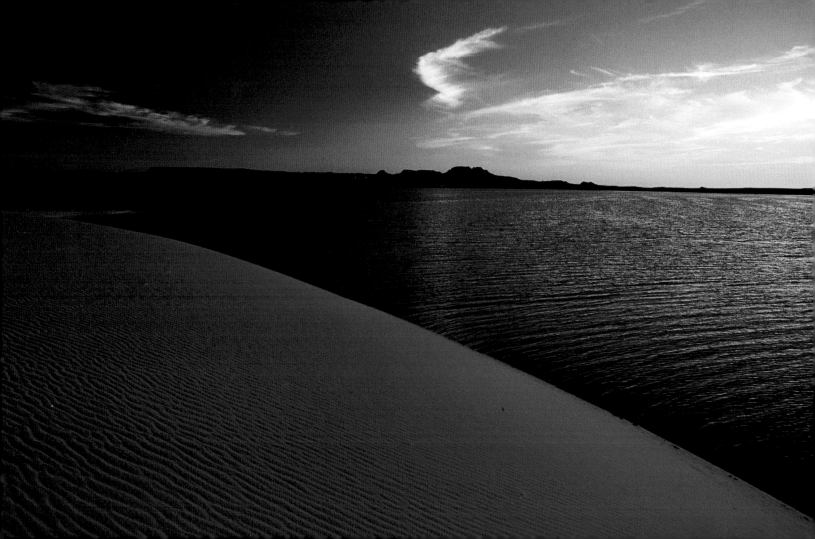

Go bicycling as a family.

Between 10% and 30% of children in developed countries are overweight. The reasons for these extra pounds lie in the power of television and in lack of physical exercise. Make time to take your children out on a bike ride, an activity that is as beneficial for their health as it is environmentally friendly.

Take more trips closer to home. Instead of planning a long family car trip, explore your local flora and fauna by bike. If you live in an urban environment, be sure to teach your children defensive riding habits when sharing the streets with cars; if you live in a rural area, encourage your children to use their bikes as much as possible, rather than relying on the family car for transportation.

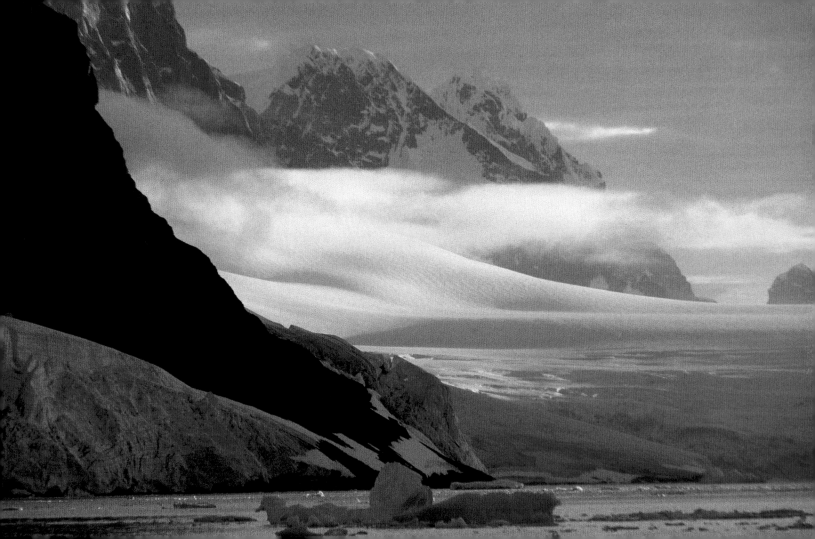

Fishermen on shore, respect your surroundings.

Contrary to appearances, the ships that sail the world's oceans are responsible for only a small part of the pollution of the seas. Oil spills account for only 2.5% of pollution, and cleaning ships' tanks at sea accounts for 25%. Most pollution (about 70%) comes from the land by means of what is emptied into rivers and estuaries. In 1996, the authorities on Corsica found a stranded whale with more than 30 square feet of plastic sheeting in its stomach.

When you fish from the shore leave pebbles, rocks, and empty shells where you found them, for they may shelter unobtrusive animal life. Make your children aware of the need to respect sea and shore habitats, which teem with life but are vulnerable.

Whale shark, Australia

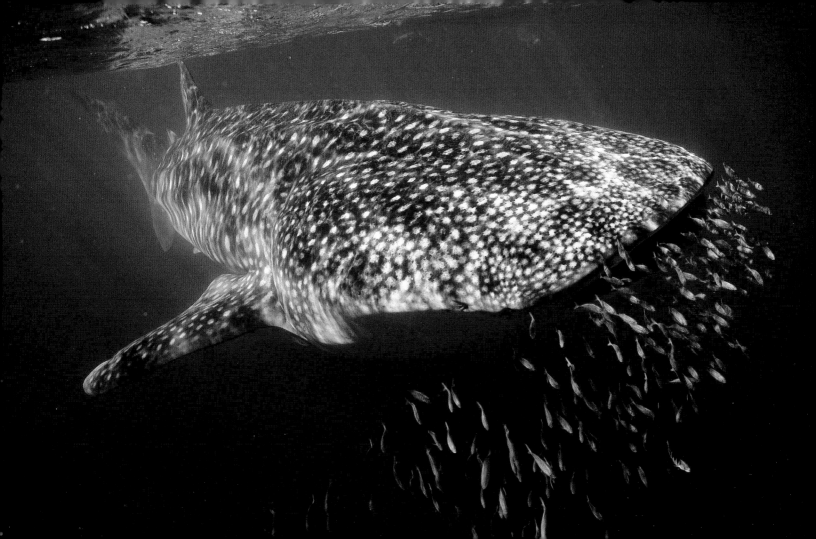

Prevent erosion.

Soil erosion is one form of soil degradation caused by water and wind, and aggravated by human development practices. The texture of the soil, the angle of the slope it is on, and the quality of the vegetative cover all play a part in erosion. Erosion degrades the health of the soil, impacts water quality through run-off, and damages river banks and pond edges. Some indicators of problems with erosion include bare spots on the lawn or property, muddy water in a stream or drainage ditch, exposed tree roots, silt build-up, and the widening and deepening of stream channels.

Minimize erosion by mulching, and installing gutters and downspouts that discharge onto the lawn (protect the soil at the outlet using splash blocks or drainage tile).

Lava, Kilauea volcano, Hawaii.

Save energy at the stove.

In March 2002, an iceberg 53 miles long and 40 miles wide broke off the Antarctic shelf. That same year, the inhabitants of the Tuvalu archipelago, in Micronesia, were forced to evacuate their islands as sea levels rose. In order to slow the warming of the seas and rise of the sea level, we must reduce world emissions of greenhouse gases quickly and drastically. This is all the more urgent because the greenhouse gases already in the atmosphere will continue to have an effect for about 10 years. Global warming will therefore happen no matter what we do.

Be sure always to put a lid on your cooking pots; in this way you can reduce the energy used for cooking by between 20% and 30%. And you will save time.

Sandstone, Chad

Unplug your telephone charger.

The world used 13% more energy in 2000 than in 1990. Half of this energy was consumed by 15% of the world's population. In 2020, world energy demand is expected to be 1.5 times what it is today, that is, 13.5 billion TOE (tons of oil equivalent) as opposed to 9 billion TOE today. Faced with such forecasts, can we really believe that the damage being done to our natural environment—first and foremost global warming—has any chance of diminishing?

Think small: by unplugging your mobile phone charger once the battery is fully recharged, you will reduce its energy consumption.

Mount Pinatubo, Philippines

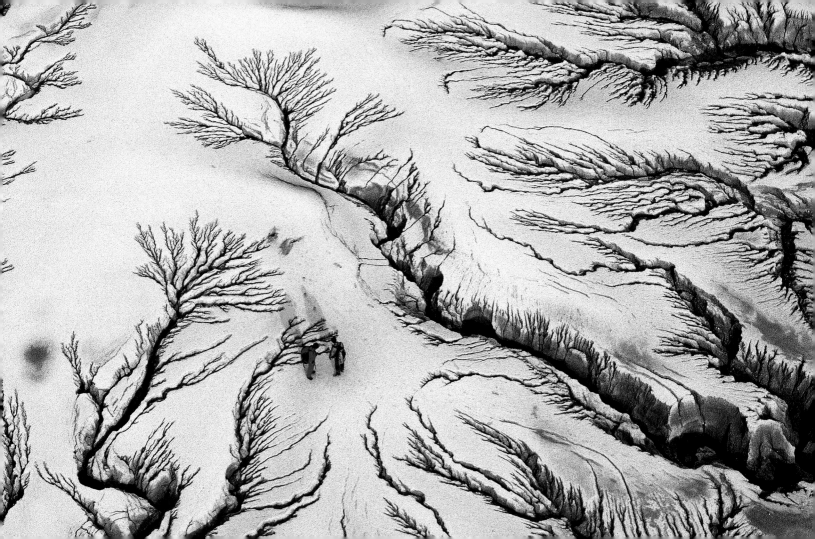

Make sure you have the necessary paperwork to import a protected species.

At present the Convention on International Trade in Endangered Species of Wild Flora and Fauna (CITES) prohibits the trade of more than 800 animal and plant species, including tigers, turtles, and rhinoceros, and controls the trade of an additional 25,000 species and their products—such as coral, cactuses, parrots, reptiles, animal skins, shells, and orchids—through a system of permits.

The United States was one of the first countries to sign the CITES agreement. When traveling, be sure you do not bring home in your luggage souvenirs made from animal or plant species whose international trade is forbidden. Obtain a permit if one is required.

Pelican, Galápagos Islands

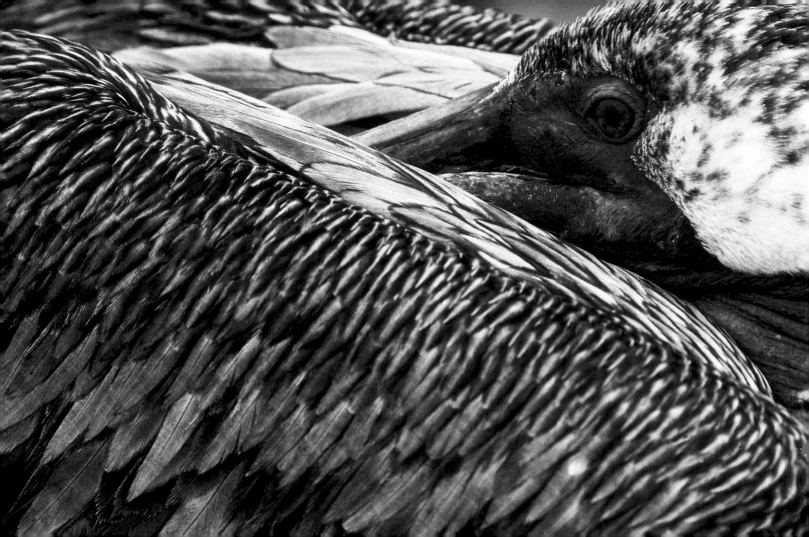

Practice equitable tourism.

Tourism has become the world's biggest industry, and exotic destinations jostle for space in tourist company brochures. The developing countries, however, often gain nothing; only 30% of the money spent by vacationers remains in the host country. Still, there are new ways of going on vacation that promote equitable tourism.

Pay a little more, for a more just economic arrangement: fair wages for local workers, finance for wells, support for humanitarian activities, and organized trips showing visitors what local conditions are really like are just a few of the features of this type of tourism. When you travel, you can also have a positive effect.

Great Barrier Reef, Australia

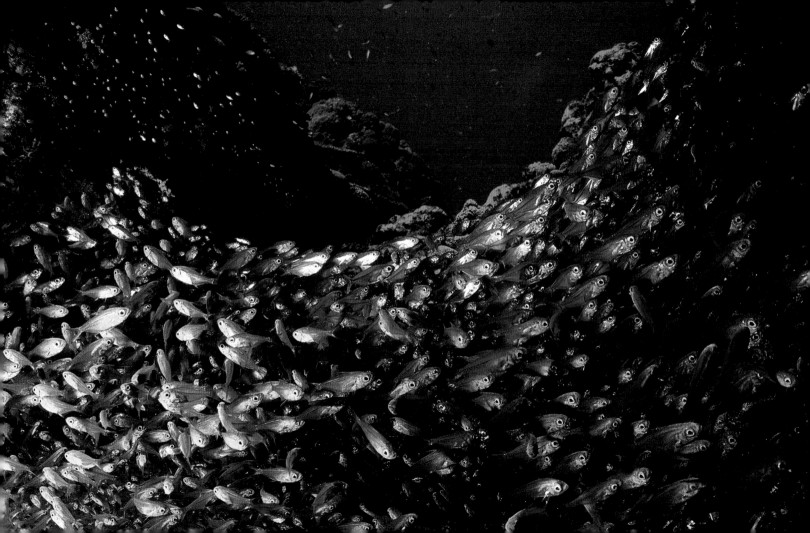

Do not drive your car on very hot days.

The city of Los Angeles suffers severe pollution on 150 days per year. Poor air quality in cities is caused by polluting gases, such as tropospheric ozone, the main ingredient of photochemical smog, which can cause breathing difficulties. It is formed at ground level from car exhaust gases reacting under sunlight and heat.

On very hot days, drive more slowly. Or, better yet, leave the car in the garage on most days. Invest the money you save in maintaining your bicycle or buying a nice pair of running shoes.

Ounianga Sérir lake, Chad

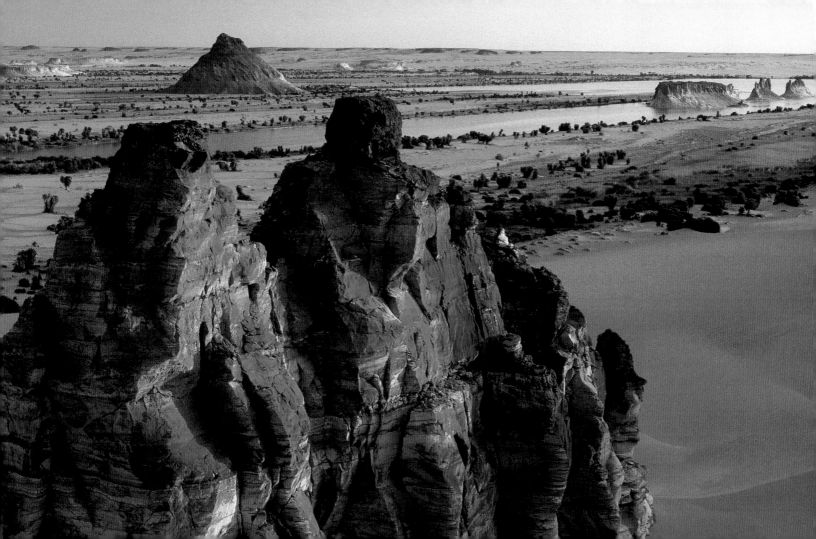

Install your boiler close to where hot water is used.

Thanks to the sun, wind, rivers, and geothermal energy, human beings are able to tap into renewable energy sources that neither pollute nor produce waste that can threaten the future of the planet for generations to come. If we used the best available technology in our buildings, and in transport, industry, food, and services, global energy use could be cut in half. Until these sources are widely used, however, we should not forget that the smartest energy use is not using energy.

It is best to locate the boiler close to the hot water's exit points—such as the kitchen and bathroom—to reduce heat loss (and therefore, energy waste) through pipes.

Hot springs, Iceland

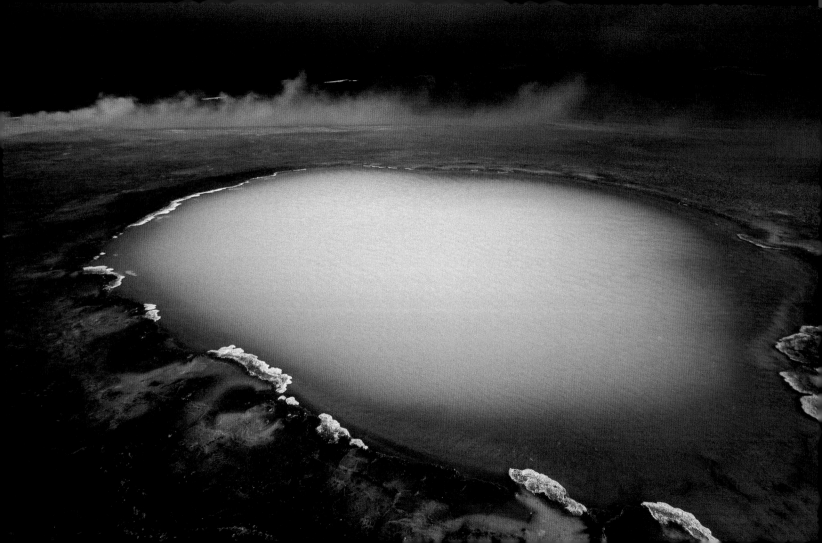

Give preference to locally produced wood.

Around 9 million acres of U.S. forest have been certified by the Forest Stewardship Council, a drop in the bucket of the 700 million acres of forested land in the United States. FSC-certification guarantees that the wood was grown and harvested in an environmentally responsible, socially beneficial, and economically viable way.

For furniture and carpentry work, abandon exotic woods and rediscover chestnut, oak, pine, fir, and beech; they can be treated in such a way that they become extremely tough. You will be protecting tropical forests, as well as avoiding needless, polluting transportation.

Kokerbooms (or "quiver trees"), Namibia

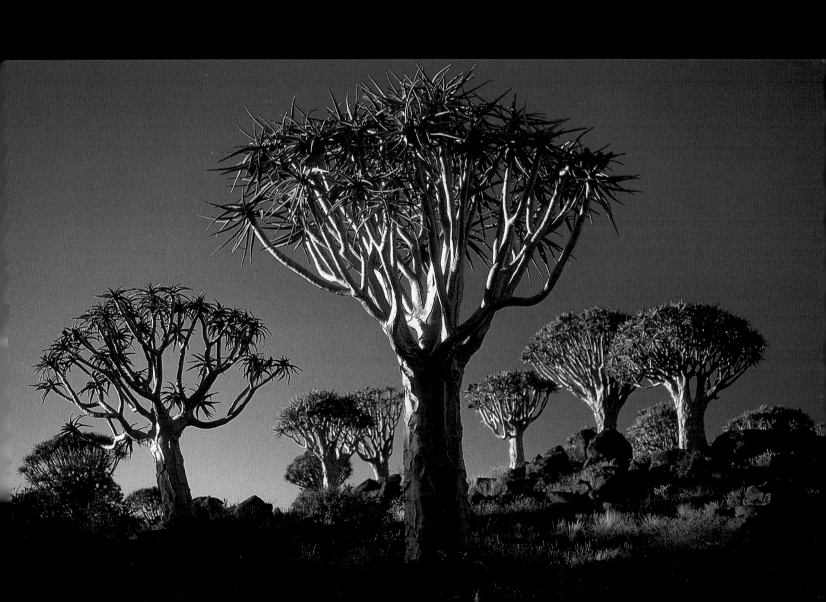

Clean your air-conditioner filter.

Since 1850, the industrial revolution in the West has led to a sharp increase in energy needs due to the combined effects of rising standards of living and population growth. Energy consumption accompanies growth in any sphere of human activity; it is rising at 2.7% per year in developing countries and is expected to continue to do so until 2025. In the industrialized world, the rate is 1.2% per year, and in Eastern Europe and the former Soviet Union growth in energy demand is expected to average 1.5% per year until 2025.

If you really must install air-conditioning, to avoid excess energy consumption never use it with open doors or windows, and regularly check that the unit is working properly and that the filter is clean.

Ice floe, Greenland

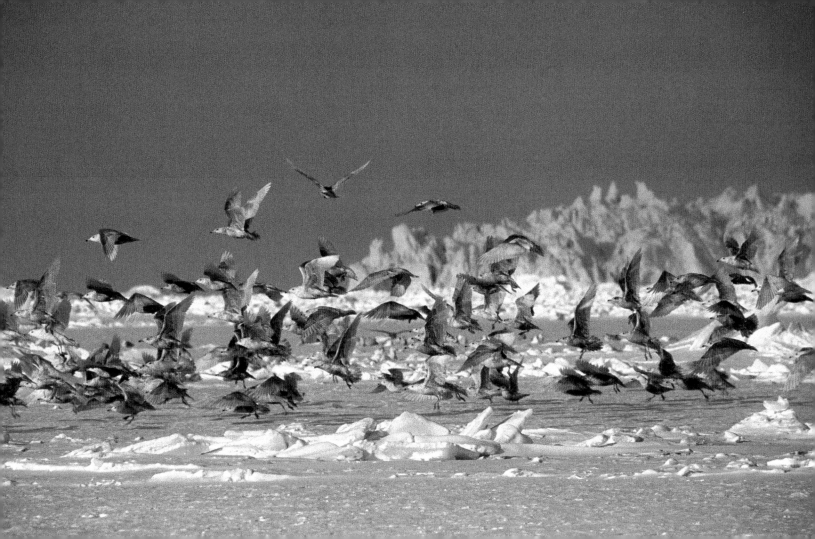

Fishermen, do not throw out nylon fishing line.

At present, 60% of the planet's inhabitants (more than 3 billion people) live less than 50 miles from coastlines and 6 of the world's 8 biggest cities are by the sea. In 30 years, 6 billion people, or 75% of the world's population, will live by the sea. Effluents from agriculture, industry, and households, which are already building up along coastlines, will continue to increase. The build-up will lead to the destruction of natural habitats, extinction of species, poisoning of fish stocks, lifeless seashores, and illness among sea-goers.

If you fish for sport, never leave your nylon fishing line behind, even if it is broken. It will remain intact for 600 years, and will pose a threat both to sea life and boat propellers.

Andaman Sea, India

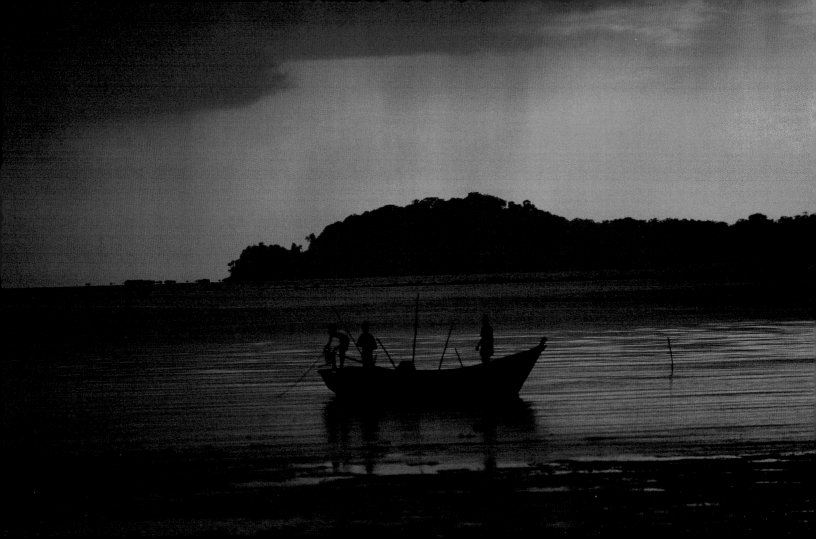

Choose cooking oil in glass bottles.

Glass is the recyclable material par excellence: it can be reused or recycled indefinitely, without loss of weight or quality. Unlike paper, the primary benefit of recycling glass comes not from protecting the original source of the material, but rather in conserving the energy it would take to create the new material. Recycled glass melts at a much lower temperature than the raw materials needed to make glass, thus using less energy.

Cooking oil is available in nonrecyclable plastic bottles, and in infinitely recyclable glass ones. Make the right choice.

Ténéré Desert, Niger

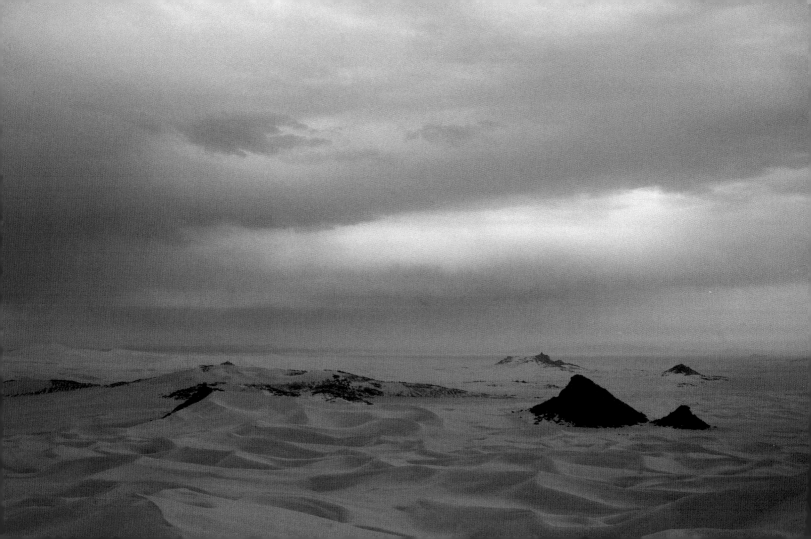

Drink tap water.

The world market for bottled water, estimated at $35 billion per year, is flourishing. In the United States, sales of bottled water surpass those of beer, coffee, and milk, and are second only to soda. However, the most natural of all drinks is much less natural once it is packaged. To contain the world's bottled water, 1.5 million tons of plastic are required. Manufacturing the bottles, packing, and transporting the water (25% is drunk outside its country of origin) uses natural resources and energy and generates mountains of waste, since most plastic bottles are not recycled.

Do not forget that our tap water is treated to be perfectly drinkable, and its quality is rigorously checked. Moreover, it is between 240 and 10,000 times cheaper than bottled water.

Reflection, Australia

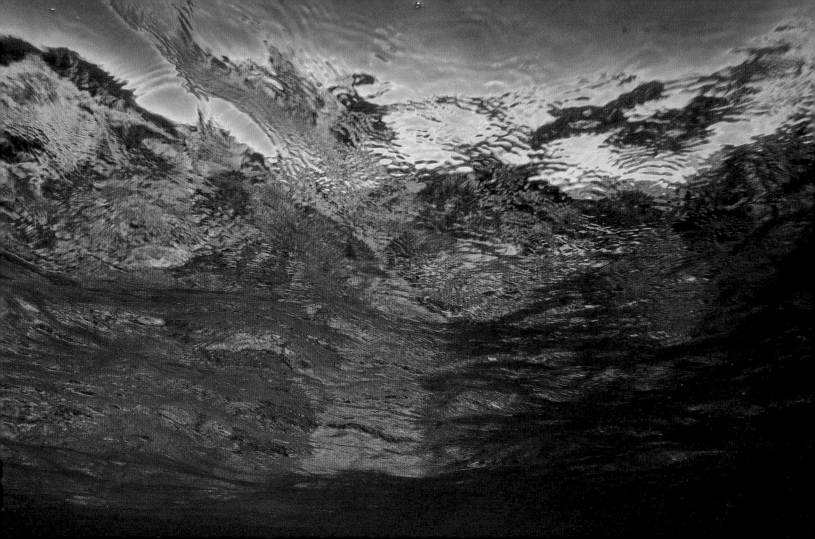

Divers, respect the sea.

A tiny rise in sea temperature is enough, in some cases, to disturb the growth of coral and cause bleaching, and there have been many instances of this in recent years as a result of global warming. In general, corals recover afterwards, but if the stress to which they have been subjected is too intense or too prolonged it can kill between 10% and 30% of the colony. When this happens, all the fauna living on the reef suffer, and fish stocks are also affected.

When you are diving in tropical seas, be as discreet as possible. Use your flippers carefully to avoid damaging anything around you; do not touch anything and do not feed the animals to avoid interfering with their behavior. When you are not diving, remember all the ways to save energy, and thus limit climate change.

Nudibranch (sea slugs), Australia

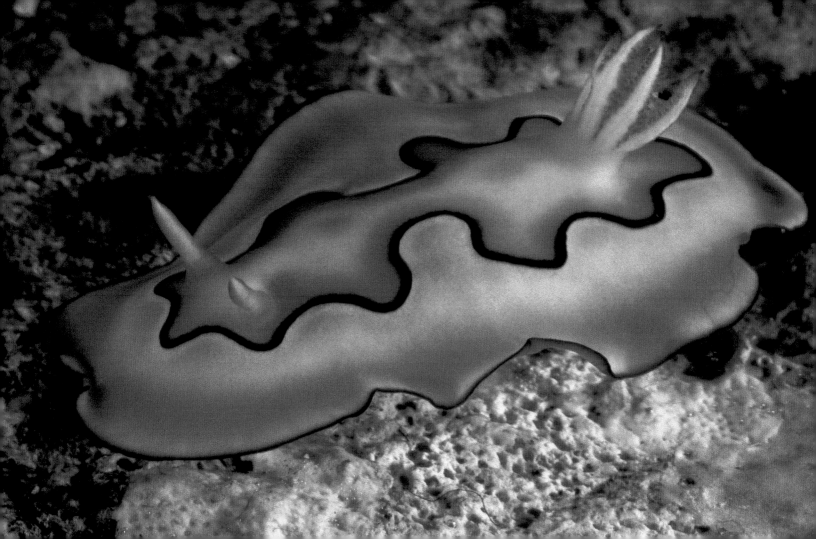

Buy retreaded tires.

Every year, about 281 million tires are scrapped. Of this number, 42% are used for fuel (to provide energy), and 26% are recycled to make material for industrial use. Although 8 out of every 10 tires find a reuse, more than 300 million tires still sit in tire stockpiles that breed rat and mosquito populations and cause air and water pollution.

——————————

Retreading uses half as much energy as making a new tire. To encourage this economical and environmentally friendly practice, choose retreaded tires.

Gulf of Goubbet, Djibouti

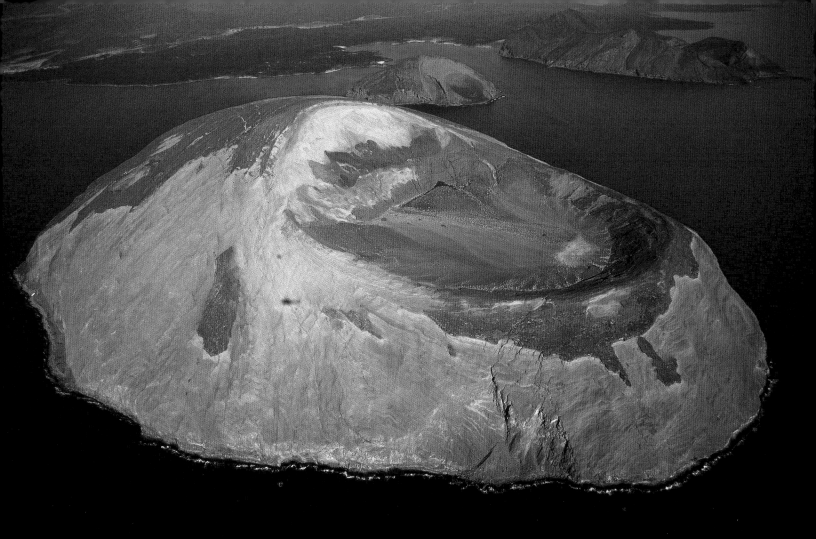

Support the Blue Flag when vacationing abroad.

Every year, billions of gallons of wastewater from cities are poured into the Mediterranean. Three-quarters of this water has not been treated. To help curtail marine pollution, the Blue Flag, a European eco-label, annually rewards and honors local authorities and vacation resorts for their efforts toward achieving a quality environment—for their water quality; for educating and informing the public; for environmental management and safety; and so forth. The Blue Flag's high profile acts as an incentive to local elected officials who do their best to gain and keep this distinction.

Look for the Blue Flag when you choose a beach for your vacation abroad. In 2004, it was awarded to almost 3,000 beaches and marinas in 29 countries in Europe and elsewhere.

Andaman Island, India

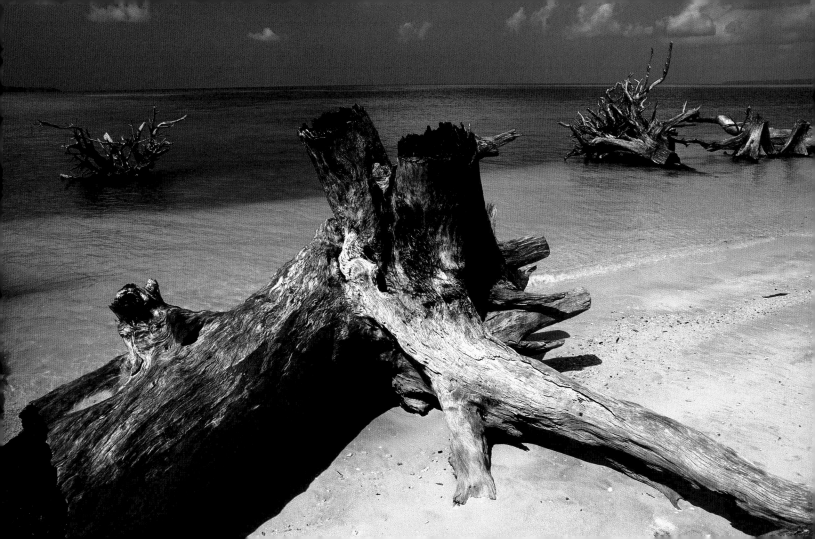

See the trees, protect the forest.

Today, a quarter of the planet's mammal species, an eighth of birds, a third of fish, and probably more than half of all flowering plants and insects are threatened with extinction. Protecting species themselves, however, is not enough unless steps are taken to preserve their habitats as well. Similarly, bodies of water are part of watersheds—the area of land that drains to the water body—and in order to protect the quality of water and the habitat of the body of water, we must consider what happens on the land that drains to it. In the long term, the best approach to environmental problems and solutions is holistic.

Discover the breathtaking landscapes and wild species of America's national parks and waterways, but don't forget that protecting nature demands both curiosity and restraint. Respect the rules of these protected areas.

Mount St. Helens Volcanic National Monument, United States

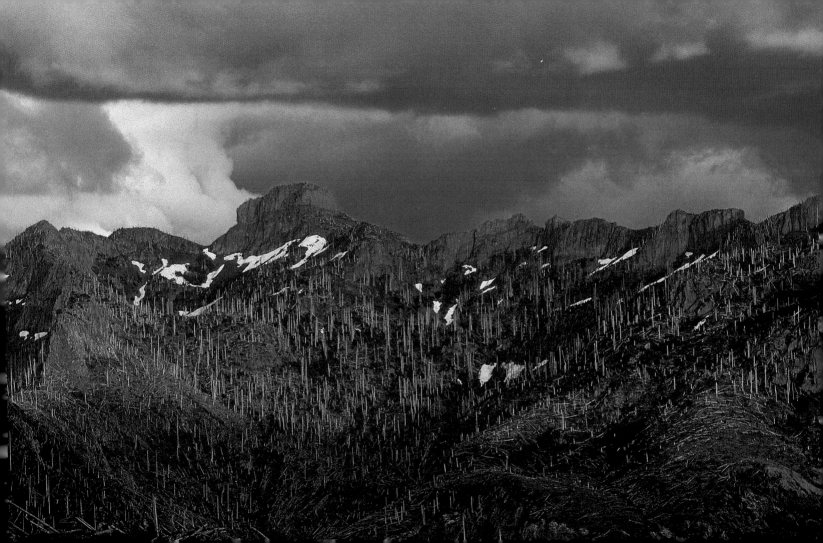

Do not make excessive use of the tumble dryer.

Fifteen percent of the world's energy comes from renewable sources. This share could rise to 40% if wind, solar, hydroelectric, and biomass energy were developed, thus relieving the planet of the pollution produced by burning fossil fuels and by nuclear power. Worldwide photovoltaic installations increased by 927 megawatts in 2004, up from 574 megawatts the year before.

Of all household electrical appliances, the clothes dryer consumes the most energy. It uses two, or even three, times as much power as a washing machine. The cheapest and most environmentally sound way of drying the wash will always be to hang it up.

Tassili n'Adjer, Algeria

Buy a green energy certificate.

Every time you use an appliance or turn on your lights, resources are used to generate the electricity needed to run the appliance. Ninety-eight percent of the electricity produced in America comes from traditional, nonrenewable resources, which are the number one cause of industrial air pollution in this country. The remaining 2% is generated from renewable resources, such as solar, geothermal, small hydro, biomass, and wind.

Investigate options for supplying your home with green energy. One option is the tradable renewable certificate (TRCs or "green tags"), which allow you to purchase renewable power generation that will displace nonrenewable sources from the regional or national electric grid.

Altiplano, Bolivia

Ask for the MSC (Marine Stewardship Council) label.

Worldwide, fish stocks are in free-fall. Populations have dropped by a third in less than 30 years. Now there are labels that encourage good practice, by identifying products that come from sustainably managed fisheries; that is, areas where efforts are made to preserve the natural marine environment and the richness of species, while guaranteeing a decent wage for fishermen. In this way consumers can encourage ecologically responsible fishing practices.

Look for seafood products bearing the label of the Marine Stewardship Council, an independent, global, non-profit certifier of sustainably produced seafood.

Piton de la Fournaise volcano, Réunion

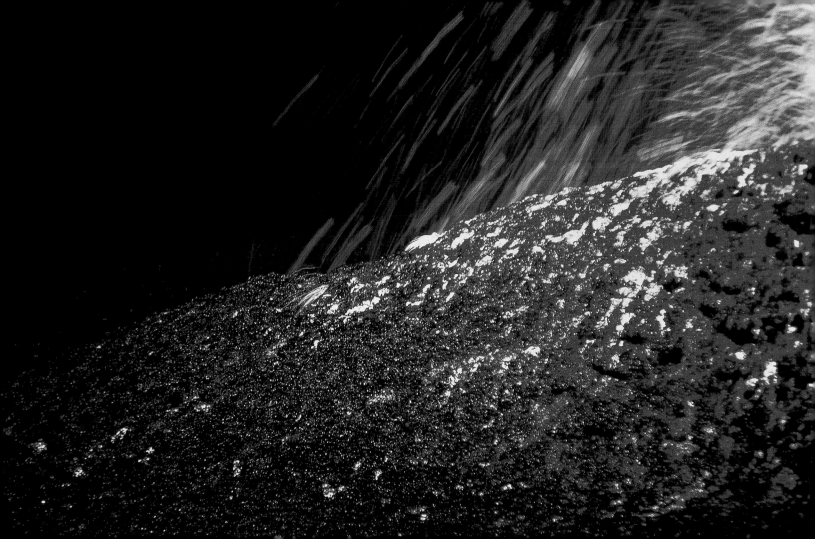

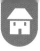

Do not use air-conditioning to excess.

The world's energy consumption is increasing relentlessly as standards of living rise. Air-conditioning, a modern comfort, has a particularly voracious appetite for energy. If it is used to excess (that is, to produce cold rather than a comfortable temperature) it uses large quantities of electricity pointlessly.

———————

Air-conditioning should be set to a temperature five degrees below the temperature outside. By being content with a degree or two less, you can save up to 10% of daily energy consumption. Use it in moderation in your car as well.

Glacial corridor, Greenland

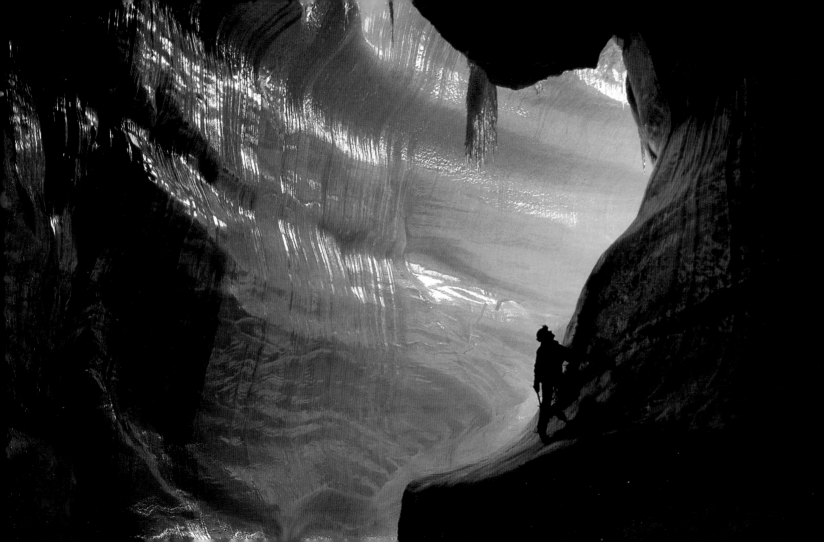

Choose a trailer rather than a roof rack.

A roof rack on a car contributes to pollution and climate change. When loaded, it increases wind resistance by up to 15%, which is reflected in fuel consumption. Even when empty, it increases consumption by 10% at the same speed.

If you need to carry a large amount of luggage when you go on vacation, use a trailer—or ship bags and bicycles to your holiday destination by train, which will produce less pollution. If you must use a roof rack, remove it when you don't need it.

Blizzard on the ice cap, Greenland

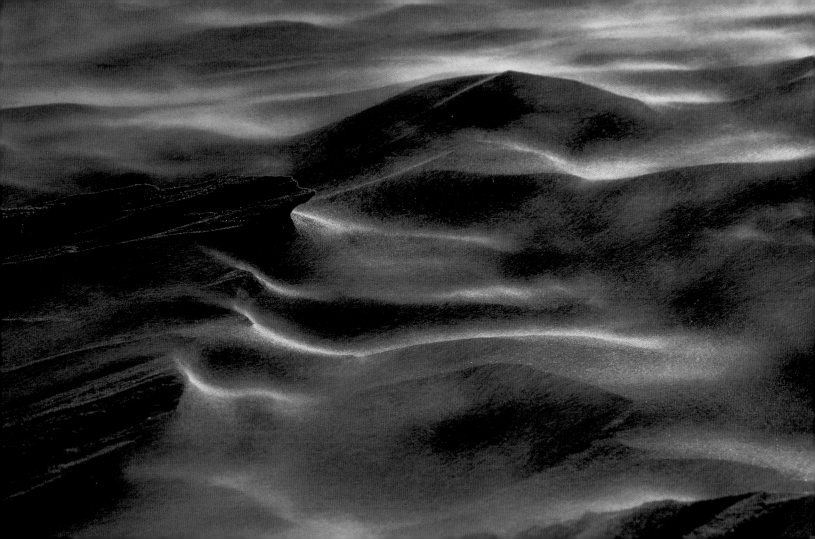

Decide what you want before you open the refrigerator door.

Things aren't as they used to be. Replacing a 10-year-old refrigerator bought in 1990 with a new Energy Star model would save enough energy to light the average household for over three months, and save more than 300 pounds of pollution each year. In a well-equipped household, the fridge alone accounts for a third of electricity consumption (20% for the freezer and 12% for the refrigerator).

In order to avoid increasing your already high consumption needlessly, close the refrigerator door as soon as you have taken out what you need. Every time you open it, up to 30% of the cooled air can escape. And remember, that the tidier the contents, the less time the door needs to be kept open.

Icebergs, Greenland

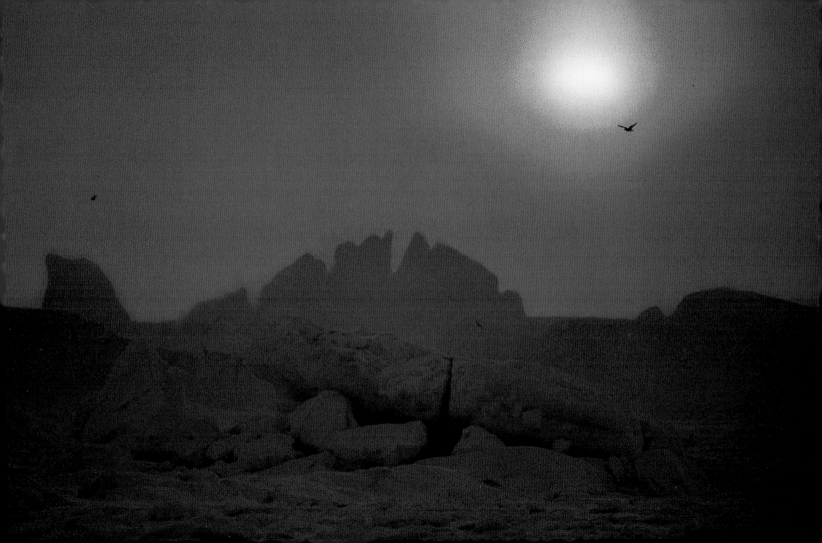

Make those around you aware of the problems.

Not everyone has the same level of awareness of environmental problems, although there is general agreement that the planet should be preserved. It is up to you to convey the urgency of the problem.

———

Share your knowledge and help those around you (family, friends, neighbors, and colleagues) become aware of the need for a good quality environment, and to conserve resources. Encourage them to take simple actions with this in mind.

Animal footprints in ash, Philippines

Reduce your meat consumption, and you'll feed the world.

In the United States and Europe, two-thirds of the grain produced each year is destined for livestock feed. More than half of the grains produced worldwide are not fed to humans. If it were, it could feed 2 billion people. This system is too costly in natural resources such as water, soil, and energy sources and will not be able to sustain the 8 billion people predicted to be living on earth in 2030.

Begin to reduce your meat consumption slowly. Choose one day a week to eat vegetarian and increase the number of days at your own pace. The variety of foods for vegetarians and the availability of local farm-fresh organic produce make the vegetarian lifestyle more appealing than ever, and you will be helping to relieve a small part of the pressures of our global appetite.

Cayman, Venezuela

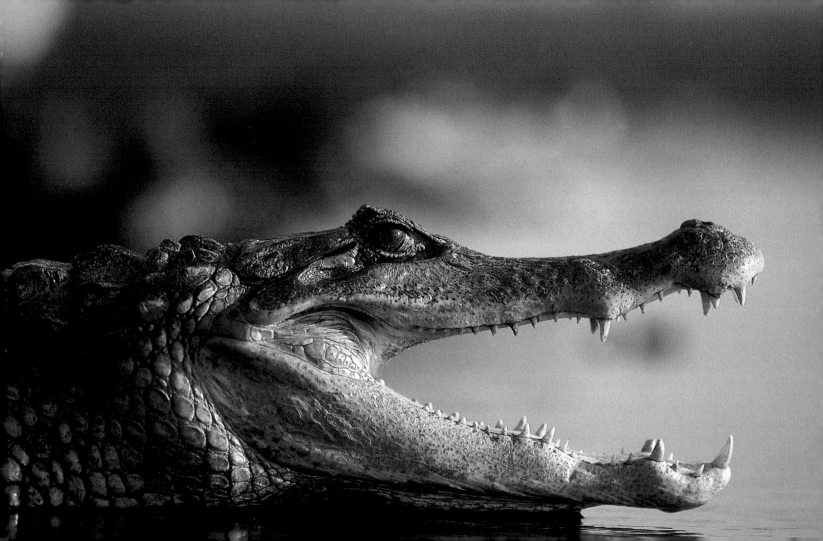

Do not waste water where it is scarce.

In a developing country such as Thailand, a golf course uses 3,300 pounds of chemical fertilizer, herbicides, and pesticides, which pollute the soil and water resources. It also uses as much water as 60,000 villagers and 6,000 Bangkok residents.

———————

When you travel in tropical lands, your hotel may offer to wash your sheets and towels only when you ask, rather than every day, in order to save water. Support such initiatives.

Namib Desert, Namibia

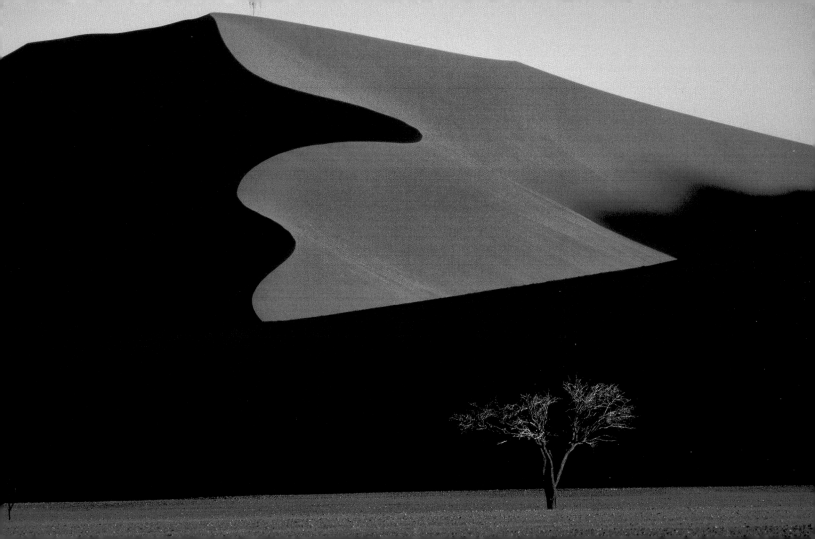

Unplug chargers.

Progress loves the wireless appliance: the cordless phone, hand-held vacuum, telephone answering machine, and electric toothbrush, not to mention your cellphone, pager, and PDA (personal digital assistant). As these devices proliferate so do their chargers, the devices that provide the energy they need to run while out in the world. There are different types of chargers—some continue drawing 2 to 6 watts of power even after the appliance is fully charged, while others will reduce their consumption to a trickle when the appliance is removed.

———

Remember to switch off your electrical chargers when they are not in use, and look for the specification -dV, which indicates that the charger will reduce its energy use when it is not charging an appliance.

Icebergs, Greenland

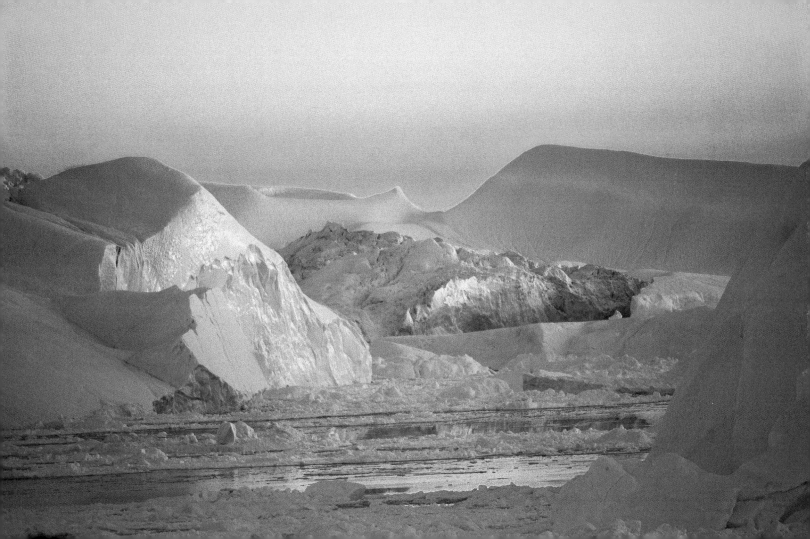

Use heat for weeding.

Everyone knows that using too much fertilizer, insecticide, herbicide, and fungicide on crops damages the environment, in particular, water resources. However, most of us do just that in our own gardens and produce the same type of pollution.

———

You can dispense with chemical herbicide, for example, by using heat: pour boiling water on the weeds. The weeds darken almost immediately and turn brown within a few hours, much like the effect of a contact herbicide, but there is no toxic residue and the area is immediately safe for children.

Acacia, Niger

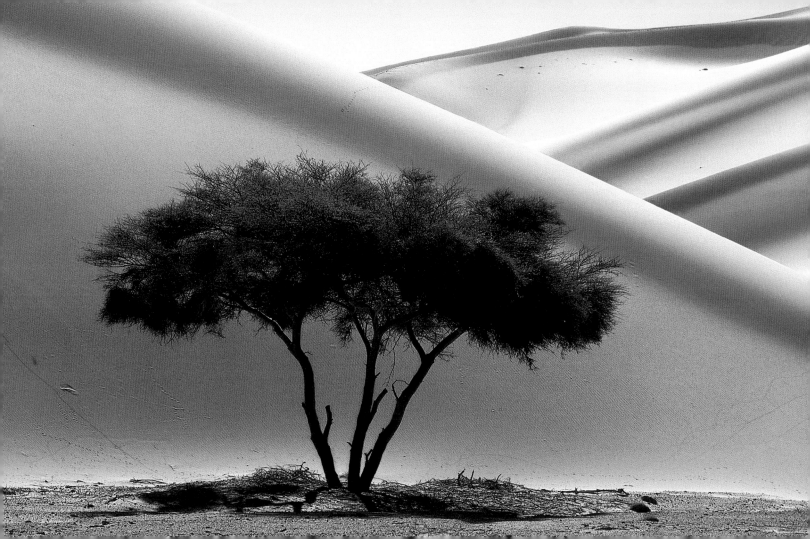

Take the train rather than the car.

Most people start their day in a car, fighting traffic and boredom. A passenger on a train, whether traveling for business or pleasure, has the option to roam freely through the train, sleep, read, or interact with fellow passengers. The American rail system, at the turn of the nineteenth century regarded as the bastion of progress, is slowly dying due to lack of passengers.

Discover the comfort of train travel. Your journey will be safer and less tiring, and you will considerably reduce your contribution to global warming.

Stalactites, Greenland

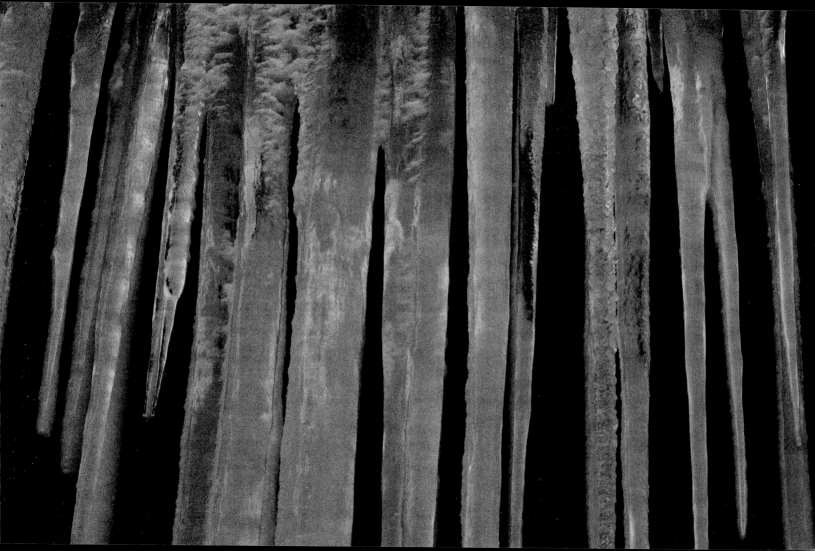

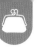

Use phosphate-free washing detergents.

Phosphates are contained in some detergents, such as washing powders and tablets, and are used to counteract the effect of hard water. Their introduction into the environment produces too high a concentration of nutrients—a sort of over-fertilization—that causes excessive growth of algae. This is a process called eutrophication. As a result of eutrophication algae chokes our rivers and water supplies and eventually causes the asphyxiation of fauna and flora.

Washing powder manufacturers now add smaller quantities of phosphate to their products. However, this is not enough. Buy products that contain none at all.

Hot springs, Kamchatka, Russia

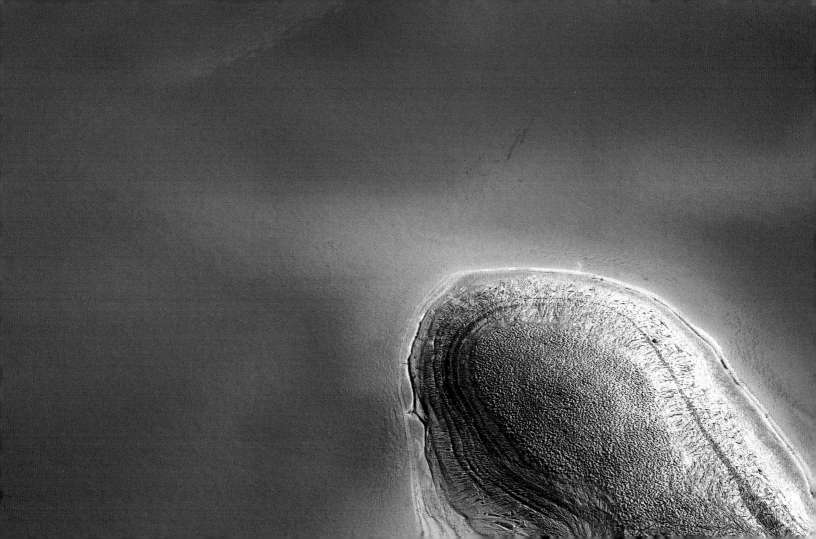

Recycle ink cartridges.

Every year 300 million laser printer and inkjet cartridges are used in the United States. These are made of plastic, iron, and aluminum, none of which is biodegradable, but all cartridges can be re-used up to 50 times. Recycling cartridges seems like common sense, yet only 2% are recycled, while the rest, worth at least $588 million, end up in landfills.

Contribute to the growth of recycling by handing in used cartridges and urging your employer to do the same. There are also organizations that collect them and use the proceeds for humanitarian or educational purposes.

Blue octopus, Australia

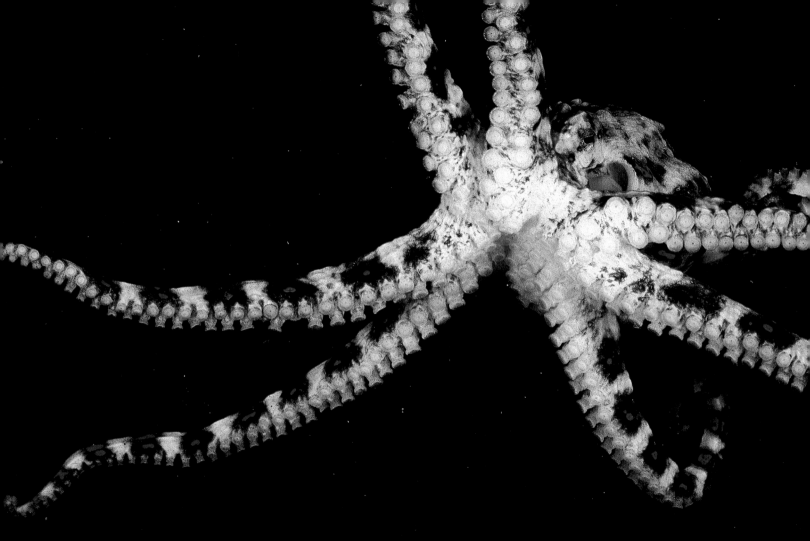

Take bulk waste to the dump.

What to do with domestic appliances, furniture, garden waste, old plaster, sheets of metal, tires, and everything else that does not fit in the trash? This waste, which we need to dispose of from time to time, is too bulky for the regular household waste collection service. It belongs in the dump, where it will be sorted, reused, recycled, or treated, depending on what it is.

By taking bulk waste to the dump, you are helping to reduce illegal dumping, which happens all over the country. If you cannot take it yourself, your local town hall or public works department will have information on door-to-door collection services.

Namib Desert, Namibia

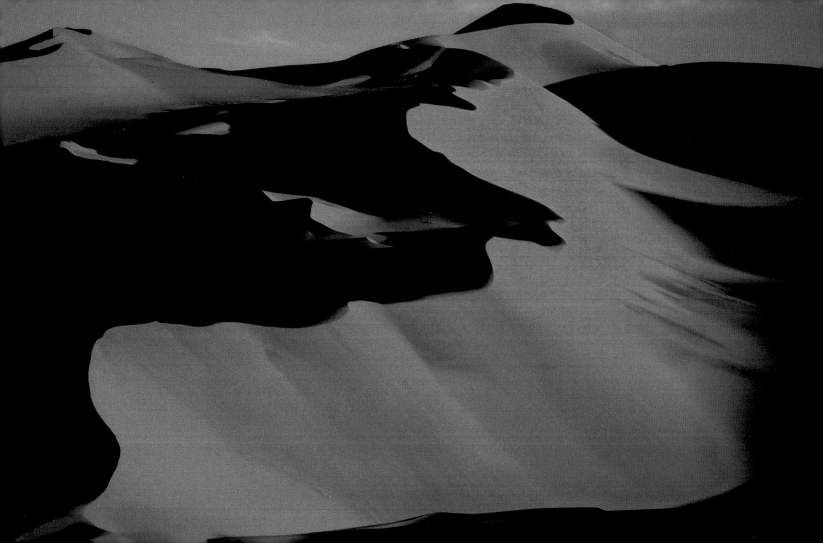

Say "no" to so-called disposable products.

Disposable products have invaded our day-to-day life. Paper napkins, paper plates, paper tablecloths, plastic razors, plastic knives, forks, and spoons, and plastic cups: everything is used once and thrown away! In addition to increasing the volume of waste, disposable products involve a waste of the energy used to make and transport them. It is not difficult to do without them, since each has a reusable—and therefore, sustainable and more environmentally friendly—alternative. These are considerably less expensive, too.

A household that cleans with a broom and a sponge spends about $35 per year on these supplies. Using disposable cleaning wipes may cost as much as $700 per year.

Tungurahua volcano, Ecuador

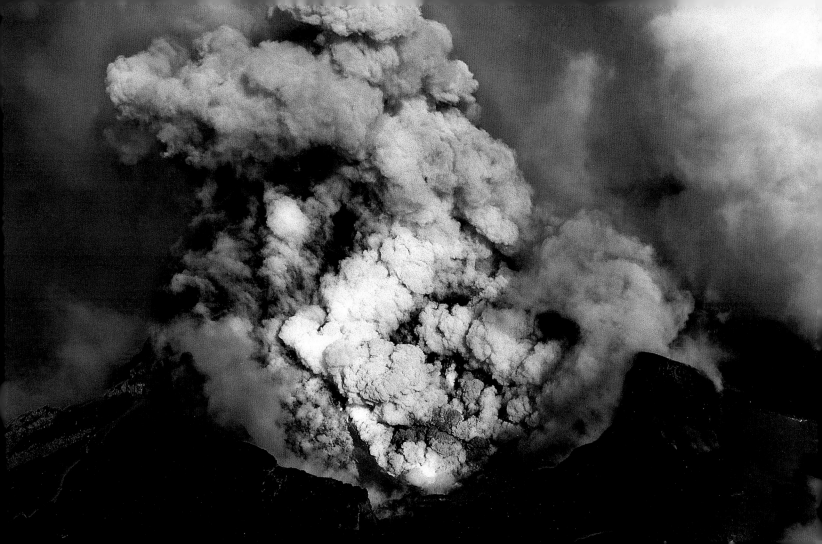

Look for the Green Globe 21 certification on your vacation destination.

Green Globe 21 is based on Agenda 21 and the principles for sustainable development that were endorsed by 182 heads of state at the United Nations Earth Summit in Rio de Janeiro. Green Globe 21 provides companies, communities, and consumers with an independent, certifying standard for sustainable tourism. It certifies everything from accommodations and adventure activities to golf courses and vineyards. The standard ensures that these tourist destinations apply ecologically sustainable development principles and practices to their operation. Participating ventures are reevaluated every year.

Seek out the Green Globe 21 logo. Patronize these companies and destinations that are attempting to leave a smaller ecological footprint on our world.

Glacier National Park, United States

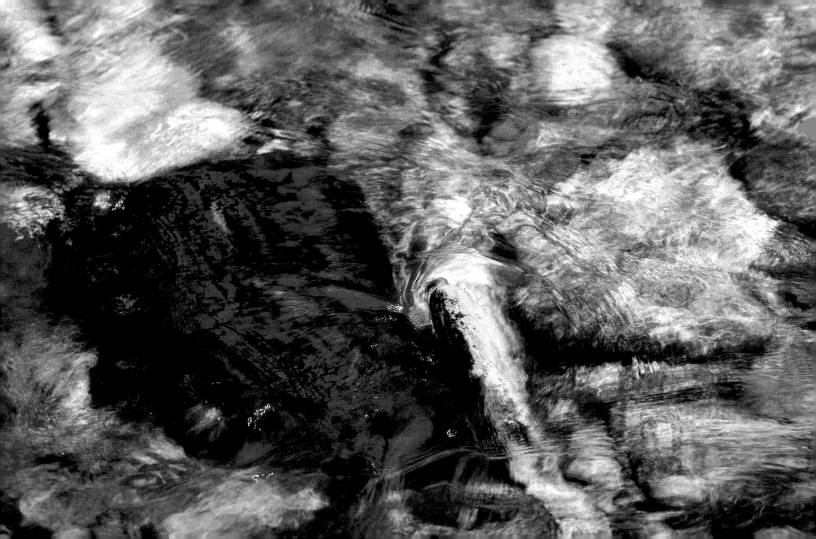

If you don't like tap water, use a filter.

Deteriorating water infrastructures, pollution, and outdated treatment technologies have combined to degrade the quality of water being delivered to Americans. Sources of drinking water are continually degraded by development and pollution. For the moment, drinking water treatment facilities are adequate to ensure that our water is fit to drink—but how long will this be the case?

To reduce the chlorine taste in water, you can install a filter on the tap, or add a few drops of lemon juice to your water pitcher. Or, simpler still, place the pitcher in the refrigerator for a few hours: chlorine is volatile and will evaporate.

White Desert, Egypt

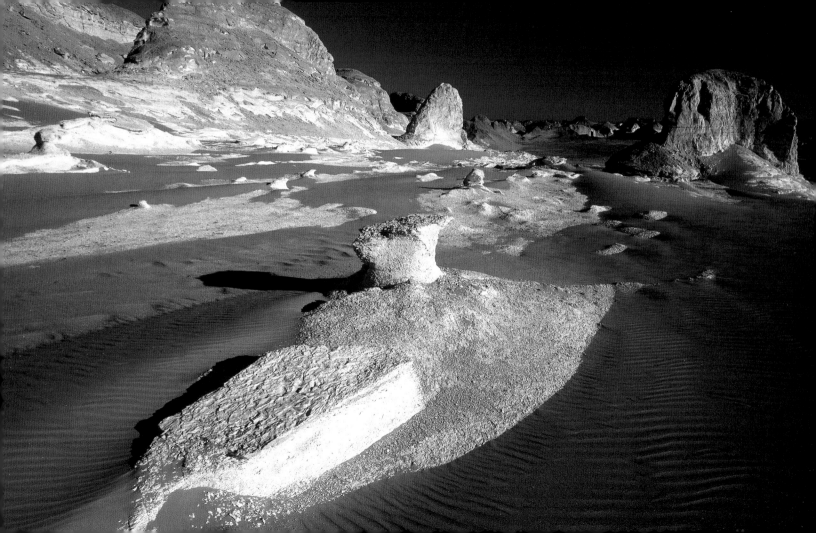

Reduce the noise you make in your neighborhood.

Noise is part of our environment and plays a part in our quality of life. In the 1970s, the Environmental Protection Agency determined the level of noise necessary to protect human health and welfare. The Occupational Safety and Health Administration also began to set limits and regulations for workplace noise levels.

Noise pollution has clear effects on our bodies—it can cause irritability, indigestion, high blood pressure, and lack of sleep. Be aware of the noise level in your home and work environments and try to eliminate as much noise as possible.

Sandstone, Chad

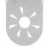

Do not buy souvenirs made from protected species.

Over-exploitation of living things—as a result of hunting, fishing, or excessive harvesting—is one of the main reasons for species extinction. When trade of a species continues despite its being protected, it is called trafficking. Illegal trade in threatened animal and plant species is the third largest form of trafficking in the world after arms and drugs; this trade affects 13% of the bird and mammal species threatened with extinction.

By buying certain objects or souvenirs that come from protected species, you are encouraging this traffic and speeding up the extinction of species. Seek information from the authorities of the countries concerned (such as the consulate, customs, or environmental ministry) before you bring home live animals or articles made from protected species.

Elephants, Kenya

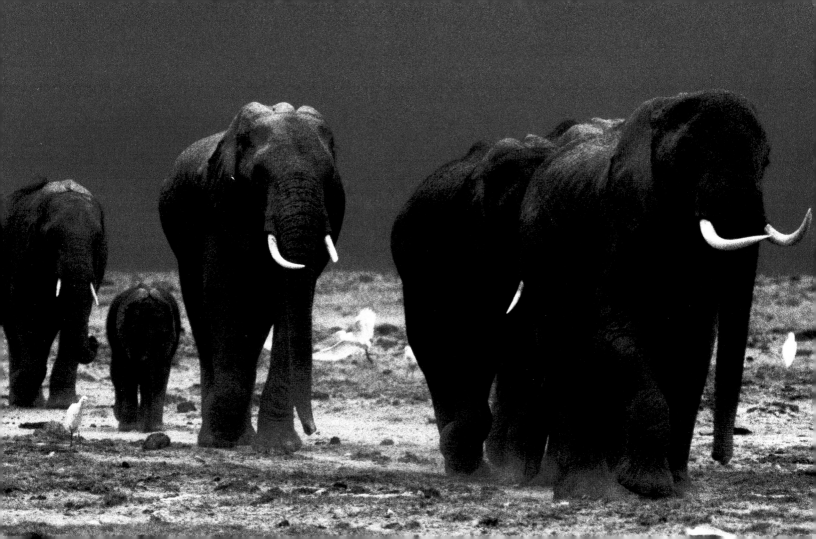

Take your old batteries back to the store.

Inside a battery, the chemical reaction that takes place produces energy, which is converted into electricity. Most cylinder and button batteries contain toxic metals such as cadmium, mercury, lead, and nickel, which are extremely harmful to the environment. Even though newer batteries may be disposed of in the trash, it is strongly recommended that you recycle your alkaline batteries.

Many large commercial stores accept batteries for recycling. They may not advertise this fact, so it is a matter of asking the manager. Try to limit the number of products you use that require batteries, and buy a battery charger and rechargeable batteries.

Erosion, Kamchatka, Russia

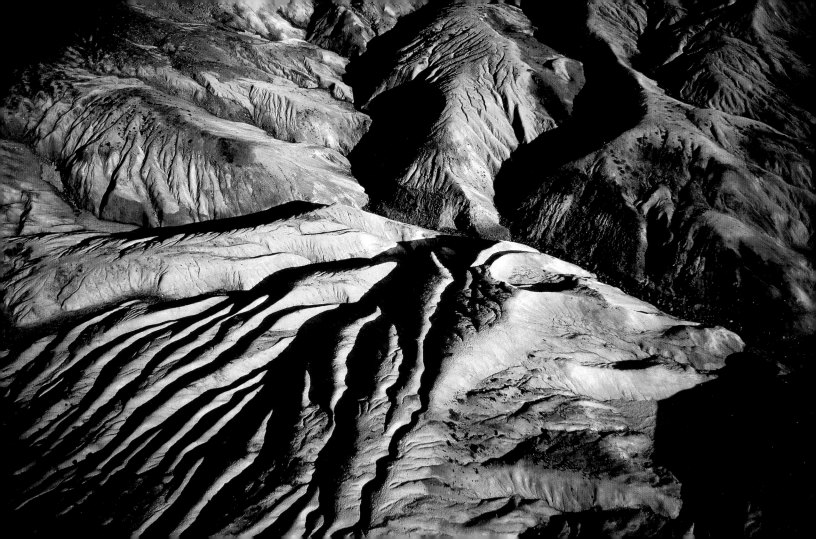

Use less air-conditioning in your car.

CFCs (chlorofluorocarbons), the gases used in aerosol sprays, refrigerators, and air-conditioners destroy the ozone layer. It appears that the hole in the ozone layer has now stabilized, but only after reaching a record size—three times as big as the United States—in the southern hemisphere at the end of 2000. Even though most countries have already banned CFCs and replaced them with more environmentally friendly alternatives, the CFCs already in the atmosphere will continue to have a damaging effect for several decades!

Car air-conditioners lose between 15% and 20% of their coolant gas, which is harmful to the ozone layer, every year. Do you really need a car with air-conditioning?

Ice floe, Alaska

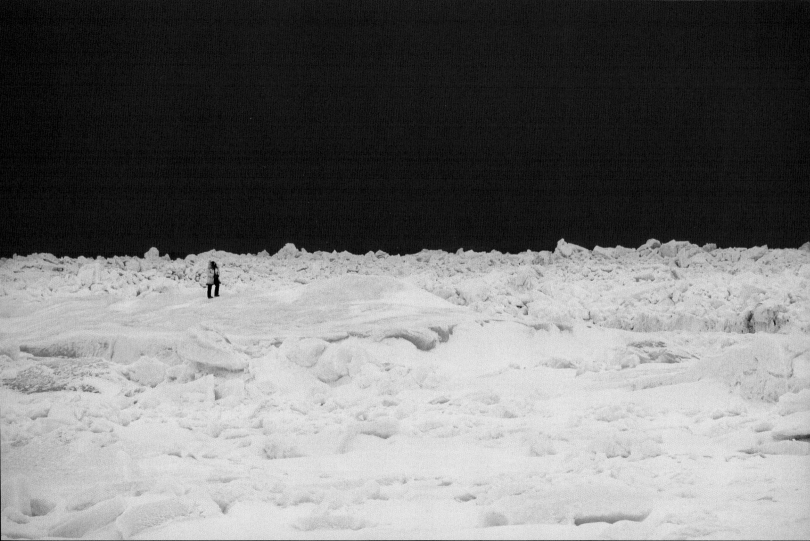

Do not light fires in the forest.

Emissions of carbon dioxide are one of the chief sources of the air pollution that is causing the proven upheaval in the climate. The emissions are caused chiefly by the burning of coal, oil, and gas, which human beings use to meet their energy needs. Forest fires are the next biggest source of carbon emissions in the atmosphere; tropical deforestation is responsible for 22% of world emissions. The fires may be accidental, but it is more likely that they are started deliberately to clear vast areas for agriculture.

In 2002, 6.17 million acres of forest land and wildlife habitat burned because of forest fires. Preserve the planet's forests: don't light fires.

Patagonia, Argentina

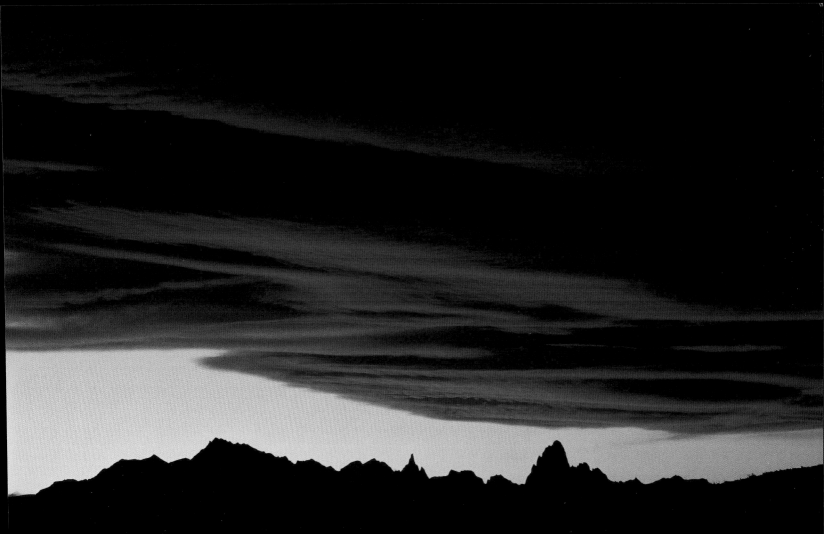

Beware of invasive species. Do not introduce non-native plants or animals.

Nature relies on delicate balances. An alien species, whether deliberately or accidentally introduced into a habitat, may find conditions so favorable that it becomes invasive. Miconia, an ornamental bush introduced to Tahiti in 1937, now covers two-thirds of the island. Caulerpa, a tropical seaweed, monotonously blankets vast areas of the Mediterranean. The water hyacinth, originally from Brazil, chokes rivers in Africa. In Hawaii, the Indian mongoose was released to eradicate rats in sugarcane fields. The mongoose did nothing to slow the proliferation of rats, but instead destroyed most of the local native flora and fauna of the island, bringing many of those species close to extinction.

To avoid an ecological disaster, do not release any exotic animal into the environment, and never smuggle plants or animals in your luggage.

Niger River, Mali

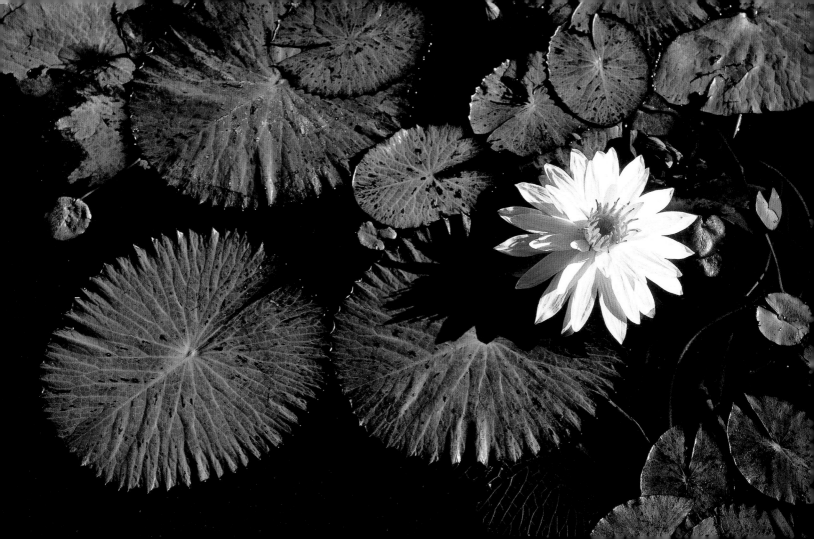

Observe the law and regulations.

No one is above the law and that applies everywhere. Like other countries, though the severity of laws and enforcement differs between them, the United States has an arsenal of environmental laws and regulations from protecting endangered species and threatened habitats, to preventing pollution, and regulations regarding building, waste and water management, transportation, industry, agriculture, fishing, and so forth.

If everyone observed the law and regulations at all levels of society, far less damage would be done to the planet. Make sure you observe environmental laws at all times.

Banc d'Arguin, Mauritania

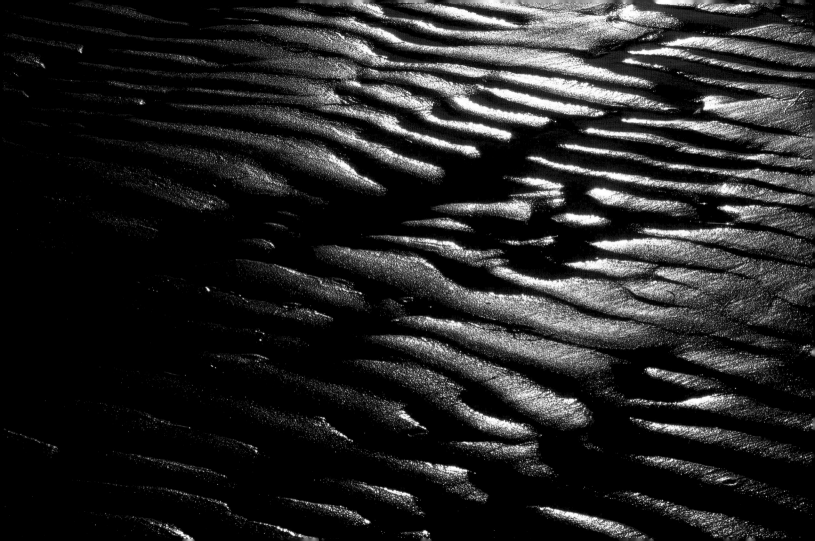

Take your trash with you.

Some waste is biodegradable, which means that it decomposes easily in the environment. Other waste does so much less quickly. Bear in mind that a tissue dropped in nature takes 3 months to decompose, a piece of paper takes 4 months, and chewing gum takes 5 years; an aluminum can decomposes over 10 years, a plastic bottle takes at least 100 years, and a glass bottle requires several centuries.

———

No matter how quickly you think it will decompose, do not leave waste behind. Always take it with you and find a garbage can, or better yet, a recycling bin.

Old volcanic cone, Bolivia

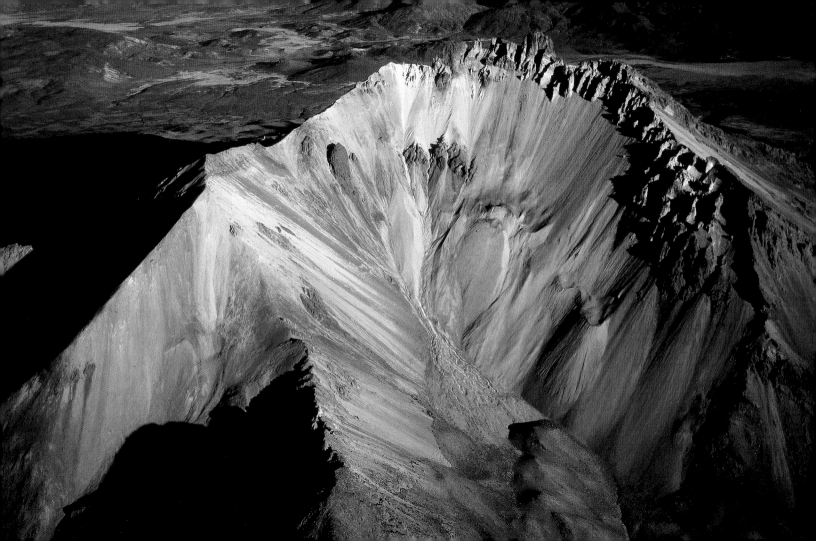

Protect mangroves.

Mangrove forests, which grow on swampy shores, are a vital habitat for marine life as well as significant to local economies. They offer a refuge and spawning ground for fish and crustaceans; they protect the shore by trapping sediment washed down by rivers; and they slow erosion caused by waves. Mangroves carpet almost a quarter of tropical coasts but this is only half their former extent, for this fragile, unique habitat is continually receding as a result of logging, pollution, and increasingly, the expansion of shrimp farming (especially in Asia, which produces 80% of the world's farmed shrimp). Half of the mangroves that remain are considered degraded in some way. The impact of the destruction of mangroves on the coastal ecosystem was recently found to be even more vital when scientists discovered that mangrove forests are crucial nurseries for some coral reef fish species.

Avoid eating farmed shrimp, especially when staying in foreign countries.

Mantis shrimp, Australia

Choose solar-powered heating for your home.

Renewable energy sources produce no greenhouse gases and their reserves are inexhaustible. Why not use the sun to heat your water and your house? People often mistakenly believe that solar heating only works in tropical regions. This is incorrect—it is just as economical to choose solar power at our latitudes. Depending on the situation, energy from the sun can supply 40% to 80% of hot water needs, and 20% to 40% of heating needs. A solar hot water heater may allow a 40% to 70% reduction of energy consumption during the summer.

Various financial subsidies for renewable energies are available, especially when constructing on a large scale—find out about them. Even without subsidy, a solar panel installation pays for itself in about 12 years on average, while its life is generally longer than 25 years. The sunlight is free, courtesy of Mother Nature.

Ice crystals, Greenland

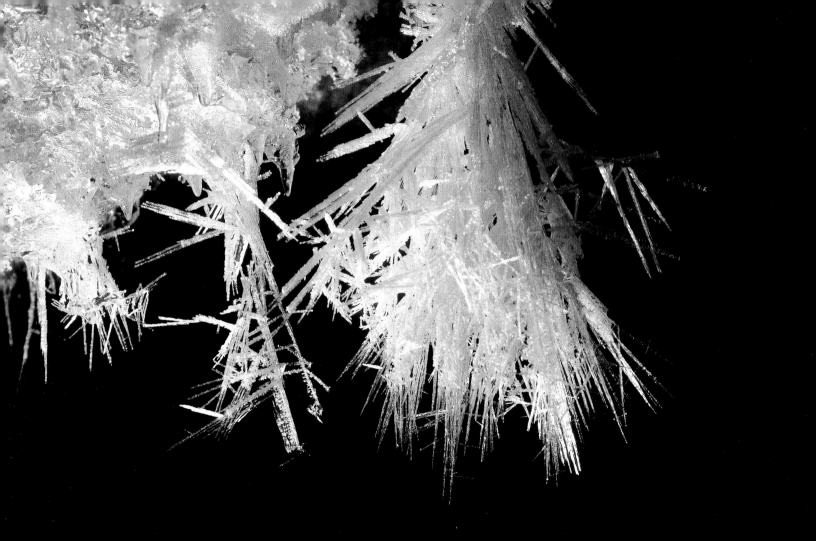

Donate your time to an environmental organization.

The United States is blessed with a multitude of environmental organizations—local, regional, and national. Some focus on issues of access to resources, some on biological and natural integrity, some on public education, and many on all three. Some citizens choose to support these organizations by giving a donation or becoming a member in order to support initiatives financially; others give their time to take part in the organization's activities.

These organizations have a great deal to contribute. They also need you. Investigate the environmental groups in your area, and support their work in some way.

Practice environmentally friendly camping.

Camping would appear to be close to nature and do little environmental damage, but in practice this can vary. Making smarter choices about where and when you camp will reduce the amount of impact your camping trip has on the environment. Always camp in designated campgrounds; choosing your own site to pitch a tent will compress soil and impact vegetation.

Timing of your holiday is also important. If you choose a popular outdoors destination for your trip, choose to go at an off-peak time of year; fewer people in the park will not only add to the enjoyment of your trip but also reduces the amount of impact visitors have on a given day.

Olympic National Park, United States

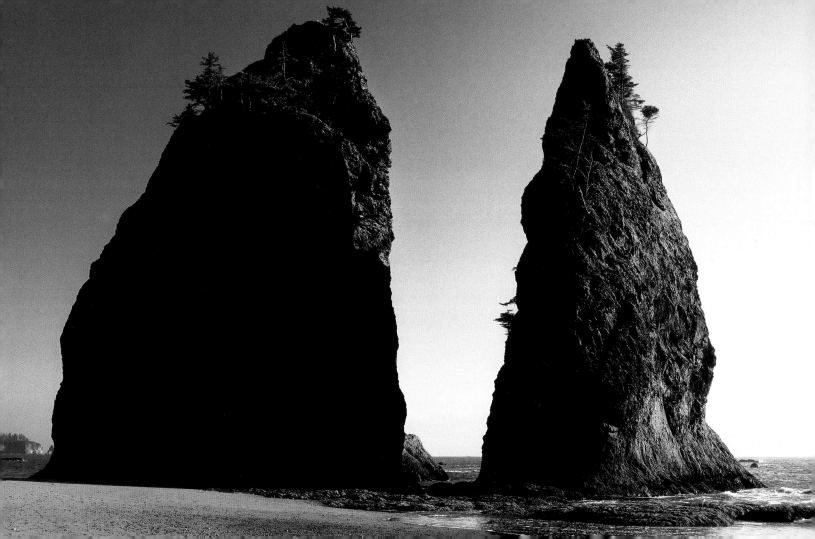

Make your children aware of the natural world that surrounds them.

Before we want to protect something, we must first get to know it. Inaction is often due to ignorance rather than negligence. Those who are young today will soon have the Earth's future in their hands. Let us give them the means to do better tomorrow than we have done today.

———————

Suggest nature trips to your children, such as visits to the botanical gardens, the local environmental center, natural sights, walks, and other open-air activities. Give them binoculars, magnifying glasses, notebooks, and pencils. Complement these with books, nature guides, and discussions about their newfound knowledge. By broadening their interests you will help to increase their awareness and will certainly learn a lot yourself.

Sea crocodile, Australia

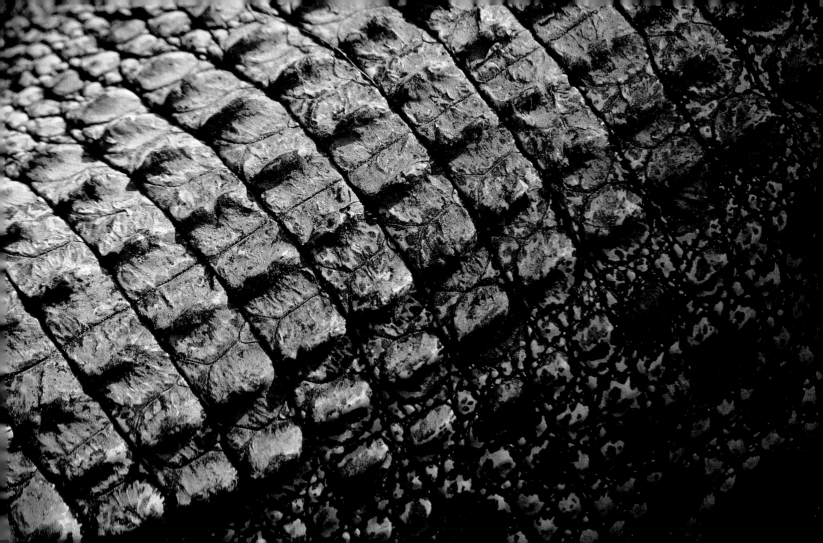

Keep your tires properly inflated.

Keeping tires fully inflated reduces wear and lengthens their life, thus saving money—new tires can be expensive, on average $120 to replace all four tires. It also saves precious raw material: it takes seven gallons of crude oil to create a new tire. Under-inflated tires can increase fuel consumption by up to 10%. Americans waste 4 million gallons of gasoline a day driving on tires with low pressure.

Take care to keep your car's tires at the pressure recommended by the manufacturer. Take five minutes every month to check the pressure of your tires.

Glacier, Greenland

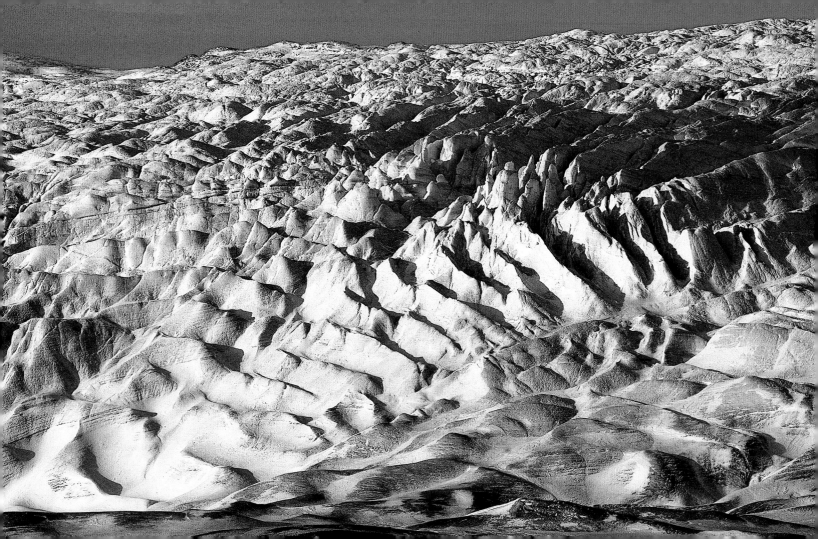

Buy a refrigerator that does not damage the ozone layer or the climate.

International measures for halting the destruction of the ozone layer stipulate that chlorofluorocarbons (CFCs) in refrigeration equipment must be replaced by hydrochlorofluorocarbons (HCFCs) and hydrofluorocarbons (HFCs), which do not damage the ozone layer. Unfortunately, they do contribute significantly to climate change because they contain chlorine, which makes them far more powerful greenhouse gases than carbon dioxide. The anticipated increase in the use of HFCs by the year 2050 will contribute as much to global warming as all the private cars on the planet put together.

Refrigerators are available that contain neither CFCs nor HCFCs, but use isobutane instead. When you change your refrigerator, find out about models that do not damage either the ozone layer or contribute to climate change.

Uzon caldera, Kamchatka, Russia

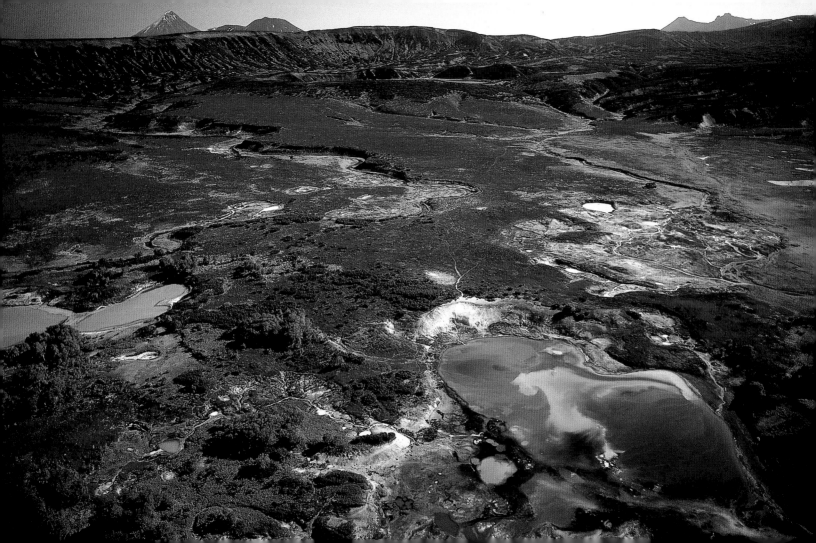

Use the right dose of detergents and other chemicals.

Thanks to the efforts of detergent manufacturers, you now need far less detergent to wash a load of laundry or dishes.

Check the recommended dosage on the packages of the products you use to wash dishes, floors, or laundry, especially for concentrated detergents, and stick to them. Using more soap does not give better results, but it is more costly, wastes more packaging—and therefore natural resources—produces more waste, and contributes to the degradation of already polluted rivers.

Iceberg, Greenland

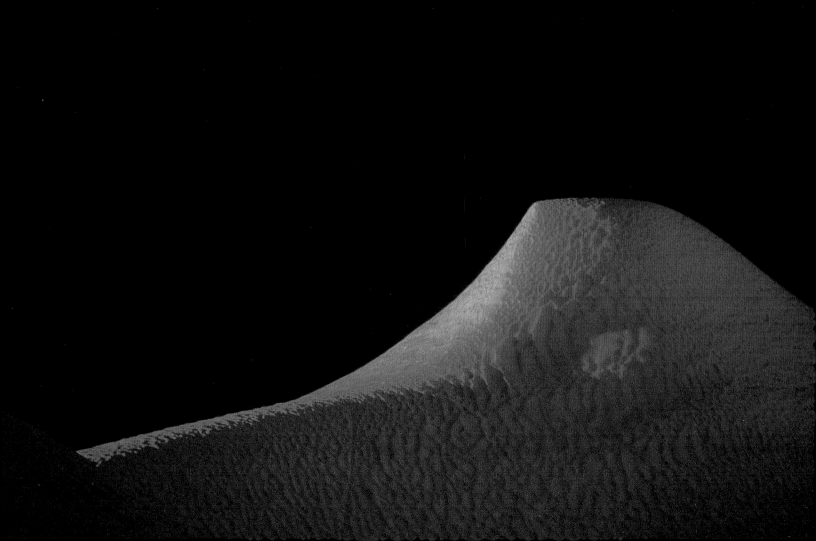

Choose organic cotton.

Cotton accounts for only 2.5% of the world's farmed land, but it uses 25% of the world's pesticides, making it the most pollution-causing crop. In order to grow the pound of cotton needed for the average T-shirt the conventional cotton farmer uses about one-third of a pound of hazardous chemical pesticides and fertilizers. Industrial processing of the raw fibers is equally harmful to the environment; it involves chlorine bleaching and the use of dyes made with heavy metals that are harmful to people and the environment. When grown without the use of pesticides, organic cotton restores soil fertility and preserves the balance of ecosystems. It is harvested by hand and processed without the use of chemical treatments.

Choosing organic cotton contributes to your well being as well as that of those who grow it, and safeguards the health of all humans and the environment.

Sangay volcano, Ecuador

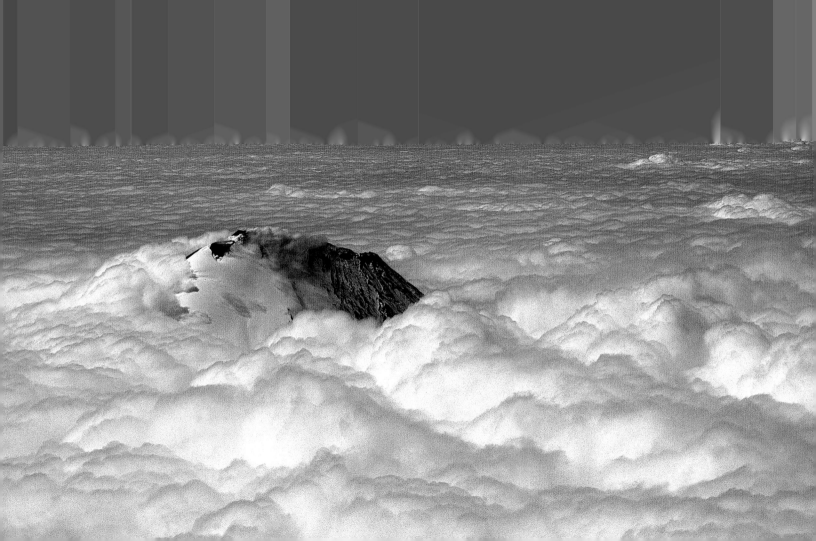

July 26

Do not throw out solid waste.

A motley carpet of some 300 million tons of waste covers the floor of the Mediterranean Sea. Some of the waste will remain there, intact, for centuries. A newspaper takes 6 weeks to decompose in the sea, and a cardboard box takes 3 months. A cigarette butt takes 2 years, and a steel can 80 years. An aluminum can will last 100 years, and a plastic bag 300 years. A piece of polystyrene or a plastic bottle will both remain intact for 500 years. Glass lasts even longer.

Vast though it is, the sea cannot absorb all our pollution. It is becoming saturated. Do not leave any waste on the shore, or throw any overboard.

Elephant crossing a sea channel, Andaman Islands, India

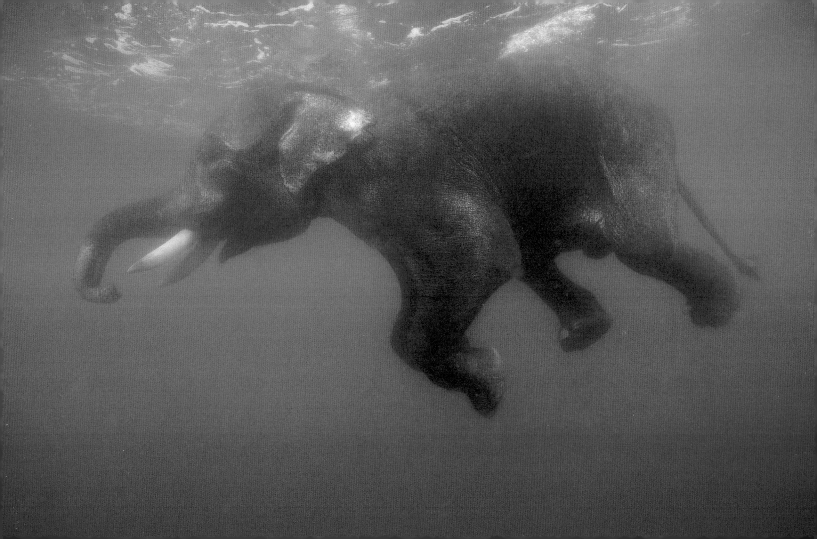

Say "no" to rare fish species on your plate.

Consumption of fish products has more than doubled in the last 50 years. Today, 47% of the world's commercial sea fish stocks are fished to the limit of their capacity, 15% are over-fished, and 10% are exhausted or slowly recovering. For example, in the waters off Newfoundland, cod stocks are struggling to recover despite a moratorium on fishing. A modern factory ship can catch as much cod in an hour as a typical sixteenth-century boat could haul in an entire season. Only a quarter of the world's fish stocks are moderately fished or under-fished, and species that were once plentiful have become rare.

Watch your consumption of bluefin tuna, cod, hake, monkfish, sole, Atlantic salmon, pollack, and herring: these are just some of the threatened species.

Shoal of bonitos, Australia

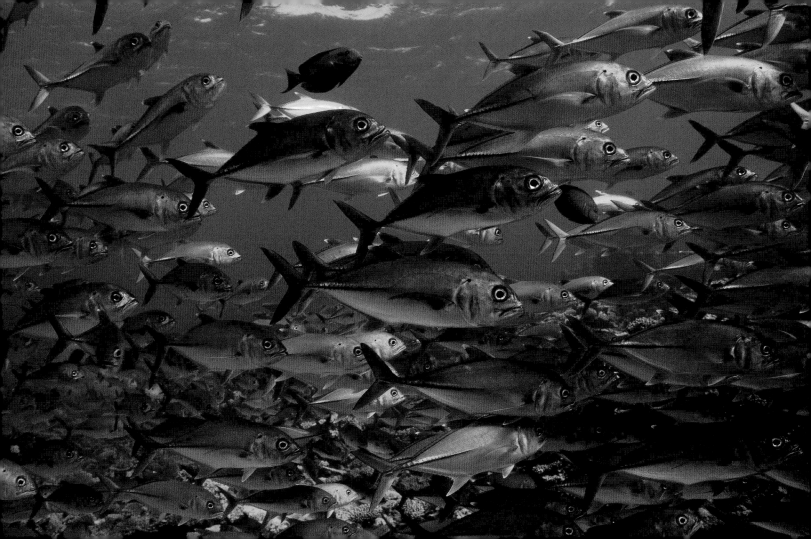

Rediscover the shopping list, to distinguish between desire and need.

We are easily tempted by things we "want," but rarely stop to ask ourselves what we "need." As a result much of what we buy is surplus to our needs. If the entire planet lived the American way of life, we would need four planets like Earth; for everyone to live like Europeans, two would be enough.

———————————

We only have one Earth. Do not allow yourself to be trapped into over-consumption; bring back the "shopping list" when you visit the supermarket. You won't forget anything, and you will avoid impulse purchases that were not planned and might account for up to 70% of what you buy.

Landmannalaugar, Iceland

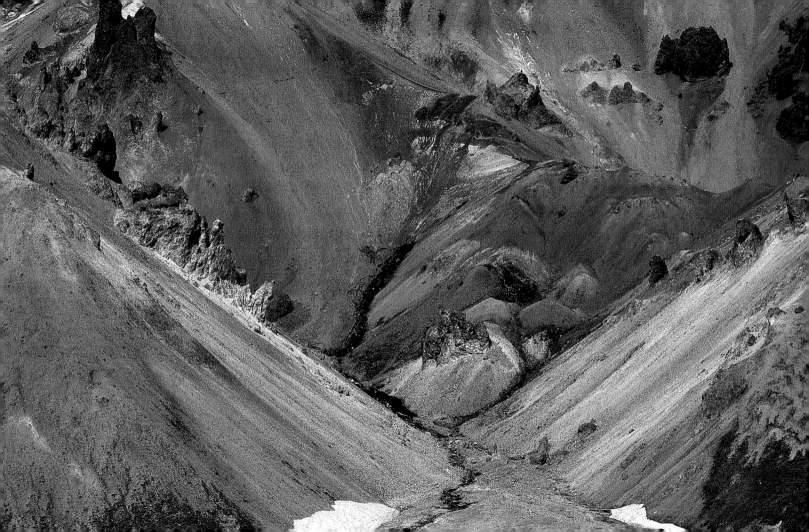

Use your library.

Tropical rainforests are being destroyed at the rate of 78 million acres a year. Every second a tract of rainforest the size of a football field disappears from this planet in order to provide space for cattle or crops, or to provide wood for paper products and furniture. World wood consumption is expected to rise by 58% over the next 20 years. In some tropical forests, a single tree can be home to up to 100 species. What will be left of this biological wealth?

———————

Even if you can afford it, rather than buying novels and other books new, subscribe to your local library. Libraries are precious civic spaces in which everyone should participate.

Ice floes run aground, Iceland

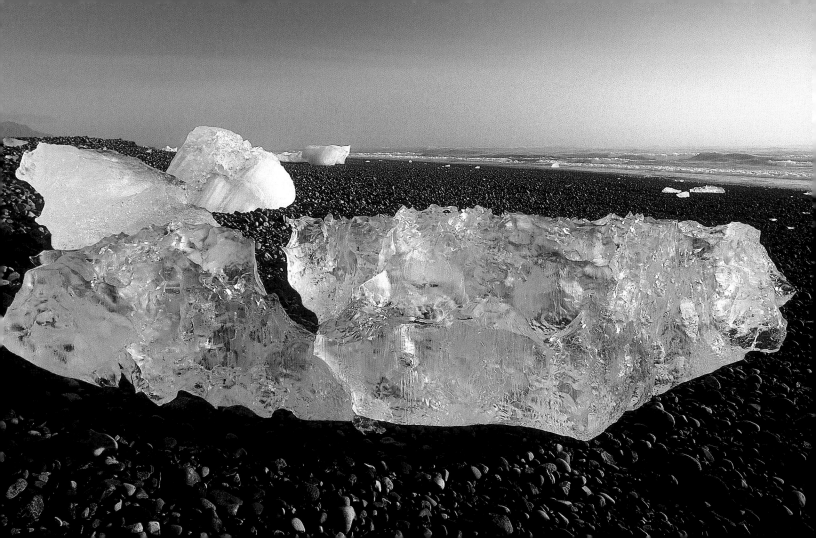

Suggest an eco-vacation or eco-tour to your children.

Sustainable tourism attempts to make as small an impact on the environment and local culture as possible, while attempting to generate sustainable income and employment for the local population. It seeks to be both ecologically and culturally sensitive. Ecotourism is the fastest growing market in the tourism industry.

If today's children are to become tomorrow's informed and responsible decision-makers, it is essential that they are provided with the means to develop environmentally aware values now. The next time you plan a big family vacation, consider the breadth of environmentally friendly travel options.

Ibis, Venezuela

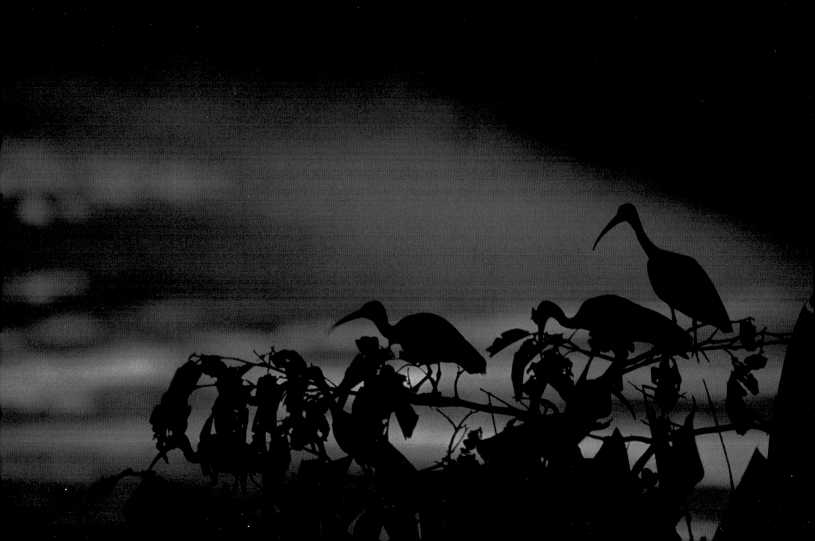

Do not buy objects made from the shells of sea turtles.

After habitat destruction, illegal trade remains the greatest threat to wild species. Many traffickers deal in products that, by weight, are more valuable than cocaine or heroin. For example, a shawl made from shahtoosh, the extremely fine wool of the Tibetan antelope (which is on the verge of extinction), may be worth more than $15,000. Sea turtles, having inhabited the planet's oceans for several tens of millions of years, are now in danger of extinction as a result of human activity.

———

When you are on vacation, do not buy whole shells, preserved animals, or jewelry, combs, eyeglass frames, or trinkets made from the shells of sea turtles.

Green turtle, Australia

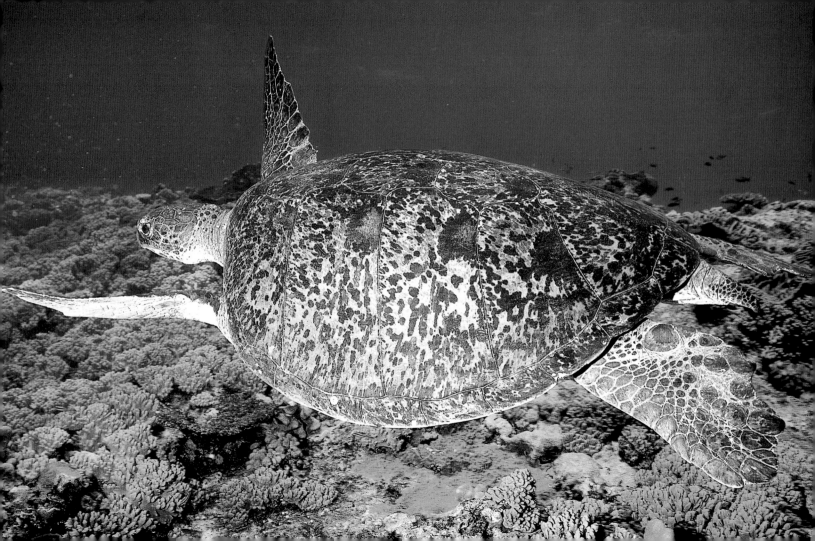

Use a bucket when you wash the car.

More than 1 billion people in the world—one person in five—cannot quench their thirst by drinking a glass of clean water. In certain countries, this is an extremely rare luxury. Only 30% of the population in Cambodia, 27% in Chad, 24% in Ethiopia, and 13% in Afghanistan has access to clean water.

When you wash your car with a hose, it uses 10 gallons of drinking water every minute. It is better to use a few bucketfuls and a sponge. You will achieve the same result and use far less water. If you insist on running water, visit a professional car wash; these use anywhere from 8 to 40 gallons of water per car. However, most carwashes reclaim and treat their wastewater.

Lake Magadi, Kenya

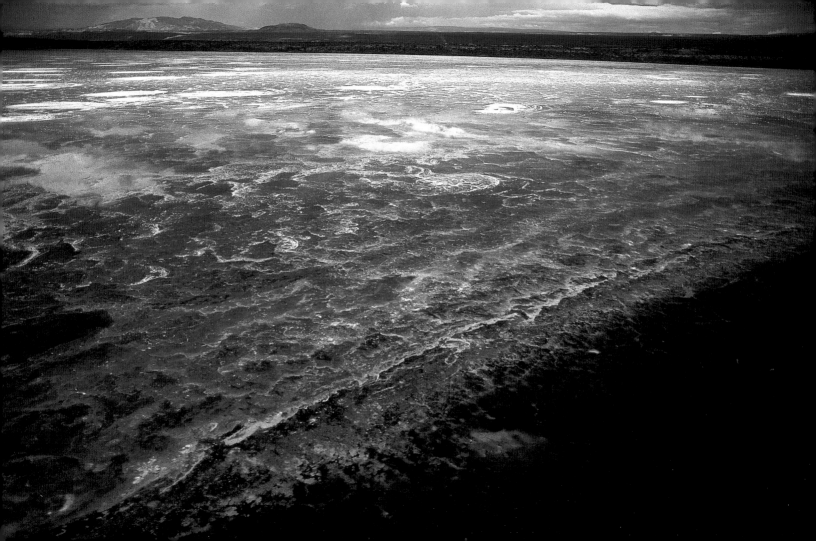

Take nature vacations.

If you are looking for vacation accommodations that are oriented toward the discovery of natural surroundings, try one of the many hostels in the United States located in or around areas of natural significance. From Cape Cod in the Northeast, to Point Reyes National Seashore in Northern California, and in many locations in between, hostels offer a cheap option to exploring the natural areas of the United States.

———————————

When you do travel to these areas, be sure to bring binoculars, wildlife and plant handbooks, maps, and other books with local information. These will all help you to explore the natural beauty before you.

Ruwenzori mountains, Uganda

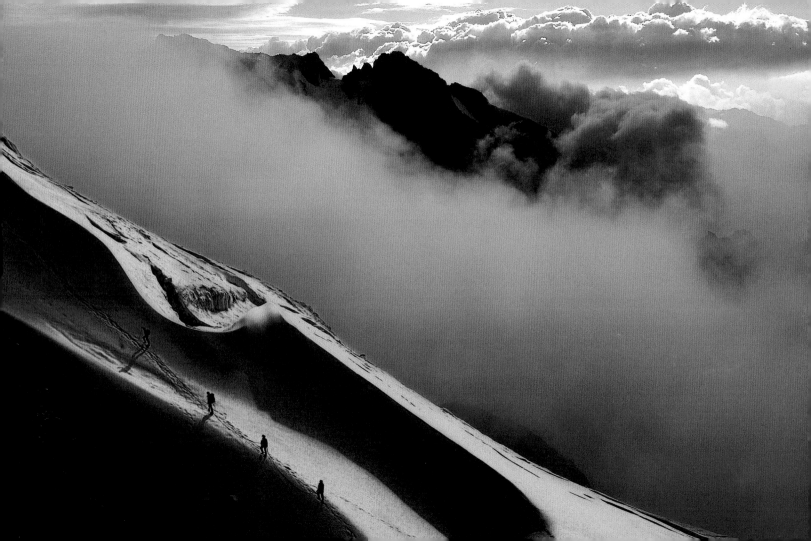

Buy products that are free of genetically modified organisms.

In 2003, about 167 million acres cultivated by 7 million farmers in 18 countries were planted with crops that had been genetically modified (GM) in some way. In that same year, the United States grew 63% of the genetically modified crops in the world; Canada, on the other hand, grew just 6%. Pro-GM groups claim that their products are more efficient and environmentally friendly; anti-GM groups argue that too little is known about the effect of GM foods on the environment, and that multinational biotech groups are the only people who stand to gain. Currently, five companies control all of the genetically engineered crops in the world, with Monsanto producing 90% of all genetically modified crops.

Until more is known of the effects of GM foods on society and the environment, try to limit the amount that you buy. Look for "No GM" or "GM-Free" labels.

Cranberries, United States

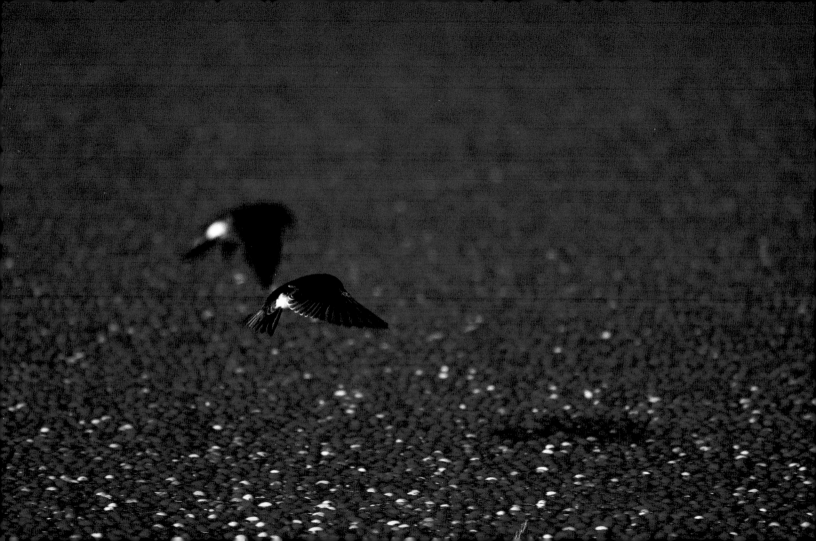

Take the train rather than the plane.

Each year, aviation generates as much carbon dioxide as all the human activity in Africa. Carbon-dioxide emissions are not the only environmental concern. Deicing airplane wings creates 200 to 600 million gallons of wastewater each year.

Avoid traveling by plane for journeys less than 300 miles. The train or bus are usually the least polluting means of transportation for such distances.

Depression, Tasmania

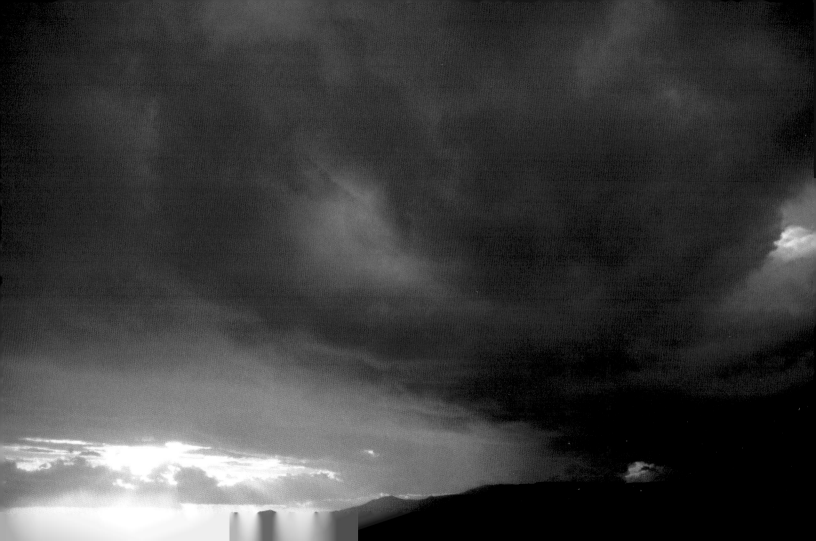

Use public bicycles in your city or create your own program.

For transportation in town, the bicycle has some unique advantages: it is clean, silent, compact, fast, and economical. The city of Rennes in France decided to make 200 bicycles available to its citizens, free of charge. Users must first obtain a magnetic card from the city council, which gives them access to the bicycles between the hours of 6 a.m. and 2 a.m. The bicycles must be returned after use to any one of the 25 pickup points provided all over the city. The system has been running since 1998 and has some 2,000 regular users.

If you find this idea ingenious and would like to see its benefits reproduced in your city, let your town hall know. It has had varying degrees of success in the United States in Austin, Texas; Portland, Oregon; and Saint Paul, Minnesota, under the name "Yellow Bikes."

Close-up of sandstone, Chad

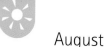

Don't smoke in the woods.

In 1997, huge forest fires devastated more than 11 million acres of forest in Indonesia. The populations affected were exposed to the equivalent of smoking 1,600 cigarettes per day, and 40,000 people were hospitalized. As they burned, the forests released into the atmosphere 3.7 billion tons of carbon dioxide—the principal greenhouse gas—or three times Japan's annual carbon-dioxide emissions. It is likely that the fires were started deliberately to clear land for agriculture and livestock.

Do not smoke when walking in the woods, and never throw cigarette butts out of your car window, even if you think you have stubbed them out.

Yellowstone National Park, United States

Do not pour cooking oil down the drain.

A city of 100,000 people produces nearly 80,000 gallons of wastewater every day. Before being returned to nature, this dirty water must be cleaned in a treatment plant.

———

Avoid pouring food oils in the sink: vinaigrette, oil from tuna cans, and oil used for frying form a film on water that interferes with the functioning of water treatment plants by suffocating the bacteria that remove pollution. It is better to put such oils aside in a closed plastic container that, once full, can be discarded with other nonrecyclable waste.

Sand, Mauritania

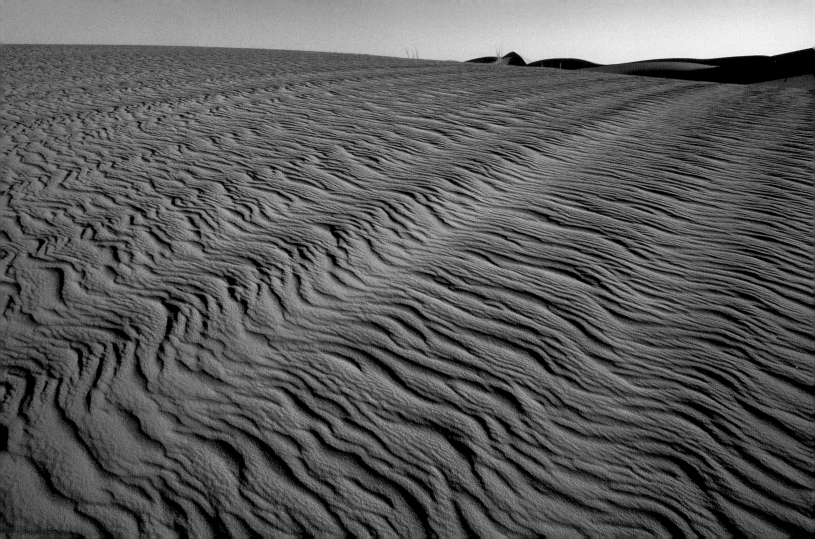

Oil tankers are not the biggest cause of oil pollution in our oceans.

Oil tankers may be the most striking polluters, but oil spills at sea are just a tiny part of the oil pollution that corrupts our oceans. More than 50% of the oil in the Earth's oceans results from residential and industrial discharges. We know that storm water runoff (carrying automobile oil from parking lots and streets) pollutes rivers and all rivers eventually flow into the sea. Compare this to oil spills, which account for just 5% of the oil polluting our oceans.

Fix a leaky car right away, and never dump your used oil into a storm drain.

Pink flamingoes, Kenya

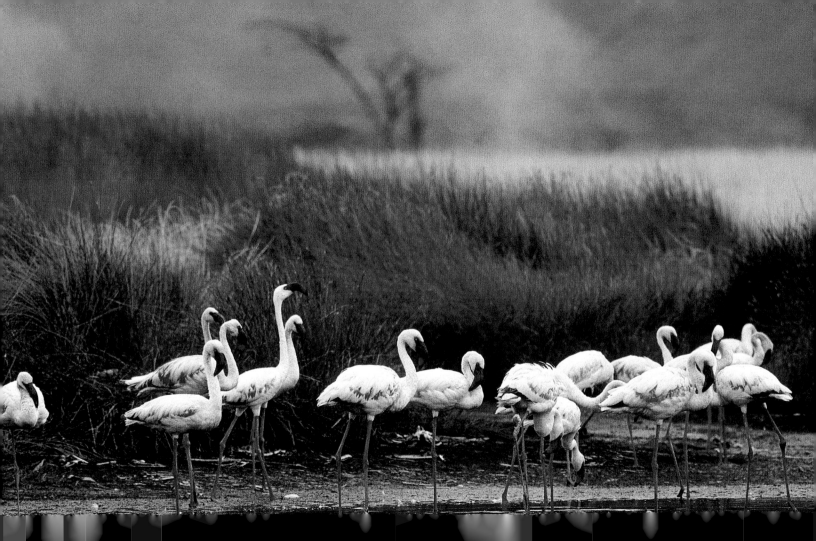

Recycle your old refrigerator.

A two-mile-long ice core sample taken from Antarctica has shown that the levels of heat-trapping greenhouse gases are higher now than at any time in the last 420,000 years. The heat these gases trap will cause sea levels to rise by about 3 feet, among other things. The agents responsible include coolant gases such as Freon (a trade name of the infamous CFCs, or chlorofluorocarbons), which are contained in the cooling circuits of old refrigerators, freezers, and air-conditioners. The formidable greenhouse gases are released into the atmosphere when those appliances leak, or are dumped.

More than 8 million refrigerators are disposed of every year in the United States. Take your old refrigerator to a facility where it will be dealt with properly, or ask your public works department how to dispose of it correctly.

Namib Desert, Namibia

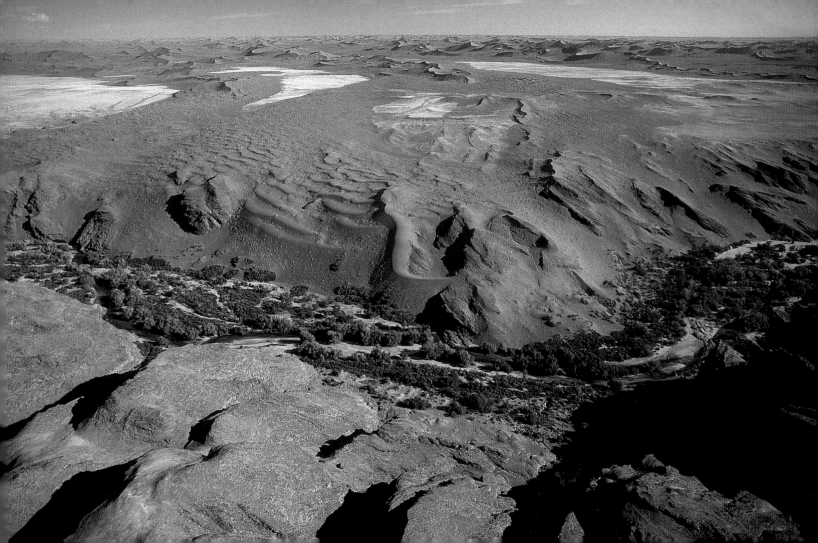

Say "no" to individually packaged portions.

Each person in America generates about 1,500 pounds of trash—called solid waste—every year. By the end of our lifetimes, we will have each created about 117,000 pounds of trash.

The fashion for pre-packaged mini-portions is no more than a marketing strategy. Take the time to create your own portions. Stop buying individual portions, cans, and other superfluous packaging for children's meals, or mid-morning snacks. Invest instead in reusable plastic containers and drinking bottles. When you explain your choice to your children, you can also make them aware of the threat to the planet that prompted your choice.

Glacial corridor, Greenland

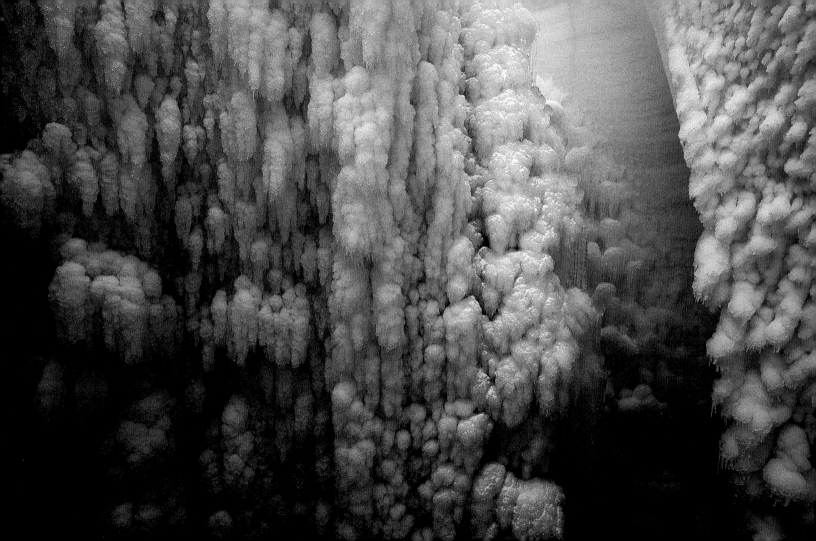

Buy in bulk when possible.

For every garbage can placed at the curb, 71 garbage cans of waste were created in the course of the production, transportation, and industrial processes used to convert raw materials into finished products and their packaging.

———

Limiting the amount of waste for disposal inevitably involves reducing the volume of packaging. For cheeses, sliced meats, and grains, buy food in bulk, by weight, or cut to your needs, rather than in prepackaged sizes. This also benefits your pantry, since you will be able to find ingredients for your next meal instead of heading for the store every time you prepare a meal.

Bacteria, Kamchatka, Russia

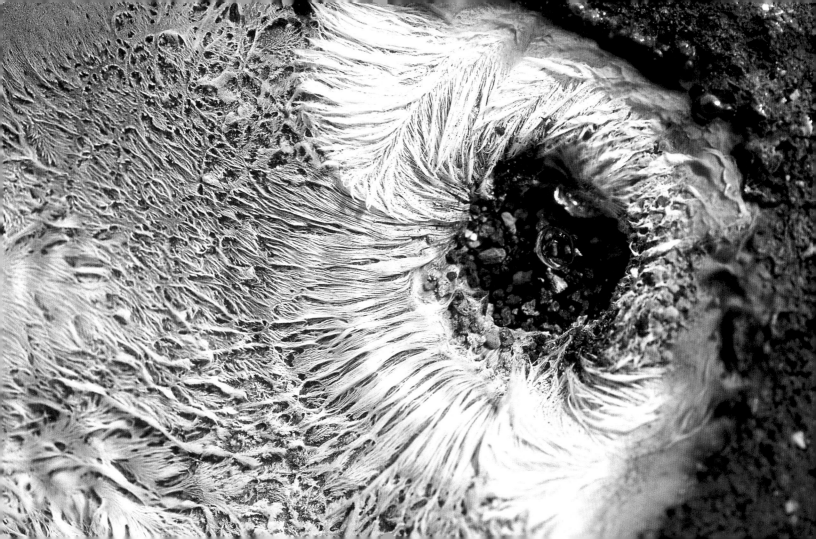

Mow the lawn at reasonable times.

If you need to do something noisy at home, take care not to cause a nuisance in your neighborhood, or disturb its quiet. A drill can produce between 90 and 100 decibels; the threshold of discomfort is 60 decibels.

——————————

We all contribute to the audible environment. Be aware of the time of day that you run a lawn mower, or revert to using a manual mower. Rake leaves instead of investing in a leaf-blower. Enjoy the time in your yard with the sounds of birds and the wind in the leaves, not your machinery.

Prairie, United States

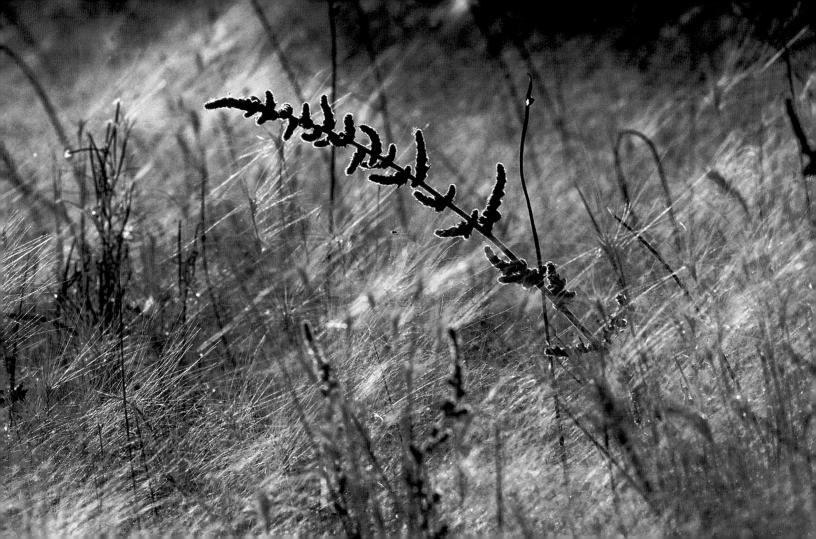

Find or offer a ride.

Natural disasters have become more dangerous in the last 50 years. Human beings have disturbed natural habitats and made the land less resilient to the planet's sudden changes of weather. Natural disasters occur more frequently, especially extreme weather events, due to climate change. During the 1990s there were four times as many natural disasters as during the 1950s. These caused economic losses of about $608 billion—more than the four previous decades put together.

For more environmentally friendly journeys between cities, research organizations that can put drivers and passengers in touch with each other to share journeys. If you don't need to find a ride yourself, perhaps you have room to offer someone else. Local universities and colleges often post ride boards on their campuses.

Lava, Kilauea volcano, Hawaii

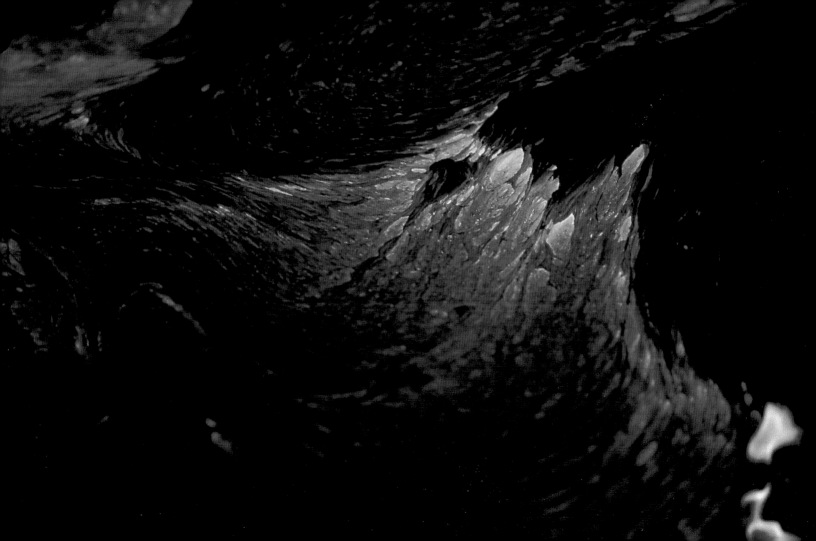

When traveling abroad, take a vacation with an ecological label.

The European eco-label identifies accommodations that respect certain environmental criteria, such as water consumption, use of renewable energy, waste management, and environmental education. The label encourages those who run tourist facilities to adopt good environmental practices, and promotes sustainable tourism initiatives. There are other, equivalent international certification programs, as well. Investigate them when planning your next vacation abroad.

Take a vacation where the attention is paid to the environment on a daily basis—take an eco-holiday.

Sandbanks, Mexico

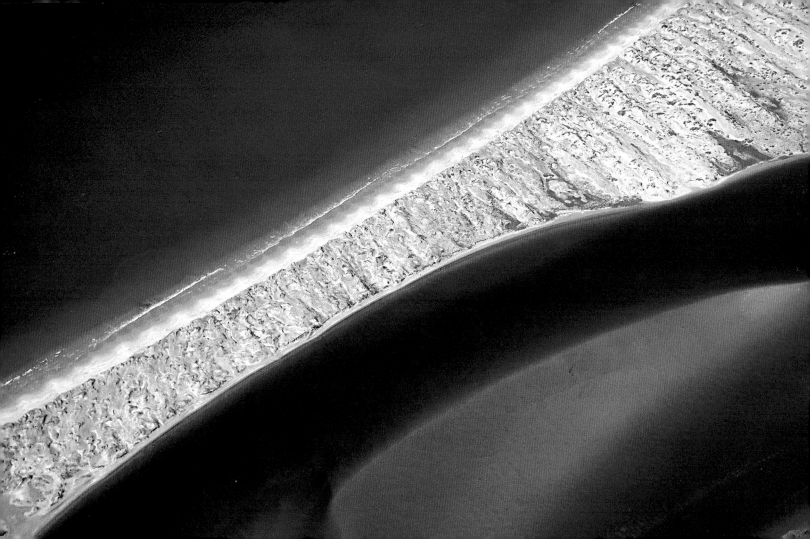

Help to clean up a river.

Local nature conservation organizations regularly organize river cleanup operations. These involve removing the waste that pollutes a watercourse and clearing riverbanks of the detritus of human life. Excessively dense vegetation creates a closed habitat that does not favor aquatic life. This maintenance is beneficial even if the water is not polluted, because it preserves the ecosystem and its biodiversity.

———

These operations always need volunteers. Do not be afraid to join one: it is an opportunity to learn more about the stream, its banks, and the fauna and flora that live there.

Great Smoky Mountains, United States

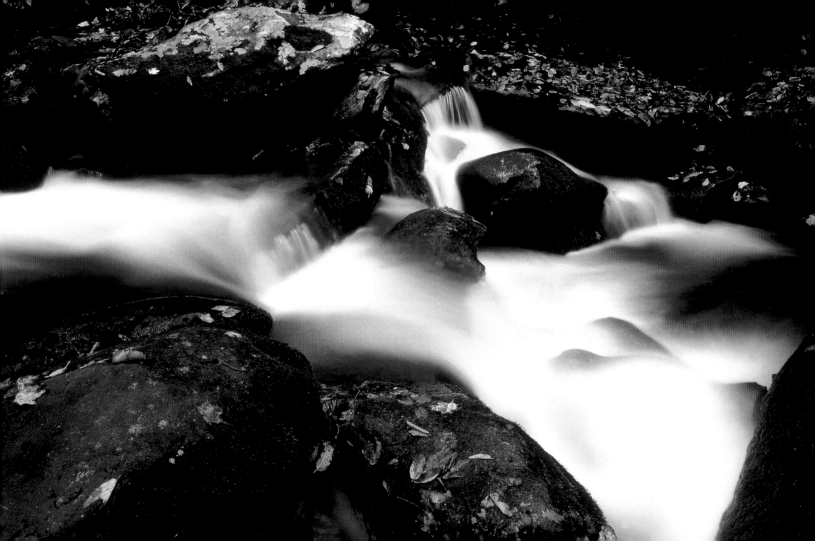

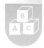

Walk in the forest with your children.

The planet's forests are home to an incalculable number of species; forests retain rainwater, which replenishes underground reserves; they are buffers against wind, absorb the force of rain, and retain soil to efficiently prevent erosion; and they absorb carbon dioxide and give off oxygen, helping to combat global warming (which is why they are referred to as carbon sinks). Every year, each of us consumes the equivalent of 9 full-grown trees in the form of paper.

Take your children for a walk in the forest, and explain its ecological function and some actions they can take to safeguard the woods.

River, Iceland

Say "no" to digital displays.

At present, a quarter of the world's population controls three-quarters of the energy produced on the planet, while a third of the world's population does not even have electricity. For example, the United States uses 22 times as much energy per inhabitant as India does. Part of the energy consumption in wealthy countries is due to superfluous gadgets.

If you are choosing between two different models of refrigerator, oven, or microwave, choose the one with a mechanical display rather than one with a digital display; the digital display is always on and wastes energy.

Mehedjibat *erg* (sand desert), Algeria

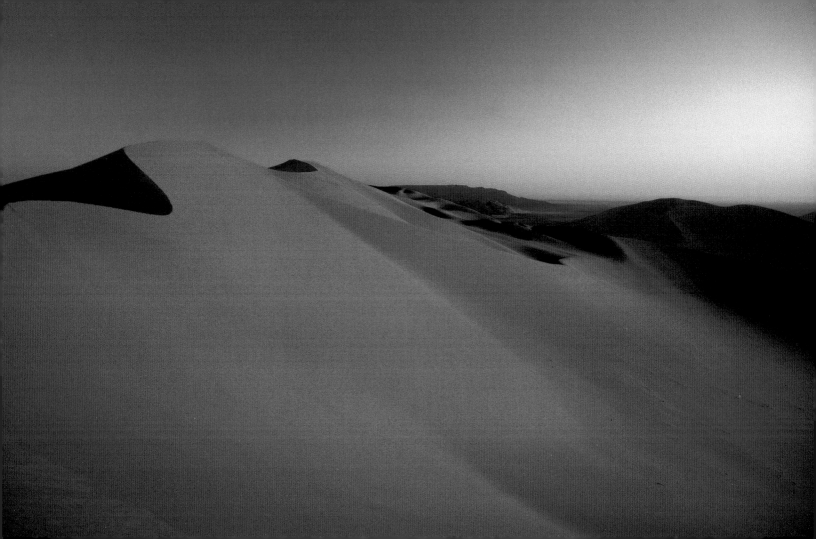

Avoid Black Flags when traveling Europe.

The world's oceans play an important role in counteracting the greenhouse effect: they are the biggest producer of oxygen (via plankton) and the biggest carbon sink (carbon is dissolved in water) on the planet. Of the 7 billion tons of carbon dioxide produced by human activity every year, the seas absorb 2 billion. They also interact with the atmosphere, a process that governs currents, winds, clouds, and climate. Rich in fish, geological resources (oil, and minerals at great depths), and energy (ocean currents and tides), as long as the seas are in good health they are utterly vital to human beings.

The Black Flags are assigned by the Surf-rider Foundation in Europe to tell local authorities and travelers which coastal resorts are polluted. Avoid them.

Cuttlefish, Australia

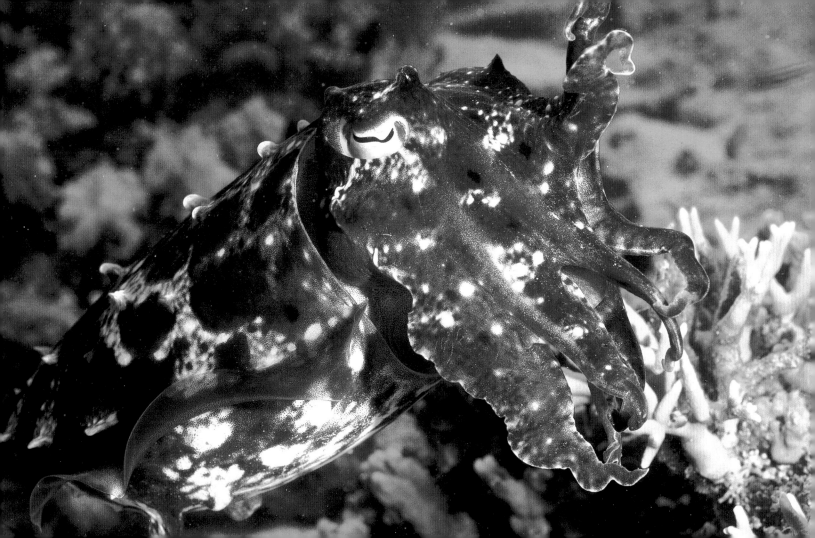

Choose the most energy-efficient appliances.

Over 10 years, the difference between the cost of the electricity consumed by a highly energy-efficient refrigerator and by one that uses a lot of power can be as much as five times the cost of a new refrigerator.

Check the energy rating label before you buy an electrical appliance. Refrigerators are of particular concern, since they are usually the biggest energy consumer in a house. Replace a refrigerator bought in 1990 with an Energy Star model and you will save enough energy to light the average household for almost five months.

Blizzard, Canada

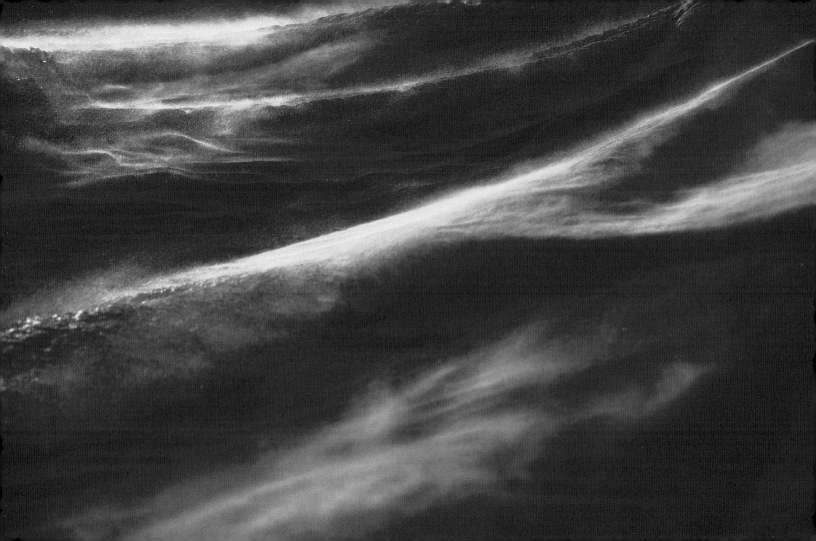

Avoid noisy motoring activities.

Some leisure activities seem far from appealing in light of their impact on the environment and landscape. These include off-road driving, hunting, golfing (whose landscaping demands excessive fertilizer and watering), and skiing, the infrastructure of which permanently blots the landscape.

Devotees of these activities should observe certain rules. For example, avoid noisy motorized activities (such as jet skis, 4 x 4 vehicles, trail bikes, and snowmobiles) that disturb plants and animals outside the areas set aside for them. Never drive an off-road vehicle on a beach, in a marsh, or anywhere near birds' nests.

Lake Titicaca, Bolivia

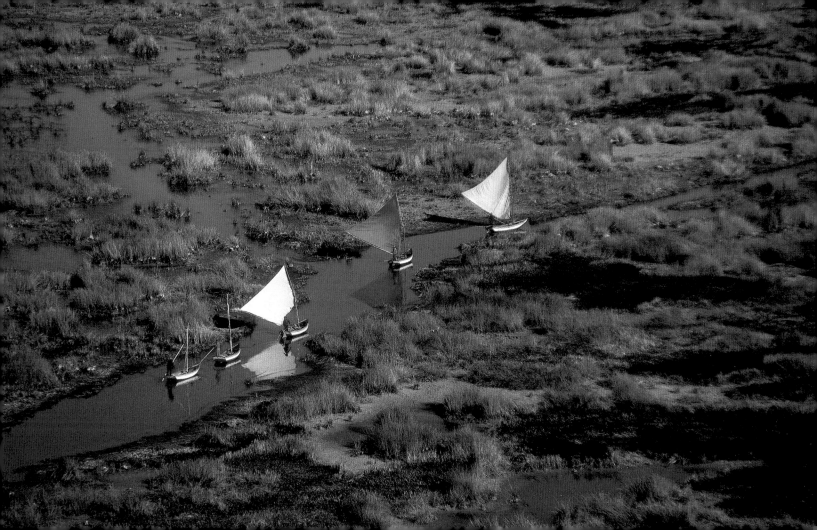

Replace paper towels with a sponge.

The volume of waste produced on the planet is rising relentlessly. This is partly because as a species we are ever more numerous, and because each of us throws away more and more material. As standards of living rise, more household waste is generated. Each inhabitant of industrialized nations produces three times as much waste as they did 20 years ago. The more the average income rises in developing countries, the more the global problem of waste will worsen. At the present rate, by 2020 world production of waste will rise by 70% despite the fact that there are countless ways to reduce waste without damaging our standard of living.

Use a sponge or a fabric towel in the kitchen rather than paper towels.

Grasses, Iceland

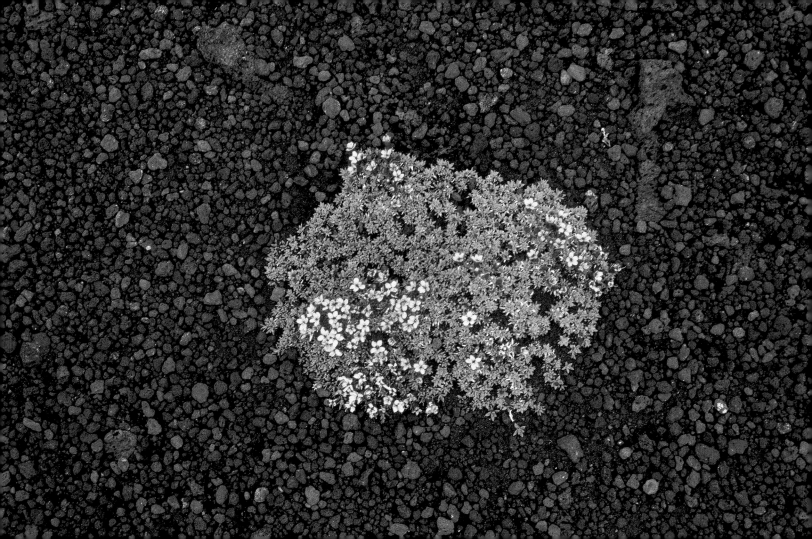

Choose furniture made of SmartWood, or FSC-certified wood.

During the last century, half the world's tropical forests disappeared. Tropical forest uses are all around us—from wood furniture, to insulation, rope, and medicine. The United States National Cancer Institute has identified 3,000 plants that are active against cancer cells; 70% of these plants are found in the rainforest.

Before buying any piece of furniture, ask where the materials come from, especially where exotic woods are concerned: mahogany, teak, ipe, and ebony are examples of popular exotic wood types. Choose sustainable products, like SmartWood-certified products, from environmentally responsible companies, where resources are used without plundering biodiversity or abusing local people.

Icebergs, Greenland

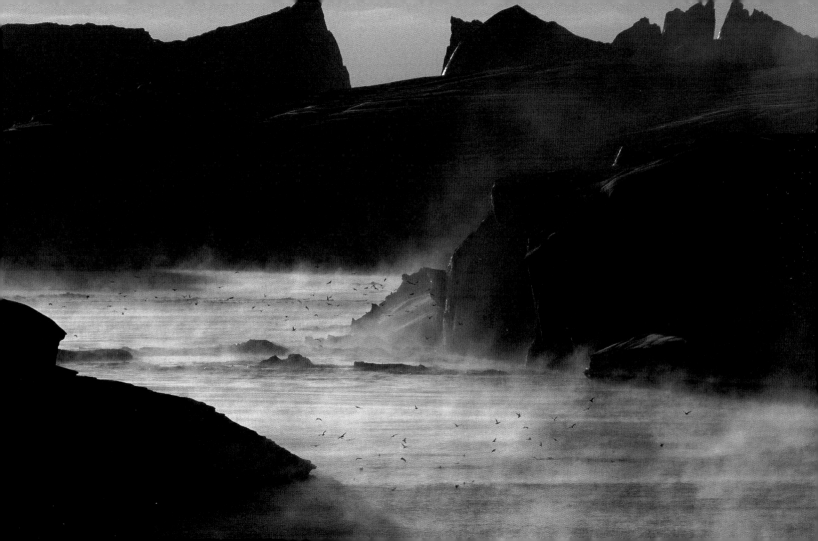

Buy fair-trade coffee.

Fair trade endeavors to establish equitable commercial relations between rich and poor countries so that underprivileged workers and farmers can live and work with dignity. Workers on conventional farms must often meet harvesting quotas in order to receive a daily wage, forcing them to enlist their families to help them make their quota. Technically, their children are not employees and thus are not protected by any laws. Fair-trade coffee demands that coffee sell for a minimum of $1.29 per pound. Workers' earnings are unaffected by market fluctuations, thus eliminating the need for unfair quotas. In addition, fair-trade coffee is usually grown on small farms that cultivate under the rainforest canopy and without the use of pesticides.

More than 100 brands of fair-trade coffee are now available in over 35,000 markets worldwide. Make a commitment to only buy fair-trade coffee, or buy conventional coffee occasionally and gradually integrate fair-trade products in your coffee mug.

Lake Titicaca, Bolivia

Cook with gas rather than electricity.

The 1,500 researchers of the United Nations Intergovernmental Panel on Climate Change (IPCC) set up jointly by the UN Environment Program (UNEP) and the World Meteorological Organization now agree that human activity is affecting the world's climate: every year, human beings emit more than 30 billion tons of greenhouse gases as they meet their energy needs in transportation, heating, air-conditioning, agriculture, industry, and so forth.

We should be equally aware of this when dealing with the little, day-to-day things in life. On average, a gas cooker uses half the energy of an electric cooker, as long as the burners are regularly cleaned. A clogged burner can use up to 10% more energy than a clean one.

Nautilus, Australia

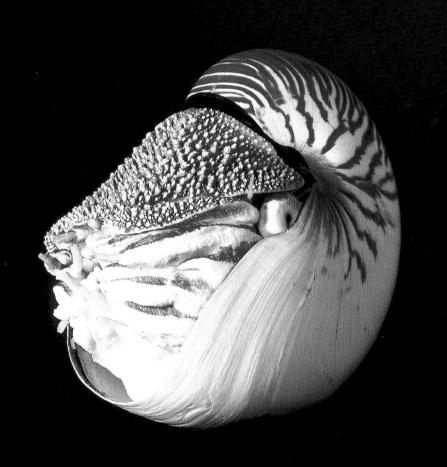

When traveling, take your polluting waste home with you.

In some developing countries you may visit, waste is not collected, disposed of, and treated. Often such countries cannot afford to establish the necessary infrastructure—indeed, most developing countries have this problem.

Take your most polluting waste, such as batteries and plastic bags, home in your luggage, so that they can be disposed of properly when you return. On the other hand, you may leave cans behind with a clear conscience: local people are often highly skilled in the art of reusing them.

Detail of scorpion fish, Australia

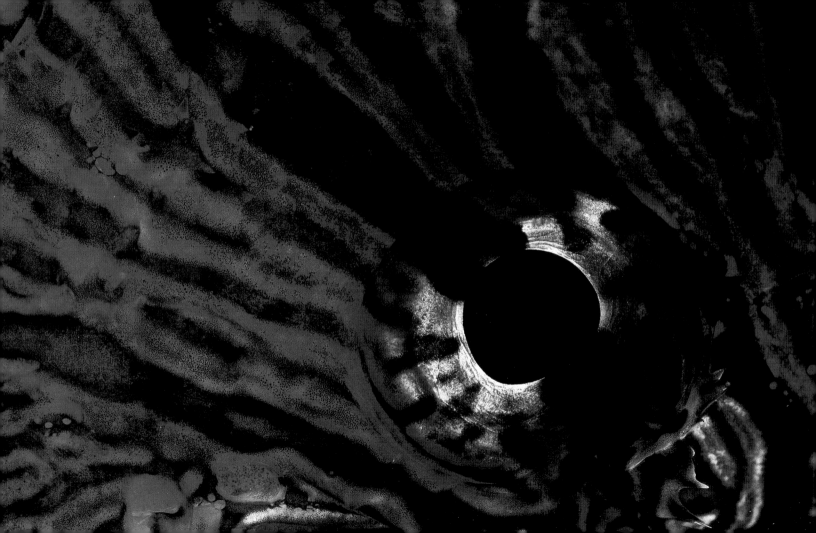

Reduce your impact on global warming and you'll be saving our coral reefs.

In the last few decades, more than 35 million acres of coral reefs have been destroyed. Twenty-five percent of all marine life finds shelter in coral reefs. Because of climate changes and the resulting increase in the temperature of the ocean, the algae that inhabit the reefs and provide the reefs with both energy and color are leaving the coral. This process is called "coral bleaching."

Next time you are on vacation on a tropical beach, look upon the wonders of the reef through different eyes. Connect the reefs to your everyday actions back at home, and decide to leave your car in the garage as often as possible.

Coral reef, Australia

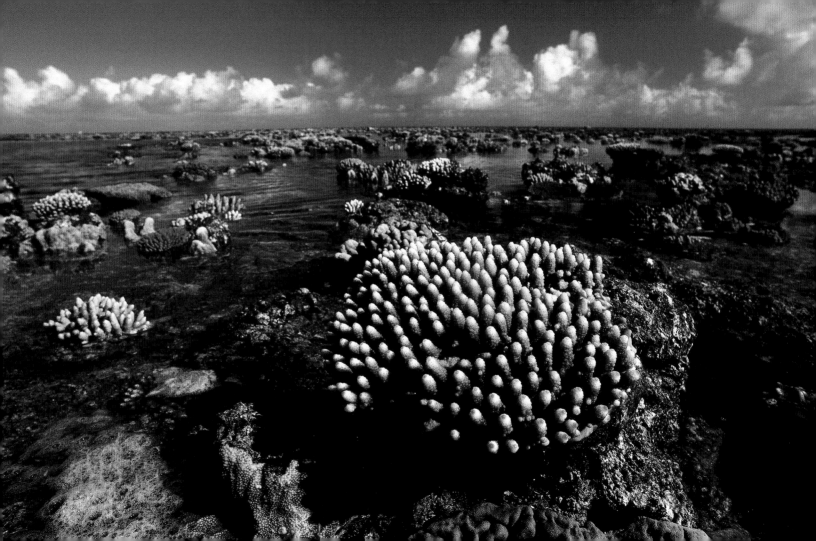

Buy refillable products.

One-third of the waste generated in the United States is packaging. Every year Americans use enough plastic film to shrink-wrap the state of Texas. By definition packaging is disposable—you open the package, remove the product, and discard the container.

Reducing packaging enables raw materials to be saved, pollution to be reduced, and needless transportation to be avoided. To cut the volume of packaging that is thrown out after just one use choose refillable products—soap, liquid detergent containers, coffee cans, rechargeable batteries, pens, and so forth.

Ol Doinyo Lengai volcano, Tanzania

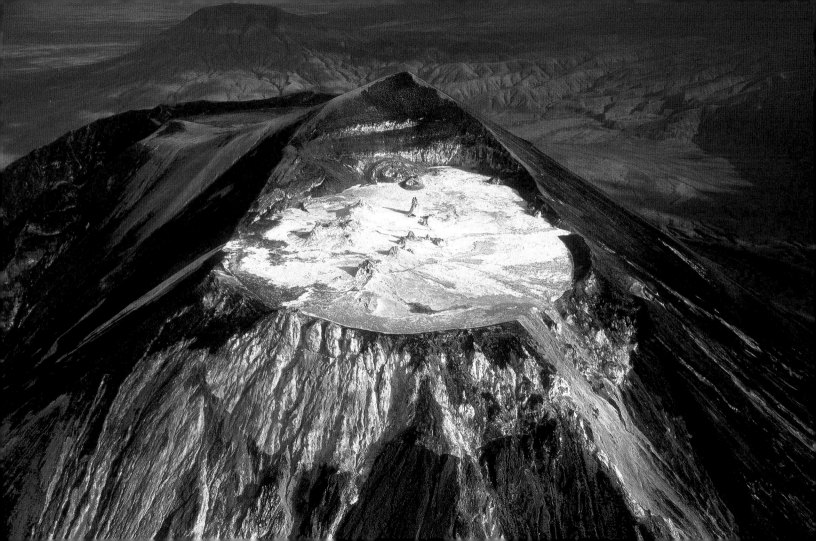

Invest in a reusable filter for your coffeemaker.

In 2001, the United States produced more than 229 million tons of garbage, or municipal solid waste, which is nearly 4.5 pounds of trash per person per day. Compare this to the average in 1960: 2.7 pounds per day.

———

If you use disposable paper filters in your coffee machine, replace them with a reusable filter made of cloth or stainless steel. The washable, reusable option is also cheaper. Add the coffee grounds to your compost pile, instead of to the volume of waste.

Maple, United States

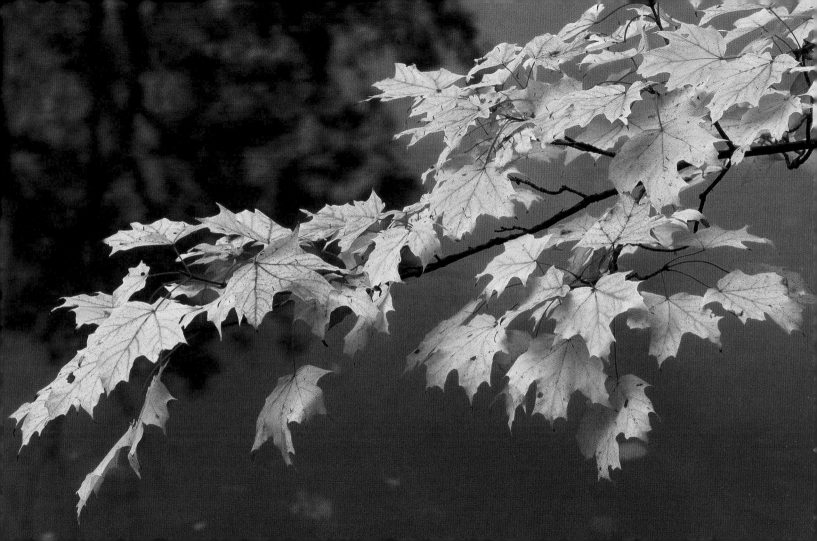

Say "no" to disposable diapers.

Disposable diapers are made from paper pulp, plastic, and absorbent chemicals. Their manufacture requires 3.5 times as much energy, 8 times as much nonrenewable raw material, and 90 times as much renewable raw material as washable diapers. It also produces twice as much wastewater. In all, disposable diapers are responsible for 60 times as much waste as washable diapers, and by volume account for 4% of all waste. Every child produces more than a ton of dirty diapers, as landfill sites rapidly reach capacity.

Using washable diapers daily for your child not only benefits the environment—you may be able to save more than $3,000, depending on how you choose to diaper your baby.

Altiplano, Bolivia

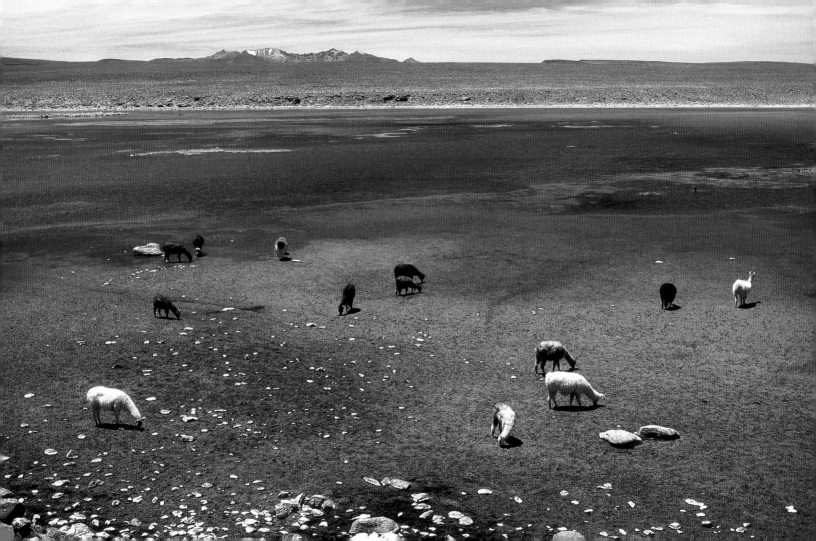

Computers: a new environmental problem.

Over the past 25 years, we have witnessed the birth and proliferation of the personal computer. The lifespan of PCs is absurdly short, and they are out-of-date almost as soon as they are out of the box. A recent U.S. study estimates that over 315 million computers became obsolete over the last 4 years. This represents more than 1 billion pounds of lead, 4 billion pounds of plastic, and hundreds of millions of pounds of other materials.

Although computers use relatively little energy when they are in use, the combination of intensive manufacturing process and short lifespan put its lifetime environment-related energy impact about equal to a refrigerator, which is near the top of the list of energy-intensive home appliances. Use your computer for as long as possible, and when you finally get rid of it, donate or recycle it to keep it out of the waste stream.

Mudflats, Alaska

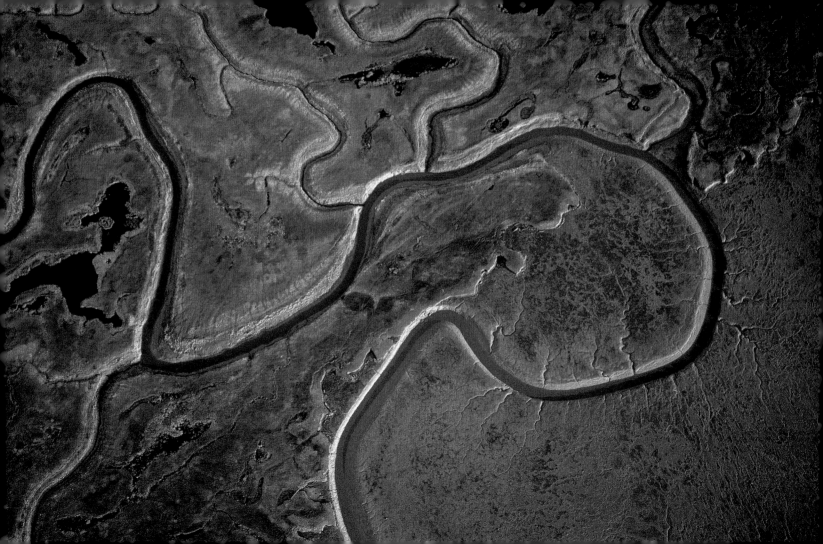

When traveling, eat local food.

One study of loss of tourism revenue in Thailand estimated that 70% of the money spent by tourists eventually left the country through hotel chains, tour operators, airlines, and the import of foods and drinks. To counteract this tendency, it is best to choose small, local hotels, local transport, and services that earn money for local people, such as guides, cooks, mule-drivers, porters, and domestic servants.

When you are thousands of miles from home, do not search frantically in strange shops for the food you usually eat at home. Those tasteless apples that traveled halfway around the planet, producing pollution in the process, will never be as good as the local mangos. Try local specialties, fruits, and vegetables, and discover new dishes in the process.

Great Smoky Mountains, United States

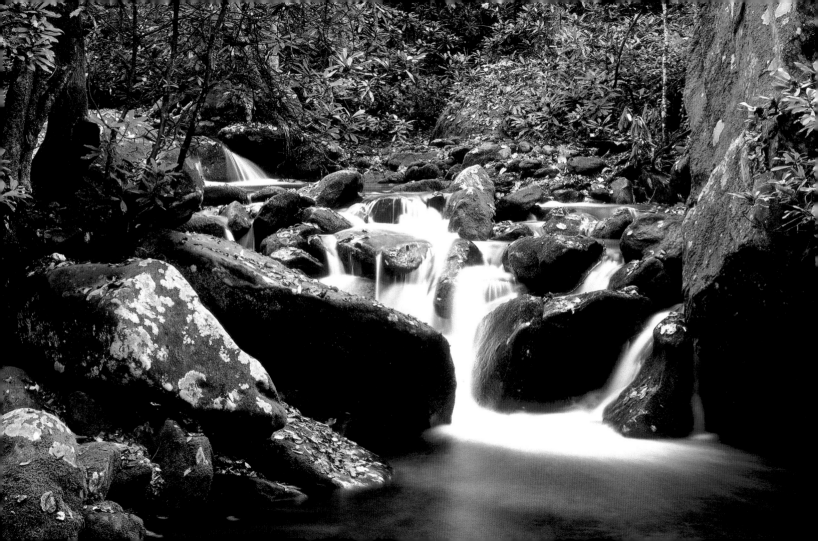

Sport fishermen: respect the sea.

Worldwide, the depletion of the oceans' fish stocks is due to over-fishing on an international scale, among other things. The fish that are caught are ever smaller; they have not reached maturity or been able to reproduce, and thus are not able to perpetuate their species and replenish stocks. Do not make this mistake when you go fishing for pleasure.

Observe the size limit for fish, crustaceans, and shellfish. You can find out which species are covered by restrictions by asking your tourist office, the port authority, or the marine and fisheries department. Make sure you tell your fellow fishermen, if necessary. And do not catch more than you need.

Shark, Australia

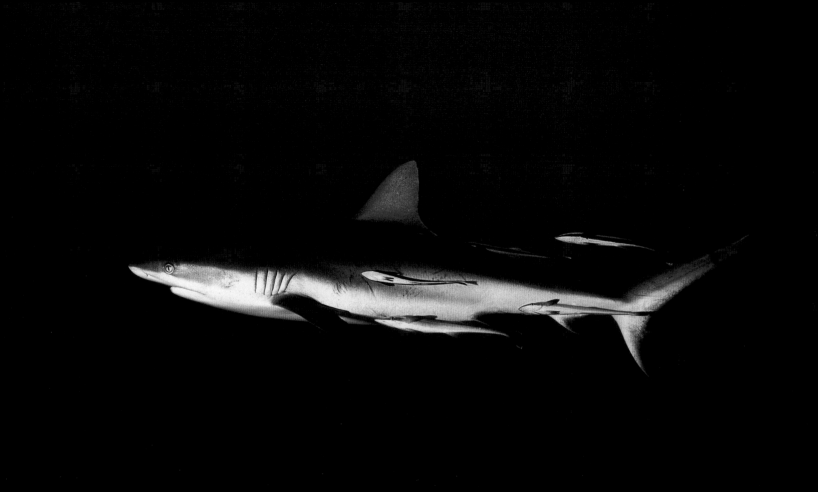

Consider using rechargeable batteries.

The manufacture of a battery uses 50 times as much energy as the battery itself will produce during its life. The only exception is rechargeable batteries. A personal stereo battery lasts six days; if you use a rechargeable battery, it can last up to four years. Like disposable batteries, some rechargeable ones contain cadmium, but since they can be recharged between 400 and 1,000 times, their impact on the environment is considerably reduced (if they are properly disposed of at the end of their life).

To reduce the ecological impact of batteries, choose those that contain neither mercury nor cadmium; better still, choose rechargeable batteries. The upfront expense of these and their charger is soon recovered: their lifetime cost is 3% of the comparable amount of disposable battery power.

Mudflats, United States

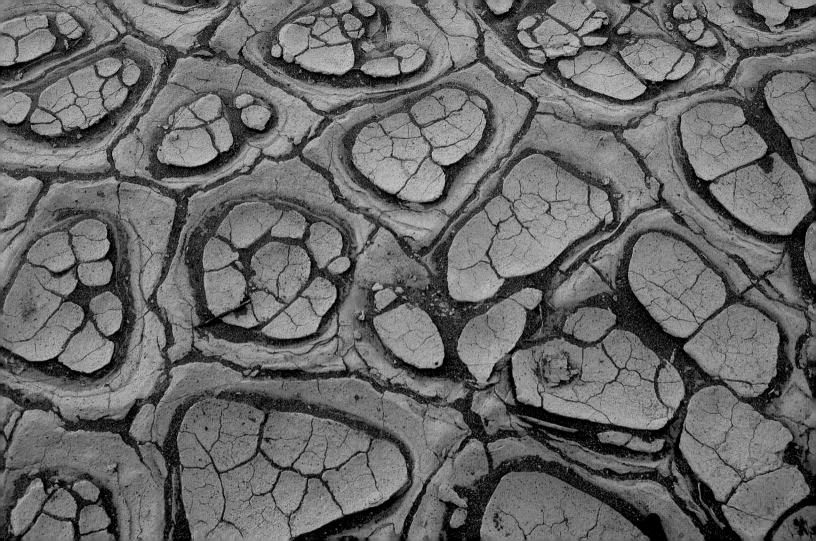

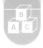

Take your children to school on foot.

Although there are 800 million vehicles on the planet today (10 times as many as in 1950), 80% of the world's inhabitants possess no car and travel by bus, bicycle, horse-drawn cart, or on foot. In contrast to this, for the first time in history, the average American household now owns more cars than it has drivers. Cars already produce a fifth of carbon-dioxide emissions, and their numbers will increase considerably over the coming decades to meet growing demand in developing countries.

Instead of taking your children to school by car, send them by public transportation or school bus, or accompany them on foot, or by bike.

Bristlecone pine, United States

Replace paper and plastic cups with regular cups and glasses.

For the last 20 years our way of living has demanded too much of the Earth, which can no longer absorb the pressure humanity is placing upon it. Human use of biological resources exceeded the earth's natural capacity by 20% in 2000. This figure is expected to rise to between 80% and 120% in 2050.

Many workplaces provide plastic cups for water and coffee. These are in our hands just a few minutes before they become waste. To stop wasting several plastic cups per day, take your own cup to work and urge your colleagues to do the same. Saving the cost of the disposable cups will also reflect favorably on the company's bottom line.

Yellowstone National Park, United States

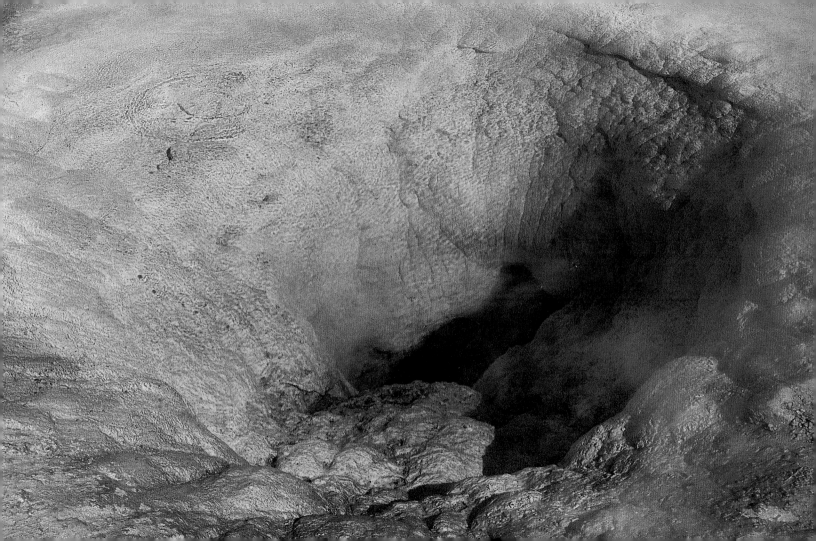

Control the temperature in your home.

Home heating is a huge energy drain, but it doesn't take much to regulate the temperature according to each room's use, the outside temperature, and the times when you are not there.

————————

Install a digital thermostat system that will allow you to set the heating as you desire, room by room, according to the time of day or night and use up to 25% less energy than if your heating were not so regulated.

Inlandsis, Greenland

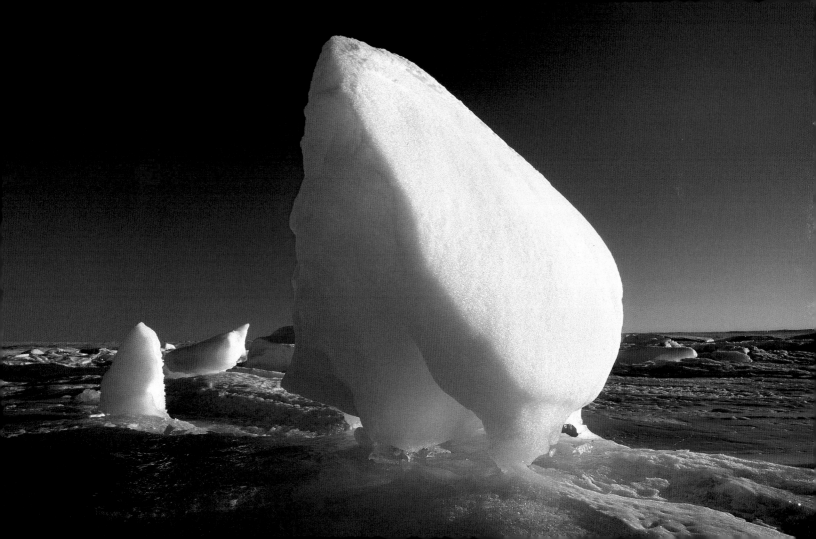

Pick up one piece of garbage every day.

Landfill remains the main method of waste disposal worldwide. In the United States, 220 million tons of garbage end up as landfill each year. Decomposing trash in landfill sites produces a third of the methane emissions that contribute to global warming. Apart from their foul smell, landfill sites also contaminate water because not all landfills are equipped with modern barriers to prevent pollutants from spreading.

Even our everyday surroundings are not free of trash. If each of us bent down once a day to pick up a piece of trash, we would remove 290 million pieces of garbage from the streets and sidewalks every day.

Prairie, Mount Rainier, United States

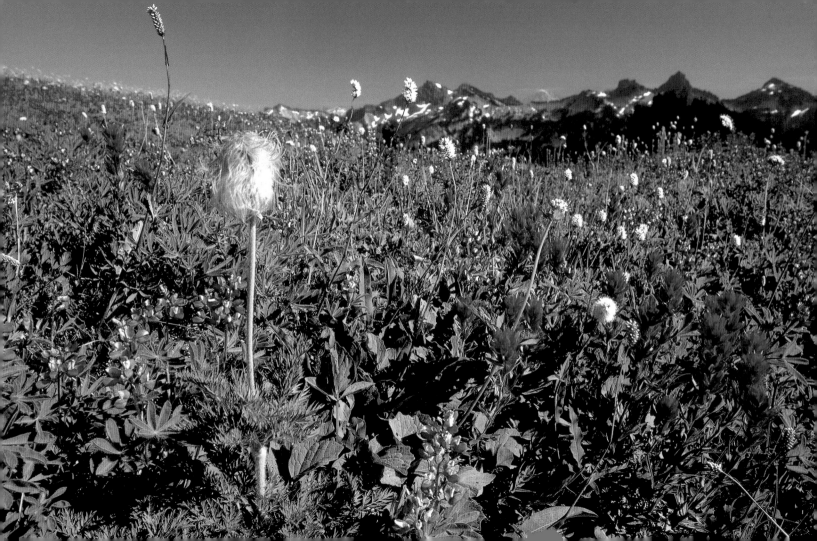

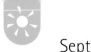

Follow the rules in protected areas.

About 34,000 plant species throughout the world, or a quarter of the total species of flora on the planet, face extinction in the coming years. Nearly 600 plant species in the United States are listed as endangered; 388 animal species are considered endangered. The United States Fish and Wildlife Service has also prescribed habitat conservation plans for 480 areas, where measures have been taken to minimize the impact on habitats, restore ecosystems, and sometimes relocate plants and animals.

Observe the instructions displayed at the entrances to parks—they are there for a reason. You will not disturb the wildlife if you keep your dog on a leash, and by following the marked trails you can avoid accidentally stepping on protected plants.

Pink flamingoes, Kenya

Soundproof your floors to avoid disturbing the neighbors.

A recent British research paper found that 21% of people questioned felt their home lives were disrupted by noise. Twice as many respondents were irritated by road noise.

Carpeting is the best way to soundproof the floor in your apartment. If you have a tiled or hardwood floor, consider putting blocks under the feet of furniture, placing electrical appliances on shock-absorbing pads to reduce the vibrations transmitted through the floor, and putting down rugs to dampen the sound of footsteps.

Crater Lake, United States

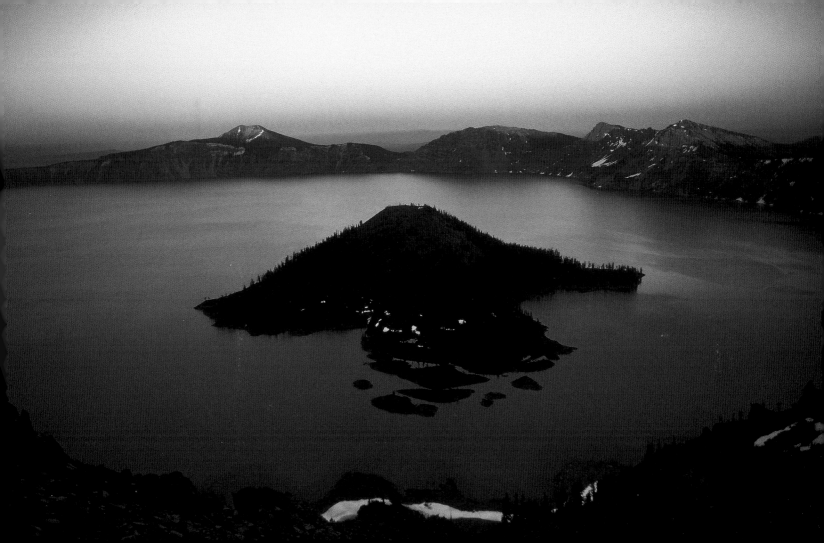

Borrow or lend your power tools.

Power tools are necessary for solid, reliable craftsmanship, but homeowners often invest in these tools without considering how often they may use them. How many hours a year will you use an electric drill? What about the power saw, the high-pressure heat gun, the concrete mixer, and the carpet shampoo machine? Our closets and garages are cluttered with equipment and tools that we use very rarely, if at all.

Rather than investing in new tools, try another approach. Why not borrow them from a neighbor or family member, or buy them together and take turns using them? Consider starting a tool-sharing program in the neighborhood. Learn your neighbor's needs and interests. It's a great way to build community.

Detail of tree bark, United States

Try sharing a car.

Carbon dioxide is one of the main greenhouse-causing gases responsible for the warming of the earth. Before the industrial revolution, carbon-dioxide levels held stable at around 280 parts per million (PPM). Levels have increased steadily over the past century and measured 360 PPM in the 1990s, and in the past decade they have risen by 20 PPM. The world is getting hotter, very quickly. The proliferation of automobiles has a lot to do with it.

In several metropolitan areas around the country, car-sharing programs have gained a lot of popularity over the last few years. A magnetic card gives you access to a fleet of vehicles that can be picked up at various points in the city; you pay according to how long you use them and how far you travel. Someone else worries about the maintenance and other costs—you just get in and go!

Red ibises, Venezuela

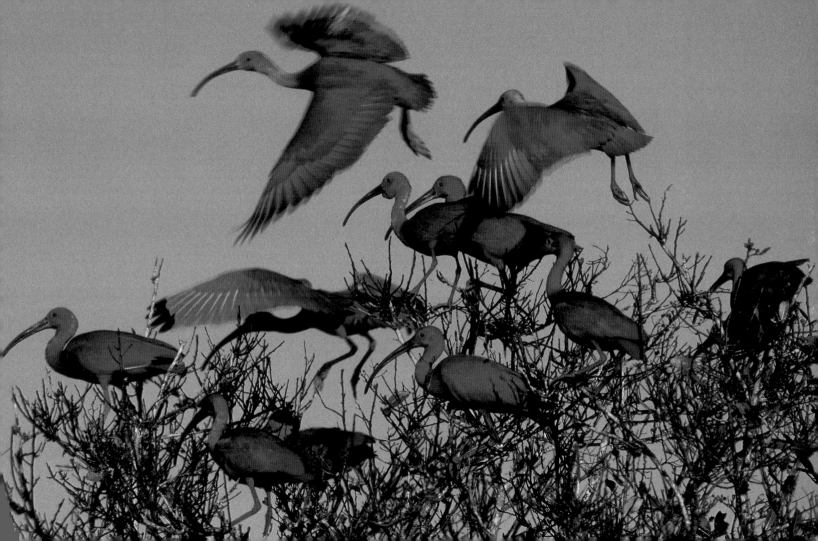

Replace meat protein with protein from vegetable sources.

The world's greatest tropical forest, the majestic Amazon rainforest, is retreating hourly before the onslaught of chainsaws that have already cut down 15% of its original area. Over the last 30 years, 40% of the cleared Amazon rainforest land has been converted to pasture for beef grazing. In Brazil, home to the largest area of the Amazon rainforest, the export of beef benefits a minority of the local population, while a quarter of that population lives in poverty on less than $1 a day.

The frequent consumption of meat in wealthy nations is a recent phenomenon, even though it has been shown to be harmful to health by increasing the risk of heart attack and obesity. Replace meat with vegetable protein, such as soy, beans, and peas. Cooked soybeans are the best source of vegetable protein and a delicious snack when boiled and salted.

Close-up of sandstone, Chad

Do not use chemicals near water.

A garden is like a miniature field; even on this very small scale, it is essential not to contribute to water and soil pollution by using too many chemicals. Sixty-seven million pounds of lawn pesticides are used in American gardens every year. Homeowners have been found to be much worse about application of pesticides than other users. They apply 3.2 to 9.8 pounds of lawn pesticides per acre; agricultural land generally receives 2.7 pounds of pesticides per acre.

———

Do not use fertilizers, pesticides, or herbicides if you are near water, such as a well, stream, pool, or marsh. After each application, these products soak into the soil, sometimes permanently polluting aquifers.

Emperor penguins, Antarctica

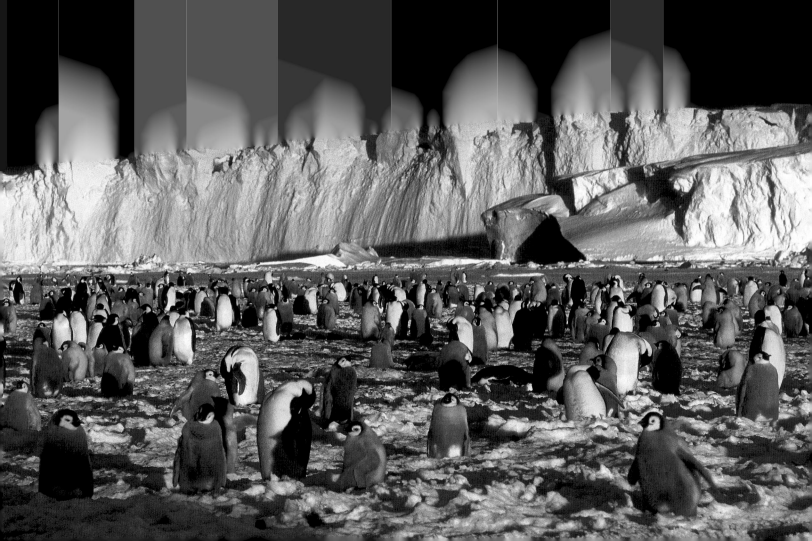

Adopt a pet from your local animal shelter.

According to the American Society for the Prevention of Cruelty to Animals (ASPCA), each year millions of dogs enter shelters, yet of the approximately 59 million dogs owned in this country, less than one-fifth are adopted from shelters. By adopting a dog or cat from a shelter, you're giving a homeless pet a new chance at life.

Read up on the ASPCA's guidelines for adopting a pet. If you decide that you and your family are ready to make this commitment, don't spend money needlessly in a pet shop, thus encouraging even more pets to be raised. Find your next family member at the local animal shelter, instead.

Bear track, Russia

Choose the right light bulbs.

Energy-saving measures need not be constraining or austere. They can involve minute changes in our surroundings.

To make your lighting more environmentally friendly, take a look at your bulbs. The powerful light of a 100-watt bulb does not suit a bedroom or a bright room. Watch your halogen lamp: it consumes as much energy as two washing machines over a year. Redirect your wall lights or general lighting that chiefly plays on the ceiling. For your garage, consider neon lights, which are as energy-efficient as compact fluorescent light bulbs. And if you are planning to do some painting, remember that light-colored walls make the best use of light, and require less artificial lighting.

Dunes, Libya

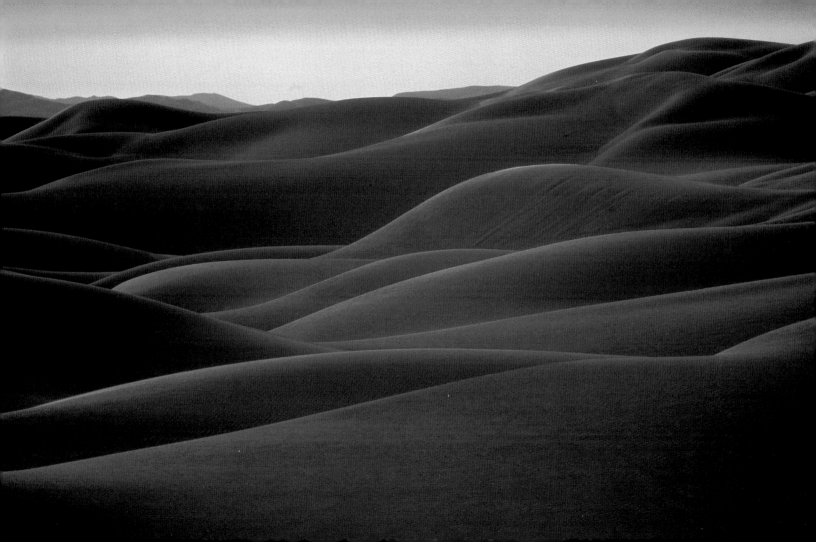

Refuse to accept paper telephone directories.

Every year, telephone companies automatically distribute paper telephone directories in several volumes. In 2001, telephone directories were recycled only 15% of the time. While recycling these is much better than throwing them away, it is even better not to accept them to begin with—remember, putting something in the recycling bin, while better than the garbage can, always results in the use of some kind resource to get the recycling done.

How many times have you looked in your telephone directories this year? If you do not use them, refuse to accept one. Use the Internet to look up phone numbers instead. The Web is also good for finding maps or looking up foreign numbers.

Niger river, Mali

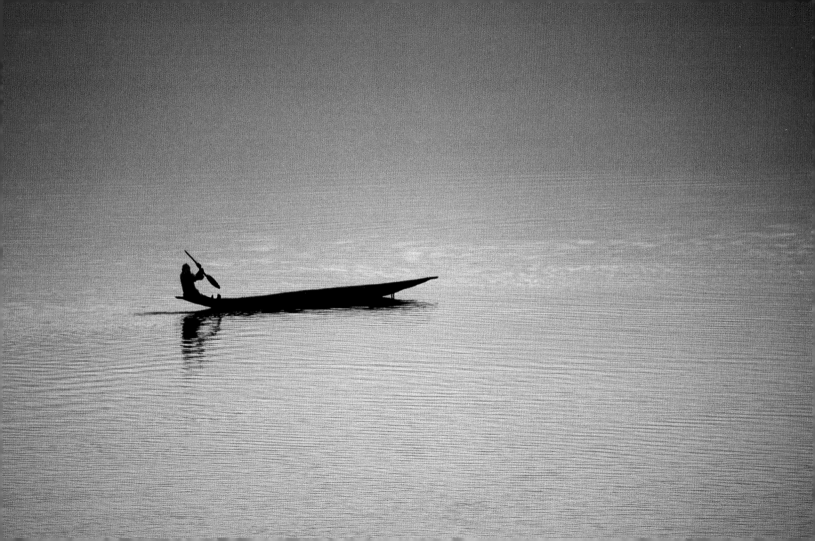

Introduce environmental education to schools.

Many local environmental nonprofits or natural reserves offer free or low-cost education presentations or field trips for school-aged children—often it is simply a matter of asking. They usually focus on environmental problems facing your area, or tours of the natural features it has to offer.

If you would like environmental education to have a higher priority in your children's education, spend some time investigating the organizations that offer educational resources. It is a good way to increase awareness among students, teachers, and other parents.

Puffin, Round Island, Alaska

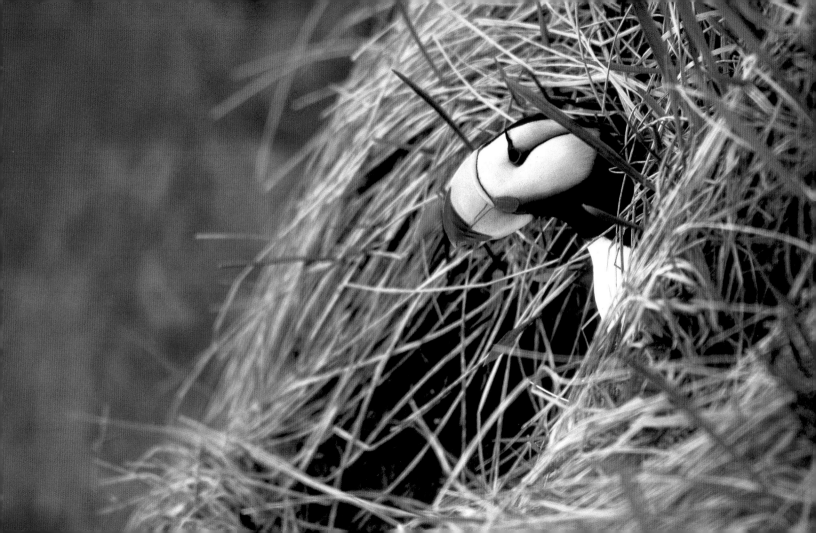

Plant a tree.

Eight thousand years ago, when human beings settled and began to grow crops, half the planet's land mass was covered in thick forest. Today, less than a third is still forested. Worldwide, over the last 10 years, forest cover has been reduced by 2.4%. In order to live, all plants on the planet release oxygen and absorb carbon dioxide. Two acres of mature forest absorb the equivalent of the carbon emissions from 100 mid-sized cars over a period of a year.

———————————

Plant a tree: you will be joining the fight against global warming and the atmospheric pollution caused by carbon dioxide emissions.

Lassen National Park, United States

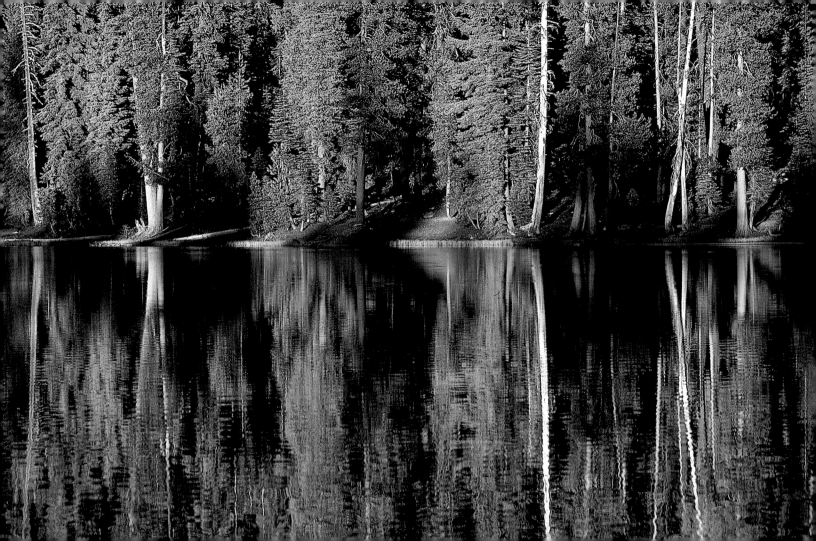

Use white vinegar to remove limescale.

Heavy metals (the mercury in batteries, or the lead in gasoline) and oil-based pollutants (especially plastic in its innumerable forms) are among the most harmful of products. When they enter water, air, and soil, they contaminate the entire food chain up to and including human beings at the top of the chain. In the United States and Europe, testicular cancer rates have tripled over half a century, and 1 woman in 8 now develops breast cancer, as compared to 1 in 20 in 1960.

Chemical compounds are widespread in farming, as well as in the household cleaners that have invaded our homes. In some cases they are unnecessary. To remove limescale from tiles, taps, kettles, and irons, just use white vinegar.

Crater Lake National Park, United States

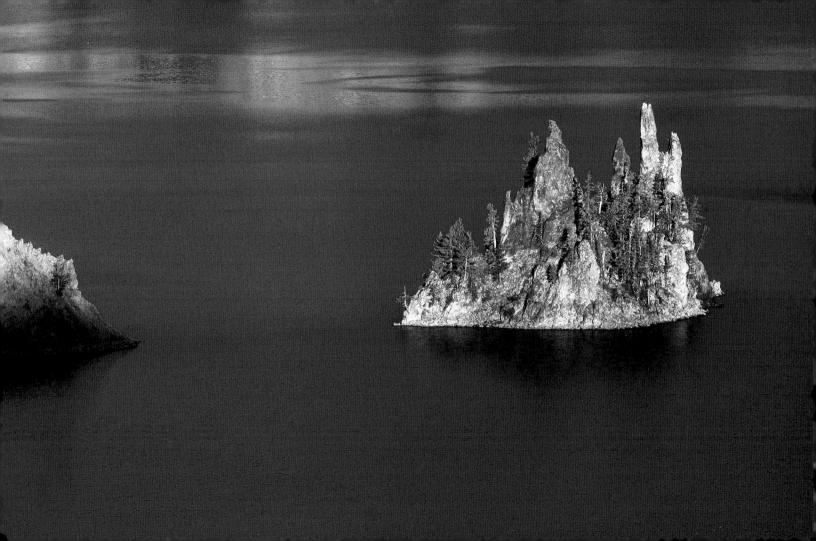

Smart growth is about smart choices.

Wild places are constantly vanishing in the face of human development. Today, the main cause of disappearing forest in the United States is the growth of suburban areas. In the last two decades, there has been close to a 50% increase in the forested and non-forested land that has been lost to development. The development of natural habitats is the greatest cause of loss of biodiversity in the world.

Smart growth is not just about how we develop land, but also about where people demand to live. Live as close to your place of work as possible. Commit to public transportation alternatives and rediscover the vibrant, urban neighborhood where you live and work.

Autumn, Canada

September 20

Choose sustainable school supplies.

The return to school in the fall provides an opportunity to choose sustainable items for your children. More than half of a family's substantial budget for school supplies at the beginning of the school year consists of paper products.

Choose pencil sharpeners and rulers in metal or wood (neither colored nor varnished). These will last longer and produce less pollution than their plastic equivalents. Choose a solar-powered calculator rather than a battery-powered one. Buy an assortment of folders and notebooks made from recycled paper. Above all, sift through last year's stationery supplies and reuse as much as possible to avoid buying the same reusable product again. Encourage your child to trade supplies with friends to foster an ethic of reuse.

Um el Ma lake, Libya

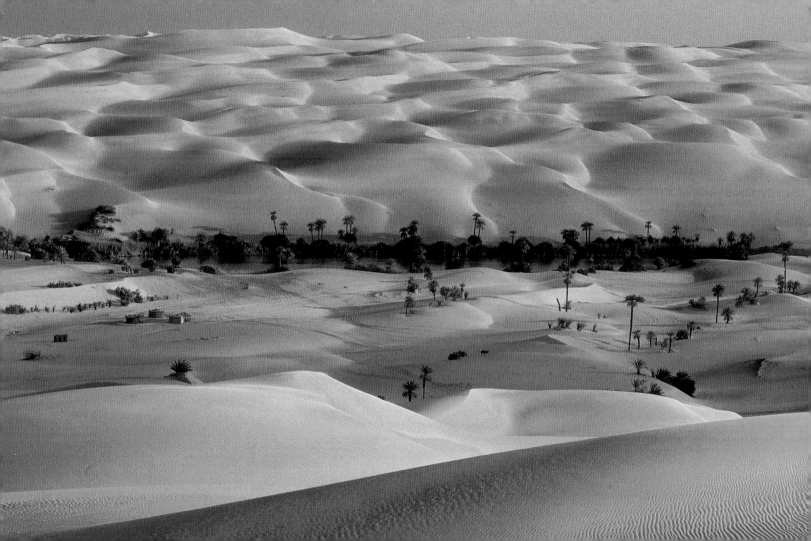

Avoid washing at too high a temperature.

If we reduce the energy used in the home for lighting, heating, cooking, and so forth, we can reduce energy demand. Less electricity needs to be produced by power stations, which in turn leads to a reduction in atmospheric pollution.

Wherever we look, energy savings are possible. Washing and rinsing your clothes on the cold-water cycle connected to a gas-powered water heater will cost you just $.40 a cycle in energy use. The same machine set to a hot wash with a warm rinse will cost at least four times as much per load.

Adélie penguins in a blizzard, Antarctica

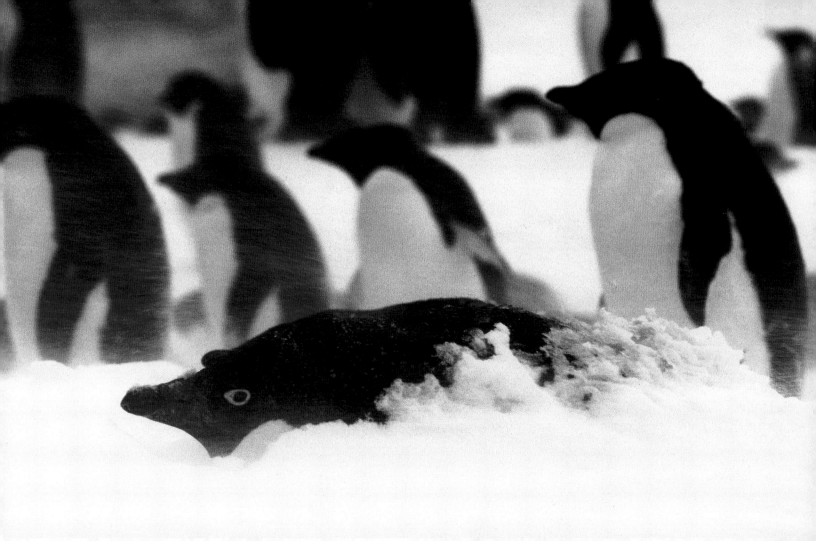

Drive smoothly.

Today the world burns as much oil in 6 weeks as it did over the course of a year in 1950. Oil reserves are running out and, at current rates of consumption, will be exhausted in about 50 years. Transportation alone accounts for half the world's oil consumption.

You can help to preserve the planet's reserves. In cities, take care to avoid accelerating and braking too hard and too frequently. This manner of aggressive driving increases fuel consumption by 40%, which means spending money needlessly and aggravating urban air pollution.

Silversword, Hawaii

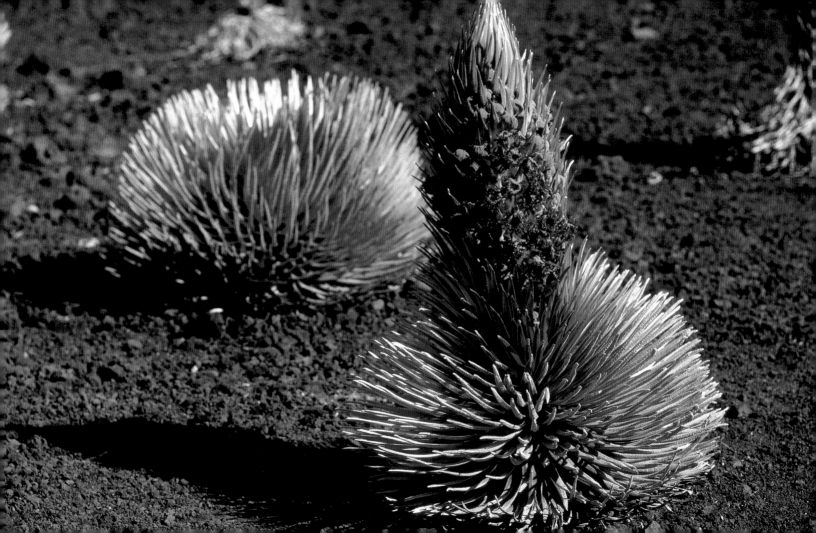

Choose household appliances that use less water.

Water use increases as wealth increases. Greater purchasing power encourages household comforts and water use increases. Affluence also encourages people to buy more goods, goods that use water in their production. More water is required, for example, for the production of paper than for any other material. Metal and steel works alone account for 20% of the water used in industry.

If you are planning to replace your household washing appliances, allow your choice to be guided by the amount of water they use. Efficient dishwashers can use about 5 gallons of water per load—half the volume used by conventional dishwashers.

Barracudas, Australia

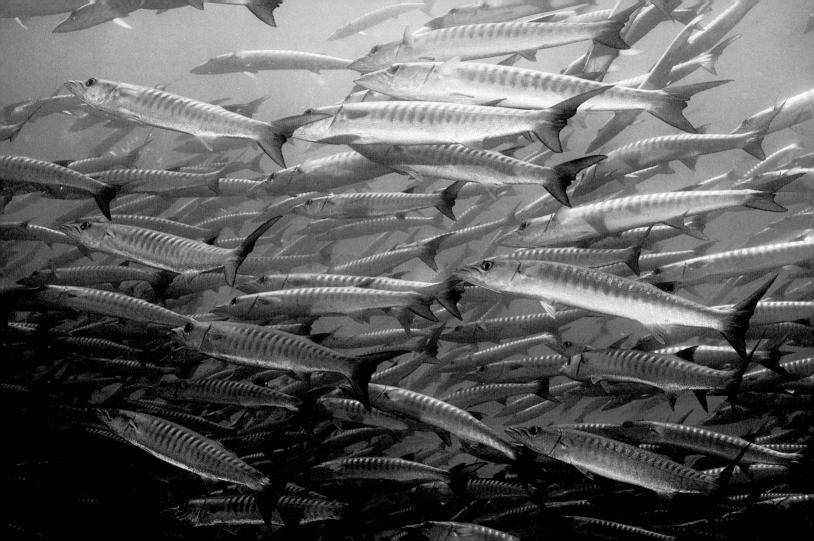

Recycle plastic.

Most plastic bottles today are made of PET (polyethylene terephthalate), which is easy to recycle. The PET symbol, which is marked on the bottom of plastic containers, consists of a triangle of arrows surrounding the number 1. Plastic packaging that has been sorted and recycled is reborn as fleece garments, tubes, watering cans, flower pots, floor coverings, water bottles, carpets, car parts, phone cards, and more. Every ton of recycled PET saves an energy equivalent of 11 barrels of oil.

At home, in the office, or when traveling, be sure to recycle plastic beverage bottles. Encourage your office to start a recycling program if it doesn't have one. Recycling a single plastic bottle saves enough energy to keep a 60-watt bulb lit for 6 hours.

Mount Pinatubo, Philippines

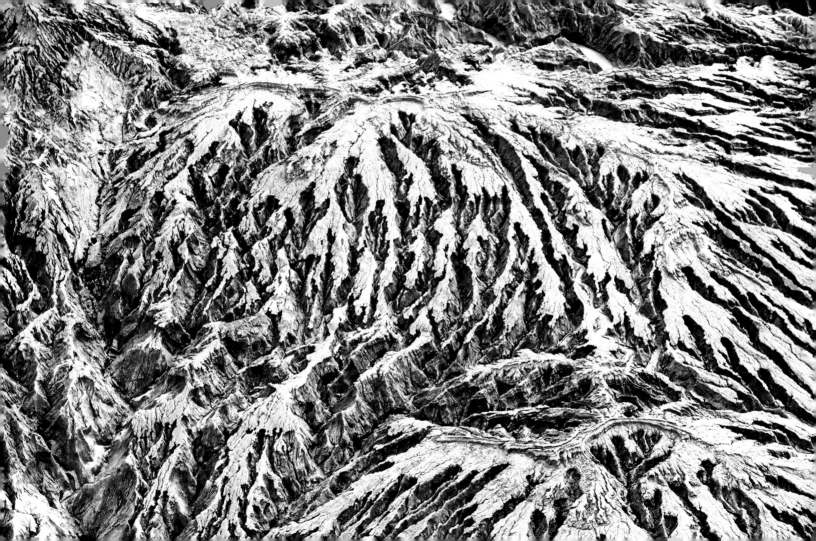

Influence your condominium association.

In our day-to-day social lives, we regularly take part in groups whose decisions may have a strong impact on the environment. Meetings of condominium associations are an example.

————————

Every measure that is voted on can contribute to preserving the planet's natural resources, limiting pollution, and reducing water use. In meetings, speak out in defense of environmental measures, such as environmentally friendly heating, sorting of waste, low-consumption lighting in common areas, creation of green spaces or shared gardens, maintenance of the plumbing system. And help your fellow members to become aware of these issues.

Wreck, Mexico

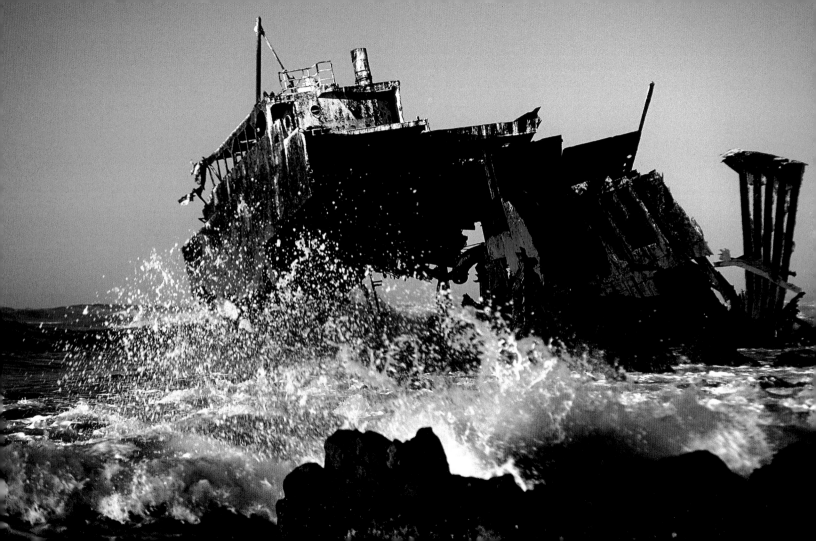

Ask your local fish dealer about the fish he offers.

Over the last 50 years or so, the world's fishing industry has undergone a real revolution: giant nets, factory ships, infallible radar, a vast increase in the fleet, and fishing agreements covering distant regions (often those off poor countries, for which the income from these agreements is essential). The result is that today 90 million tons of fish are caught every year, as against 20 million tons in 1950. By 2010, based on projected population growth, demand for fish could rise to 120 million tons a year. This is extremely worrysome, given that the level of fishing is already too high for stocks to recover naturally: 11 of the world's great fishing regions are being progressively depleted.

Ask your fish dealer where his stock comes from, and about the problem of over-fishing.

Crabs, Galápagos Islands

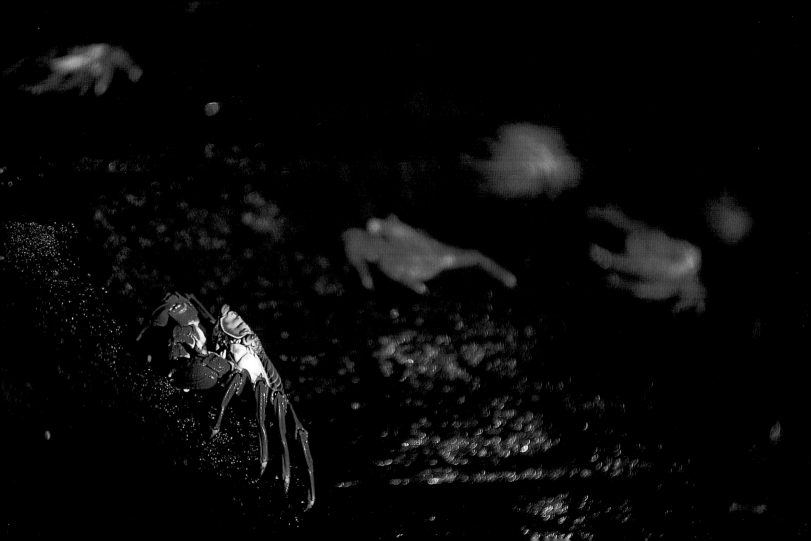

Use your vote.

Voting is the best way to make your hopes and needs known. Our power as citizens includes the election of people who represent us, and whose job it is, in theory, to set an example. Find out the environmental policies of all the political parties, and vote accordingly. It is both simple and essential.

————————

Do not forget that you also cast votes several times each day by what you buy, and by your choices as a consumer. These choices influence, sometimes even more than elections do, means of production and the way the economy is organized, and they contribute to the way in which society develops.

Moose, Alaska

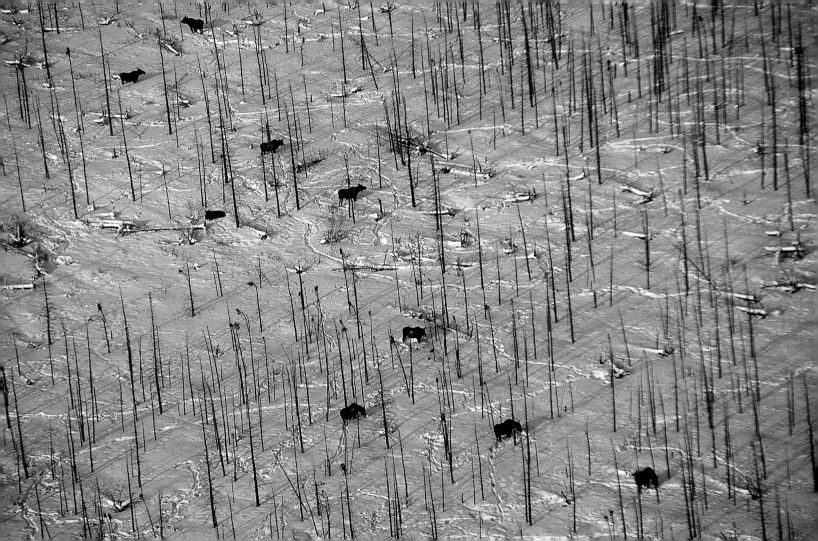

Recycle magazines and newspapers.

Each year, America uses over 85 million tons of paper. Of this, 19 million tons are recycled, when in fact, about 46 million tons of the remaining paper could be recycled. Those 46 million tons could save 782 million trees.

Do not contribute to this cycle: recycle used paper and cardboard. It will be used to make new paper and cardboard, as well as egg cartons, packaging, tissues, paper napkins and tablecloths, and toilet paper. As for your recently bought catalogues and magazines, before putting them in the recycling, offer them to the waiting room of your local laundromat, dentist or hairdresser, where they will be read again and again.

Maui island, Hawaii

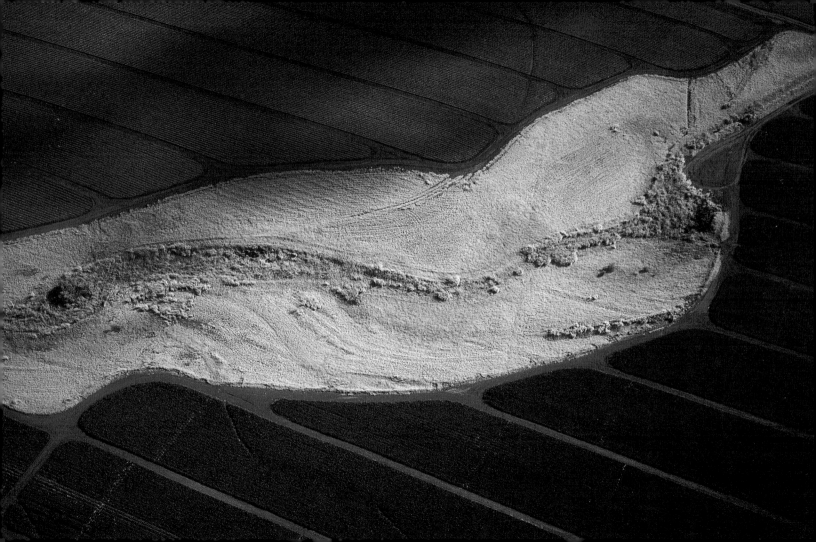

Evaluate your eco-labels and buy accordingly.

By choosing products that bear a meaningful eco-label, consumers preserve the environment and encourage manufacturers to manufacture even more environmentally friendly products. Eco-labels are useful only if an independent organization certifies the product. Make sure the labels you buy most frequently are consistent and clear, and that the certifying organization is clearly visible on the label.

Don't be a lazy consumer. Study product labels and do your homework! Both you and the environment will be rewarded.

Kap Farvel region, Greenland

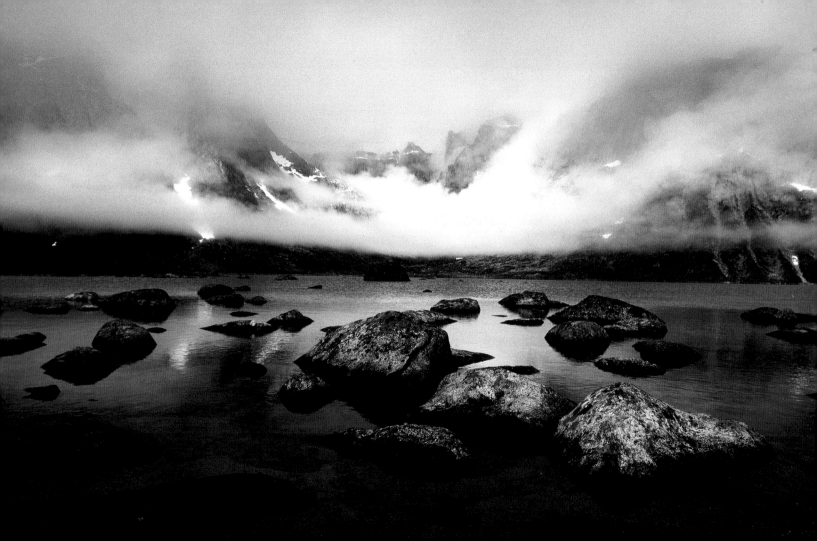

Switch off the iron when there is just one garment left to do.

Renewable energy resources are beginning to grow although it remains just a fraction of the entire energy market. Solar power technologies have matured greatly since they first entered the market. Solar technologies now offer photovoltaic systems (electricity directly from sunlight), solar hot water systems, electricity produced by the sun's heat, passive solar heating and lighting, and solar technologies for commercial spaces.

All the small habitual changes we make to our energy consumption collectively will make a difference to the planet. At home, unplug the iron when only one or two garments remain to be ironed: residual heat will be enough to do the job.

Tassili du Hoggar, Algeria

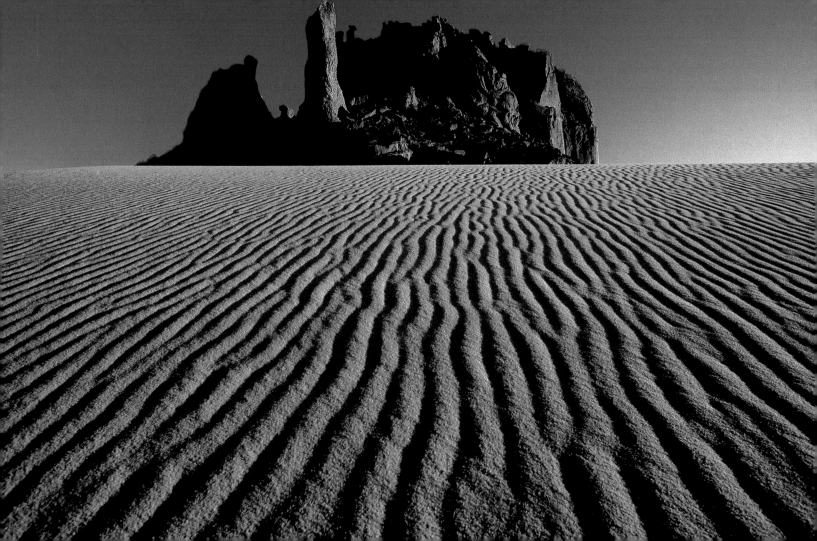

Have your windows fitted with double-glazed panes.

Most air pollution comes from road transport (nitrogen dioxide and carbon monoxide), industry (sulfur dioxide, which produces acid rain), and domestic heating (carbon monoxide). These can damage human health (by causing breathing problems, migraines, and lesions) as well as the environment. Some of these polluting gases contribute to increasing the greenhouse effect.

To reduce your consumption of energy for heating and the polluting emissions thus produced, consider fitting windows with double-glazed panes, which insulates against heat loss (and against noise). For a minimal up-front cost, you can fit window film to your panes. And remember to close the curtains at night.

Thaw, Greenland

Consider car-sharing programs.

If we do not succeed in curbing the climate change that our actions and lifestyle are causing, tomorrow's climate will be different. Various signs of this can be observed already. Since 1989 Mount Kilimanjaro has lost a third of its snow and the mountain could be completely devoid of snow within 15 years. The spring ice thaw in the Northern Hemisphere happens 9 days earlier than it did 150 years ago, and the first freeze of autumn happens 10 days later. These facts have intense effects on bird migration and crop production.

In cities, more than 80% of cars carry just one person, and almost a third of all fuel is burned standing still in traffic. Consider car sharing with your neighbors or coworkers: you will reduce fuel consumption and wear on your car, you will take up less road space, and you will help combat global warming.

Close-up of sandstone, Chad

Reject junk mail to reduce the volume of waste.

We are producing ever-greater quantities of waste. Our letterboxes are clogged with catalogues and advertising: 4 million tons of junk mail is received by American households each year. This mail, 40% of which is unread, goes directly to swell the volume of household waste, and thus the cost of collecting and treating it.

—————

When dealing with a company or an organization that knows your address, always tell them to keep your address private. This will prevent them from selling it to other organizations. Contact the Direct Marketing Association, and declare that you do not want unsolicited mail from their member companies.

Fjord, southern Greenland

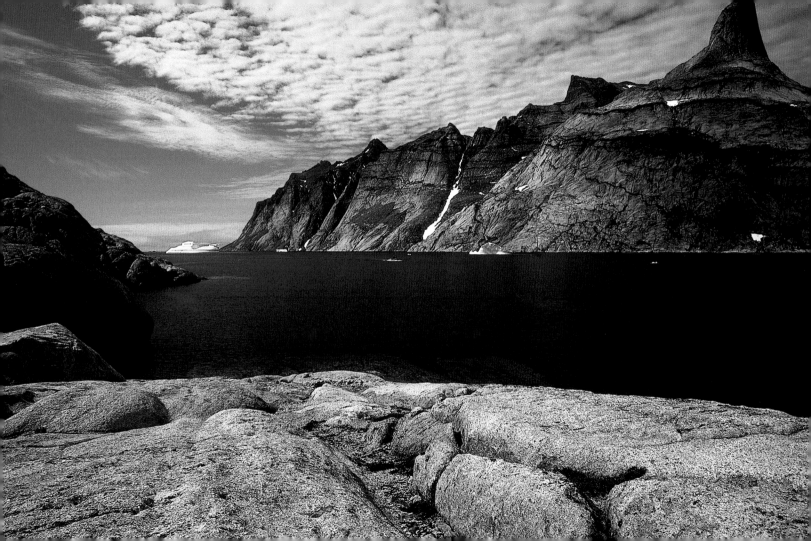

Report any unusual pollution.

About 2,500 species of fish, shellfish, and other sea life are commercially exploited worldwide. Over-fishing by a well-equipped, and excessively large, world fleet is considerably reducing fish populations' capacity to replenish themselves, and pollution of the sea is making the problem worse. Over-fishing and pollution could have severe effects on world food supplies, especially in developing countries, where 1 billion people depend on fish for food.

If you notice an instance of freshwater pollution, such as froth, a brown trail, or the smell of sewage, alert your regional or town water authority. If you notice pollution, such as waste or oil, while at the beach, notify a city or town official at once.

Scorpion fish, Australia

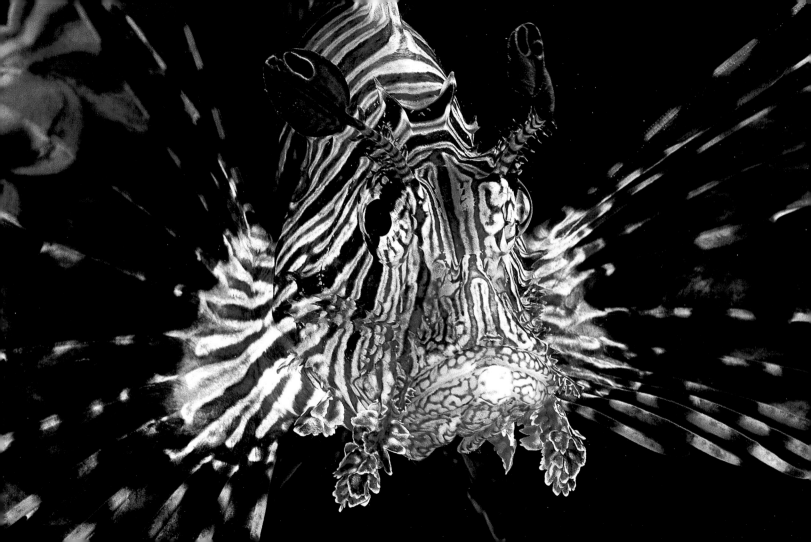

Buy recycled paper.

Recycling paper, while important, is only one part of the lifecycle of paper. We must also look at consumption of paper. Recycled paper products are widely available, and are considerably less damaging to the environment in production. Producing a ton of virgin paper requires 3,688 pounds of wood, 24,000 gallons of water, 216 pounds of lime, 360 pounds of salt cake, and 76 pounds of soda ash. Eighty-four pounds of air pollutants, 36 pounds of water pollutants, and 176 pounds of solid waste are then treated and thrown out. The EPA has found that making paper from recycled materials results in 74% less air pollution and 35% less water pollution. This means that every ton of recycled paper keeps almost 60 pounds of pollutants out of the atmosphere.

—————————

Choose paper, box files, folders, envelopes, cards, toilet paper, and paper towels made from recycled paper and cardboard.

Northern forest, Finland

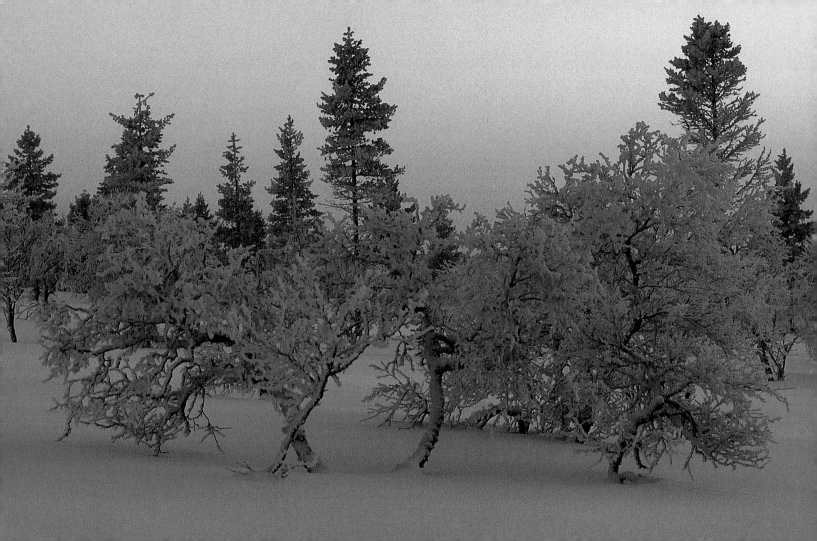

Do not use aerosol air fresheners.

Chlorofluorocarbons (CFCs), which first appeared in the 1930s, have been used chiefly in refrigerators, aerosol canisters, and fire extinguishers. They are now known to be responsible for about 80% of the damage to the ozone layer, the layer in the atmosphere that protects us from the sun's damaging ultraviolet rays. One molecule of CFC can destroy up to 100,000 ozone molecules, and the concentration of CFCs in the atmosphere has risen fivefold since the 1970s.

Even without considering CFCs, air fresheners in aerosol cans are toxic, flammable, and produce waste. Replace them with potpourris, essential oil diffusers, candles, incense, fragrant plants (for example, citronella or honeysuckle), citrus fruit peels, or oranges studded with cloves.

Krakatau volcano, Indonesia

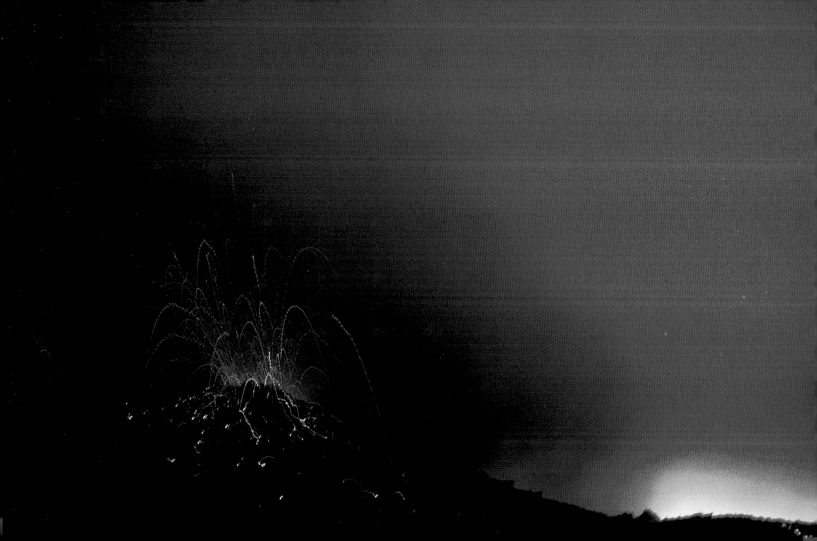

Support the requirements of the Basel Convention.

The Basel Convention standard, which came into effect in 1992, provides an effective legal framework for controlling and reducing cross-border movements of dangerous waste. It was drawn up by 152 states and, in 2002, led to the issuing of a list of 12 chemical products declared to be persistent organic pollutants (POPs), whose manufacture and use are now prohibited. Among wood treatments, the most toxic, such as arsenic, are now banned, but those that have replaced them are not without dangers of their own.

The United States is the only developed country in the world that fails to control or prohibit toxic waste trade, and has not ratified the Basel Convention. Learn about the hazardous waste trade and what you can do to prevent it.

Humpbacked whale, Polynesia

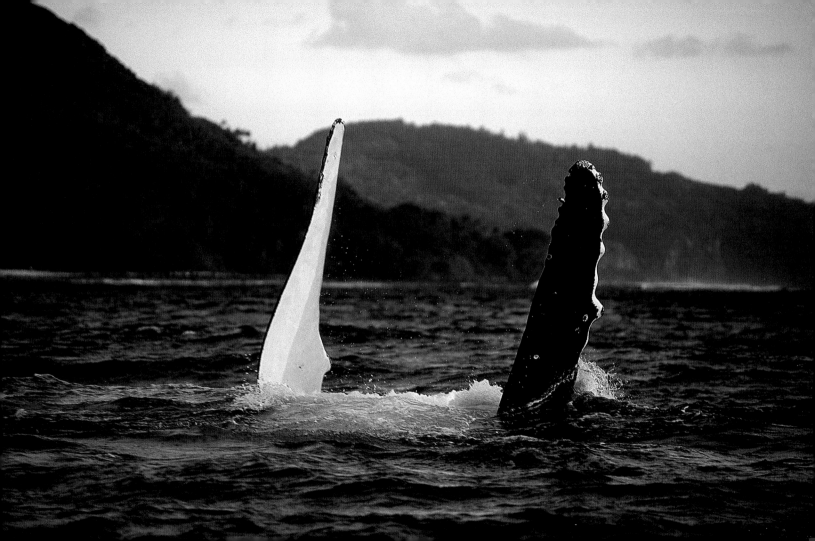

October 8

Use reusable shopping bags.

Each year, the United States uses 30 billion plastic shopping bags, which require 12 million barrels of oil for their manufacture. If dropped in nature, a plastic bag will last for 200 years. If incinerated, they produce pollutants. In the sea, they prove fatal for crustaceans, which swallow them, mistaking them for jellyfish. And they are not biodegradable in the ocean. A single square mile of ocean may be contaminated by as many as 46,000 pieces of plastic.

Bring reusable bags when you visit the supermarket, and rediscover your trusty old shopping bags, baskets, and boxes. Keep bags on a hook by the front door so you can grab them on your way out to the store.

Mount Rainier National Park, United States

Find out what happens to your wastewater.

Water is the source of all life. We depend upon it completely. It is also the chief constituent of all living things: 65% of our bodies and 75% of our brains are water. It plays a crucial part in the economy, and allows the irrigation of cultivated land, the manufacture of industrial products, and the production of electricity. It provides superb leisure facilities. It is irreplaceable, and also guarantees hygiene, and the comfort of our day-to-day lives.

Once it is dirty, water vanishes down the drain. Where does it go? Find out where your wastewater goes, how your local treatment plant works, and what happens to the sediment it produces. Let your vision of water see beyond the drain's vanishing act.

End of glacier, Greenland

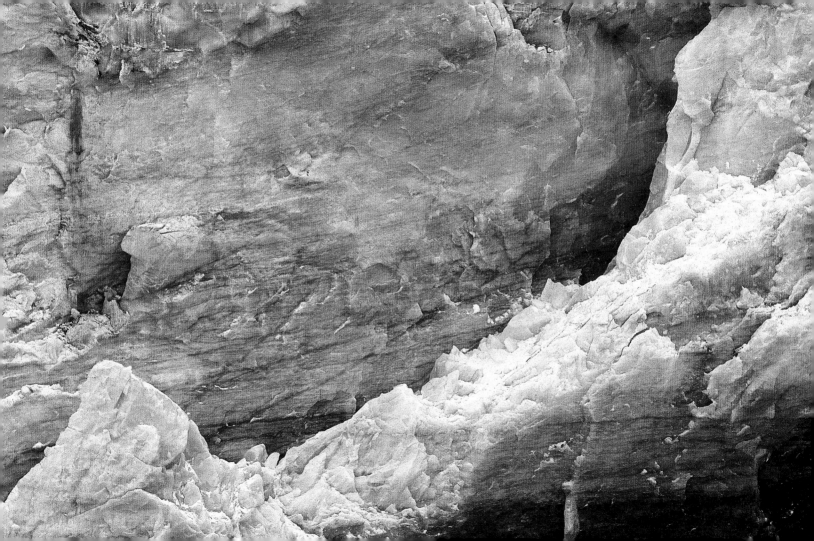

Say "no" to disposable diapers.

It takes 4.5 trees to produce the pulp needed for the 4,600 disposable diapers an average baby needs. A glassful of crude oil is needed to make the plastic found in a single disposable diaper. The diaper is worn only a few hours, but will take about 400 years to decompose in the waste dump. There has always been an alternative: washable diapers. Absorbent, effective, and comfortable, reusable modern diapers are very different from the old, folding variety. A single washable layer can be used for several years. When it is finally thrown out, it decomposes in six months, without producing any pollution.

Choose the economical, and ecological, diaper: cover your baby's bottom in a cloth diaper.

Forests in the Ruwenzori massif, Uganda

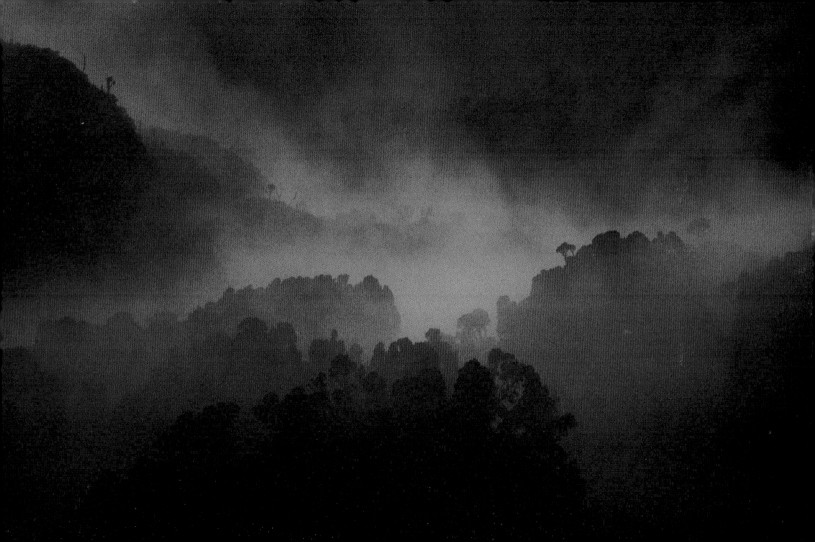

Invest in socially responsible companies.

One in five adults worldwide can neither read nor write. Of these, 98% are in developing countries, and two-thirds are women. In 2001 in Sub-Saharan Africa, almost 1 in every 10 people aged between 15 and 24 was infected with HIV, and 2.4 million people died of AIDS. In 1966, Indira Gandhi pointed out that the greatest source of pollution on earth was poverty. And yet 4% of the wealth accumulated by the 225 richest people in the world could educate, feed, and provide medical treatment for the entire population of the planet.

Reward companies that acknowledge that societal inequalities can be alleviated by their actions—invest in socially responsible companies.

Autumn, United States

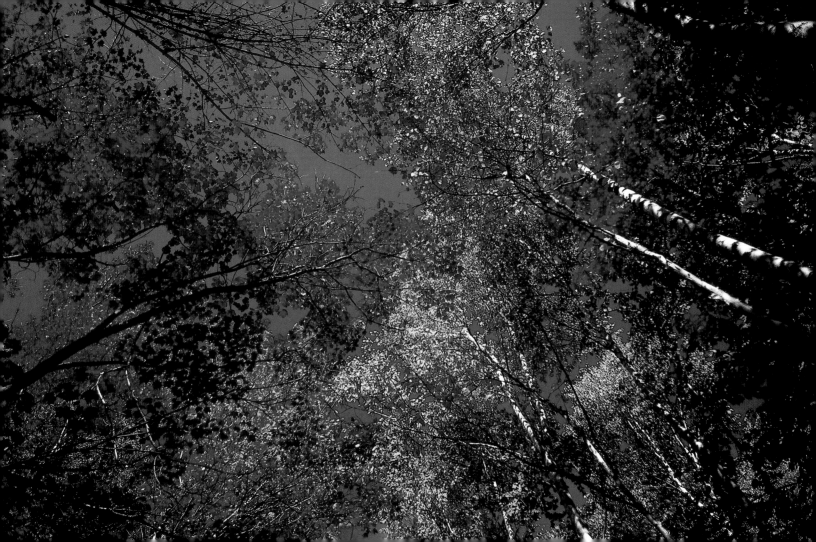

Use the sleeper timer.

Scientists say that in the coming years the habitats, natural resources, and species that make up life on earth will be able to adapt only to an average temperature increase of 1°F, and a 4-inch rise in sea levels. To remain within these limits, worldwide greenhouse gas emissions would have to be cut by 60% at once. This is impossible. The faster warming takes place, the more difficult it will be to control its consequences. Hence the need to act at once.

Televisions and stereos often have sleep timers, which allow the appliance to shut off after a given amount of time. If you normally fall asleep watching television or listening to music, use the timer to avoid wasting the energy of the appliance running all night.

Mount Adams volcano, United States

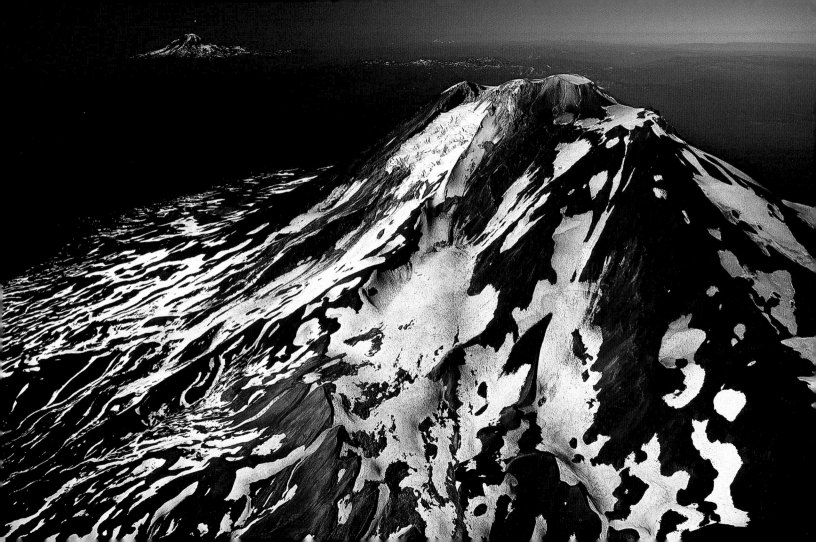

Print on both sides of the paper.

Human beings exploit forests to produce wood for industries, including construction, carpentry, and the manufacture of paper and cardboard. The paper industry uses 40% of commercially produced wood; however, 17% of the wood used to produce printing or writing paper comes from virgin forest that contains centuries-old trees.

———————————

Thanks to technological innovation, photocopier and fax machine manufacturers now offer machines that can handle all types of recycled paper, and print on both sides. Urge your employer to invest in these; the money saved on paper will be substantial.

Sponges, Australia

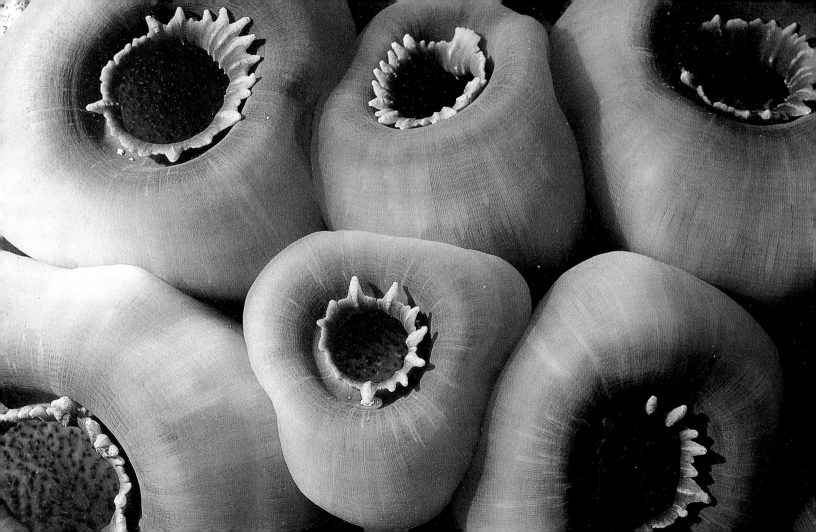

Recycle old tires.

An old tire, replaced by a new one, still has several centuries of life left in it: it takes 400 years for a tire dumped in a landfill site to start to decompose. In 2001, Americans discarded 281 million tires, weighing 5.68 million tons. These are a threat to the environment, because of the pollution their storage and disposal create. Alternatives exist, however; specialized companies can grind them up, melt them down, and convert them into material used by industry. These companies also incinerate tires, providing the same energy production as does coal incineration.

It takes seven gallons of crude oil to produce one new car tire. Buy your new tires from dealers who take part in tire collection programs and avoid those that do not.

Detail of tree trunk, United States

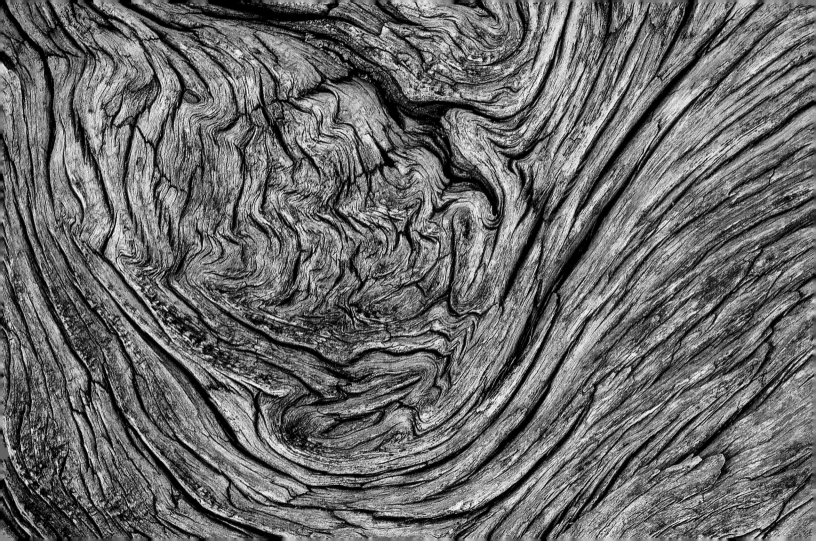

Eat fruits and vegetables in season.

How do grocery stores obtain fruits and vegetables out of season? Most produce is from specially grown crops (using soil-less cultivation or heated greenhouses) that use large amounts of water, energy, and raw materials or are from distant countries where the climate is more favorable. In the latter case, transporting this produce uses considerable amounts of energy (especially if the produce travels by air), increases pollution, and contributes to climate change. A meal from a conventional grocery store uses 4 to 17 times more oil for transport than the same meal using local ingredients.

Eat fruits and vegetables in season: they are better quality and healthier, and their cultivation has a minimum impact on the environment.

Pink flamingoes, Kenya

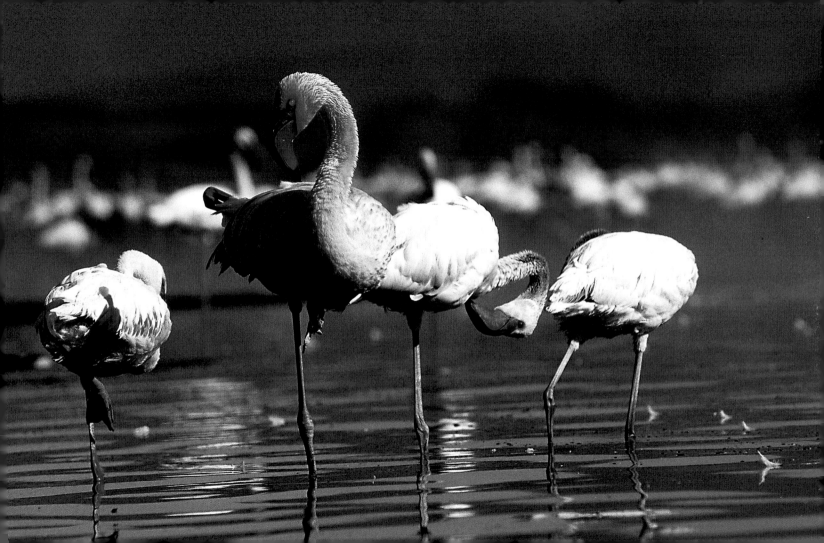

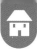

Have your home fitted with thermostatic valves.

Water is essential to the survival of all living things, making it all the more precious. If no wide-ranging action is taken, within 50 years about 3 billion people in the world will suffer from water shortages. Human beings can go without food for several weeks, but without water they die within 4 days. Access to fresh water has already become a vital issue of the twenty-first century.

To reduce water consumption, have your showers and taps fitted with thermostatic valves. These are expensive but they can enable water savings of up to 30%.

Death Valley National Park, United States

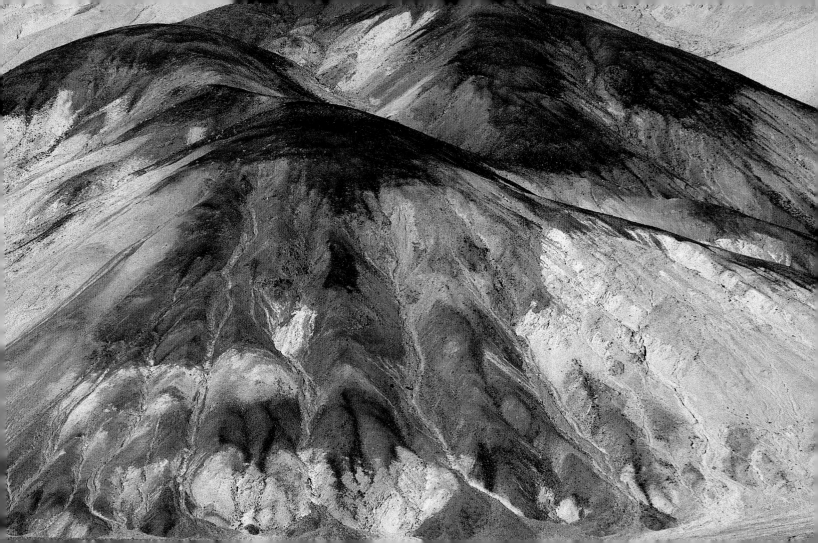

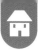

October 17

Take the time to think about life on this planet generations from now.

Every year, $800 billion is spent on arms worldwide. Almost none of the financial pledges made by the countries that signed the accords at the 1992 United Nations Conference on Environment and Development have been honored. By the middle of the century, the Earth will be home to 9 billion people: an additional 3 billion mouths to feed, all needing housing, heating, and light. All this while 800 million people still go hungry, 1.5 billion do not have clean drinking water, and 2 billion are without electricity. In 2050, if each inhabitant of developing countries uses as much energy as someone living in Japan did back in 1973, world energy consumption will be 4 times what it is today!

Other generations will live on the Earth after us. What are we going to leave for them?

Glacier National Park, United States

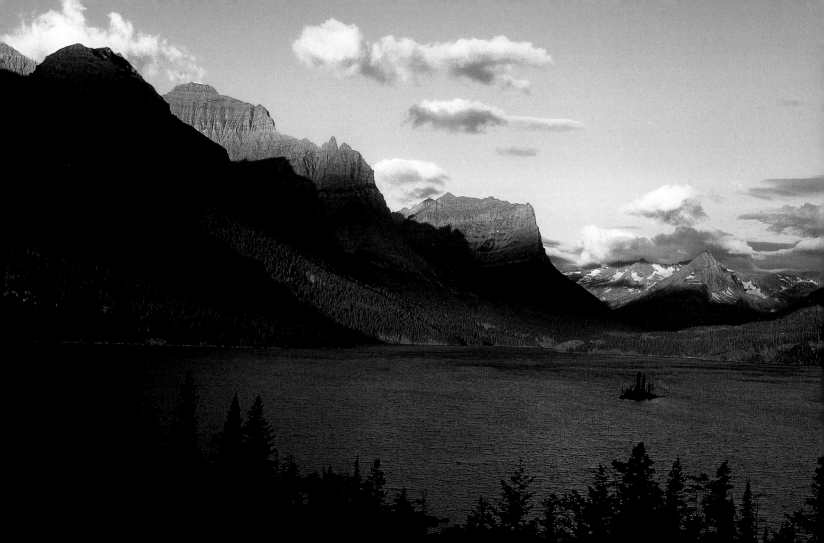

Recycle aluminum.

Aluminum is extracted from bauxite in the form of alumina. Open-cast bauxite mining causes defor-estation and destroys ecosystems. The conversion of alumina into aluminum also pollutes water and air, and consumes enormous amounts of energy. Producing recycled aluminum, however, saves 90% to 95% of the energy needed to produce new aluminum.

Take care to recycle your aluminum cans: they will reappear as aircraft and car parts, as well as new cans. The United States could rebuild its entire commercial airline fleet from all the aluminum cans discarded by Americans in one year.

Yellowstone National Park, United States

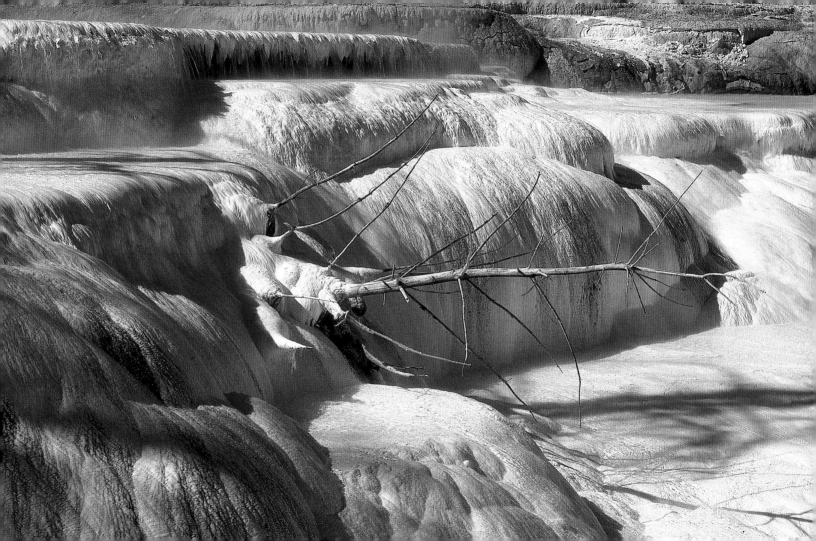

Invest in products and souvenirs that encourage sustainable living.

During the last century, whales, tigers, rhinoceros, and elephants reached the edge of extinction. Every day, several dozen species vanish from existence. Half the plant and animal species on earth may disappear before the end of the twenty-first century. Over-exploitation is one of the leading causes, because poaching—whether for meat, eggs, feathers, or skins—is very lucrative and is a strong temptation to people living in poor countries.

In developing countries, poaching often brings greater profits than respectable jobs in a sustainable industry. The best way to discourage poaching is to invest in products that have been developed sustainably, for a fair wage, in equitable conditions. It may take some extra research, but do some research on the country you are visiting and seek out sustainable cottage industries that employ native people. Then buy their wares.

Coyote, United States

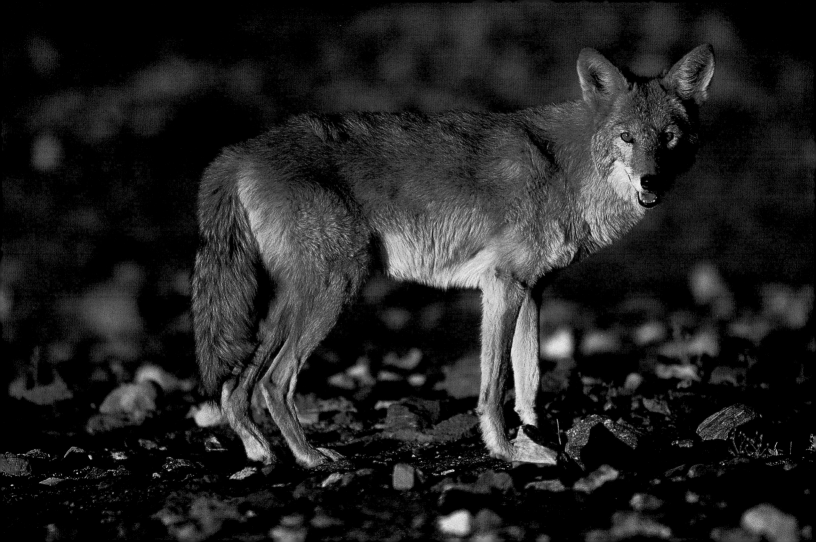

Find out about the decisions made by your local authorities.

Information is indispensable if we are to understand what is truly at stake in environmental issues, and properly assess how much room there is to maneuver. This information is needed before action is taken, and primarily concerns the projects planned in local areas and regions. Are these in keeping with sustainable development, respect for the environment, and a fair society?

Look for information and demand it! Circulate it, too, to break down the barriers between the different players—citizens, elected representatives, businesses, and other organizations—in the development process.

Mud spring, Kamchatka, Russia

Buy used, sell used.

In 2050 there will be almost 3 billion more people on earth than there are today. Many will be living in developing countries, and what will happen when the inhabitants of these countries want to live more comfortably, buy their own cars, and use more water or more electricity? The Earth's resources cannot be increased at will, and we don't have a spare planet at our disposal.

———————

Rediscover the joy of used goods, second-hand stores, and garage sales and bargaining to buy or sell used items.

Namib Desert, Namibia

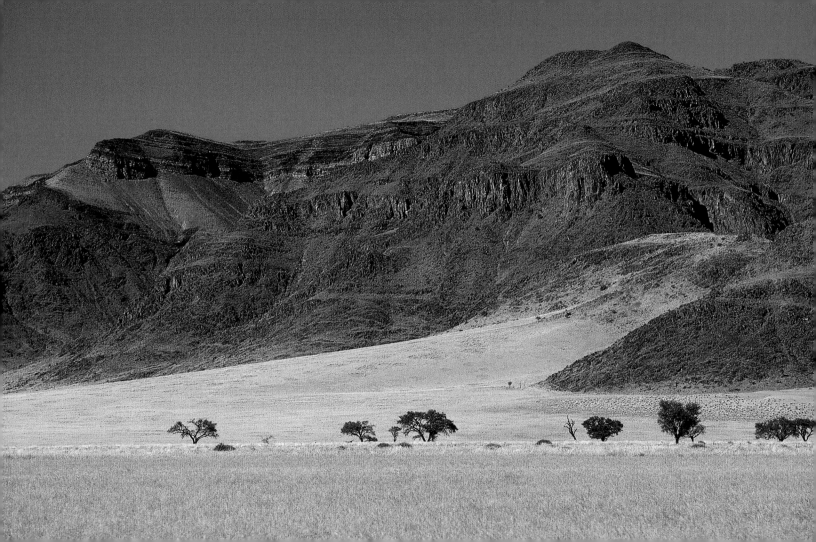

Replace disposable paper towels with washable ones.

Disposable products have been with us for several years. In our throwaway world, 90% of the materials used for the production of consumer goods and their containers enter the sanitation system less than six weeks after the product was sold. Do not encourage this waste of natural resources.

Are disposable paper towels used in the washroom at your place of work? Why not suggest that they be replaced by washable towels? If you work as part of a small team, you could take turns washing them at home, which will benefit both the company and the environment.

Tassili n'Adjer, Algeria

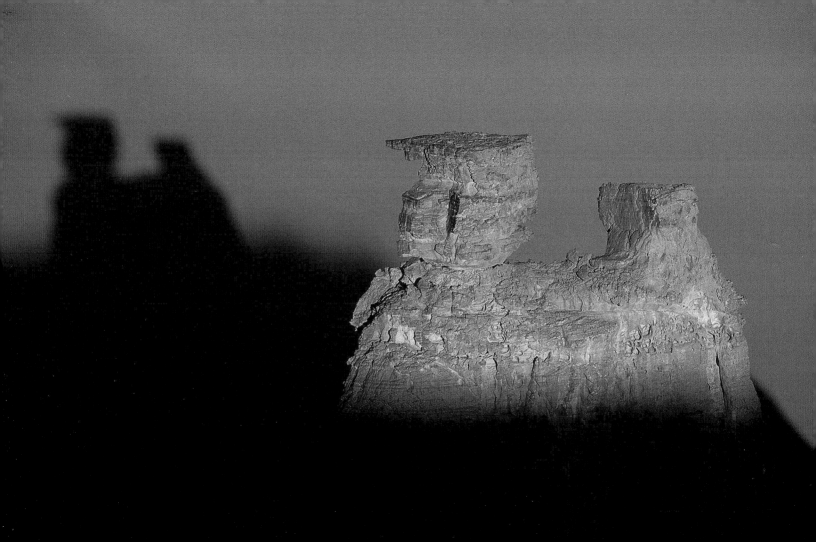

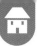

Do not use chemicals to unblock the toilet.

Chemicals affect our health—causing asthma, allergies, cancers, and reduced fertility—and the health of the environment. They disturb the reproduction of certain species, kill aquatic life, make wastewater even more difficult and expensive to treat, and pollute air and soil. Despite all this, human beings continue to come up with about 1,000 new substances every year, which are added to the 70,000 chemical products already on the market.

Most of the toxic chemicals used to unblock pipes contain lye or sulphuric acid. They are highly corrosive and extremely dangerous. Instead, use a mixture of boiling water, baking soda, and a plunger.

River, Iceland

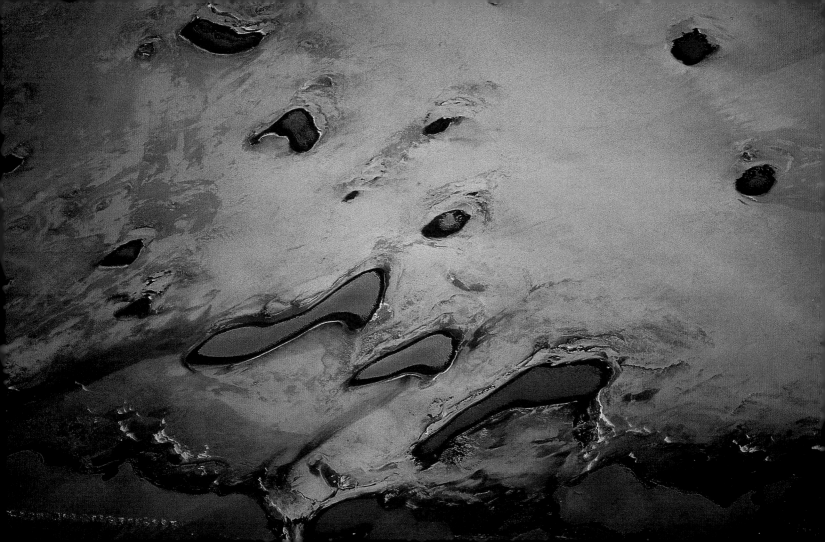

Write to store owners and manufacturers.

The owner of a store is your main point of contact regarding the social and ecological aspects of the goods on sale. Customers' demands, if repeated by enough people, always find their mark. Demand fair-trade products and products with ecological labeling, or goods with less packaging.

Write to the businessmen who own stores or manage industries to encourage them to take the environment into consideration when they design goods, and to favor the manufacture and distribution of environmentally friendly products.

Emperor penguins, Antarctica

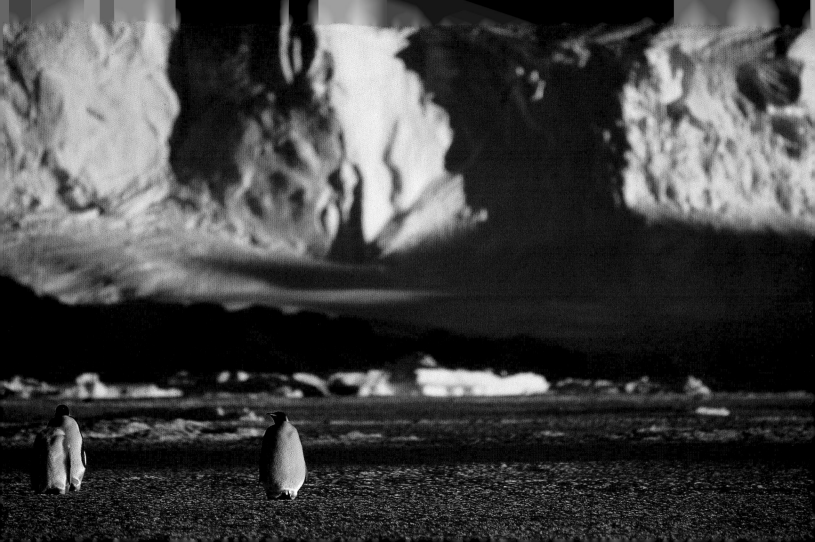

October 25

Learn where your paper products originate.

Eighty-five percent of the virgin forests in the United States have been logged, with losses closer to 98% in the lower 48 states. Longleaf pine growths, once dominant along the coast in the South, have been reduced by 98%. Only 20% of the world's ancient forests remain large enough to maintain their biodiversity.

Consider switching to alternative fibers for your paper products, including 100% post-consumer recycled paper, or paper made with agricultural residue. There are hundreds of alternative paper companies from which to choose.

Lava, Kilauea volcano, Hawaii

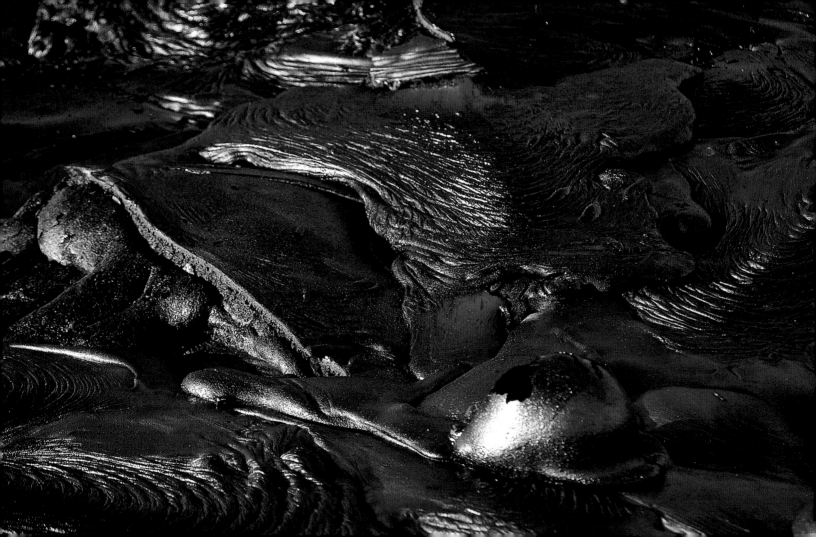

Discover the wetlands in your area.

Wetlands—the collective term for marshes, peat bogs, ponds, wet grasslands, and estuaries—account for 6% of the earth's land mass. They filter out pollution and purify the waters that are seeping toward rivers and underground reservoirs and at the same time act like sponges to guard against both flooding and drought. Despite this vital ecological role, they are constantly receding in the face of encroaching human activity: urban expansion, development along rivers and coasts, and agriculture. This is a heritage in danger: since 1900 half of the world's wetlands have disappeared.

Wetlands have long inspired our country's artists and writers and can be found in nearly every county and climatic zone in the United States. It is likely that wetlands exist in your city or town or quite close to it. Find out where the nearest wetlands are and visit them.

Geyser, Lake Bogoria, Kenya

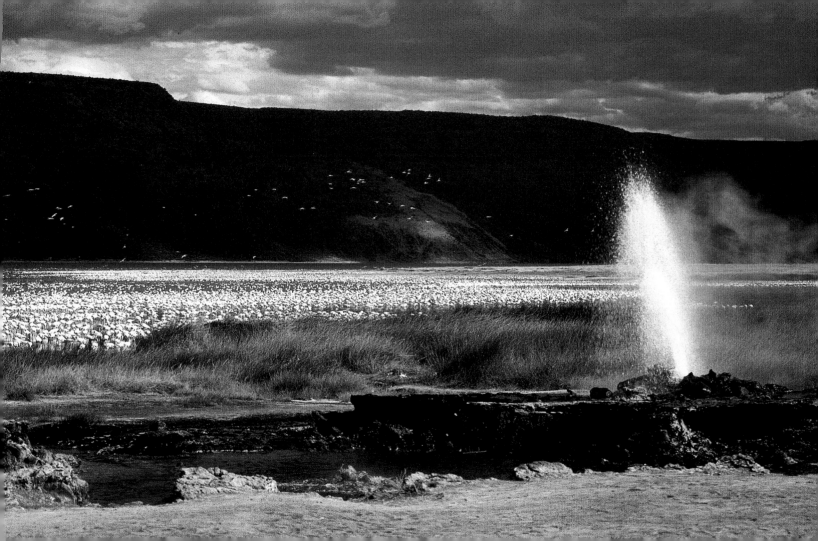

Discover Slow Food.

The Slow Food movement began as a response to the industrialization of the food system, and the subsequent loss of food varieties and flavors. The movement began in Italy and has moved around the globe. In 1900 there were about 200 varieties of artichokes in Italy: today only a dozen survive. The mission of the Slow Food movement is to: educate consumers on land stewardship and ecologically sound food production; encourage cooking as a method of strengthening relationships between people; further the consumption of local, organic, and seasonal food; and create a collaborative, ecologically oriented community.

Opt for diversity and discover Slow Food. This international movement opposes the standardization of tastes imposed by fast food. It has more than 80,000 members in 50 countries.

Sequoias, United States

Have your engine serviced and tuned.

The decade of the 1990s was the warmest ever recorded, particularly the end of the decade. By 2100, global warming will have brought major changes. The earth's average temperature will have risen by between 3° and 9°F.

To avoid contributing to global warming, have your engine regularly serviced (carburetor, ignition, air filter) by a professional. With a properly tuned engine, you will reduce your vehicle's polluting emissions by 20% and save up to 10% on fuel.

Iceberg, Greenland

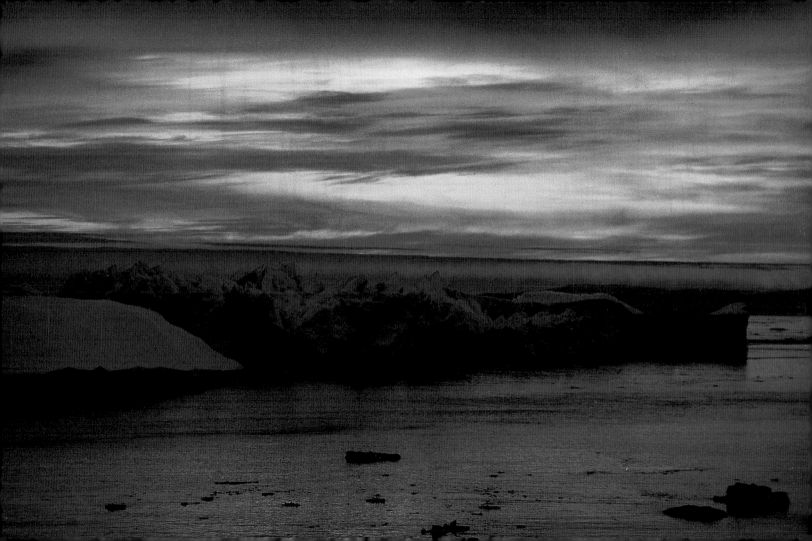

Choose packaging that produces less pollution.

New Zealand is implementing a zero-waste strategy, which aims to reduce waste at the source and maximize recycling. The goal is to dispense with incineration and achieve a 90% reduction in the amount of waste that is dumped by 2020. This resolution should be an example to all industrialized countries.

Start your own zero-waste program: when you buy, choose recyclable packaging (paper, cardboard, glass) and reject packaging that combines several different materials. Choose glass containers rather than plastic for yogurt and fruit juice; purchase cardboard egg boxes rather than polystyrene.

Lake Natron, Tanzania

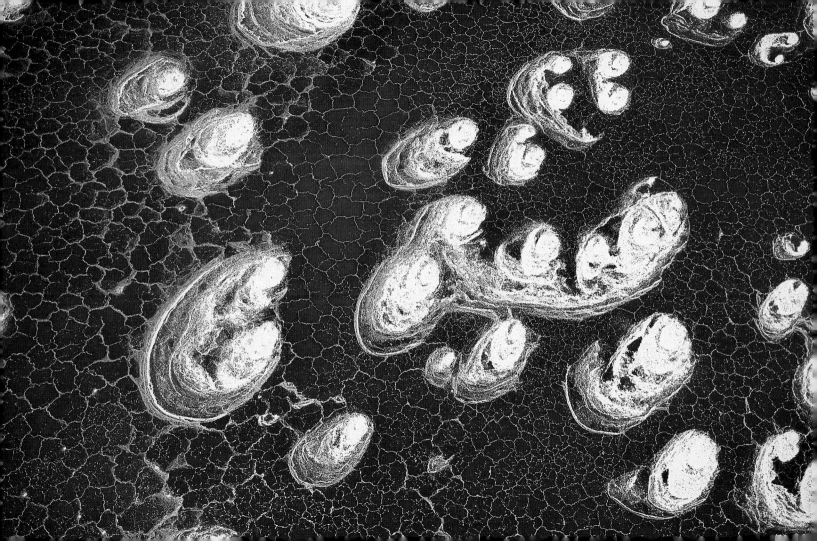

Recycle clothing.

Each American disposes of about 35 pounds of clothing and other textiles every year. An additional 10 pounds are recycled. Of all the old clothing donated for recycling and reuse, almost 50% ends up as second-hand clothing somewhere in the world, 20% is used for cleaning rags, and the remainder is used for other fiber products.

Give your clothes to charities or to collection programs. They will be recycled as second-hand clothes or as rags, or shredded and reused as raw material (for textiles or packaging), thus saving energy and natural resources.

Scorpion fish, Thailand

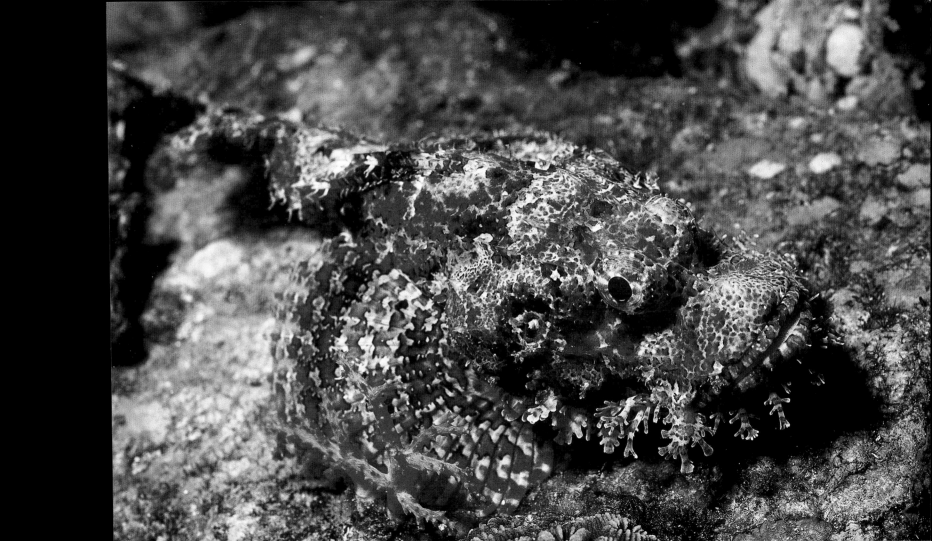

Choose renewable energy for your home.

When a house is being designed, ensuring that it is oriented to receive the maximum amount of sunlight can reduce heating requirements by between 15% and 30%. Solar energy, which is free, easily accessible, and easily converted, can help to heat water and the rest of the house, without producing pollution or greenhouse gases. Geothermal heat pumps that use the energy calories stored in the ground (also free, renewable, and non-polluting) can provide part of your heating and reduce your electricity bill. Most of these installations qualify for grants and financial aid.

————————

Find out more. The energy information section of the Environmental Protection Agency (EPA) provides free practical advice on energy use and renewable energy, which will reduce your bills while protecting the planet.

Ice, Iceland

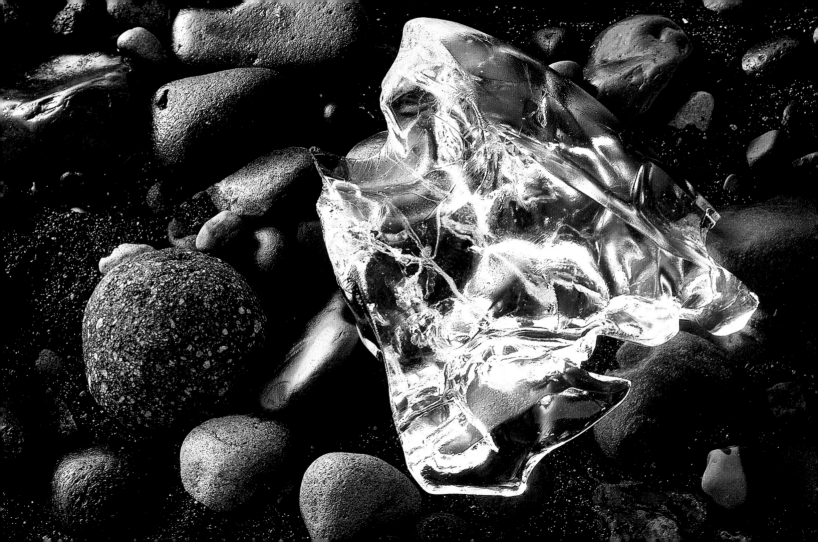

Switch off your television and computer.

The average American household now watches 8 hours of television daily, and a television uses 55 to 90 watts per hour. One computer left on all day for a year releases 1,500 pounds of carbon dioxide into the atmosphere. Even "sleep" mode does not save as much energy as simply turning the computer off. Screen savers are also deceptive, for they do not save energy.

Plug all your computer equipment into a single surge-protector for easy shut-down. And don't forget to turn off your desk lamp!

Aurora borealis, Finland

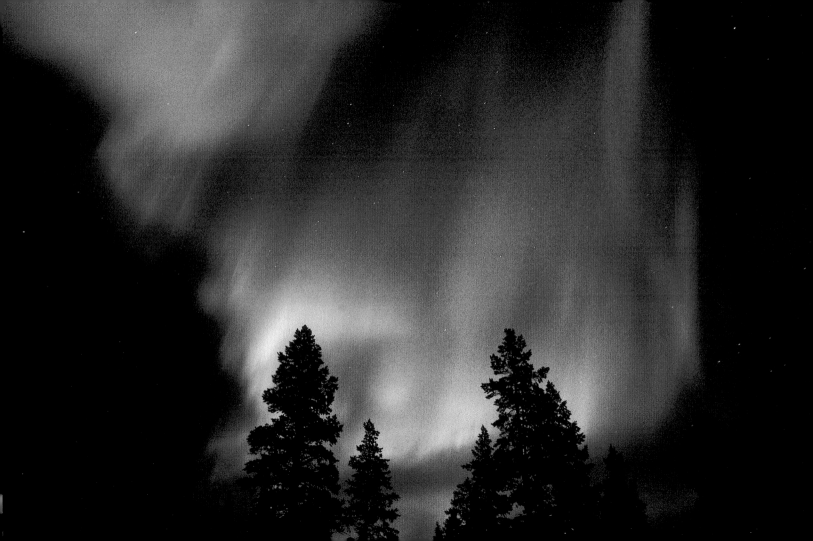

Drive an electric car.

Electric cars are well suited to city use. They are powered by batteries, which are recharged from the main supply via a charger and a plug similar to that of a washing machine. Electric vehicles emit no pollutants and are silent in operation, and are thus effective in reducing urban pollution. Moreover, the cost of the electricity needed to travel 60 miles is a fifth of that of gasoline.

In case you are still unconvinced, an electric car's maintenance costs are 40% lower (there is no need to change the oil), insurance is cheaper, registering the vehicle is less expensive, and parking is free in some cities. Mention it to your employer.

Talkeetna Mountains, Alaska

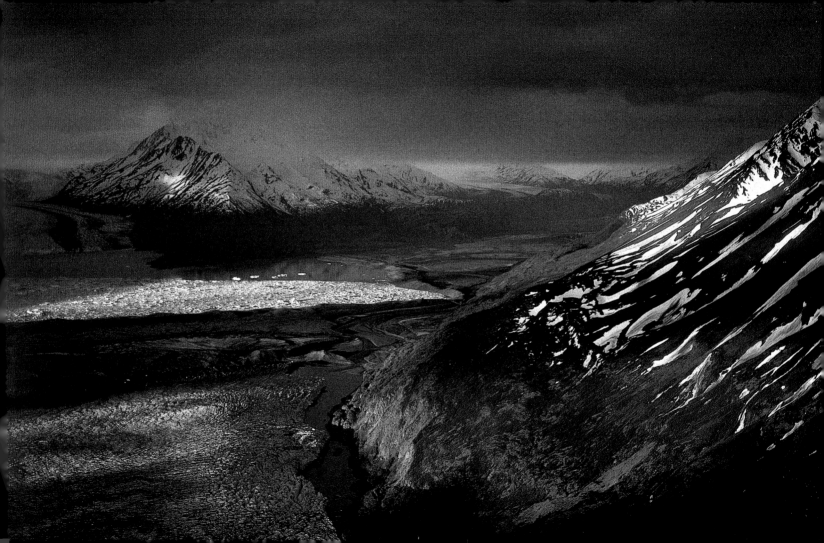

November 3

Take action through committees at work.

In your workplace, various measures can be taken to make room for the environment in day-to-day life. These include an employee travel plan, use of clean vehicles, adoption of non-polluting and energy-efficient technologies, waste recycling, and purchase of recycled, organic, and fair-trade products.

Talk to your colleagues about these choices. Discuss them with those responsible for purchasing, with members of your workplace committee, with the cafeteria chef, and with management, to come up with appropriate plans. This is an opportunity to make the staff in your workplace aware of these issues.

Waterlilies, Venezuela

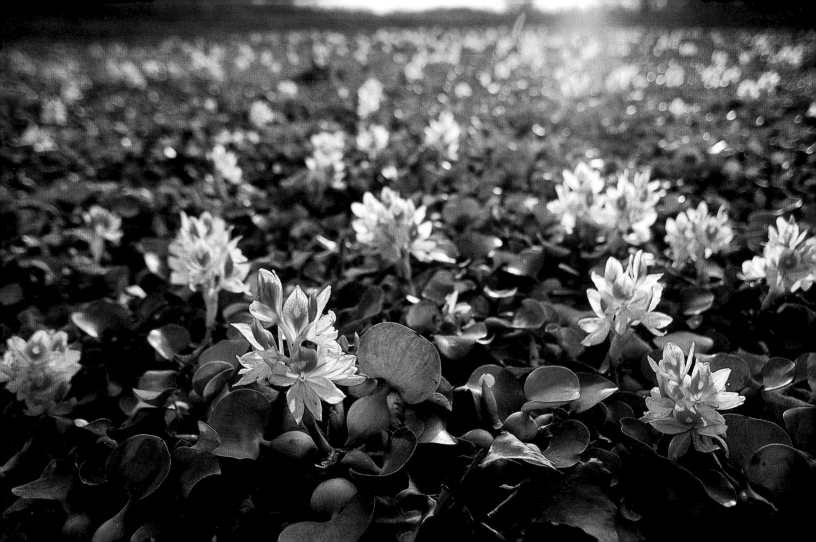

In addition to fruits and vegetables, buy local products.

The abundance of cheap oil has made the world a small place. Products from around the world crowd our grocery store shelves. Plastic toys hail from a multitude of Asian countries, such as China, India, and Thailand, and every year world transportation statistics rise.

Think of the waste of resources, the pollution, and the contribution to the greenhouse effect from cargo aircraft and trucks. Do not encourage the transport of goods over long distances: seek out locally made products. This will help create jobs by stimulating economic activity, and encourage the development of shorter, less polluting delivery routes.

Basalt columns, Italy

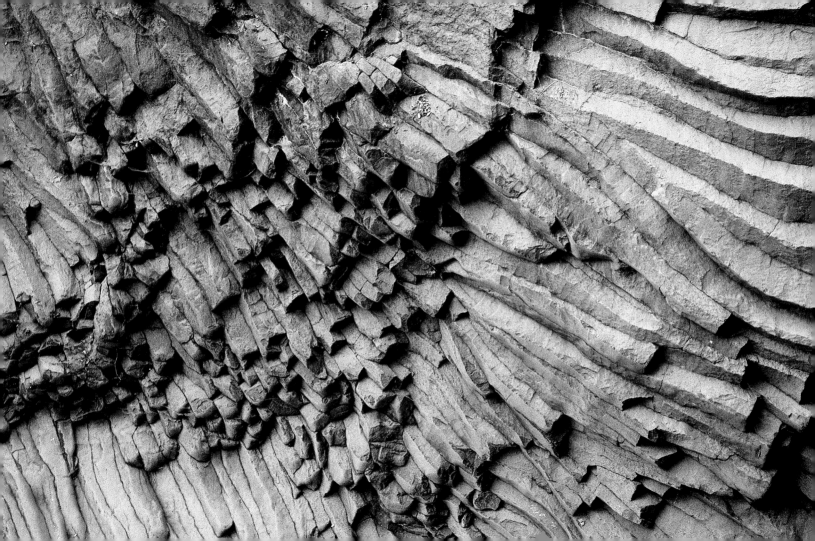

Hot water, yes—but not too hot.

Up to a third of the energy used in the average household goes into heating water. The hotter the water, the more energy it requires.

Check your water heater's setting to avoid needless energy consumption. Too high a temperature can damage your equipment and plumbing. Water that is too hot is as unpleasant as it is dangerous, especially if there are young children in the house.

Hot springs, Kamchatka, Russia

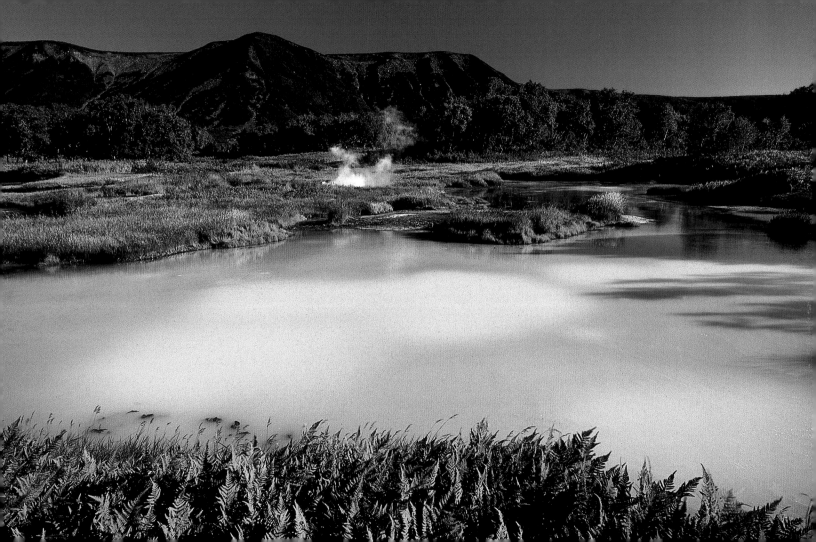

Respect the environment when driving an off-road vehicle.

Long before human beings appeared, the earth had already seen several mass extinctions of species as a result of climate change, volcanic eruptions, and changes in sea level. The most well-known of these, 65 million years ago, wiped out the dinosaurs and 70% of species on earth. The one we are experiencing at present has an extinction rate between 1,000 and 10,000 times higher than the most severe of its predecessors.

When you drive an off-road vehicle, do not go where you are not allowed; use trails that are wide enough to drive along without damaging them or the surrounding environment, and control your speed so you don't disturb walkers and animals.

Ripples in the sand, Algeria

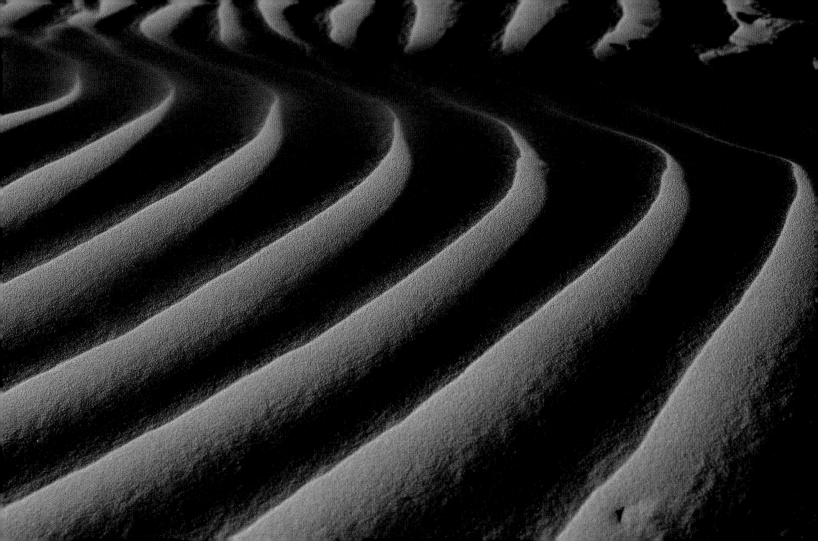

Give away your old furniture and household appliances.

There are charitable organizations that collect unwanted furniture and old appliances and will repair and sell them, either intact or for parts. At last report, there were some 6,000 organizations in the United States devoted to diverting reusable items from the waste stream. Institutions and companies will discover that finding new uses for housewares, or recycling waste instead of disposing of it, will actually reduce costs, as well as provide tax benefits.

Rather than throwing out unwanted goods, find a reuse center in your neighborhood. The town dump is often a good place to start; some dumps have paint exchange programs and book swaps that are free to the public.

Olympic National Park, United States

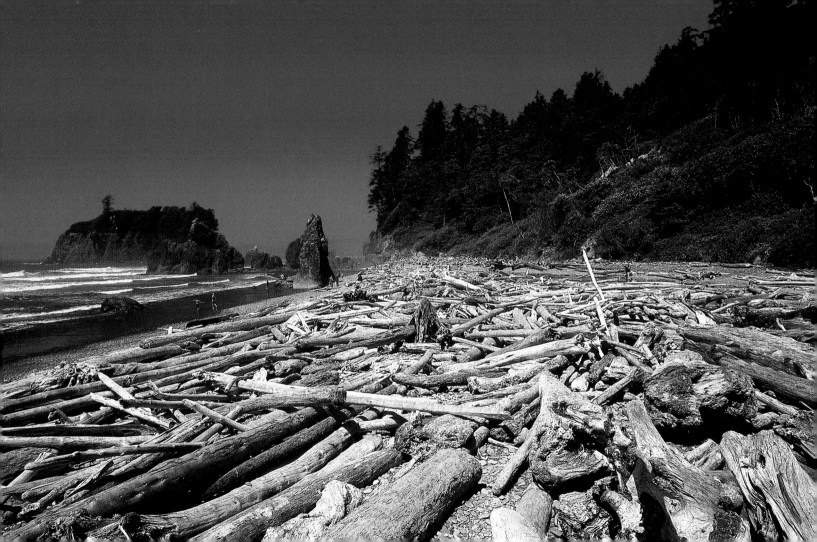

Sign petitions.

The size of a budget allocated to a certain activity gives an indication of its economic importance or humanitarian value. Worldwide defense spending is close to $800 billion, whereas international development aid does not even amount to $60 billion. World agribusiness spends $40 billion on advertising, and half the world's people live on less than $2 per day.

What sort of world do we want? Support public campaigns—sign petitions. By keeping quiet, we become the architects of global catastrophe.

Walruses, Round Island, Alaska

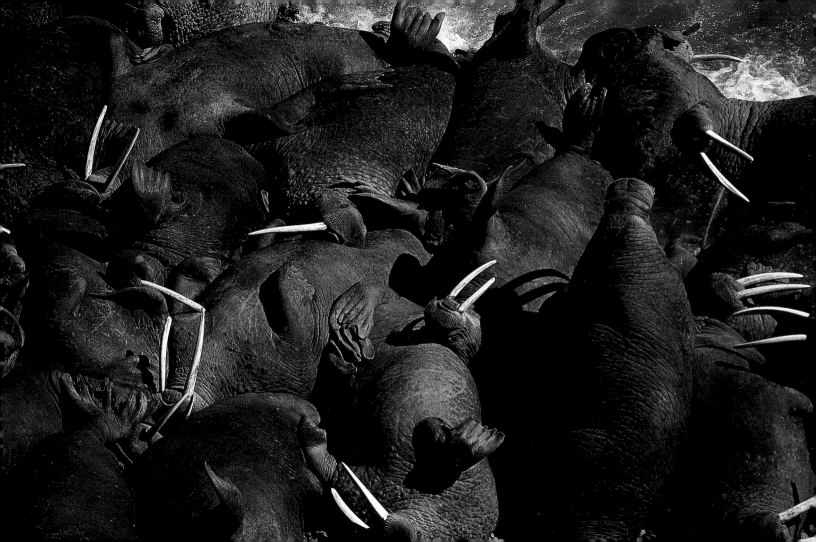

Buy household appliances with the Energy Star label.

Every product comes with an ecological footprint. Everything we buy draws on natural resources for raw materials and for the energy needed for its manufacture, and releases the waste and pollution it generates into the environment. Our present mode of consumption is therefore one of the biggest reasons for the rapid degradation of the environment that we are experiencing on a global scale.

The Energy Star label was developed by the United States Environmental Protection Agency in 1992, and is an internationally recognized indicator of products with superior energy efficiency. Last year alone, America's reduction in greenhouse gas emissions due to the use of Energy Star appliances in the home and office was equivalent to the emissions of 20 million cars. Look for the Energy Star label and save money and the environment.

Haleakala volcano, Hawaii

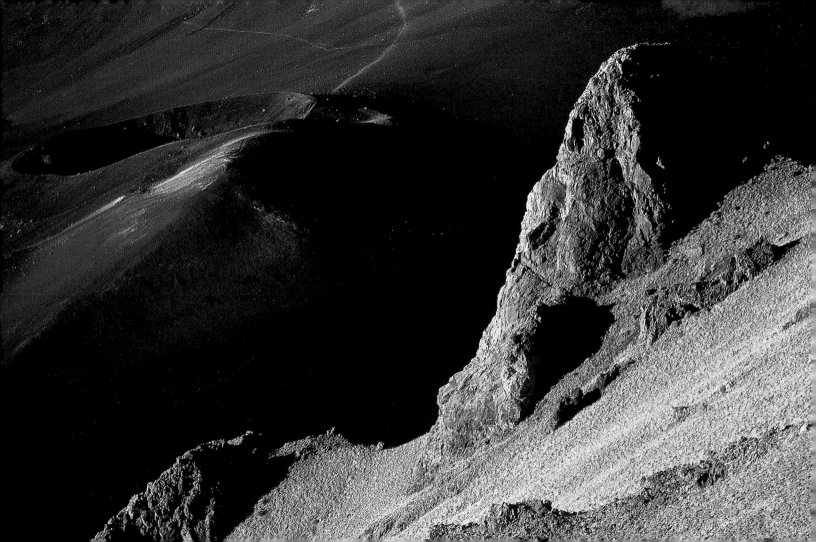

Do not leave the coffee machine on all day.

The list of global energy-related problems makes grim reading: stark inequalities, waste, depletion of natural resources, and irreversible environmental damage. And yet energy consumption is rising inexorably, as are its effects—and we do not seem concerned about leaving the problem of dealing with our pollution to future generations. We can look to technology to make more efficient use of energy, to turn to renewable energy, and to prevent waste on a daily basis, but we must also learn to live with less. All of this is possible without our quality of life suffering.

A coffee machine left on all day uses as much energy as it takes to make 12 cups of coffee. Switch it off: what have you got to lose?

Inlandsis, Greenland

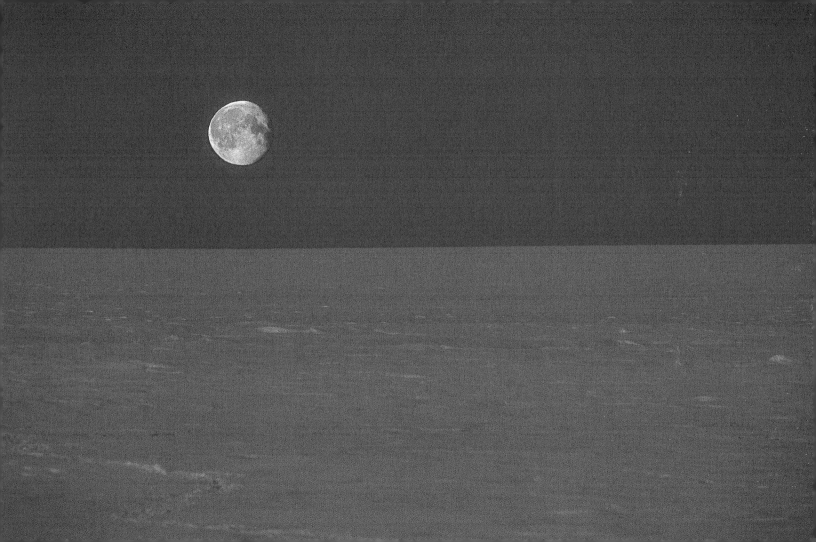

Take dangerous waste to the dump.

Leftover insecticide, weed-killer, paint, solvents (such as acetone and paint thinner), fuel, and lubricants are all toxic, corrosive, polluting, or explosive. They should never be thrown in the trash, where they could endanger the lives of people who collect household trash. Neither should they be thrown in the lavatory, sink, or gutter, let alone left in the environment or a river, for they pollute water and threaten some species. Moreover, treating water contaminated with these substances uses a lot of energy and money, money that usually comes out of the taxpayers' pockets.

Take care to dispose of dangerous waste properly.

Hot springs, Yellowstone National Park, United States

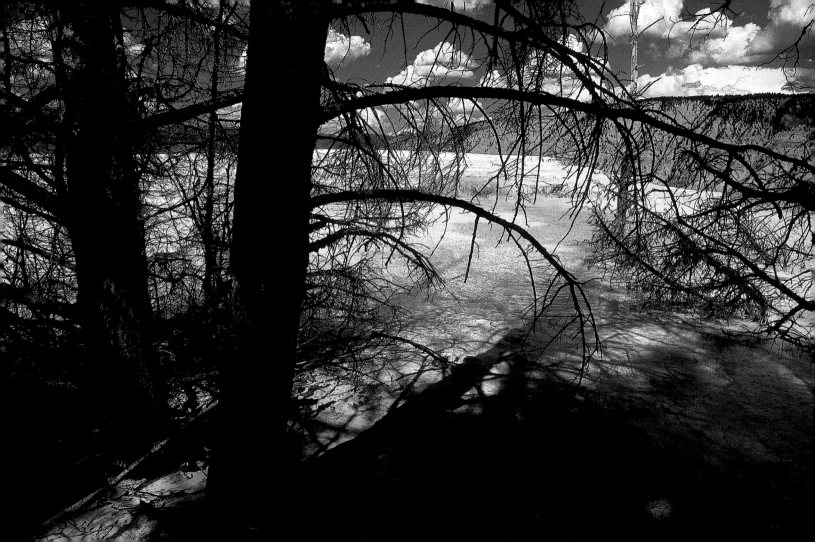

Choose low-VOC (volatile organic compound) paints.

Paints used inside the home may contain up to 50% organic solvents. These render them more liquid and easier to apply. However, they emit volatile organic compounds (VOCs) that are diffused in the air and are a threat to health. Inhalation and absorption through the skin can affect the nervous system and internal organs, as well as irritating the eyes, nose, and throat.

Choose paints that do not contain harmful solvents, heavy metals, or synthetic binders. They have minimum impact on the environment and on health, and their quality is just as good.

Tassili du Hoggar, Algeria

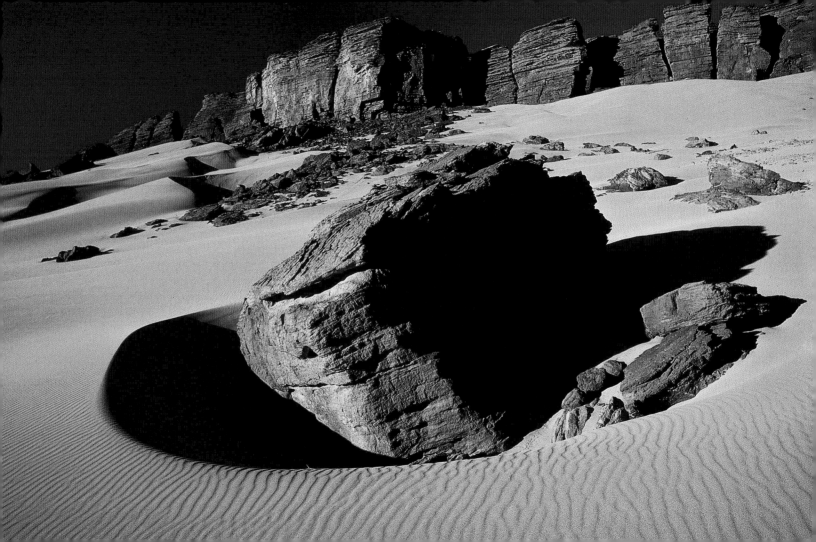

Encourage your place of work to conserve energy and invest in renewable resources.

The United States, which houses just 5% of the world's population, produces a quarter of the world's greenhouse gas emissions. Greenhouse gases come chiefly from the burning of fossil fuels to meet the energy needs of industrialized countries. The United States has refused to sign the Kyoto Protocol, the agreement that binds countries to individualized, legally-binding targets to limit or reduce their greenhouse gas emissions.

At work, write a list of ways to save energy, and ask management to circulate it to the staff. Encourage energy-saving habits at work, and channel information to management about investing in renewable energy.

Waterfall, United States

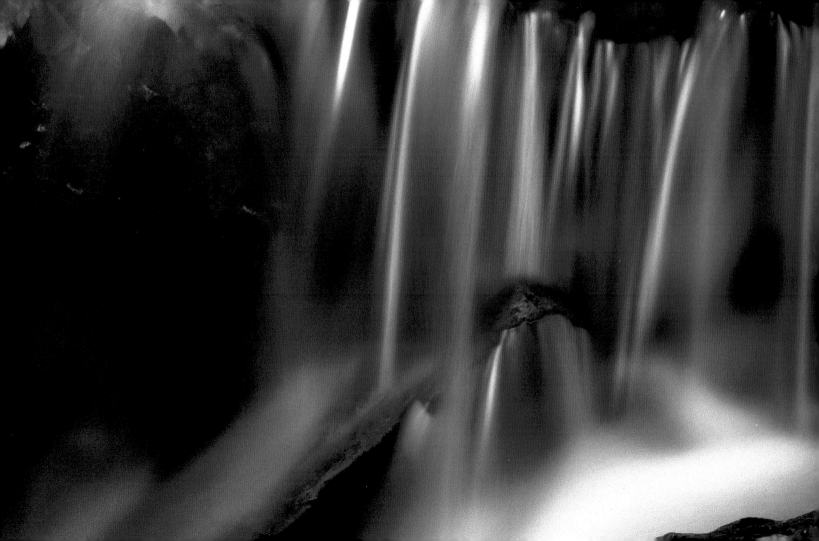

Sort your waste to save raw materials.

For steel, aluminum, paper, cardboard, plastic, and glass packaging, there can be life after the trash! Recycling these materials avoids wasting the raw materials and natural resources (such as wood, oil, minerals, and water) taken from the natural environment for their manufacture. Other than consuming less, recycling is the best way to reduce the amount of waste generated, and in addition to the obvious environmental benefits, recycling creates more jobs than waste disposal and incineration. Despite the clear benefits of recycling and recovery programs, 28 states reported a decrease in their recycling rates for 2003.

Don't let your recycling program be the victim of budget cuts; let your local legislators know how economically and environmentally beneficial recycling can be.

Maple, United States

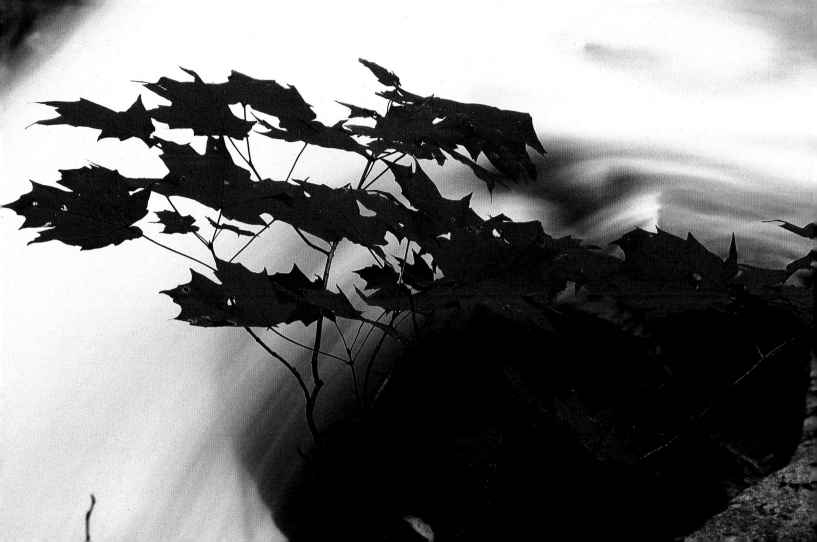

Dust your light bulbs.

You can cut your electricity consumption by using less light and heating at home. If everyone does the same, global electricity demand, and thus consumption, will fall—and so will the use of coal, gas, and oil, along with the corresponding carbon dioxide emissions that contribute to climate change. Conservation is also cheaper and more efficient than technological fixes—that is, changing to an energy-efficient compact fluorescent bulb (CFL) is very good, but turning off the lamp with a CFL in it is even better.

Remember to wipe the dust off your light bulbs; this increases the amount of light they give off by 40% to 50% and provides better lighting for the same cost.

Mount Rainier National Park, United States

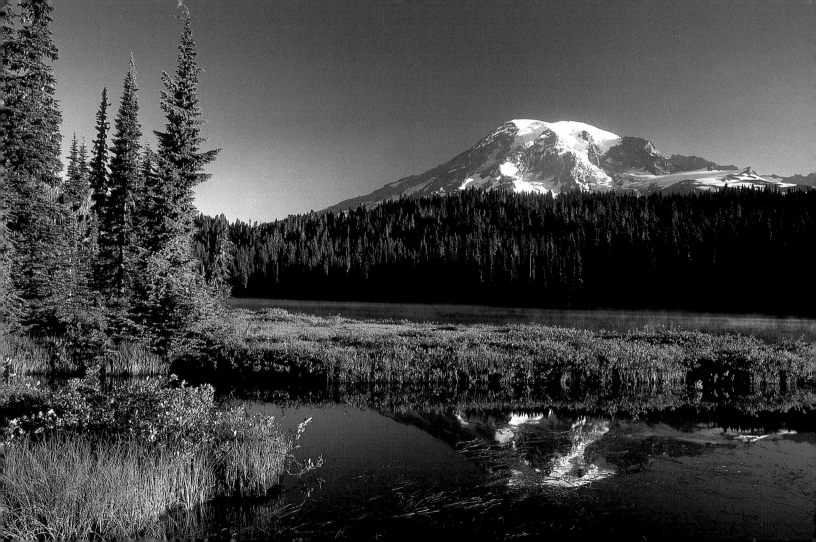

Defrost your freezer.

Our refrigeration appliances use a lot of energy. They use even more if we do not look after them. When the layer of ice inside a freezer is thicker than a quarter of an inch, it is time to defrost it. Any thicker and the ice acts as an insulating layer that can increase electricity consumption by up to 30%.

Take care when defrosting: do not try to save time by using a sharp object to break the ice. You risk making a hole in the cooling system, which would release polluting gases into the atmosphere, as well as damaging your appliance.

Orinoco basin, Venezuela

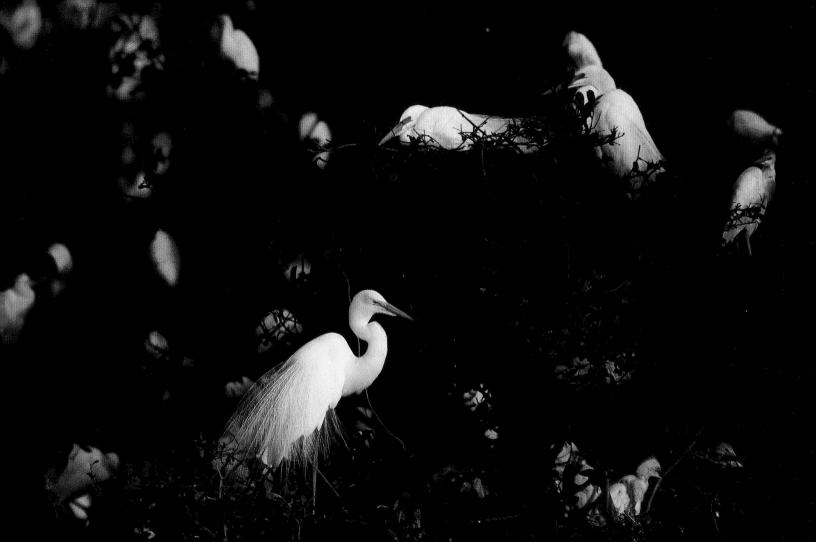

Support organic poultry farming: buy an organic turkey.

Our choices of food can encourage sustainable farming practices that treat animals humanely and favor ways of raising the animals that respect their basic needs and normal growth patterns. Organic livestock farming does not allow the use of antibiotics, growth hormones, genetically modified organisms, or artificial light. It also supports organic agriculture, since the livestock eat grains and feed produced by such methods.

Make it a rule to buy an organic turkey for Thanksgiving, and investigate so-called heritage breeds; producers of these breeds of turkey seek to put a traditional, more flavorful bird on your table rather than the bland, conventional all-white-meat turkey most of America buys on Thanksgiving.

Aïr massif, Niger

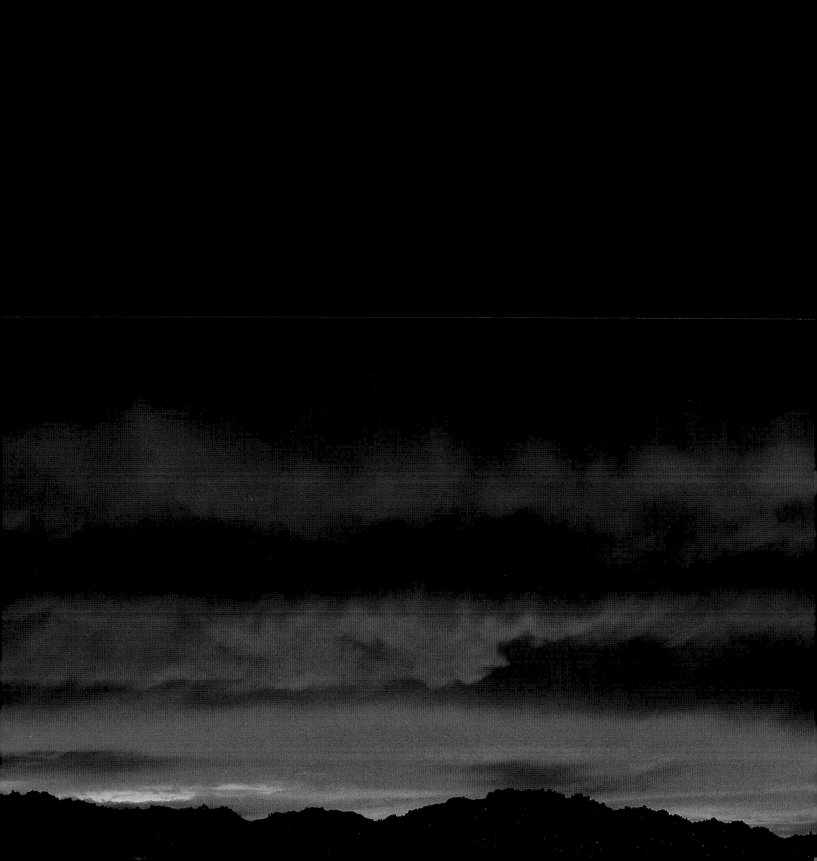

Choose your heating apparatus carefully: consult a specialist.

Electric heating uses a lot of energy and is expensive: this is apparent on your bill in the winter, especially if rooms are not well insulated. If you are having building or renovation work done, now is the time to choose a heating system that uses renewable energy, such as wood energy or solar heating. Among fossil fuel energy sources, natural gas heating is the least polluting.

To choose the most energy-efficient and least polluting heating system, consult a specialist, who will be able to advise on the best energy options for your home and your needs.

Gray whales, Mexico

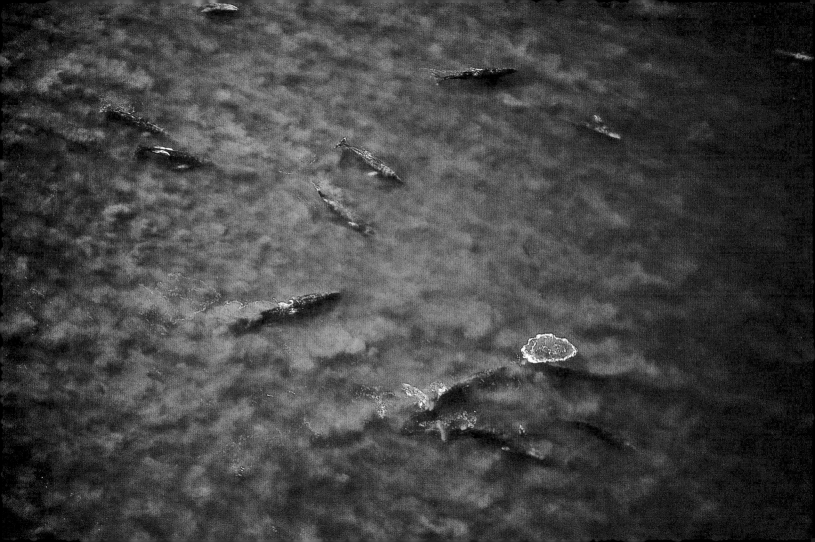

Be prepared to pay more for quality.

The combination of globalization and consumerism often leads us to buy irresponsibly. Cut-rate prices are tempting, but products are often made as cheaply as possible on the other side of the world, in countries devoid of environmental legislation. Often of poor quality, these products soon break down, break apart, and stop working, and are soon discarded.

Choose the alternative that is locally made and of better quality, even though it may be more expensive. Your purchase will be more environmentally friendly, and may save you money in the long run because you won't be forced to replace it right away.

Elephants, Kenya

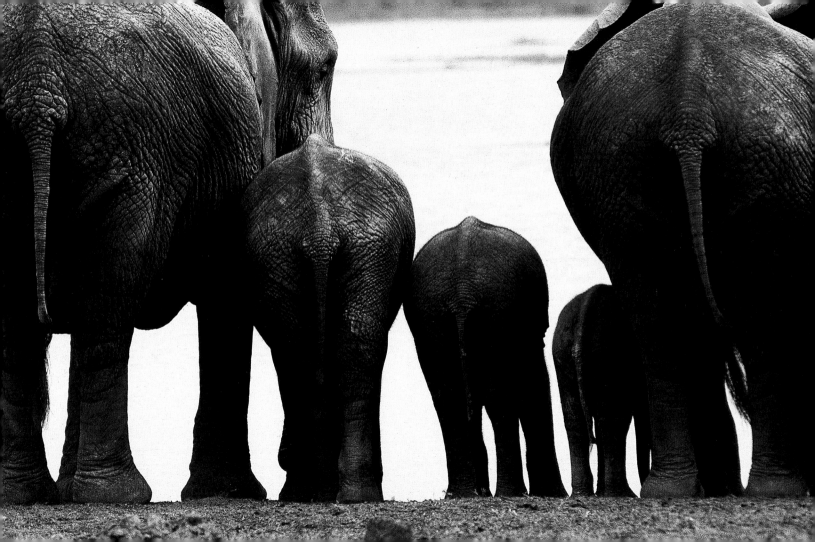

Recycle your computer.

Waste in the form of discarded electrical and electronic equipment—called e-waste—is increasing at the rate of about 20% every five years (that is, three times faster than ordinary municipal waste). This could double in quantity within the European Union by 2020. In the United States, 10 million computers end up in dumps every year. Their toxic components—heavy metals and organic pollutants—are harmful to water, air, and soil, and must be treated accordingly.

There are organizations that collect computers for resale, or to donate to schools or humanitarian programs. Donate your old computer rather than throwing it away.

Ray, Australia

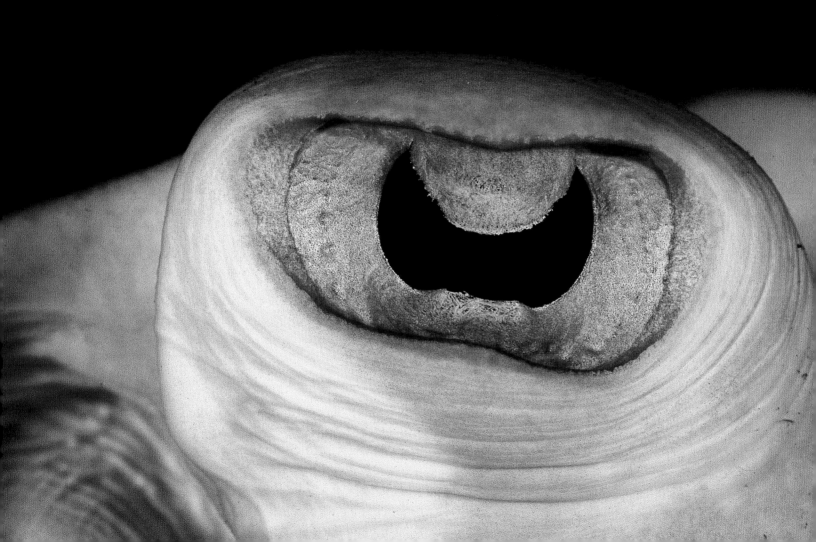

Your saucepans can save energy, too.

Putting a saucepan on the cooker is an utterly commonplace act, yet by paying attention to small details you can use less heat and save energy without changing the way you cook.

———————

Use pots and pans with flat bottoms. Do not place a pot on too big a ring if using an electric cooker; if you are cooking on gas, turn the flame down so that the contents does not boil over and spill around the sides. This wastes the heat that was used to heat the liquid. When boiling food in water, use just enough water to cover it—it is pointless to boil twice what you need.

Atacama Desert, Bolivia

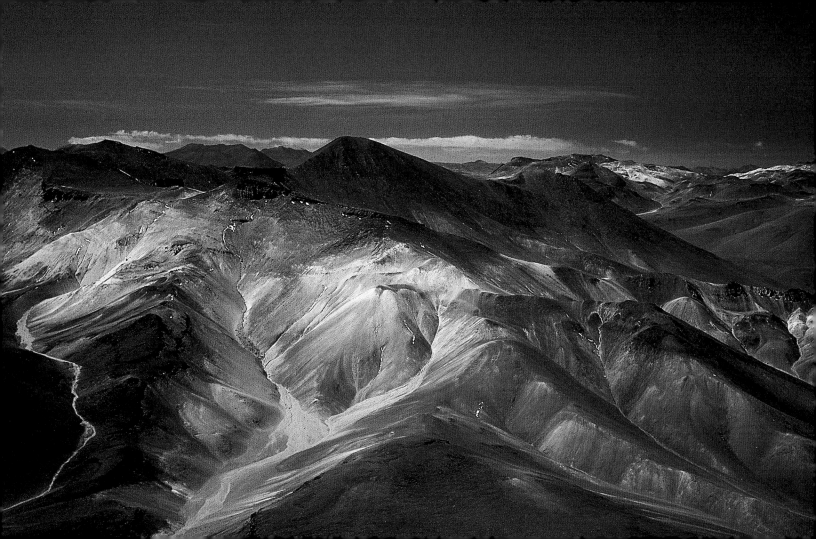

Say "no" to guaranteed 48-hour delivery times.

A one-foot rise in sea level causes coasts to recede by 100 feet. Scientists expect the sea level to rise 3 or 4 feet over the next 100 years. This scenario, which the world's climate change experts believe is likely to become reality within less than a century, would completely redraw the world's coastlines, without considering which regions currently are inhabited: 6% of the Netherlands, 17% of Bangladesh, and most of the Maldives could be submerged. Transportation is the biggest contributor to global warming. If distributors are allowed more flexible delivery times, they can make full use of their trucking capacity, or use less polluting modes of shipping such as rail and canal barges.

The demand for guaranteed delivery within 48 hours requires the use of more trucks. Is it really so urgent?

Mount Etna, Italy

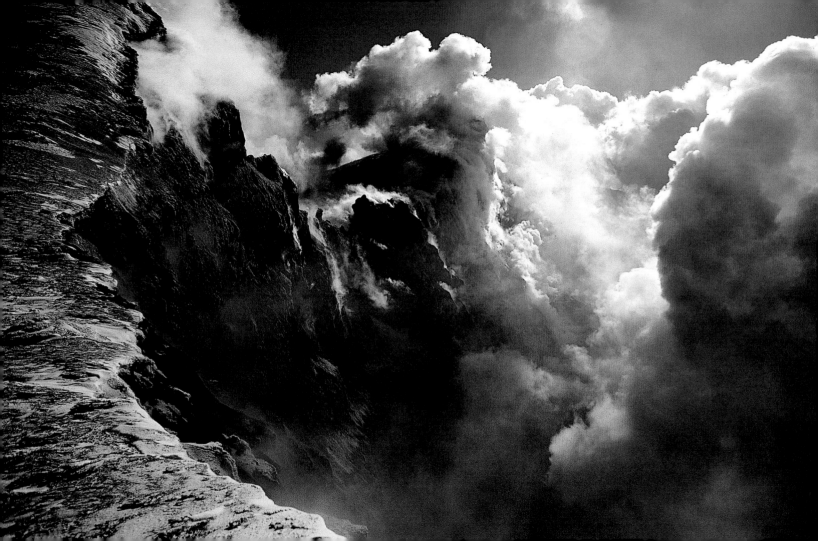

Buy juice in bulk.

Two of the world's largest landfills, now closed, are set to become symbols of restoration and environmental health over the next 30 years. The Paterson landfill site in Glasgow, Scotland, and the Fresh Kills landfill on Staten Island, in New York, are both slated for ambitious urban environmental renewal projects. In Glasgow, 1 million trees will be planted over 230 acres of landfill over the next 12 years, making it the largest urban forest in the United Kingdom. Once the largest landfill in the world, Staten Island's Fresh Kills landfill is poised to become New York City's newest parkland. Its 2,200 acres will be developed into a park three times as large as Central Park over the next 30 years.

———————

Help reduce the need for huge landfills like Paterson and Fresh Kills. A household of four people can drink more than 45 gallons of orange juice a year. Buy juice in the largest container possible and you will cut down on the amount of packaging waste that goes to the landfill. Most recycling centers accept large plastic juice containers; some will accept wax-coated paper containers. Always check before adding it to your recycling bin.

Stalactites, Greenland

Do not buy a primate as a pet.

Three-quarters of the Earth's primates live in the tropical forests of Brazil, Congo, Indonesia, and Madagascar, regions where deforestation is destroying their habitat. Deprived of their shelter and hunted for their meat, one species of monkey after another are being wiped out. Out of 240 species of primate, half (including the orangutan) are in danger of becoming extinct by the end of the century. Only 300 mountain gorillas remain.

When traveling, do not engage in trade in endangered species: do not be tempted to buy a monkey in a tourist market.

Yellowstone National Park, United States

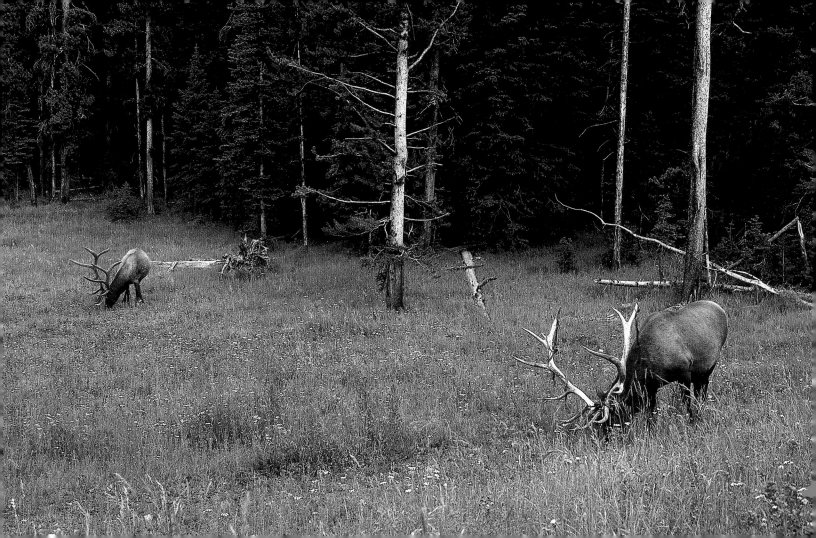

Use organic methods of control rather than pesticides.

Chemical insecticides for garden use have several drawbacks: they harm all insect life, including beneficial species that prey on pests, such as greenfly, caterpillars, and arachnids; and they pollute the land and water. Living biological controls are an alternative; they are the natural enemies of pests and can be used to keep pest populations below destructive levels. They allow the population of an undesirable organism to be reduced by being devoured by its natural predator!

Living biological controls include spiders, ladybugs, lacewings, praying mantises, predatory mites, parasitic flies, wasps, and more. Most beneficial species can be purchased through the Internet or mail-order catalogs. Beware though, for such organic methods affect the natural balance. Before each treatment, make sure that the predator you plan to introduce will attack only the species that is causing the trouble.

Orinoco basin, Venezuela

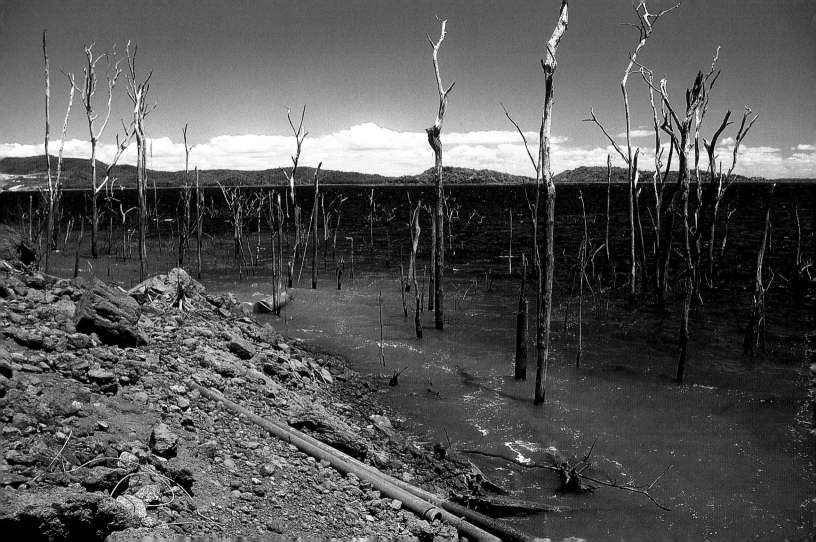

November 26

Take part in Buy Nothing Day.

Since 1970, world production of goods and services has multiplied sevenfold. The earth lost a third of its natural resources over the same period.

———————

If you are weary of our overconsuming society, don't miss Buy Nothing Day at the end of November. It provides an opportunity to think about the social, economic, and ecological impact of global consumption. If you feel particularly resourceful, promote a local Buy Nothing Day once a month, or even once a week.

Volcanic lake, Kamchatka, Russia

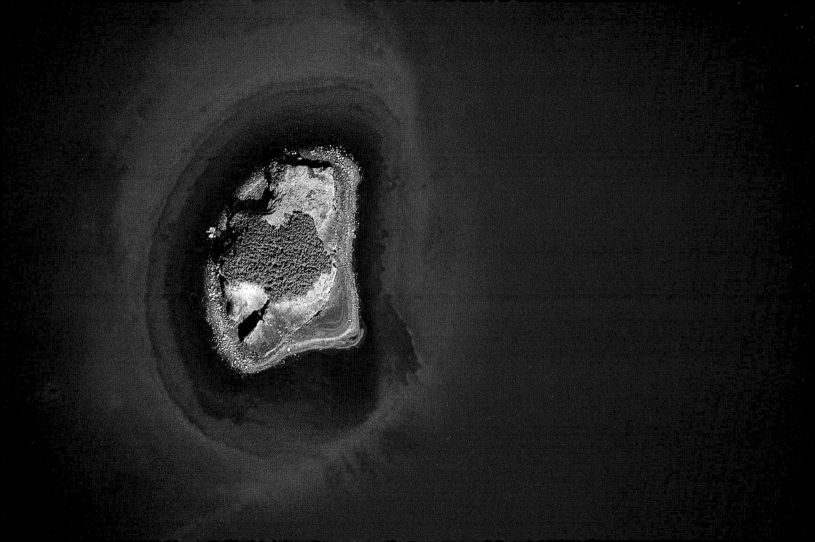

Take the bus.

Global pollution, such as greenhouse gas emissions, is worrying because of its impact on the balance of the planet's climate. Local pollution directly damages health and well being, especially in big cities. Thirty thousand American lives are prematurely cut short because of air pollution every year. Cars are the biggest source of urban air pollution: each car emits, on average, three times its own weight— that is, several tons—in various pollutants.

Fight air pollution by using your car less often. And take the bus: a fully loaded bus can keep as many as 40 drivers off the streets.

Geyser, Kamchatka, Russia

Do not smoke in enclosed spaces or public places.

Everyone knows that tobacco is harmful to our health. More than 3,000 substances have been identified in tobacco smoke, including nicotine, which causes addiction; tars, which cause cancer; and carbon monoxide. Moreover, smokers pollute their immediate surroundings and are the worst source of pollution in public premises. However, the damage does not stop there: every year about 9 million acres of forest go up in smoke to provide space to cure tobacco leaves.

If you smoke, avoid doing so in enclosed spaces, and keep to smokers' areas in public places. Better still, smoke less, or not at all.

Hot springs, Yellowstone National Park, United States

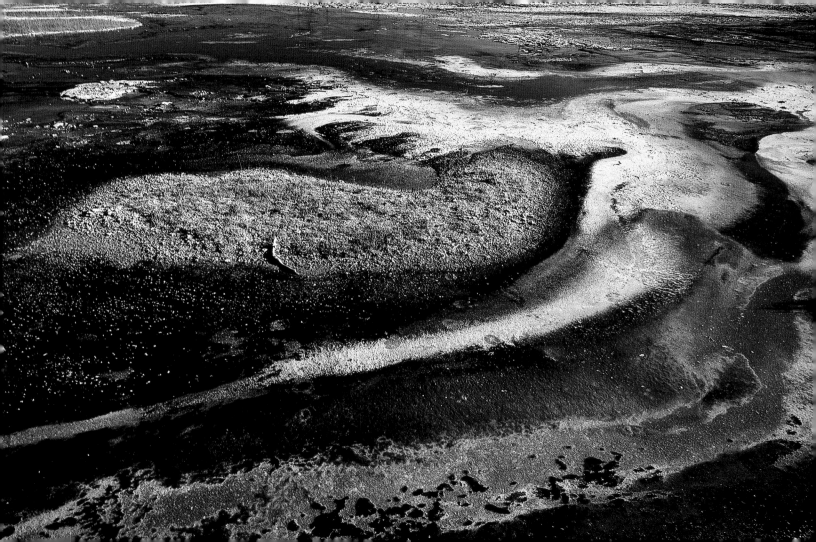

Donate your eyeglasses for recycling.

In developing countries, 200 million people could live normal lives if only they possessed a pair of eyeglasses. Thousands are handicapped by poor sight, which they lack the means to correct; meanwhile, many households in developed countries have eyeglasses that are no longer needed.

The next time you replace your eyeglasses, donate your old pair, and any unused cases, to an organization that collects and distributes them where they can be reused. Some opticians take part in collection programs. Every year more than 100,000 pairs of glasses find a new pair of eyes that they can help.

Kap Farvel, southern Greenland

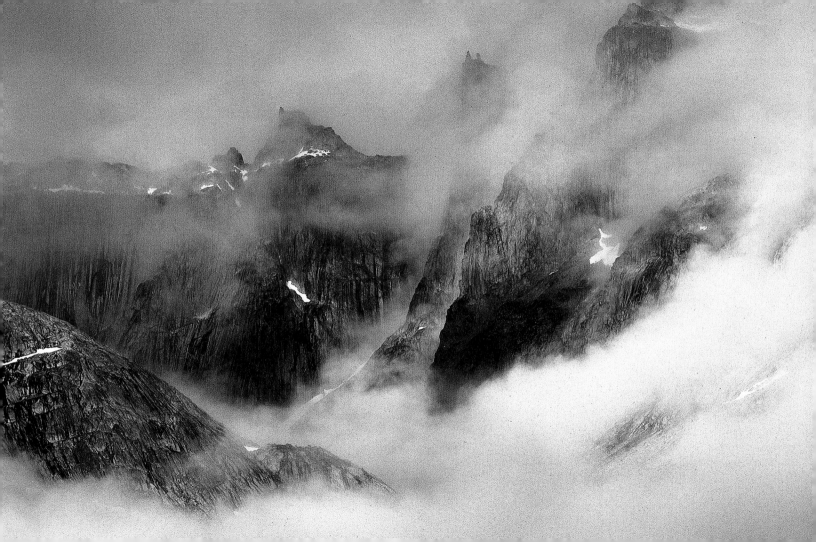

Do not throw away your baby's clothes and accessories.

Joy at the birth of a child is followed by a multitude of expenses for the necessary equipment. The list can be long and the bill high, especially since we generally want the best, most attractive, most modern and, above all, the newest products for the latest addition to the family. A large proportion of these accessories and clothes will see use for an extremely short length of time.

To lessen the impact of a new baby on the family finances, consider looking in consignment stores, obtain what you need from other family members, or borrow it from friends. Then lend things in turn, sell them, or give them away. If the same plastic bath is passed down among four children, that makes three fewer baths that need to be manufactured.

Lava, Kilauea volcano, Hawaii

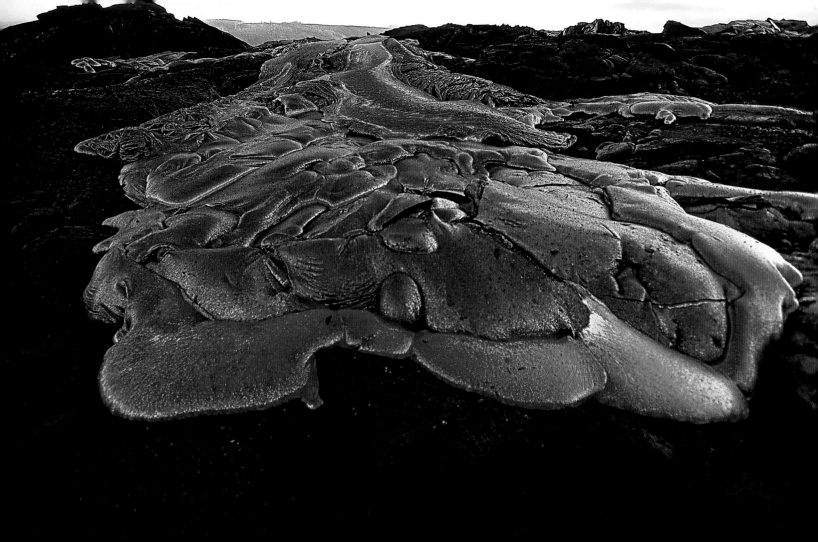

Do not use your car for short journeys.

Every large city on the planet is suffocating because of car traffic, oil-fired domestic heating appliances, and industry. Half of all car travel in America is for trips under three miles—an easy distance for most people to bike or walk. While citizens of Europe and Japan make 20% to 50% of their trips on foot, Americans make only 5%.

———

Avoid using your car for short trips. A vehicle produces the most pollution when being started from a cold engine. Moreover, the catalytic converter is fully efficient only when it reaches a certain temperature, which happens after a few miles have been covered.

Reflections, Alaska

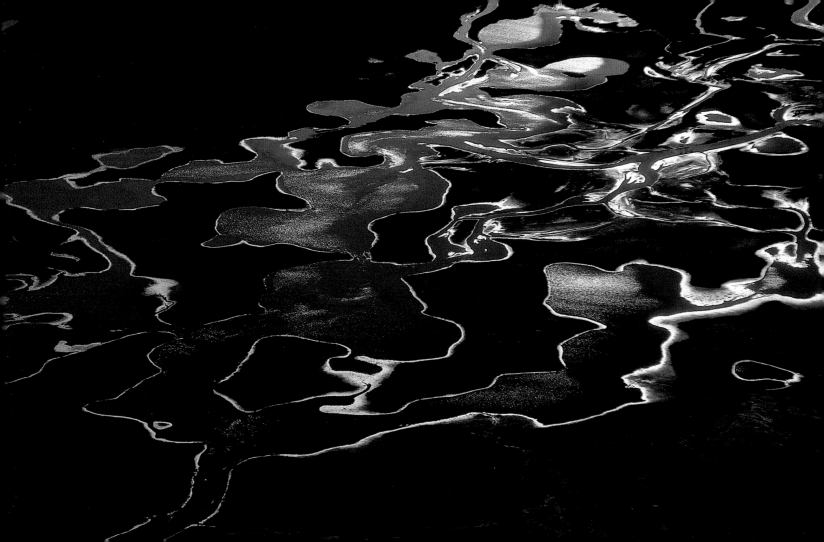

Use baking soda to clean the oven.

Between 1940 and 1982, production of synthetic substances increased by 350 times. Since 1970, world sales of chemical products have risen from $171 billion to $1,500 billion. This vast market leads to the release into the environment of millions of tons of different chemical compounds. This pollution is widely implicated in the increase in cancer rates, loss of biodiversity, and destruction of the earth's ozone layer.

Household oven cleaners contain corrosive and toxic substances. You can replace them with a solution of water and baking soda, which is less damaging and just as effective.

Tassili du Hoggar, Algeria

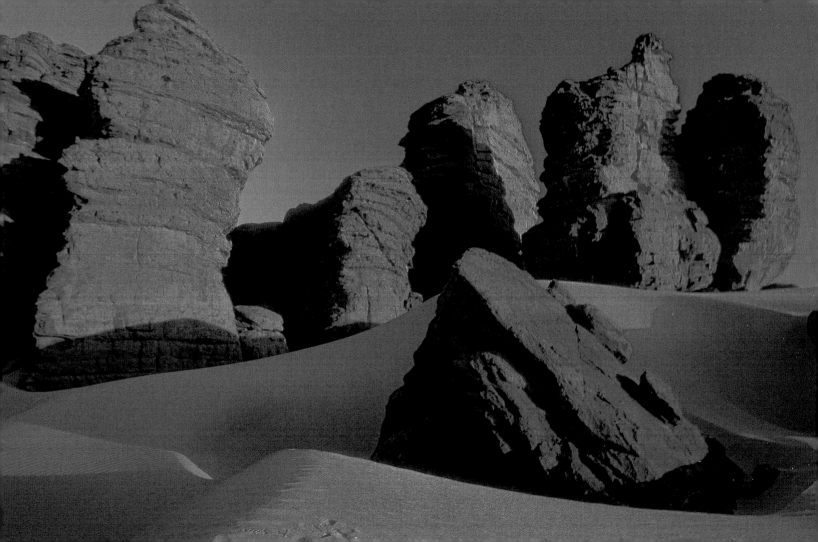

Persuade your workplace to buy fair-trade coffee and tea.

In many regions of the developing world, earnings are too low for farmers to support their families. Unable to make a decent living from the land, they are sometimes forced to leave it and join the swelling ranks of the urban poor. In some regions, they yield to the temptation to grow coca (from which cocaine is produced) or poppies (which produce opium), both of which will earn them more money.

By building more equitable commercial relations, fair trade ensures a decent wage for craftsmen and farmers, who can then live in dignity from their work. Tell your colleagues about fair-trade coffee and tea, and urge your employer to buy them.

Patagonia, Argentina

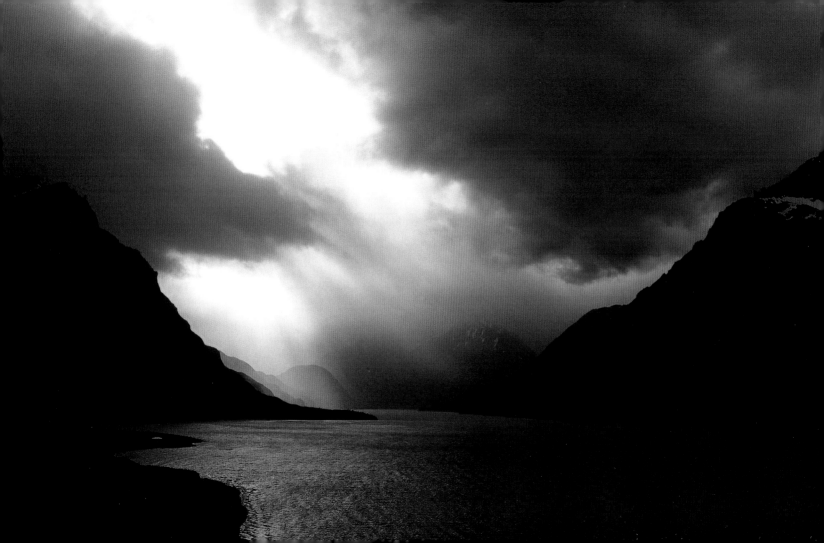

Take biodegradable waste to the compost center.

Composting is nature's way of recycling its own waste. Dead leaves, branches, and plant debris fall to the ground and are digested by bacteria and microscopic fungi. As weeks pass, humus—the natural compost produced by this process—is formed. Composting in specialized facilities gets rid of our biodegradable waste (fruit and vegetable peelings, garden waste) using the same process. This natural fertilizer, which can restore degraded soil to a condition in which plants thrive, is the reason that community composting is so important, particularly given current agricultural practices.

If your local municipal authority does not collect biodegradable waste, find a compost center nearby. Some cities around the United States, recognizing that the reduction of solid waste benefits everyone, have instituted curbside compost pickup. Encourage your local legislators to consider the option of municipal composting.

Autumn, Canada

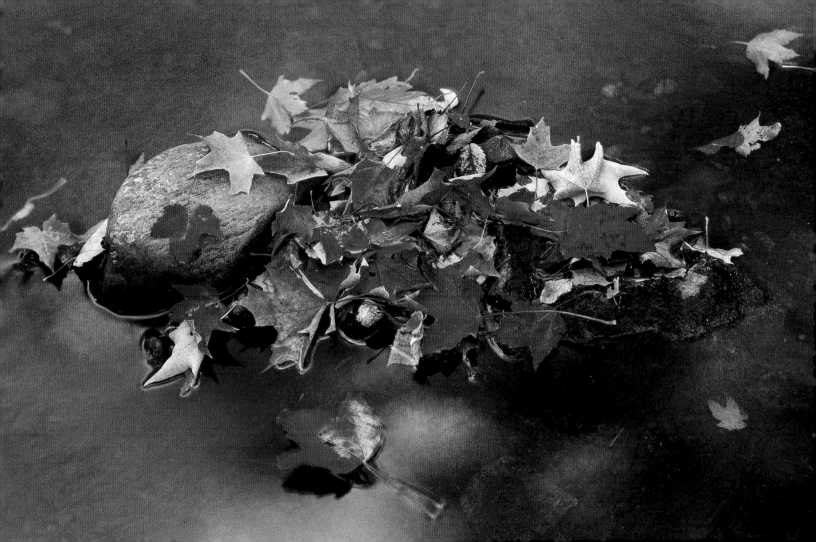

Set your refrigerator to 40°F.

Worldwide, the transportation sector produces a quarter of all emissions of carbon dioxide. Electricity generation produces more than a third of carbon-dioxide emissions. In industrialized countries, electricity generation's share is half of all emissions. The comfort of our day-to-day life consumes vast amounts of electricity, and sometimes wastes vast amounts, as well.

The ideal temperature for the inside of the refrigerator is 40°F. Similarly, the freezer should be set to 5°F. Any setting below these temperatures does not affect how well food keeps, but it does increase energy consumption by 5%. Keep a thermometer in the refrigerator and freezer to check the temperature.

Icebergs, Greenland

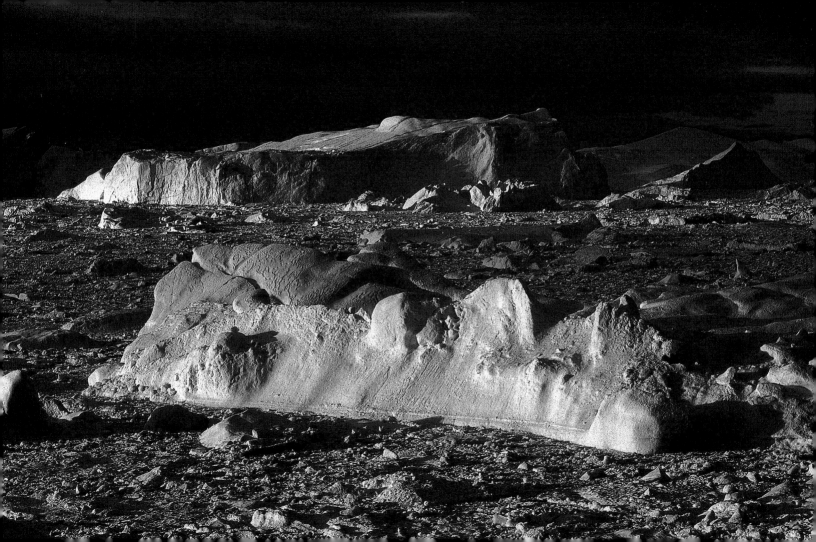

Follow LEED regulations when building or renovating.

Tomorrow's dwellings will have to be of high environmental quality. The LEED (Leadership in Energy and Environmental Design) Green Building Rating System® enables the reduction of energy consumption and emissions of carbon dioxide by means of highly efficient insulation, the use of renewable energy, and better integration of dwellings with their natural environment. Using recycled rainwater reduces the consumption of fresh water and keeps polluted storm water from entering waterways. Moreover, LEED guidelines create a healthy, comfortable indoor environment. Environmentally friendly building is not more expensive, and in fact, pays for itself in less than 10 years, thanks mainly to its savings in energy and water.

If you are planning to build or renovate your home, find out about LEED standards. You will enjoy the satisfaction of respecting nature and turning to it for your day-to-day comfort at the same time.

Emperor penguins, Antarctic

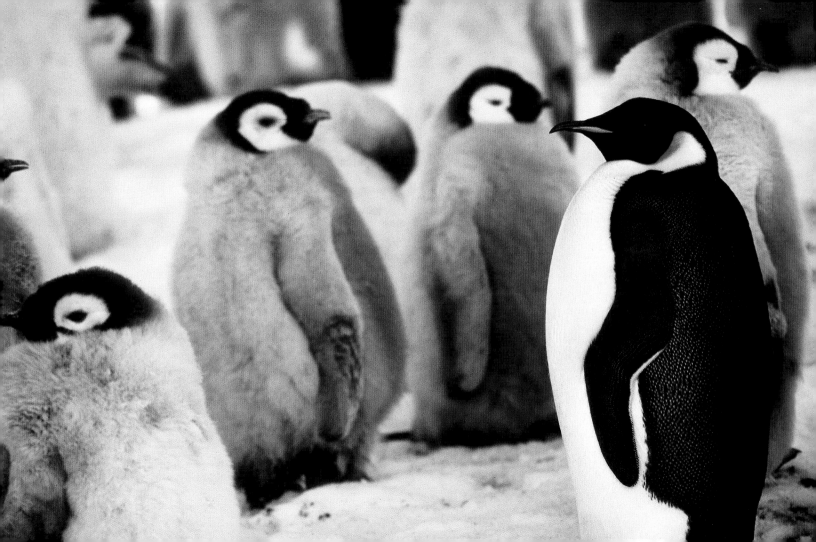

Keep your car's noise to a minimum.

Three-quarters of the noise in cities comes from motor vehicles. It is so pervasive that we no longer even notice it. A typical pick-up truck passing at 50 miles per hour is 4 times as loud as an air-conditioner and 8 times as loud as a refrigerator. Too much noise causes fatigue and stress, and affects our nervous system.

──────────

For cities to remain livable, it is essential to keep noise pollution to a minimum. Car exhausts must be fitted with a muffler. Have yours changed when it becomes too noisy.

Red ibises, Venezuela

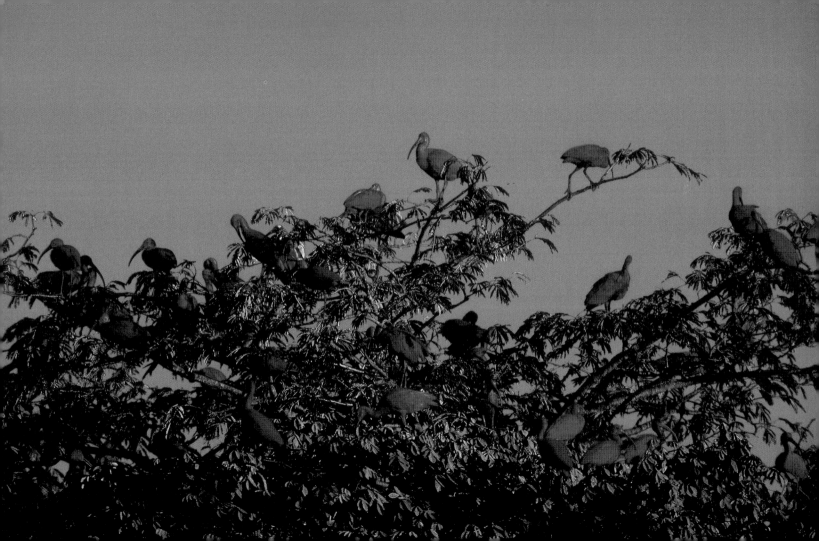

Replace your old domestic appliances.

Recent years have seen a considerable reduction in the amount of water used by domestic washing machines. The Energy Star label is the certified assurance that consumers are investing wisely. Energy Star dishwashers are at least 13% more energy efficient than standard models, and save water, as well. An Energy Star dishwasher saves approximately 1,200 gallons of water a year, which is equivalent to the amount of water that 6 people can drink in a year.

Your appliances may have served you faithfully for years, but if they use much more water and energy than newer models it is better to replace them—especially if they are used frequently. Energy- and water-efficient models may require greater initial investment, but you will continue to see the benefits over the life of the machine.

Erg (sand desert), Mauritania

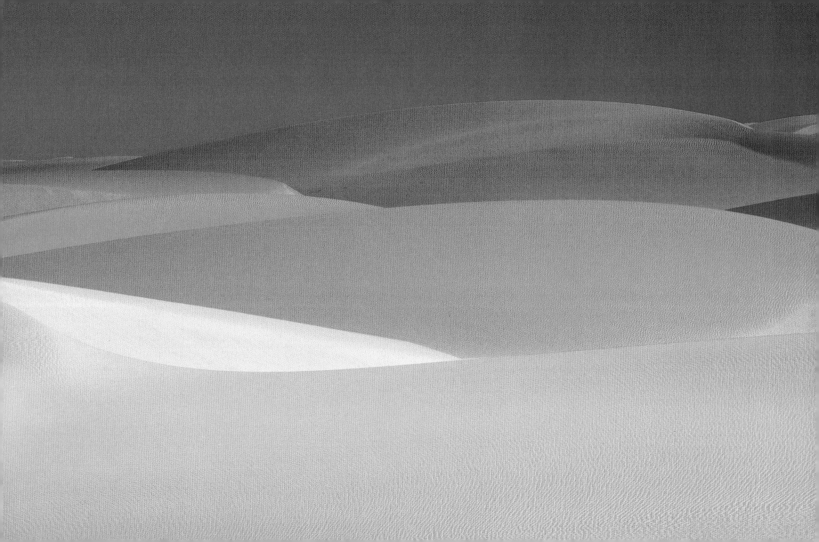

Encourage your employer to invest in an environmental audit.

Not surprisingly, companies, institutions, and schools have a larger impact on the environment than the individual, and thus, when these entities choose to act sustainably, their potential for influence is much greater. There are numerous ways for companies and institutions to assess their footprint on the earth in a quantifiable and productive way. Environmental audits are accompanied by individualized, self-proposed goals and improvements for the short- and long-term that are made by organizations to become more ecologically sound in their operations.

You can encourage your employer to invest in an environmental audit. The goal-making process that follows—where the company or institution decides how best to reduce its environmental footprint—can be a motivational, team-building experience for all involved.

Twisted streams of lava, Kilauea volcano, Hawaii

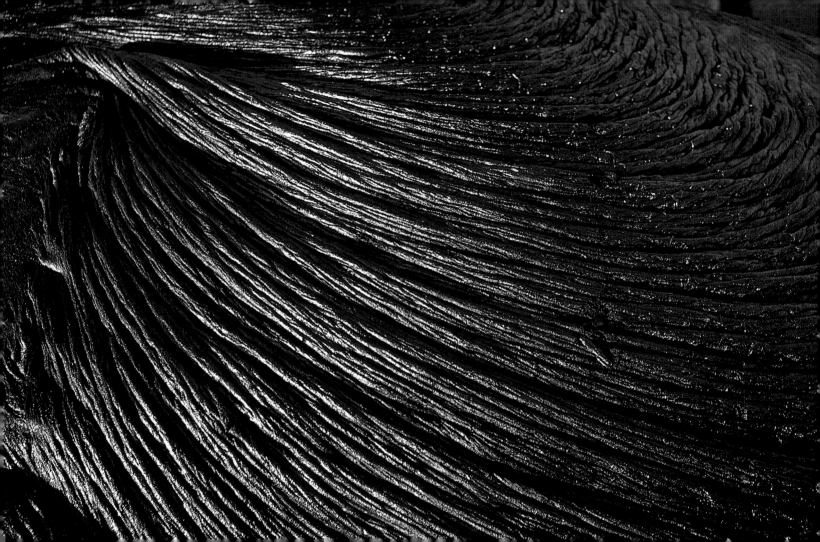

Use both sides of a sheet of paper.

Recycling a ton of newsprint saves a lot of damage to the planet. It prevents the emission of 2.5 tons of carbon dioxide into the atmosphere, and thus avoids contributing to climate change. It saves 3 cubic yards of space in a waste dump. And finally, it saves enough energy to light an average house for 6 months. However, before recycling paper, remember that a sheet printed on one side is only half-used.

In the office, place cardboard boxes next to printers to collect paper that can be used for draft prints, and let your colleagues know about it. Most printing does not require a new sheet of paper. At home, use sheets of paper printed on one side as notepads.

Ice, Iceland

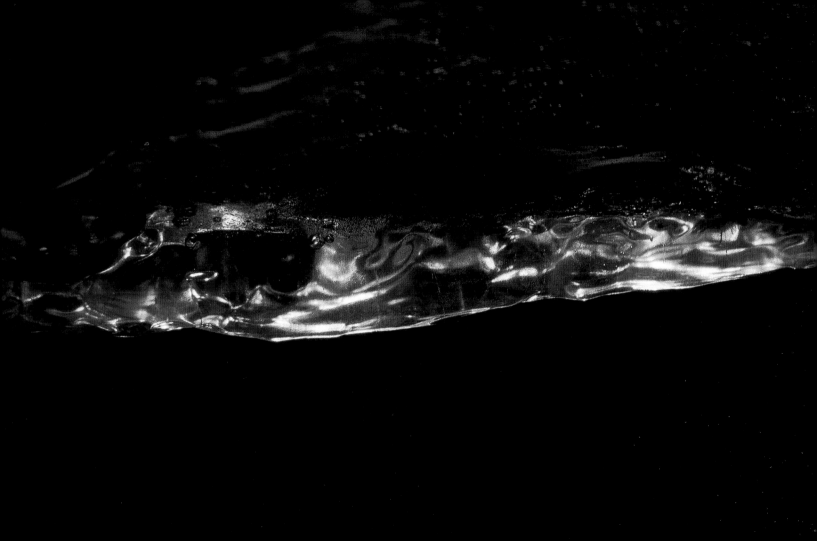

In winter, turn night-time heating down to the minimum.

Eighty percent of the energy the world uses comes from nonrenewable fossil fuel resources, the combustion of which produces greenhouse gases. Oil, natural gas, and coal reserves are replaced at 1/100,000th of the speed at which we are now using them up. The exhaustion of these resources within a few decades will probably herald the rise of renewable, nonpolluting energy sources. We may yet have cause to regret not having developed them earlier.

To moderate your energy consumption (and reduce your bills), remember that a temperature of 61°F is enough in a bedroom at night. For a healthy, economical, and ecological night's sleep turn your heating down and sleep under a good soft blanket or cozy comforter.

Iceberg, Greenland

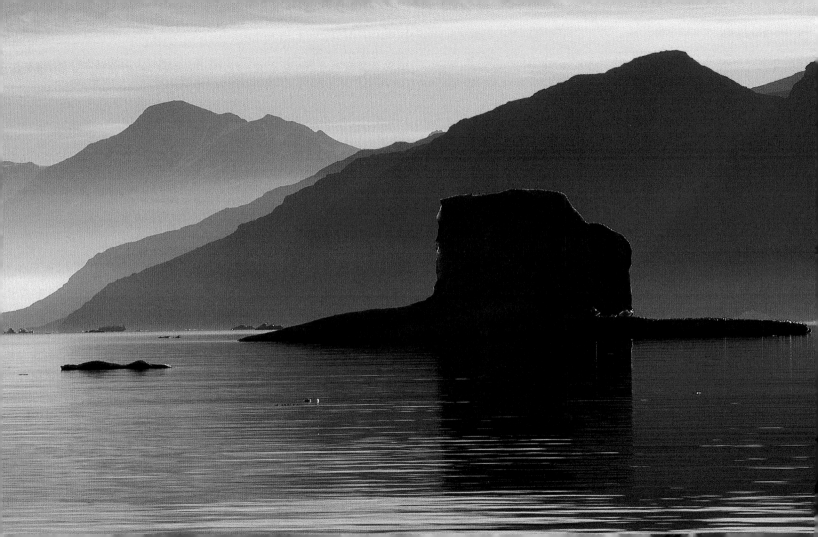

Give a waste-free gift.

You have to buy a present, and you are tempted to give a product of some sort that bears the words "Made in China." It is likely that this item has been manufactured under unfair working conditions and has been transported thousands of miles to the store at the cost of burning fuel and polluting the atmosphere. You will wrap it in paper tied with a ribbon, which will probably go straight into the trash. This gift is much more than an expenditure of money—it is also environmentally expensive.

Why not give a waste-free gift instead? How about tickets to a community theater, a massage, or a home-cooked organic meal? Why not give your time to share the pleasure of a trip to the movies, a concert, or sporting event.

Iceberg, Greenland

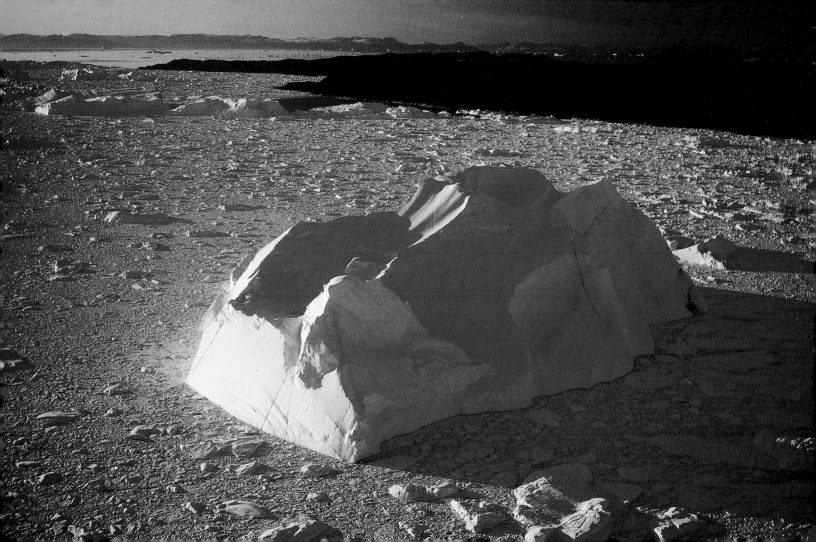

Avoid total treatments in the garden.

Many chemicals regarded as too dangerous are now banned in industrialized countries, yet they are still on the market in developing countries, where 30% of the pesticides sold do not comply with international standards.

If you must use a chemical treatment in your garden, avoid total treatments: lindane and atrazine kill indiscriminately, eliminating earthworms, which aerate the soil, and beneficial insects, as well as harming birds and the health of the user. Read the information on the packaging, and choose products described as authorized for garden use: they have less impact on the environment. Whatever treatment you use, if you must throw out what is left over, remember that the place for toxic substances is the hazardous-waste disposal facility, not the garbage can.

River, Iceland

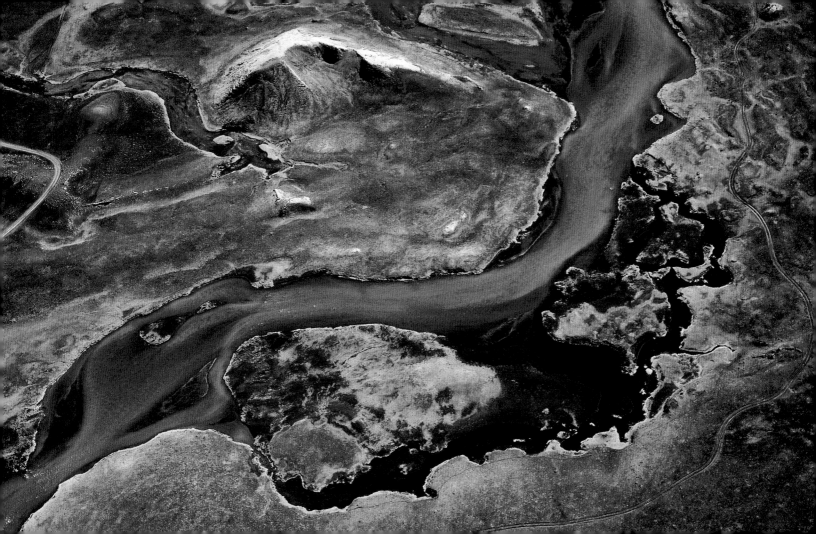

Keep warmth in by insulating your home.

Energy demand in the developing nations of Asia, including China and India, is projected to more than double over the next 25 years. Energy consumption there already has increased dramatically: from 1980 to 2001, India's rate of consumption increased by 208%, mostly due to rapid urbanization and increasing population. China's increased by 130%. The world cannot continue to sustain this output of energy—the environmental impacts are simply too great.

You can save energy by improving insulation. On winter nights, increase the efficiency of your heating by drawing the curtains on each window. During the winter, seal your windows with plastic or foam insulation.

Kilauea volcano, Hawaii

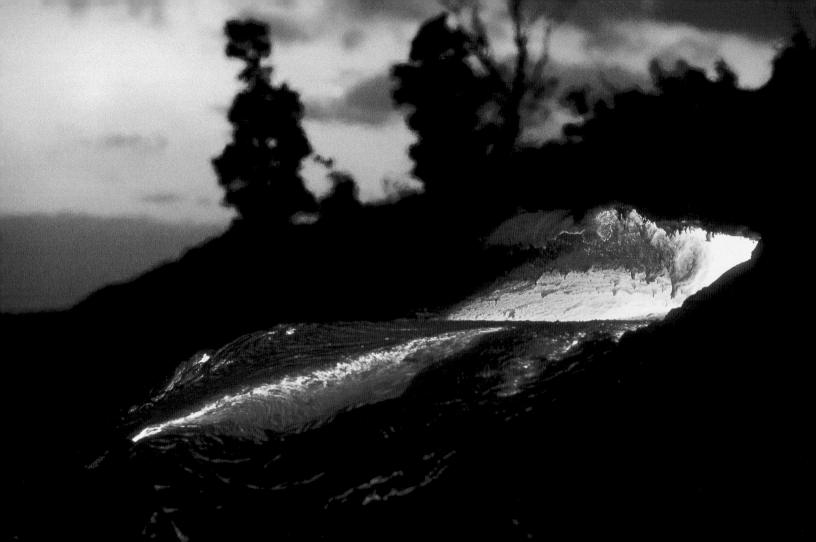

December 15

Educate your children.

Indiscriminate use of new technologies; private and state economic interests looking for short-term gain; and disregard for both the common good and for the consequences for future generations are at the foundation of the dangerous situation facing the earth today. We cannot shrug off our responsibility as consumers and as citizens.

———

Explain to your children that the Western model of consumption has limits. Teach them to have concern for the environment. Be firm about saving electricity, turning off faucets, and turning off the computer when it is not being used. Set an example! When education succeeds, it is often a result of having a model to follow every day.

Glacier, Alaska

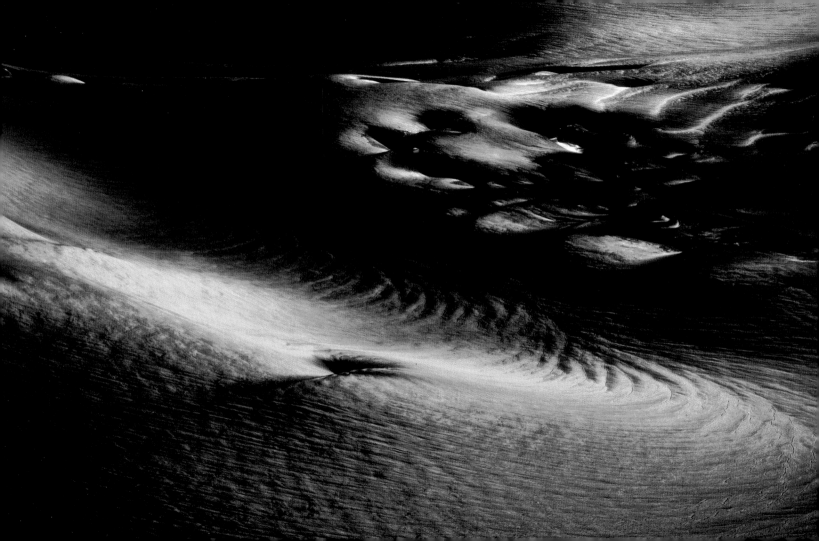

Run the washing machine only when it is full.

Although intolerable inequality still exists in the world, the quality of life is improving for a growing proportion of humanity. The more our standard of living rises, however, the more water each person uses. Indeed, our modern lifestyle is very greedy for water.

───────────

A washing machine uses 50 gallons of water per cycle. To cut your water consumption, take care not to use the washing machine unless you have a full load of laundry to do. When looking to replace your washing machine, invest in a front-loading machine: they generally use 40% less water than top-loading machines.

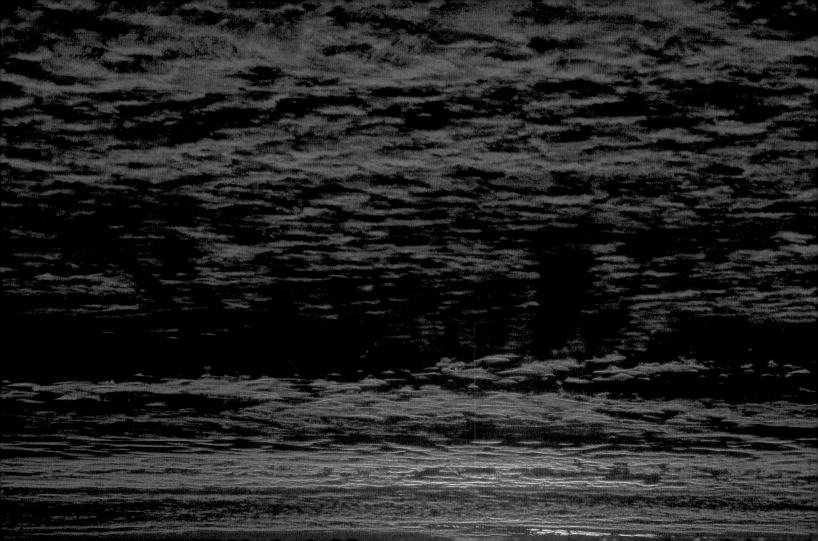

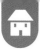

Use wood for heating.

America's forests cover 745 million acres, or 33% of the entire country. Of that total U.S. forested area, 495 million acres, or 67%, are commercial forests that are used to produce timber for wood products. As a source of energy, wood does not contribute to global warming. Although burning it releases carbon dioxide, a greenhouse gas, the amount given off is the same as the amount absorbed while the tree was growing.

———

Wood heating is more environmentally friendly than electric or gas. Consider using it for your second home, or if you live near forested regions where transport costs will be lower.

Geyser valley, Kamchatka, Russia

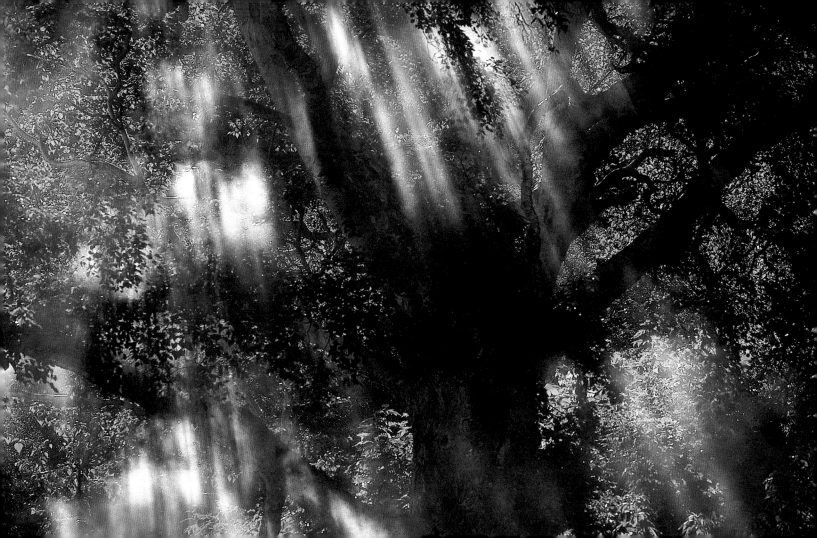

Visit threatened habitats to get to know them better.

The National Parks System in North America covers approximately 84 million acres over 387 separate sites. Around 25% of all species on federal endangered or threatened lists are found in our parks, or rely on them for part of their habitat needs. At the Great Smoky Mountains National Park's All Taxa Biodiversity Inventory (ATBI), scientists and volunteers are documenting the entire register of life within the park's boundaries. This ambitious project is expected to last 15 years. By the end of 2004, the project had identified 543 species new to science, and more than 3,300 species previously not known to inhabit the Great Smoky Mountains National Park.

──────────

There are organizations devoted to defending these natural habitats and the species that live in them. Take part in the visits they organize for the public. Getting to know nature better is a step toward helping protect it.

Red ibises, Orinoco, Venezuela

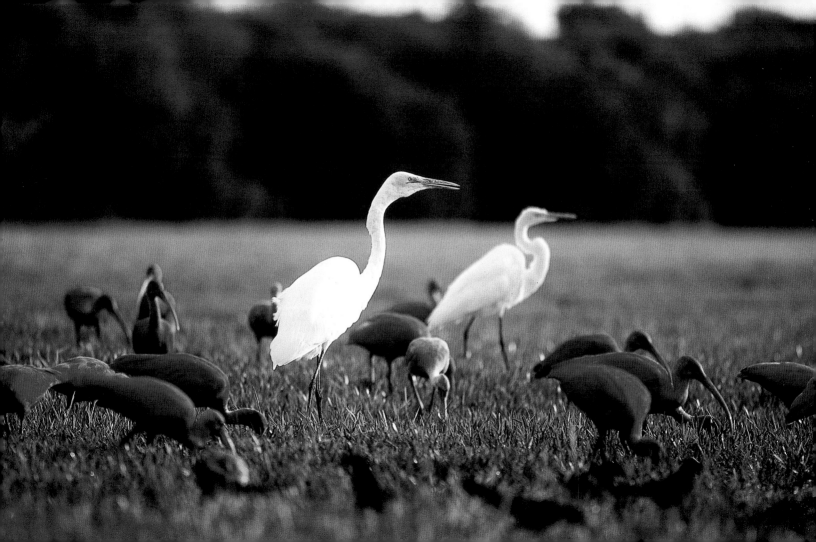

Use compact fluorescent bulbs.

If every household in the United States replaced one light bulb with a compact fluorescent light bulb (CFL), it would prevent an amount of pollution equivalent to removing 1 million cars from the road. Although their upfront cost is much more than the normal incandescent light bulb, over their life-time they will use up to 66% less energy and last 10 times as long. The savings is unquestionable.

Most states will accept CFLs in the normal trash stream, but check before putting them in the trash. They do contain a trace amount of mercury, but it is so minute it is not regulated by the EPA. If every American family switched to CFLs we could save 31.7 billion kilowatt-hours of electricity every year—enough to light a third of U.S. households for a year.

Ol Doinyo Lengai volcano, Tanzania

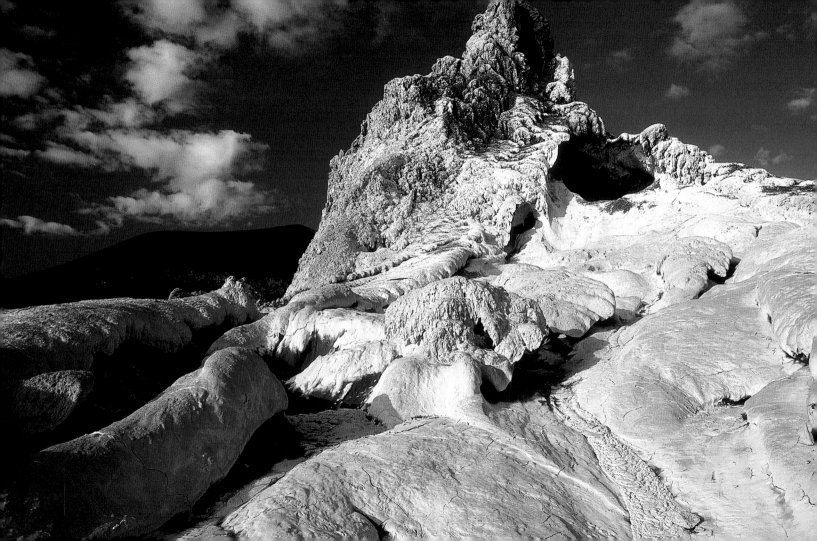

Protect the ozone layer.

Ozone is a gas that occurs naturally in the atmosphere. It is beneficial, and acts as a screen to protect living things from the sun's harmful rays. In 1985, a hole was discovered in the ozone (it is, more accurately, an area where the ozone is less concentrated) above the Antarctic. Without its shield, the earth and human beings are exposed to certain ultraviolet solar rays that can cause skin cancer and eye diseases, and disrupt the growth of plankton, which are a vital base of the food chain.

An international treaty banned the use of chlorofluorocarbons (CFCs, which were found to be responsible for the destruction of the ozone layer). Make sure the products you buy are ozone friendly.

Clouds, Hawaii

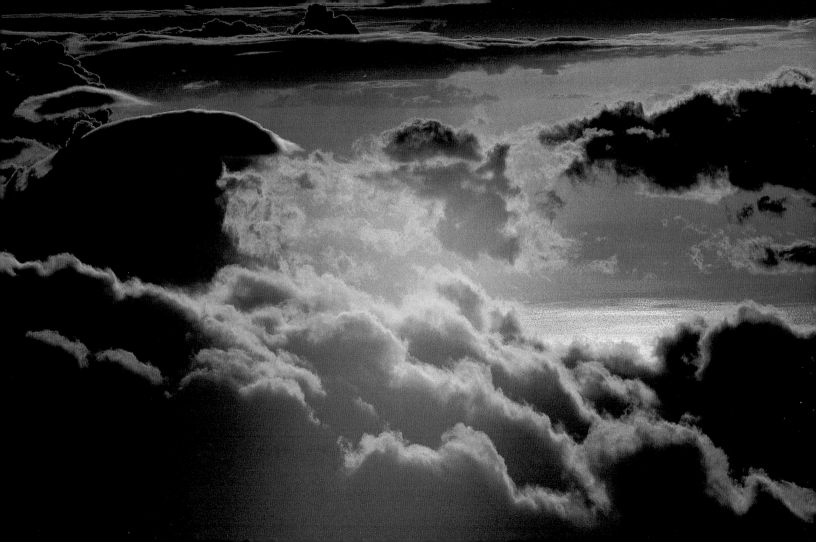

Celebrate Christmas sustainably.

When Christmas approaches, the developed world becomes gripped by a frenzy of consumption, and good environmental resolutions are temporarily forgotten. A fifth more trash is thrown out at Christmas than during the rest of the year.

You can be creative and make your own Christmas tree decorations rather than buying a plastic angel that was manufactured on the other side of the world and will perch at the top of the tree for just a few days before being thrown out. Make a donation or give your time to a charity.

Lava, Kilauea volcano, Hawaii

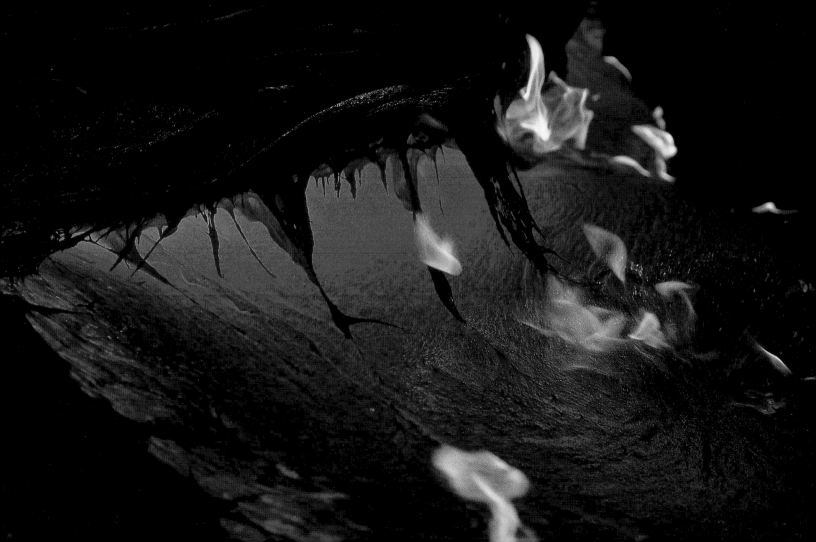

Use less wrapping paper.

Every second an area of tropical forest the size of a football field vanishes from the planet. Every year 78 million acres of rainforest are destroyed, including the extinction of 137 plant and animal species every day. Tropical forests are home to more than half the world's biodiversity.

Each year, millions of trees end up as wrapping paper. Use ribbon or cord, instead of sticky tape, to fasten your gift-wrappings: then you can reuse the wrapping paper instead of tearing it up and throwing it out.

Grasses, United States

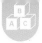

Give fair-trade toys as presents.

At a time when half of humanity lives on less than $2 per day, Americans spent $6.4 billion dollars on Christmas decorations alone and more than twice that much on presents. Sixty-three percent of toys are made in Southeast Asia, sometimes by children and with no regard for the social rights of workers, to meet demand from wealthy countries.

If you have had enough of receiving useless Christmas presents, gadgets that soon break and are eventually discarded, plastic toys that pollute, and packaging that contributes to wastage and produces more waste, then give fair-trade toys and waste-free presents. Pay more attention to the social and environmental quality of your purchases.

Denali massif, Alaska

Demand products bearing certified eco-labels.

A myriad of confusing environmental labels exist in the United States, most of which do not have any regulation or oversight. The United States Department of Agriculture's certified organic label is the most heavily regulated; other organic claims should be questioned. Several certified labels go beyond the USDA requirements for organics; for example, biodynamic farming regulates the conditions of farm and community connections, as well as pesticide and fertilizer use.

Before you spend money on a particular product that claims to be environmentally friendly, do a little background research. The Consumers Union has an entire Web site devoted to eco-labels.

Bristlecone pine, United States

Make your own greeting cards.

To date, scientists have counted 1.5 million plant and animal species on Earth and estimate there are 15 million in all. Every day, however, several species disappear before we have even recorded their existence. Deforestation is thought to be causing the extinction of 27,000 diverse rainforest species—especially plants and insects—every year. The production of newspapers consumes more than 1,300 tons of paper every day. Since making just one ton of paper requires 2.6 tons of wood, the amount of deforestation required is almost unimaginable.

When you need to send greetings, choose an e-card (a card sent by email), or one that is printed on recycled paper. Better still, be creative and make your own greeting card from recycled or recovered paper and materials.

Glacier National Park, United States

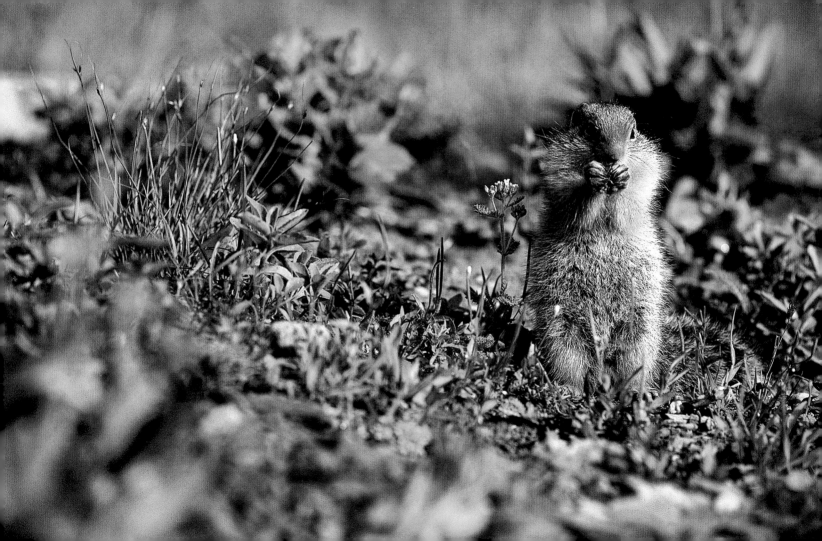

When traveling, respect the environment as you do at home.

In developing countries, the conditions under which tourists live, with swimming pools, air-conditioning, and excessive living areas, often divert natural resources at the expense of the people who live there, or the ecosystem at large. For example, a single cruise ship produces 7,000 tons of waste every year. However, some tourist destinations are attempting to reverse this trend. The Seychelles, a group of islands northeast of Madagascar in the Indian Ocean, introduced a $90 tax on travelers entering the islands. Revenue will be used to preserve the environment and improve tourism facilities.

———————————

Abroad, as at home, respect the environment and its resources: do not waste water; switch off the light and television before leaving your hotel room; do not drop your garbage indiscriminately; and use public transport.

Namib Desert, Namibia

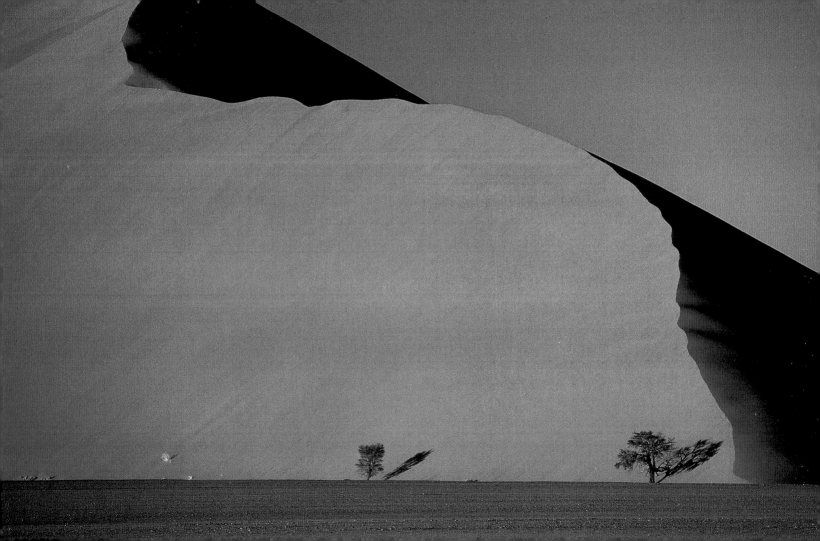

Learn to decipher logos on packaging.

According to the Federal Trade Commission, the "recyclable" label indicates a product can be separated from the waste stream and reused again in some fashion, although the label gives no indication of how environmentally friendly the packaging is.

The difference between recyclable and recycled—that is, between what is possible and what actually happens—may depend on you and whether you sort your waste. To avoid misunderstandings, learn to decipher the array of marks and logos on packaging, and ask your local recycling center what they will accept.

Tassili n'Adjer, Algeria

Turn down the heat when you are away from home.

Contrary to what is widely believed, lowering the temperature setting of heating does not cause extra consumption when the system is turned up again. For every degree you turn down your heat, you will save 5% on your heating bill.

Don't wait to turn down the thermostat. During the working day and when you are away for the weekend, turn the heating down 10 degrees below the temperature you usually find comfortable. When you are away for longer, set it just high enough to avoid freezing. On a daily basis, lower the temperature by 1 degree: you will be doing your heating bill and the environment a lot of good.

Galápagos Islands

Make socially and environmentally responsible investments.

Some banks contribute to increasing the debt burdens of developing countries; favor the manufacture or sale of arms; or support dictatorial regimes through trade associations. Socially Responsible Investing (SRI) on the other hand, not only looks at the bottom line, but also at the environmental and social impact of where your money goes. SRI seeks out companies that demonstrate that they have obligations toward the environment and society, and not just to the consumer; companies that develop collaborative relationships with employees and investors; and finally, businesses that are honest and transparent in their reporting processes.

Make ethical investments. Show business that there is more to the bottom line—that improving the conditions of the planet and our societies is just as important as making a buck.

Rock painting, Australia

Install energy-efficient lighting.

Depending on the choice of light bulb, a user can have 10 hours or 40 hours of light for the same cost. Compact fluorescent light bulbs use between 20% and 25% less electricity, and last 6 to 10 times longer than a regular filament bulb. Don't be turned off by the initial cost of compact fluorescent bulbs. Though they are initially more expensive, you save money in the long run. If you pay $.08 per kilowatt-hour for your electricity, a CFL can save you $45 over the lifetime of the light bulb.

If your house is already fitted with compact fluorescent bulbs, do the same at your office, your workplace, and your children's school. If everyone in the United States used energy-efficient lighting, we could retire 90 average-sized power plants.

Ice floe, Alaska

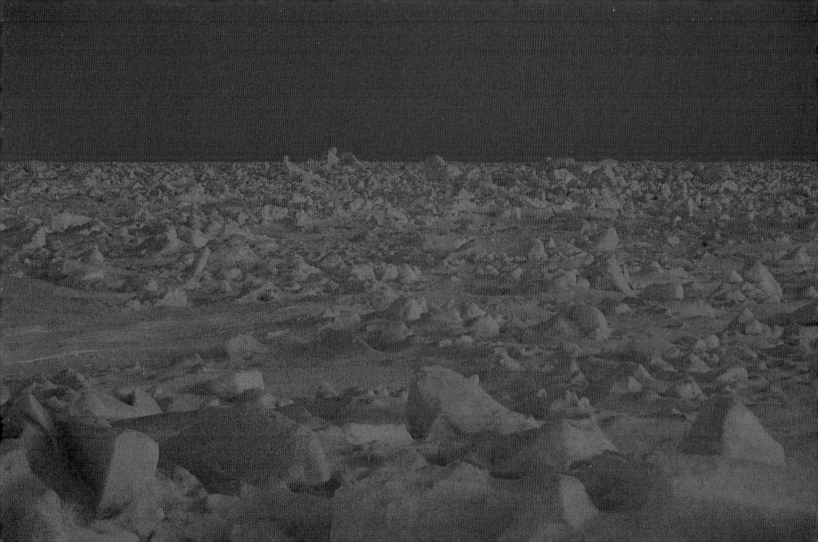

Be a responsible consumer: choose your purchases carefully.

Everything we buy has a direct or indirect effect on the environment. When buying a product we must learn to ask ourselves several questions: How was it made? Did its manufacture produce pollution? Does it use too much energy? Can the packaging be recycled? Does the availability of this product here mean the depletion of resources elsewhere?

Action to protect the environment can begin at the market stall or supermarket shelf. Begin to think about the items that you can buy from local craftspeople—candles, honey, or greeting cards, for example—because the closer you are to the source of the product, the easier it is to estimate its ecological footprint.

Gray whale, Mexico

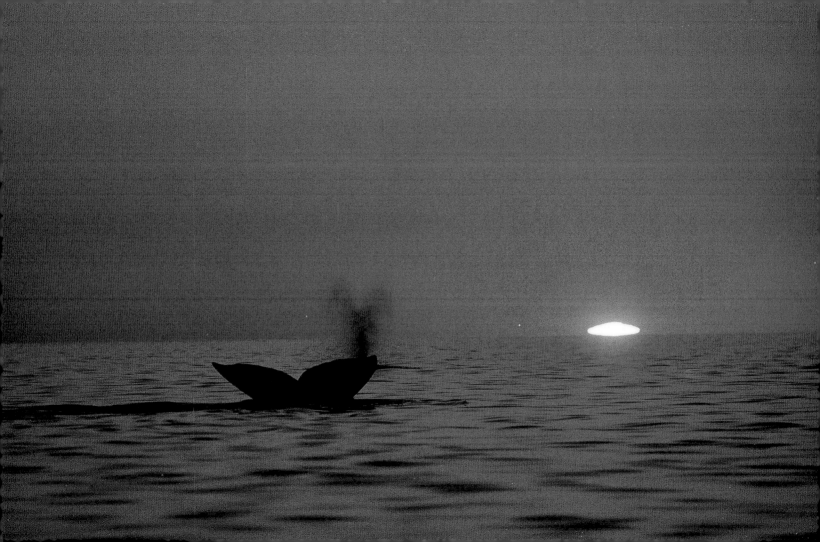

Web sites

AIR

The Indoor Air Quality Association: www.iaqa.org

AGRICULTURE

The United States Department of Agriculture (USDA): www.usda.gov

International Federation of Organic Agriculture Movements: www.ifoam.org

USDA's National Organic Program: www.ams.usda.gov/nop

The Organic Consumers Association: www.organicconsumers.org

Information on pesticides from an Indian NGO: www.toxicslink.org

EarthSave promotes a shift toward a healthy plant-based diet: www.earthsave.org

Food Alliance, which promotes sustainable agriculture: www.foodalliance.org

AGRICULTURE/BUYING LOCALLY AND IN SEASON

Electronic directory of local produce sources: www.localharvest.org

Information on buying local produce: www.foodroutes.org

Electronic directory of Community Sponsored Agriculture Programs: www.csacenter.org

AGRICULTURE/GENETICALLY MODIFIED PRODUCTS

A campaign to label genetically engineered foods: www.thecampaign.org

Greenpeace's GMO site: www.greenpeace.org/international/campaigns/genetic-engineering

AGRICULTURE/ORGANIC COTTON

Resources on organic cotton: www.sustainablecotton.org

Source for organic and environmentally friendly bedding: www.ahappyplanet.com

Source for sustainable and ethically produced clothing: www.americanapparel.net

Source for environmentally friendly clothing: www.patagonia.com/enviro

AGRICULTURE/ORGANIC FARMING

The Organic Trade Association: www.ota.com

The Slow Food movement: www.slowfood.com

Information on pesticides and produce: www.foodnews.org

BIODIVERSITY

Convention on International Trade in Endangered Species of Wild Fauna & Flora: www.cites.org

Traffic, a joint program of the World Wildlife Fund and the World Conservation Union: www.traffic.org

The International Affairs Section of the U.S. Fish and Wildlife Service: www.international.fws.gov

BIODIVERSITY/BIRDS

National Audubon Society: www.audubon.org

Birdlife International: www.birdlife.org

BIODIVERSITY/NATURAL HABITATS

The Global Conservation Organization: www.panda.org

The National Parks Service: www.nps.gov

The National Wildlife Federation: www.nwf.org

The United States Fish and Wildlife Service: www.fws.gov

Wetlands International: www.wetlands.org

BUSINESS/ENVIRONMENTAL MANAGEMENT, ENVIRONMENTAL AUDIT COMPANIES

Environmental audit company: www.naturalstep.org

Environmental audit company: www.goodcompany.com

The Pew Center's site on climate change: www.pewclimate.org

CLIMATE CHANGE/GREENHOUSE EFFECT

Intergovernmental Panel on Climate Change: www.ipcc.ch

The United Nations Framework Convention on Climate Change: http://unfccc.int/2860.php

Solutions for Climate Change: www.climatechangesolutions.com

Climate Action Network: www.climatenetwork.org

Map of the local consequences of global warming: www.climatehotmap.org

Nine scientists blogging about climate change: www.realclimate.org

NRDC's global warming Web site: www.nrdc.org/globalWarming

CONSUMPTION/CONSUMER PRESSURE GROUPS ENVIRONMENT

Public Interest Research Group: www.pirg.org

The Consumers Union: www.consumersunion.org

Public Citizen—protecting health, safety and democracy: www.publiccitizen.org

Consumers International—the global voice for consumers: www.consumersinternational.org

CONSUMPTION/ECO-LABELS

The Consumers Union site analysis of eco-labels: www.eco-labels.org

Information on biodynamic labeling: www.demeter-usa.org

Animal-friendly cosmetics: www.leapingbunny.org

CONSUMPTION/ETHICAL CONSUMPTION

Consumer action and advocacy: www.consumer-action.org

Global Policy monitors policy making at the United Nations: www.globalpolicy.org

The Humane Society of the United States: www.hsus.org

Project Laundry List's site on personal decision-making and the environment: www.laundrylist.org

Green matters—buyer's guide to living green: www.greenmatters.com

CONSUMPTION/OVERCONSUMPTION

Tools for conscious, simple, healthy and restorative living: www.simpleliving.net

Buy Nothing Day information: www.adbusters.org/metas/eco/bnd

CONSUMPTION/SUSTAINABLE AND ENVIRONMENTALLY FRIENDLY PRODUCTS

Electronic information clearinghouse on organic products: www.organic.org

Online source for organic and natural products: www.shopnatural.com

Green merchant guide: www.convictionsoftheheart.com

Organic Trade Association's searchable directory of organic products: www.theorganicpages.com

Directory of eco-friendly products: www.greenpeople.org

Environmentally friendly products for your baby: www.purebeginnings.com

Online source for environmentally friendly products for the entire family: www.earthyfamily.com

Online information and product guide for environmentally friendly choices: www.thegreenguide.com

Electronic information clearinghouse on organic products: www.greenseal.org

CONSUMPTION/RECYCLED PRODUCTS

Recycled products cooperative: www.recycledproducts.org

Grassroots Recycling Network: www.grrn.org

ENERGY

Renewable Energy Access, an information clearinghouse: www.renewableenergyaccess.com

National Center for Appropriate Technology: www.ncat.org

United States Department of Energy's Energy Efficiency and Renewable Energy: www.eere.energy.gov

Smart energy choices guide: www.energyguide.com

Source for energy tips: www.consumerenergycenter.org

ENERGY/GREEN ELECTRICITY

Renewable electricity certification program: www.green-e.org

MassEnergy Consumers Alliance: www.massenergy.com

Energy Alternatives for Canada: www.energyalternatives.ca

Resource on wind energy: www.communityenergy.biz

ENERGY/LIGHTING, HEATING, AIR CONDITIONING

American Council on an Energy-Efficient Economy: www.aceee.org

Sustainable Development International Corporation: www.smartoffice.com

ENERGY/HOUSEHOLD APPLIANCES, ELECTRIC EQUIPMENT

Energy Star, an international energy-efficiency label for appliances: www.energystar.gov

ENERGY/RENEWABLE ENERGY

Center for Renewable Energy and Sustainable Technology: www.crest.org

Source for renewable wind energy: www.visionquestwind.com

American Wind Energy Association: www.awea.org

Solar Electric Power Association: www.solarelectricpower.org

Renewable Energy Action Project: www.reapcoalition.org

ENVIRONMENTALLY FRIENDLY BUILDINGS

The United States Green Building Council: www.usgbc.org

The Low Impact Development Center: www.lowimpactdevelopment.org

EPA's site on green building: www.epa.gov/greenbuilding

FAIR ECONOMICS/ETHICAL FUNDS

www.socialfunds.com

www.socialinvest.org

Education on the environment, young people www.projectwild.org

National Wildlife Organization's Education: www.nwf.org/education

Council for Environmental Education: www.c-e-e.org

National Environmental Education and Training Foundation: www.neetf.org

FAIR ECONOMICS AND LENDING/ETHICAL INVESTMENT

www.greenmoneyjournal.com

www.firstaffirmative.com

FAIR TRADE

Fair trade certified products: www.transfairusa.org

Fair trade products: www.equalexchange.com

Global Exchange, an international human rights organization: www.globalexchange.org

The Fair Trade Resource Network: www.fairtraderesource.org

Fair-Trade Labeling Organizations: www.fairtrade.net

FORESTS

Forest Stewardship Council: www.fsc.org

Great Smokey Mountains National Park All Taxa Biodiversity Inventory: www.discoverlifeinamerica.org

GARDENING

National Coalition Against the Misuse of Pesticides: www.beyondpesticides.org

LEISURE

National Ski Areas Association Environmental Charter: www.nsaa.org/nsaa/environment

Charter for responsible diving: www.longitude181.com/charte/charte-en.html

SUSTAINABLE DEVELOPMENT

International Institute for Sustainable Development: www.iisd.org

UN Website for the 2002 World Summit on Sustainable Development: www.johannesburgsummit.org

Sustainable Development International: www.sustdev.org

Sustainable Development Communications Network: www.sdcn.org

Citizens Network for Sustainable Development: www.citnet.org

TRANSPORTATION

Information on solutions to global warming: www.cleanair-coolplanet.org

Calculate greenhouse gas emissions from airplane flights: www.chooseclimate.org/flying/mapcalc.html

TRANSPORTATION/ALTERNATIVE METHODS

www.bikemonth.com

www.bikeleague.org

www.bike-to-work.com

www.bicyclefriendlycommunity.org

Register your bike against theft: www.nationalbikeregistry.com

TRANSPORTATION/EMISSIONS

The U.S. Department of Energy's Web site on cars and fuel: www.fueleconomy.gov

Find information on carbon dioxide emissions: www.cdc.gov

TRAVEL/ENVIRONMENTAL

Hostelling International, USA: www.hiusa.org

The international eco-label for tourism facilities: www.green-key.org

Registry of hotels that operate on sustainability principles: www.greenhotels.com

Information on sustainable travel in the European Union: www.eco-label-tourism.com

Sustainable travel and tourism information: www.greenglobe21.com

TRAVEL/ENVIRONMENTAL VOLUNTEERING

Eco-volunteer Nature Travel: www.ecovolunteer.org

Voluntary Work Information Service: www.workingabroad.com

Global Volunteers: www.globalvolunteers.org

Volunteer vacations: www.volunteeramerica.net/vacations.htm

TRAVEL/SUSTAINABLE AND EQUITABLE TOURISM

National Geographic's sustainable tourism Web site: www.nationalgeographic.com/travel/sustainable

World Tourism Organization: www.world-tourism.org

VOLUNTEER WORK

www.i-to-i.com

www.volunteermatch.org

WASTE

EPA's information about Municipal Solid Waste: www.epa.gov/epaoswer/non-hw/muncpl

Online guide on composting: www.howtocompost.org

National Recycling Coalition: www.nrc-recycle.org

Zero Waste America program: www.zerowasteamerica.org

Online resource recovery program: www.freecycle.org

WASTE/ADVERTISING/JUNK MAIL REDUCTION

United States Postal Service's junk-mail reduction website: www.stopthejunkmail.com

Techniques for reducing your junk mail: www.junkbusters.com

Techniques for reducing your junk mail: www.privacyrights.org

WASTE/MEDICINES

Information on donating old medication: www.aidforaids.org

WASTE/DONATION OF EYEGLASSES

www.lenscrafters.com

www.uniteforsight.org

WASTE/DONATION OF PROFESSIONAL CLOTHES

www.cetweb.org

www.dressforsuccess.org

www.salvationarmyusa.org

WASTE/OFFICE, BUSINESS

Computer equipment donation: sharetechnology.org

Environmentally sustainable paper: www.rethinkpaper.org

WATER

American Water Resources Association: www.awra.org

American Rivers: www.americanrivers.org

International Rivers Network: www.irn.org

United States Geological Survey's Water Resources Webpage: http://water.usgs.gov

Information Clearinghouse on Rainwater Recovery: www.rain-barrel.net

Center for Watershed Protection: www.cwp.org

WATER/THE SEA/POLLUTION

The Ocean Conservancy: www.oceanconservancy.org

International Coastal Cleanup: www.coastalcleanup.org

Save Our Seas: www.saveourseas.org

Global web services on oceans, coasts, and islands: www.globaloceans.org

WATER/THE SEA/POLLUTION NOTIFICATION

www.blueflag.org

www.surfrider-europe.org

WATER/THE SEA/FISHING

The Marine Stewardship Council: www.msc.org

UNITED STATES/ORGANIZATIONS INVOLVED WITH THE ENVIRONMENT

Environmental Protection Agency (EPA): www.epa.gov

Energy Information Administration: www.eia.doe.gov

Department of Energy: www.energy.gov

EPA Hazardous Waste Cleanup: www.clu-in.org

UNITED STATES/NATIONAL ENVIRONMENTAL GROUPS AND MULTI-ISSUE WEBSITES

International Council for Local Environmental Initiatives: www.iclei.org

Union of Concerned Scientists: www.ucsusa.org

World Wildlife Fund: www.worldwildlife.org

Greenpeace International: www.greenpeace.org

Sierra Club: www.sierraclub.org

Natural Resources Defense Council: www.nrdc.org

Earth 911: www.1800cleanup.org

The Trust for Public Land: www.tpl.org

The Nature Conservancy: www.nature.org

The Pollution Information Site: www.scorecard.org

Earth Share, a nationwide network of environmental organizations: www.earthshare.org

INTERNATIONAL/MAIN ORGANIZATIONS AND INSTITUTIONS

The World Conservation Union: www.iucn.org

Conservation International: www.conservationinternational.org

Earth Policy Institute: www.earth-policy.org

Worldwatch Institute: www.worldwatch.org

World Resources Institute: www.wri.org

INTERNATIONAL/UNITED NATIONS ORGANIZATION

Food and Agriculture Organization of the United Nations: www.fao.org

The United Nations Environment Program: www.unep.org

The United Nations Development Program: www.undp.org

The United Nations Development Program—World Conservation Monitoring Center: www.unep-wcmc.org

The World Health Organization: www.who.int

The United Nations Educational, Scientific and Cultural Organization: www.unesco.org

Bibliography

Bartillat, Laurent de and Simon Retallack. *Stop.* Paris: Éditions du Seuil, 2003.

Bouttier-Guérivé, Gaëlle and Thierry Thouvenot. *Planète attitude, les gestes écologiques au quotidian.* Paris: Éditions du Seuil, 2004.

Callard, Sarah and Diane Millis. *Le Grand guide de l'écologie.* Paris: J'ai lu, 2003.

Chagnoleau, Serge. *L'écologie au bureau.* Paris: Maxima, 1992.

Dubois, Philippe J. *Un nouveau climat.* Paris: Éditions de La Martinière, 2003.

Dubois, Philippe J. *Vers l'ultime extinction? la biodiversité en danger.* Paris: Éditions de La Martinière, 2004.

Dupuis, Marie-France and Bernard Fischesser. *Guide illustré de l'écologie.* Paris: Éditions de La Martinière, 2000.

Glocheux, Dominique. *Sauver la planète, mode d'emploi.* Paris: Éditions J. C. Lattès, 2004.

Matagne, Patrick. *Comprendre l'écologie et son histoire.* Paris: Delachaux et Niestlé, 2002.

Ramade, François. *Dictionnaire encyclopédique de l'écologie et des sciences de l'environnement.* Paris: Dunod, 2002.

Children:

Durand, Jean-Benoît. *Protégeons notre planète.* Paris: Flammarion – Père Castor, 2002.

Jankéliowitch, Anne. *Y a-t-il un autre monde possible?* Paris: Éditions de La Martinière jeunesse, 2004.

Laffon, Martine. *Sauvons la planète.* Paris: Éditions de La Martinière jeunesse, 1997.

Masson, Isabelle. *L'écologie, agir pour la planète.* Toulouse: Milan Jeunesse, 2003.

Acknowledgments

I would like to particularly thank:

My editor Hervé de La Martinière for his loyalty.

Benoît Nacci for his attentive photographic selection.

Anne Jankéliowitch for the quality of her research and her work on the 365 texts that accompany my photographs.

Catherine Guigon and Emmanuelle Halkin for their thoughtful arrangement of the texts.

The team at Éditions de La Martinière: Dominique Escartin, Sophie Giraud, Audrey Hette, Marianne Lassandro, Valérie Roland, Isabelle Perrod, Sophie Postollec, Cécile Vanderbroucque.

Thanks to:

Everyone who participated in these trips at close quarters or from a distance: Claude Arié, Yann Arthus-Bertrand, Jean-Philippe Astruc, Jacques Bardot, Allain Bougrain Dubourg, Jean-Marc Bour, Monique Brandily, Yves Carmagnolles, Sylvie Carpentier, Jean-François Chaix, Carolina Codo, Richard Fitzpatrick, Alain Gerente, Patrice Godon, Robert Guillard, Nathalie Hoizey, Gérard Jugie, Janot and Janine Lamberton and the Inlandsis expedition team, Monique Mathews, Frédéric and Mimi Neema, Stephan Peyron, Philippe Poissonier, Gloria Raad, Le Raie Manta club, Margot Reynes, Hoa and Jean Rossi, John and Linda Rumney and the Undersea Explorer team, Diane Sacco, Hervé Saliou, Vincent Steiger, Sally Zalewski...

Gero Furcheim, Gaelle Guoinguené, Jean-Jacques Viau at Leica, who have been loyal followers for so long. I worked with excellent Leica R9 and M7 cameras and 19 mm to 280 mm lenses that are reliable in any circumstance.

Marc Héraud and Bruno Baudry at Fujifilm for their help and support. All the photos were shot on Fujichrome Velvia (50 Asa) films.

Olivier Bigot, Denis Cuisy de Rush Labo, Jean-François Gallois de Central Color, and Stephan Ledoux at *cité de l'Image.*

The Richard Lippman team at Quadrilaser.

My apologies to all those I have forgotten to name and who helped me in this work.

I am sincerely sorry and thank them wholeheartedly.

Project Manager, English-language edition: **Magali Veillon**
Editor, English-language edition: **Marion Kocot**
Design Coordinator, English-language edition: **Shawn Dahl**
Jacket design, English-language edition: **Mark LaRivére** and **Shawn Dahl**
Illustrator: **Izumi Cazalis**

Library of Congress Control Number: 2005927761

ISBN 0-8109-5951-8 (hardcover)

Copyright © 2005 Éditions de La Martinière, Paris
English translation copyright © 2005 Harry N. Abrams, Inc.

Printed and bound in France - n° L20324B
10 9 8 7 6 5 4 3 2 1

Harry N. Abrams, Inc.
100 Fifth Avenue
New York, NY 10011
www.abramsbooks.com

Abrams is a subsidiary of LA MARTINIÈRE GROUPE